—

OFF LIMITS

—

OFF LIMITS

—

RUTGERS UNIVERSITY

AND THE

AVANT-GARDE,

1957–1963

—

EDITED BY

JOAN MARTER

WITH ESSAYS BY SIMON ANDERSON,

JOSEPH JACOBS, JACKSON LEARS,

JOAN MARTER, AND KRISTINE STILES

THE NEWARK MUSEUM
NEWARK, NEW JERSEY
AND
RUTGERS UNIVERSITY PRESS
NEW BRUNSWICK, NEW JERSEY, AND LONDON

Off Limits: Rutgers University and the Avant-Garde, 1957–1963
has been published to accompany the exhibition of the same
name, shown at the Newark Museum from February 18 through
May 16, 1999. The exhibition and related public programs
are made possible through the generosity of The Henry Luce
Foundation, Inc. and The Geraldine R. Dodge Foundation, Inc.
This project is supported in part by the National Endowment
for the Arts.

NEW JERSEY STATE COUNCIL ON THE ARTS

NATIONAL ENDOWMENT FOR THE ARTS

Exhibition Curator: Joseph Jacobs
Co-organizer and Guest Consulting Scholar: Joan Marter
Exhibition Coordinator: Julia Robinson
Exhibition Designer: Stephen Hutchins

THE NEWARK MUSEUM
49 Washington Street
P.O. Box 540
Newark, New Jersey 07101-0540

The Newark Museum receives operating support
from the City of Newark, the State of New Jersey, and
the New Jersey State Council on the Arts/Department of State.
Funding for acquisitions and activities other than operations
must be developed from outside sources.

Library of Congress Cataloging-in-Publication Data

Off limits : Rutgers University and the avant-garde, 1957–1963 / edited
 by Joan Marter ; with essays by Simon Anderson . . . [et al.].
 p. cm.
 Catalog of an exhibition held at the Newark Museum, Newark, N.J.,
Feb. 18–May 16, 1999.
 Includes bibliographical references and index.
 ISBN 0-8135-2609-4 (cloth : alk. paper). — ISBN 0-8135-2610-8
(pbk. : alk. paper)
 1. Artists as teachers—New Jersey—New Brunswick—Exhibitions.
2. Arts, American—New Jersey—New Brunswick—Exhibitions.
3. Arts, Modern—20th century—New Jersey—New Brunswick—
Exhibitions. 4. Avant-garde (Aesthetics)—New Jersey—New
Brunswick—History—20th century—Exhibitions. 5. Rutgers
University—Influence—Exhibitions. I. Marter, Joan M.
II. Anderson, Simon. III. Newark Museum.
NX510.N42N486 1999
707'.1'174942—dc21 98-37637
 CIP

British Cataloging-in-Publication data for this book is available
from the British Library

Designed and typeset by Ellen C. Dawson

Printed by BookCrafters, Inc., Chelsea, Michigan

Manufactured in the United States of America

CONTENTS

PLATES

ILLUSTRATIONS

FIGURES

Beginning in 1957, the New Brunswick campus of
Rutgers University, the State University of New
Jersey, slowly evolved into a hotbed for avant-garde
art. This was the year that Allan Kaprow, who was
teaching at Rutgers College, the men's school, started
working on his Environments with sound, lights, and
odors, which he first exhibited at the Hansa Gallery in
New York in 1958. In 1958, Robert Watts, who was
teaching in the art department at Douglass College,
the women's school at Rutgers, began making
assemblages that incorporated light and sound. That
same year, Kaprow and Watts, along with artist
George Brecht, a scientist working at nearby Johnson
& Johnson, completed a grant proposal begun in
1957 that they called "Project in Multiple
Dimensions." It was their hope to receive funding to
establish at Rutgers an institute for experimental art
that would integrate art with science, among other
disciplines.

While the artists were not immediately
successful in their funding quest, that did not deter
them from making radical art. Their new art was
designed to break down the barrier between art and
life. Consequently it was based on real objects rather
than on abstraction or on the illusionistic magic of
paint on canvas, chiseled marble, or cast bronze.
This art married, in the words of George Segal,
"physical reality and spiritual insight." It was often a
participatory art, where the visitor handled the object
and played a role in its creation, confusing the issue
of who was actually the maker and who determined
the meaning of the work. It was equally often a
temporary or ephemeral art, made of throwaway
materials that challenged the premise that art was

valuable and precious. By 1959, Watts, Brecht, and Kaprow had created Environments, Happenings, and Events, and by 1961 they had conceived Conceptual Art and Mail Art as well. Pop Art had even appeared in New Brunswick by then, if Robert Watts's 1958 appropriations of commercial logos can be considered "proto-Pop." From 1958 to 1960, Kaprow's prize students, Robert Whitman and Lucas Samaras, were keeping pace with their seniors—Whitman by making constructions of disposable materials, as well as Happenings that he called theater pieces; Samaras by making art out of smoke on tinfoil, or razor blades or nails embedded in wood covered with toilet paper, paint, or feathers. Roy Lichtenstein was a conservative, Abstract Expressionist painter when he arrived at Douglass in 1960, but the radical climate at the University transformed him into the Pop artist we know today. The following year, George Segal, who had been teaching extracurricular drawing at Rutgers, developed the work for which he would become famous: white plaster sculptures installed in found environments. And in 1962–63, Geoffrey Hendricks, who had been teaching at Douglass since 1956, began making assemblages of found objects.

Off Limits: Rutgers University and the Avant-Garde, 1957–1963 traces this lost history. Kaprow, Watts, Brecht, Whitman, Samaras, Segal, Lichtenstein, and Hendricks are well known as seminal figures in the history of Happenings, Pop Art, and Fluxus, and for their major role in the evolution of Conceptual Art and Mail Art. Virtually unknown is the fact that they knew each other and that their thinking and styles developed in New Brunswick through their interactions and long dialogues with one another. By 1963, they were identified not with Rutgers but with the international movements and styles they helped develop. They had become New York artists, not New Brunswick artists, as they had been known until then. The fact that Whitman and Samaras had left Rutgers by 1959, Kaprow by 1961, and Lichtenstein and Segal by 1962, helped distance them from a New Jersey context. Brecht, who had never had an affiliation with the University, by 1963 was already looking toward Europe, where he moved shortly thereafter. Only Watts and Hendricks remained at the University.

Off Limits is not a history of art activity at Rutgers, for many wonderful teachers and students from this period have not been included, despite the fact that they, too, went on to have eminently successful careers. Instead, the emphasis is on the role that Rutgers University played in the evolution of the eight artists in the show, and the impact that they in turn had on the evolution of New York art of the 1960s. These eight artists may not have become influential figures without the environment of the University and their dialogue with one another, however brief in some instances. As Roy Lichtenstein will express later in this book in talking about the development of his signature style, "I am sure that if I had stayed in Oswego nothing would have happened."

Off Limits also looks at how two small art departments at Rutgers University blossomed into a leading art school as they embraced a radical teaching philosophy that encouraged experimentation. By the mid-1960s, the school had graduated such well-known artists as Alice Aycock, Gary Kuehn, Mimi Smith, Joan Snyder, Keith Sonnier, and Jackie Winsor. To this day, Rutgers incorporates an innovative, influential school, now called the Mason Gross School of the Arts, staffed with a high-profile faculty and producing top-caliber artists and teachers.

It is with great pride that The Newark Museum has organized the *Off Limits* exhibition and this accompanying book. Given the Museum's major holdings and commitment to scholarship in the field of American art, it is especially fortunate that we have had the opportunity to sponsor research on such a pivotal chapter of American art history that happens to have taken place in New Jersey.

This exhibition and accompanying book would not have been possible without generous external support. On behalf of the Trustees of The Newark Museum, I express our deepest appreciation to The Henry Luce Foundation, Inc.; its Chairman and CEO, Henry Luce III; and Ellen Holtzman, Program Director for the Arts. The Geraldine R. Dodge Foundation has once again shown its support of innovative scholarship, and we thank Scott McVay, the recently retired Executive Director, and

Janet D. Rodriguez, Program Officer. The National Endowment for the Arts has also provided an essential implementation grant. We also thank Dave Barger and Continental Airlines for their ongoing support.

Also on behalf of the Trustees, I thank co-organizers Joan Marter, Professor of Art History at Rutgers University, who served as guest consulting scholar and editor of this book, and Joseph Jacobs, Curator of American Art of The Newark Museum, for his role as curator and organizer of the exhibition. More than five years ago, Professor Marter brought her interest in this topic to our attention. Her devotion to this rich history and her impressive research and editing skills have yielded a publication of great distinction. Joseph Jacobs has been a worthy partner in this endeavor. His excitement about the art and artists of the Rutgers period and his discerning eye have created an exhibition that is both challenging and engrossing.

Once again, I take great pride in commending the enormously capable staff of The Newark Museum for attending to every detail of a complex, multiyear exhibition project. I especially thank Ward L. E. Mintz, Deputy Director for Programs and Collections, for his central role as project supervisor; Isimeme Omogbai, Deputy Director for Finance and Administration; Peggy Dougherty, Director of Development; David Mayhew, Deputy Director for Marketing; David Palmer, Director of Exhibitions; Rebecca Buck, Registrar; Jane Stein, Program Coordinator; and Ruth Barnet, Curatorial Secretary;

as well as their staff members. Project Coordinator Julia Robinson ably assisted both Professor Marter with the book and Mr. Jacobs with the exhibition. I thank the countless others, including Sid Sachs, an independent curator in Philadelphia, who have brought many aspects of this period in American art history to our attention. Among these individuals are the scholarly advisors to the project named in Professor Marter's Introduction, who gave freely of their time and insight to help frame the issues that should be addressed in both the book and the exhibition.

The Newark Museum could not have attempted such an ambitious project without the support and encouragement of Rutgers University, the State University of New Jersey. The Trustees and I express our gratitude and appreciation to Francis L. Lawrence, President; Joseph J. Seneca, Vice President for Academic Affairs; and the staffs of the art department and the Rutgers University Press.

We especially thank the artists whose words appear in this book, who have loaned works or reimagined installations for the exhibition, who have been willing to take this journey of reexamination and reconsideration of a significant but too-little-known period in the evolution of American art along with our scholars and curators. They are, indeed, the wellspring of imagination and creativity from which all that follows has been made possible.

Mary Sue Sweeney Price
Director
The Newark Museum

My interest in this project dates back to the early 1980s, when I offered graduate seminars titled "Art of the 1960s." The exhibition *Blam! The Explosion of Pop, Minimalism, and Performance 1958–1964* opened at the Whitney Museum of American Art in 1984, and my graduate class joined me in contacting Allan Kaprow, George Segal, and Roy Lichtenstein, who were included in the show. These former members of the Rutgers faculty expressed enthusiasm about our plans for an exhibition and publication on Rutgers's special involvement with Pop Art and Happenings. A graduate student in my seminar, Virginia Carnes, wrote a master's essay with the title "Pop Goes Rutgers," in 1985, but an exhibition could not be organized immediately following the Whitney's related efforts.

A full decade later, Joseph Jacobs, curator at the Newark Museum, became interested in planning a show based on Rutgers's important legacy to Happenings, Pop Art, and Fluxus. As part of the museum studies program in the art history department at Rutgers, I offered an exhibition seminar on this topic. Preliminary research and a bibliography prepared by the seminar participants have been of some assistance with the organization of the current project. To Dennis Raverty, Rosemarie Dvorak, Sandra Kozar, Michele Marcantonio, and Ann Helene Iversen, I offer special appreciation.

—

Off Limits is intended to present a group of artists who came together on the Rutgers campus and environs during the 1950s and revolutionized art practices and pedagogy. Inspired by the theoretical pronouncements and aesthetic approaches of Allan

Kaprow, both faculty and students began to explore a new art. As Roy Lichtenstein recalled in a March 1996 interview with me, "Kaprow showed us that art didn't have to look like art." Kaprow's first public Happening took place on the Rutgers campus in April 1958. Lichtenstein produced his first Pop paintings while he was teaching at Rutgers and in close contact with Kaprow and Bob Watts, and George Segal made his first sculptures in plaster while he was an instructor for the Rutgers Sketch Club, and closely involved with his neighbor and friend Allan Kaprow.

Watts, Lichtenstein, Kaprow, and Geoffrey Hendricks were teaching at Rutgers in New Brunswick, and they challenged one another in taking art "off limits"—beyond the limits of the conventional, the predictable—even beyond the progressive, as defined by Abstract Expressionist gesturalism. Their art incorporated the gritty environs, the technological, the everyday, making art radical, outrageous, disturbing: Lucas Samaras painted incendiary nude self-portraits; Kaprow incorporated sounds, smells, and lights into his assemblages and eventually abandoned the production of fixed objects entirely for his Happenings. Watts "borrowed" real stamp machines, and filled them with stamps of his own design, titled *Safe Post*. Performance events by Robert Whitman, Kaprow, and Brecht challenged participants and audiences alike.

Rutgers University also became a prime locus for revitalizing the education of artists after World War II. With the GI Bill available, aspiring artists attended college. Kaprow noted: "It is a fact that though the older artists were often quite intelligent and privately well-read, the style of the time was to suppress that. . . . My generation, which is post-war, had the GI Bill, where everyone went to school for free. To get through it, you had to learn how to speak up" (interview with Kostelanetz, *Theatre of Mixed Means* [New York: Dial Press, 1968], 121).

In the 1950s, the university enrolled art students who also learned philosophy, literature, and art history. The inarticulate studio artist became the sophisticated, well-read aesthete who was frequently called upon to explain his or her ideas. Students were encouraged to learn about Marcel Duchamp, Dada, Futurism, and Surrealism. They were urged to push

themselves beyond their instructors—to explore a personal direction and to maximize their creative energies. Mastering technical skills was no longer the reason to take studio classes; rather, aspiring artists sought the interchange of ideas with their mentors. Advanced students were urged to become entirely professional, to begin exhibiting their work and participating in art world activities. Opportunities for exhibitions and performance events took place on the Rutgers campus, but these young adults were also expected to go to New York, where the downtown art scene included co-op galleries and avant-garde theater.

From the changing concepts about art practice that were percolating in New Brunswick emerged a startling new art, an art of the industrialized fifties, a nonrelational and totally participatory art that was opposed to the formalist dictates of Post-Painterly Abstraction and to the growing commodification of Pop Art and Minimalism. At the core of the Rutgers art program is the example of Black Mountain College, which was frequently evoked by Rutgers faculty as the model for progressive art pedagogy. At Black Mountain College in 1952, John Cage, Robert Rauschenberg, Merce Cunningham, and poets staged an "event" that became the prototype for Kaprow's Happenings on the Rutgers campus and environs.

Off Limits presents the history of events, the personalities involved in this history, and the works of art produced during their Rutgers years. The material is unavailable in any other publication. Although scholars, art historians, and critics have an idea of the involvement of these artists with major developments of the 1950s and 1960s, no publication exists that considers their contributions and interaction as a group at Rutgers University. The early years of Samaras, Lichtenstein, and Segal are considered briefly in monographic studies, but Kaprow's importance, as both a theorist and an artist, warrants specific attention. The documentation and critical analysis of the 1950s and 1960s as presented here are based on interviews with artists, critics, and dealers from the period.

Regarding the dates chosen for this study, by 1957 most of the artists, with the exception of Roy

Lichtenstein and Brecht, were already teaching or studying at Rutgers, and their group exhibitions, collaboration on curriculum development, and general exchange of ideas had begun. By 1963, Kaprow, Whitman, Samaras, Lichtenstein, and Segal had left Rutgers to pursue their artistic careers elsewhere, although most remained closely involved with one another. By the time of the *Yam Festival* events of 1963, which culminated in the riotous afternoon at George Segal's farm on May 19, and included various performances and Fluxus activities, the artists originally associated with Rutgers had been launched on their individual careers. These artists became linchpins for a number of major developments of the 1960s: Roy Lichtenstein and Robert Watts were identified with Pop Art; Brecht, Watts, and Geoffrey Hendricks as part of Fluxus; Allan Kaprow and Robert Whitman were of major importance in generating interest in performance art and Happenings. Many artists, both faculty and students, came to Rutgers in the 1960s, and participated in the legacy formulated by the progressive figures presented in this book.

—

We wish to extend gratitude, first of all, to the artists who are the subjects of this study. Allan Kaprow has met with Joseph Jacobs and me in Newark, New Jersey; New York City; and La Jolla, California, and has been of invaluable assistance. George Segal also has been enormously helpful. Repeated visits to his farm in South Brunswick have offered us special insights into Segal's own work in this period, as well as opportunities to visit the site of a number of early Happenings. Lucas Samaras met with us in his New York apartment, and showed us many examples of his early works. Robert Whitman has taken us through his studio in Warwick, New York, and answered many questions. Geoff Hendricks has been a constant source of information and encouragement from the earliest stages of work on this project. We mourn the death of Roy Lichtenstein, who expressed enthusiasm for this project from my earliest discussions with him in 1984. He was formally interviewed in March 1996. Representing the Robert Watts Estate and Studio Archives, Sara Seagull and Larry Miller have been indispensable. Our most sincere thanks for the research materials and photographs essential to the study of Watts and Brecht. Letty Eisenhauer shared her memories of Douglass College, and her personal experiences as a participant in early Happenings by Kaprow and others. Ivan Karp has spoken of his years with the Leo Castelli Gallery. Alumni of the Rutgers art program, including Jackie Winsor, Alice Aycock, Gary Kuehn, and Mimi Smith, have provided special insights about their experiences. We are also most grateful to the essayists Jackson Lears, Simon Anderson, and Kristine Stiles, and to other scholars for their contributions to this project in its early stages.

For preparation of this publication our deepest gratitude goes to Leslie Mitchner, Editor-in-Chief, and Marlie Wasserman, Director, Rutgers University Press, and to the editorial and production staff. Julia Robinson, Exhibition Coordinator, has been responsible for photographs and publication rights, and has completed her task with unparalleled professionalism. At The Newark Museum, a special word of gratitude to Mary Sue Sweeney Price for her energetic support of this project, and to Ward Mintz for his intelligent suggestions and his unfailing commitment to this undertaking. We offer special appreciation to Jon Hendricks and Robert McElroy, who provided essential photographs and documents for this publication. Shelley Lee and Cassandra Lozano of the Roy Lichtenstein Estate, and Joanna Stasuk of the Leo Castelli Gallery and Anne Prival at VAGA, have been very helpful. At Rutgers University, Thomas Frusciano and Ed Skipworth in Special Collections, Rutgers University Libraries, have assisted with archival materials. Thanks are also extended to the following individuals for assistance with research for this publication: Jonathan Applefield, Roberta Bernstein, Terry Birkett, Robert Delford Brown, Rudy Burckhardt, Barbara Clausen, Kim Cooper, William Duckworth, Marcel Fleiss, John Goodyear, Bob Harding, Dick Higgins, Scott Hyde, Billy Klüver, Steven Leiber, Marco Livingstone, Julie Martin, Barbara Moore, Kelly Nipper, Stephen Polcari, Vaughan Rachel, Sid Sachs, Denise Spampimato, Owen Smith, and Sidra Stich.

Grants for this publication have come directly from Joseph J. Seneca, Vice President for Academic

Affairs, Rutgers University, and Richard Foley, Dean of the Faculty of Arts and Sciences. The Henry Luce Foundation, the National Endowment for the Arts, and the Geraldine R. Dodge Foundation have funded our research since this project was initiated in 1995.

I am certain that Joseph Jacobs, co-organizer and curator of the exhibition, joins me in expressing our appreciation to all who have helped to make both the publication and exhibition a reality.

Joan Marter

—

OFF LIMITS

—

THE FORGOTTEN LEGACY

—

HAPPENINGS,

POP ART,

AND FLUXUS

AT

RUTGERS UNIVERSITY

—

JOAN MARTER

Four decades have passed since Pop Art, the first Happenings, and Fluxus events exploded on the New York art scene, and these innovations of the 1950s and 1960s continue to resonate. A forgotten chapter of this history is addressed here: the first Happenings by Allan Kaprow—presented on the Rutgers campus—Roy Lichtenstein's first Pop paintings, George Segal's earliest sculptural tableaux, Lucas Samaras's provocative and confrontational works, and proto-Fluxus activities by Bob Watts and George Brecht. All of these events took place at Rutgers University or in the environs, but the Rutgers group has never been fully investigated, nor has the interaction of the artists who lived and worked in New Brunswick, New Jersey, been acknowledged. The Rutgers group rejected Abstract Expressionism for an art that was often based on the immediate experience of urban and industrial life, creating startling new art forms to which contemporary artists still respond.

The overlooked legacy of Rutgers University centers around artists who were instructors and students from 1957 to 1963, including Allan Kaprow, George Segal, Roy Lichtenstein, Robert Watts, and Geoffrey Hendricks, who were all on the faculty, and Lucas Samaras and Robert Whitman, who were among their most accomplished students.[1] George Brecht, who worked in New Brunswick, was also part of the Rutgers group, and contributed to proto-Fluxus events of the 1950s and early 1960s. In the tradition of Black Mountain College, Rutgers became one of the most experimental art programs in the country. Rutgers art faculty regularly cited the example of Black Mountain College in their insistence on interdisciplinary approaches to the arts, their

advocacy of innovation in the studio, and their nonauthoritarian ideas about art education.[2]

Writings on Happenings, Pop Art, and performance include passing references to Rutgers and the artists active there.[3] Lucy Lippard, in *Pop Art*, notes:

> The cradle of Pop and avant-garde art on the Lower East Side, the Reuben [Gallery] specialized in an impermanent, perishable, gutter art. . . . Some of the first Happenings were performed there, and the group was closely associated with the prolific father of that medium—Allan Kaprow—and with other artists then teaching at Rutgers University: Watts, Segal, and Lichtenstein.[4]

In the Whitney Museum's *Blam! The Explosion of Pop, Minimalism, and Performance 1958–1964*, another reference to Rutgers appears: "Lichtenstein had been brought into contact with Happenings and junk environments while teaching at Rutgers University with Kaprow and Robert Watts."[5] In a corresponding note, Barbara Haskell adds: "Under Kaprow's leadership, Rutgers University during this period was a seedbed for experimentation in the arts."[6] These passing references aside, no essay has given details of the groundbreaking art and seminal interactions among faculty and students at Rutgers University.

The period to be considered begins in 1957, when Allan Kaprow was an instructor at Rutgers College and Bob Watts and Geoff Hendricks were teaching at Douglass College, and ends in 1963, with *Yam Festival* events at George Segal's farm and in New York City. Roy Lichtenstein became an instructor at Douglass College in 1960. George Segal taught classes for the Sketch Club at Rutgers College beginning in 1955, and contributed to innovative projects there. He enrolled as a graduate student in the art department at Douglass College in 1961, and received a Master of Fine Arts degree in June 1963.

Why did Rutgers University became a center for experimental art? In part, this was due to the progressive attitude of both faculty and administrators, particularly those at Douglass College, which was essential to this development. The Rutgers group was not a formal artists' organization, but a cluster of friendships among colleagues who found a stimulating ambiance on the New Brunswick campus and in the adjacent communities. Allan Kaprow, in his essay *Ten from Rutgers University*, recalled their involvement with the industrial landscape of central New Jersey:

> The fertility of desolation, unlike that of dung-heaps, is always compelling because there is no explanation for why it should show itself in one place and not another. New Jersey was once called the "Garden State"; but now much of it is a waste of filled-in marshes, constantly smoking dumps, treeless flats crusted over with housing projects, and vast industry whose gasses swirl permanently around the ankles. At the heart of this, located in a ghost town on a river bank, is Rutgers University. Like the State which has no flowers, Rutgers, on the surface, was barren in the 1950s. The numbness was pervasive. Yet a few of us found ourselves there for one reason or other. . . . Something had to happen there. Perhaps the others felt the same. Desolation revealed, and stood for, the authentic. . . . But this judgement was typical of the mental life of a whole generation which was making art of such scenery. . . . But the difference for us was that if we were also active in the New York studio and gallery world, we lived just far enough away from the loft parties and bars, and from each other as well, to develop independently. Later, when we joked about a "New Brunswick School" forming in our midst and without our desiring it, we understood that the one thing we had in common besides a "feel" for the environment was un-groupiness. If the new art in general was dedicated to that ideal, New Jersey made it easier to practice than did New York.[7]

Innovations in art and performance by the Rutgers group took place in an industrial town bordering the New Jersey Turnpike simultaneously with events at the Hansa Gallery, the Reuben Gallery, the Judson Memorial Church, and other alternative spaces in New York City. Investigation of the new art practices at Rutgers University in the 1950s complements the general consideration of interdisciplinary art forms in New York during the same decade. Most of the Rutgers artists joined a larger community of New York City's artists/performers/musicians. To this day, friendships among the artists remain strong.[8]

The Rutgers group can be identified as loosely affiliated artists and students on two separate campuses of the university: at Rutgers College, an all-

male undergraduate institution in downtown New Brunswick, and at Douglass College, the women's college of Rutgers located on a verdant site on the outskirts of town.[9] Rutgers College housed an art department that was primarily devoted to art history, with a few studio courses.[10] Douglass College featured a full-scale studio program with diverse art history offerings, including modern, Asian, Pre-Columbian, and Oceanic art. Although the two colleges were single-sex institutions, Allan Kaprow recalls that on an "ad hoc basis" students were permitted to "cross over" for classes on another campus.[11]

In this essay, I will consider individually each artist involved in the Rutgers group, and will present their ideas and art production of the 1950s and early 1960s as it relates to the development of new art forms.

—

ALLAN KAPROW

—

Among the most charismatic, incisive personalities to introduce theories and new art practice was Allan Kaprow, who was hired by the art department at Rutgers College in 1953 (fig. 1). Teaching both art history and studio courses, he was soon showing his paintings in New York, using his own work as examples in his art history lectures, and serving as a faculty adviser for the *Anthologist*, a literary journal published by undergraduates at Rutgers College. An article in the local press explained why Kaprow was hired:

> When Helmut H. von Erffa, chairman of the men's college's art department, was casting around two years ago for a replacement for a departing professor of art history, he hit upon the idea of engaging Kaprow, a professional painter whose works have hung in several prominent New York galleries. The objective was to have the art students in the university learn about the "old masters" and the whole history of art from the freshest possible point of view, that of a young, practicing painter of the modern school. Kaprow, a student of Hans Hofmann, acknowledged "father" of America's advanced group of young painters and an art history major out of Columbia University, was the logical choice.[12]

FIGURE 1
Allan Kaprow in his office at Rutgers College, 1955. Photograph courtesy of Special Collections, Rutgers University, New Brunswick.

Von Erffa had studied at the Bauhaus in the 1920s; as a painter who was sometimes included in faculty exhibitions on campus, he also shared Kaprow's admiration for Hans Hofmann.

Calvin Tomkins considered Kaprow "a curious mixture of the visionary and the academic intellectual."[13] Trained in philosophy and art history, Kaprow wrote articles and essays that greatly influenced both the university community and progressive artists in New York. His prophetic writings called for a "New Art," which defied the traditions of the past.[14]

In 1956, months after Pollock's death, Kaprow wrote a seminal essay, "The Legacy of Jackson Pollock," which was subsequently published in *Art News*. This article was the first postmortem of Abstract Expressionism to articulate a new direction

for young artists. As a response to the dilemma about the future of painting after Pollock, Kaprow declared that Pollock's "Act of Painting," the new space, the personal mark that builds its own form and meaning, the endless tangle, the great scale, the new materials, etc., are by now clichés of college art departments."[15] Contrary to formalist assessments, Pollock had not reduced painting to its essence, but had extended it beyond the canvas to enter into the viewer's space:

> You do not enter a painting of Pollock's in any one place (or hundred places). . . . The four sides of the painting are thus an abrupt leaving-off of the activity which our imaginations continue outward indefinitely, as though refusing to accept the artificiality of an "ending." In an older work, the edge was a far more precise caesura: here ended the world of the artist; beyond began the world of the spectator and "reality."[16]

In passages that bear direct consequences for his students, Kaprow championed an art that involved a "spatial extension" to entangle the participant, breaking with conventional painting, to an art more actively involved with ritual, magic, and life itself.

> Pollock, as I see him, left us at the point where we must become preoccupied with and even dazzled by the space and objects of our everyday life, either our bodies, clothes, rooms, or, if need be, the vastness of Forty-second Street. Not satisfied with the *suggestion* through paint of our other senses, we shall utilize the specific substances of sight, sound, movements, people, odors, touch. Objects of every sort are materials for the new art: paint, chairs, food, electric and neon lights, smoke, water, old socks, a dog, movies, a thousand other things will be discovered by the present generation of artists. Not only will these bold creators show us, as if for the first time, the world we have always had about us, but ignored, but they will disclose entirely unheard of happenings and events.[17]

By 1957, Kaprow had made significant progress on several fronts. A founding member of the Hansa Gallery, he was lecturing on both Rutgers campuses, publishing articles in art periodicals, and making serious changes in his art.

Kaprow claims to have painted in about twenty different styles in the early 1950s, ranging from exercises based on Hans Hofmann, his former

teacher, to derivations from Piet Mondrian or Henri Matisse. Although created from conventional materials, Kaprow's early work showed a preoccupation with change. *Untitled collage* (1952) (fig. 2) was reproduced in the *Anthologist* and discussed there in an article by Grover Foley, "Vigor or Violence: An Analysis on Contemporary Painting": "Here at Rutgers, Mr. Allan Kaprow has been prominently involved in the development of the new art and in communicating its significance to a wider audience. . . . [This work] can convey the feeling of motion and, somehow, the lost, futile feeling that ceaseless change has brought to everyone at some time. . . . This painting in a word is 'Change.'"[18]

Kaprow's 1953 solo exhibition at the Hansa Gallery featured figurative abstractions indebted to Matisse, and Cubist works that the artist arranged at oblique angles to one another—presaging his later environmental structures.[19] Next, Kaprow made expressionist city scenes and angular figures. After these canvases, which featured throbbing pigments heavily applied, the artist produced collages of newspaper and magazine fragments.

With the birth of his son in 1956, Kaprow occasionally injected more personal elements into his work (while rejecting the past by cutting up some of his previous paintings). Although his work had previously included few autobiographical details, he began to incorporate words that had a personal meaning. *Baby* (fig. 3), for example, is a large-scale construction containing pieces of wood, fragments of blankets, and other collaged elements. In the upper-right corner is a handwritten letter. Across the surface the letters "VAUGH" and "HAN" are repeated; together these spell the first name of his wife, Vaughan Eberhart Peters, a former student of Hofmann.

Kaprow's friendship with Robert Rauschenberg, whose studio he had first visited in 1951, can be related to developments in his art. When Kaprow saw Rauschenberg's all-white paintings in 1951, he recalled: "I was walking back and forth in the studio, not knowing how I should take these things, even though they had a kind of pedigree already, certain inclinations. . . . And then I saw my shadows, across the painting, moving. And I told him. Bob

FIGURE 2
Allan Kaprow, *Untitled,* 1952, collage as
reproduced in the *Anthologist* vol. 26, no. 3, 1955.

smiled."[20] His reaction was similar when he heard
David Tudor perform John Cage's *4'33"*:

> The weather was still warm, and windows were
> open, and you could still hear the sounds on the
> street. So, when he [Cage] did *4'33"* with David
> Tudor sitting at the piano doing nothing but
> pressing the time clock, closing and opening the
> keyboard cover, I immediately saw this as part
> of the picture. And then I heard the air conditioning
> system, I heard the elevators moving, a lot of
> people's laughter and creaky chairs, coughing.
> I heard police sirens and cars down below, and
> those shadows in Bob Rauschenberg's pictures.
> That is to say, there is no marking of the boundary
> of the artwork, or the boundary of so-called
> everyday life, but they merge, and they indeed,
> as it became very clear, we the listeners in
> Cage's concert and the lookers at Rauschenberg
> were the collaborators of the artwork. We were
> making it.[21]

Beginning in 1956, Kaprow produced a few
constructions and sculptural works, including *Woman
Out of Fire* (plate 1), a blank-eyed deformed figure
made of plaster covered with tar. *Grandma's Boy*
(plates 2, 3) is a wall construction combining photo-
graphs, mattress ticking, silver paper, and cloth
attached to a wooden cabinet. The interior includes a
mirror, reflecting the viewers and making them parti-
cipants in Kaprow's collection of memorabilia. This
work may be compared to Rauschenberg's cabinetlike
constructions of 1954, containing photographs,
paintings, and other personal items, but there are
some differences. Smaller than Rauschenberg's
combines, as these were called, some of which were
freestanding constructions, *Grandma's Boy* is a wall
construction, and includes no family photographs or
personal mementos, despite the title, which suggests
association with his own childhood. The photographs
were found in a rented farmhouse and belonged to
the Rubin family, who were the owners, thus adding a
Duchampian perversion of any search for a personal
iconography here.[22]

At the time of these radical developments in his
art, Kaprow was also exhibiting in New Brunswick. In
1956, for example, the Douglass student newspaper
noted that an exhibition of twelve Rutgers students
and faculty was being held at the Studio Gallery on

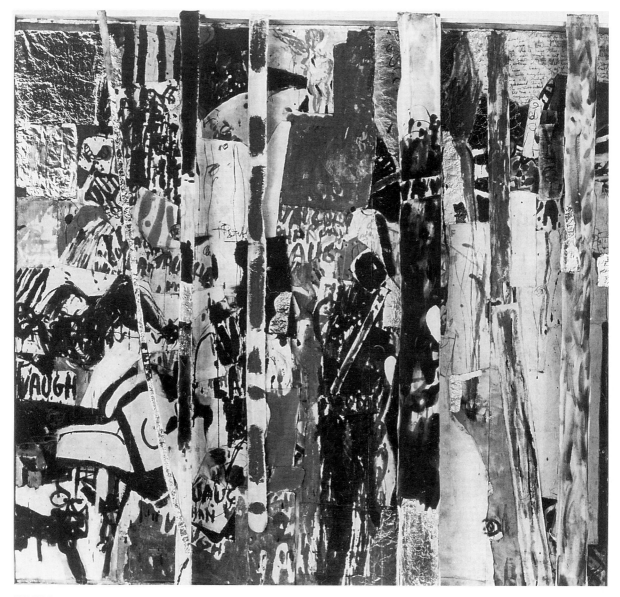

FIGURE 3
Allan Kaprow, *Baby*, 1956.
Collage: blankets, commercial paint, carpentry, 9' x 12'
Palais Liechtenstein, Vienna.

Albany Street, near the campus.[23] The show included, in addition to Kaprow's paintings, those of George Segal and Lucas Samaras, among others.

John Cage, whose classes at the New School for Social Research Kaprow first attended in the winter of 1957 or spring of 1958,[24] launched his plans to make art more participatory.[25] In Cage's "Experimental Composition" class, Kaprow explored the possibilities of introducing random noise, and presented some

untitled "proto-Happenings" in the tradition of a 1952 untitled "event" organized by Cage, Rauschenberg, and Merce Cunningham at Black Mountain College in North Carolina.[26] Cage's involvement with the *I Ching Book of Changes* must have also stimulated Kaprow's exploration of chance relationships.

In 1957 Kaprow began to make environmental work, which he dubbed "action collages."[27]

Re-Arrangeable Panels (which when arranged in a square is titled *Kiosk* [fig. 4]) represents a significant departure from conventional wall constructions.[28] Made of panels encrusted with mirrors, leaves, roofing cement, artificial fruit, and electric lightbulbs, the work can take changing forms, because panels can be repositioned. An earlier construction, *Penny Arcade* (1956), incorporated light and sound. A wheel slowly rotated, triggering electrical contacts and emitting the sounds of doorbells, rattles, and other devices. Strips of material were hung over the surface and holes were cut into the supporting panel so that lightbulbs in various colors could protrude. Blinking lights and freely hanging strips added to the theatrical effect and spontaneity.

Kaprow's first Environment was installed at the Hansa Gallery in February of 1958, and for the catalog he wrote "Notes on the Creation of a Total

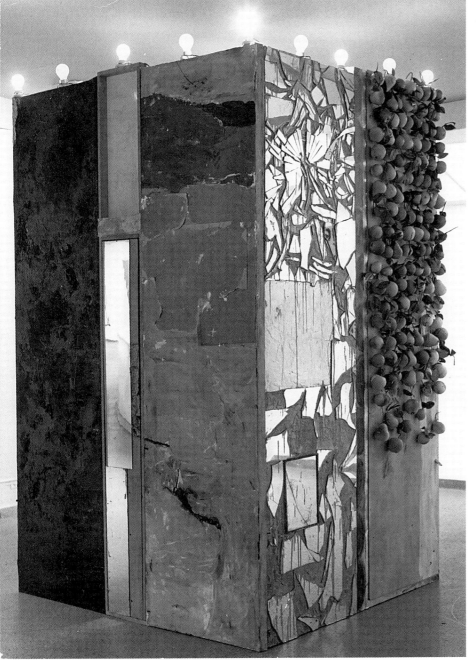

FIGURE 4
Allan Kaprow, *Kiosk*
(one version of
Re-Arrangeable Panels), 1957–59.
Leaves, broken mirrors,
artificial fruit, commercial paint,
roofing cement, red and white
electric lightbulbs on panel.
95 11/16" x 59 1/16" x 55 1/8"
Private collection.

Art."[29] The artist constructed a mazelike "atmosphere" by suspending strips of transparent and opaque materials from ceiling to floor. Attached to these strips of varying dimensions were plastic, cloth, crumpled cellophane, and colored lights. The transparencies offered glimpses of other participants as they passed through the intricate passages of cloth and tapes.[30] According to Geoff Hendricks, Kaprow had divided the Hansa Gallery space into two parts, one of which was a mirrored space with bright lights—like a theater's dressing room—while the other space had softer lighting. Visitors pushed their way through a "jungle of raffia."[31] The constant movement of participants and the changing viewpoints suggested that the work was continuously evolving. Kaprow also incorporated noises and sounds, and spoke about "'engagement' in much the same way that we have moved out of the totality of the street or our home where we also played a part. We ourselves are shapes. . . . We can move, feel, speak, observe others variously and will constantly change the 'meaning' of the work by so doing."[32]

In many of the Environments, the participant is asked to climb into an installation, write texts, squeeze oranges, or engage in other interactions with the work. For *Yard* (1961; plates 5, 6), visitors were invited to climb over tires that were scattered in the backyard of a town house occupied by the Martha Jackson Gallery. *Yard* appeared to present Kaprow's response to Pollock's drip paintings, which had been created on the floor of his studio (fig. 37). Kaprow noted in the catalog: "I am asking you, is it still aesthetically satisfying, socially responsible and emotionally possible to continue dealing with a square surface which traps a pictorial statement, in a world now become so enormously flexible, integrated and exploratory?"[33]

In his 1962 Environment titled *Words* (plates 7, 8), installed at the Smolin Gallery, Kaprow attached words to rolls of paper to allow changing combinations of words and phrases that could be put together by the visitor. Encouraging the participation of his audience, Kaprow included writing materials and urged viewers to write phrases and attach them to constructed partitions. Records on small phonographs supplied sounds for the installation. Language and

sound were essential to Kaprow's art in the 1950s and remained so thereafter.

Kaprow used the *Anthologist* as a forum for disseminating his ideas to students and colleagues. Before publishing his groundbreaking *Art News* article on Jackson Pollock, Kaprow had already completed his master's thesis on Mondrian at Columbia University (which remains unpublished) and written two articles for the *Anthologist* that outlined his strategy.[34] In "Rub-a-Dub, Rub-a-Dub," Kaprow grapples with notions of the avant-garde and with the dilemma of how to teach art, "treating the subject as a historian who talks not so much about art per se, but rather a process of change in which certain data called 'art' figure prominently." According to Kaprow, artists inhabit an "intensely private world that occupies their better energies while the rest of the world only appreciates the practical applications of their efforts."[35] He sees artists as bored with adherence to the acknowledged standards of Henri Matisse, Pablo Picasso, Piet Mondrian, Joan Miró, and others: "The issue was less of an awareness of a duel with the past than a looking ahead in the spirit of discovery." Kaprow claimed that authenticity was essential, and that artists must awaken to the crucial quality of "freshness."[36]

Kaprow's first public Happening took place on the Douglass campus of Rutgers University in April 1958, as the culmination of a series of avant-garde activities organized by Bob Watts and Kaprow for the Voorhees Assembly Board.[37] Other events at Douglass that spring included a performance by John Cage and David Tudor, a poetry reading by John Ciardi, and a dance performance by Paul Taylor's dance group. Douglass College students were required to attend the Voorhees Assemblies, and a few Rutgers College students probably came to these events.

On April 22, 1958, Kaprow staged an untitled event in the Voorhees Chapel at Douglass College for an audience of Douglass students and faculty. Later, Kaprow acknowledged that this performance was his first Happening, although he had presented earlier events in Cage's class at the New School.[38] Undoubtedly John Cage's nontraditional musical performances and descriptions of the 1952 untitled

event at Black Mountain College had some impact on Kaprow's plans for the Douglass Happening.

The event at Rutgers initiated a new art form based on Kaprow's concept of an all-encompassing artistic experience. It featured no characters or plot, but was intended as a series of disconnected events. Kaprow recalled that he wanted a formal, ceremonial effect because the event was held in a chapel.[39] There were processions up and down the aisles; Kaprow lit matches in front of a mirror. Banners were unfurled from the chapel balcony. Tapes of lectures by Kaprow

were played out of sequence from loudspeakers located in four corners of Voorhees Chapel. Samaras used tin cans in a informal game-playing routine. The event—identified only in retrospect as a Happening— emphasized the fragmentary, and required the audience to bring together disparate parts for a semblance of comprehension.

In the summer of 1958, Kaprow planned a second Happening, titled *Pastorale,* at George Segal's chicken farm in South Brunswick, as "entertainment" for Hansa Gallery members during their annual

FIGURE 5
Detail of the set for Allan Kaprow's *Pastorale* at George Segal's farm, South Brunswick, summer 1958.
Photograph by Vaughan Rachel.

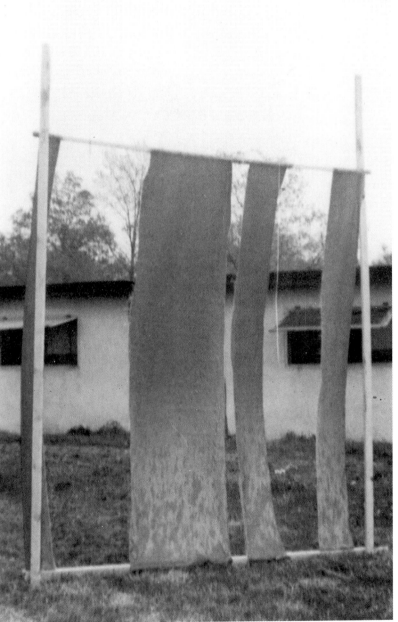

picnic. A "set" was built as a series of open wooden frames, with colored banners attached to the top edges (fig. 5). Kaprow's original score includes these directives:

1. Miles [Forst] in plastic box with trumpet and stool.
2. bell in coop
3. Whitman drawing with black enamel
3A. 2 people playing catch over group A
4. people on either side of banners reciting
5. audience in 3 spaces

The script was "to be read walking back and forth on a prescribed line, holding speech or red plaque. After speech, sit down opposite Mary and play tin cans. Begin at one minute or after you've counted sixty from time ball players begin."[40]

George Segal recalled that this Happening was called off when Aristodemus Kaldis and other artists began throwing beer cans, and were no longer willing to participate.[41]

Months later, in a 1959 issue of the *Anthologist*, Kaprow published his groundbreaking article "The Demi-Urge; something to take place: a happening." The issue also featured a cover design by its art director, Lucas Samaras, and reproductions of works by Kaprow, Robert Harding, Segal, Samaras, and Whitman.[42] Kaprow's was the lead article, and included a lengthy script for a Happening, which was never realized. Among the activities that Kaprow mentioned here were some that were similar to the Happening at Douglass College and the event at Segal's farm in 1958, but Kaprow added some new details in order to encourage the sensory stimulation of taste and smell. Kaprow's ideas for a new art form were articulated in this article, and brought to greater fruition at the Reuben Gallery event, *18 Happenings in 6 Parts*, in October 1959 (plate 4).

Close relationships among students and instructors at Rutgers and the engagement of students in the faculty's professional accomplishments are indicated by campus reports of Kaprow's New York show at the Reuben Gallery. The Douglass undergraduate newspaper, the *Caellian*, described Kaprow's *18 Happenings*:

These "18 Happenings" are in six parts, which take approximately one hour to unfold. The audience sits dispersed in three rooms built of wood, plastic and canvas, modified by paint, objects and constructions, and further changing throughout the "performance" by the activity of light, lantern slides, and by human participants who move, speak and behave according to Mr. Kaprow's arrangements. At the same time sounds are heard from varying sources, electronic, mechanical, and live. Twice during the evening the audience changes seats, but the "happenings" do not repeat. Six presentations are scheduled for 8:40 p.m. beginning Sunday, October 4.[43]

Various descriptions of and commentaries on *18 Happenings* have been published. Although Michael Kirby rightly claims that Kaprow's first use of the word "happening" occurred in connection with a 1959 article in the *Anthologist*, he does not mention that only a portion of that original script was reproduced in Kirby's *Happenings*.[44] Nor did Kirby include Kaprow's "Demi-Urge," cited earlier, an introductory essay from the same issue of the Rutgers journal. In "Demi-Urge," Kaprow wrote (in the tone of Marinetti's Futurist manifestos): "I have always dreamed of a new art, a really new art. I am moved to roaring laughter by talk of consolidating forces, of learning from the past. . . . So I am ruthlessly impatient with anything I seriously attempt which does not shriek violently out of the unknown present, which does not proclaim clearly its modernity as its raison d'être."[45]

According to Kaprow, the Happening invades the viewer's space while operating within the temporal dimension of the spectator. Relating the Happening to his advanced painting of the previous years, Kaprow stresses its connections with art rather than with theater: the actions are similar to everyday experience, and the actors plays themselves, but the script is determined by the artist.

As an outcome of *18 Happenings in 6 Parts* and Kaprow's previous publication of "something to take place: a happening," critics adopted the term "happening" for Kaprow's events. Kaprow intended the word to be neutral, and disliked the implications of spontaneity that were implied. He wrote in *Assemblages, Environments, and Happenings*: "A number of artists picked up the word informally and the press then popularized it. I had no intention

of naming an art form, and for a while tried unsuccessfully to prevent its use."[46]

Kaprow advocated a new art that defied the past. The artwork was no longer an object or commodity to be possessed, but a situation, an action, or an event.[47] Space was no longer confined to the conventional canvas, but would extend into actual space and incorporate not only color and form, but also objects and sensory elements from everyday experience. What Kaprow told his students and colleagues soon appeared in print:

> The everyday world is the most astonishing inspiration conceivable. A walk down 14th Street is more amazing than any masterpiece of art. If reality makes any sense at all, it is here. Endless, unpredictable, infinitely rich, it proclaims THE MOMENT as man's sole means of grasping the nature of ALL TIME.[48]

The idea of change and impermanence encouraged the use of new materials in works of art. Since the artist is no longer making works for posterity, he or she may choose materials at hand and favor the radically unconventional. Toilet paper, food, growing grass, and junk materials are appropriate for making art. Kaprow attempted to intensify the effective reality of everyday life by putting his audience in touch with the aesthetic valence of ordinary activities, such as brushing one's teeth or eating a meal: "The artist should choose freely from his surroundings: an odor of crushed strawberries, a letter from a friend, or a billboard selling Drano: three taps on the front door, a scratch, a sigh, or a voice lecturing endlessly, a blinding staccato flash, a bowler hat."[49]

Influential critics of the postwar years had articulated how recent developments in art were related to art history, and embraced Abstract Expressionism as the avant-garde. But Kaprow developed the Environment and the Happening as strategies to move beyond the clichés of gesturalism. In opposition to the predominant critical matrices of Clement Greenberg and Harold Rosenberg, Kaprow became a critic in his own right. Thus he realized a new role: the artist as critic/educator. Kaprow had correctly assessed the modernist crisis following Pollock's untimely death, and worried that avant-garde art

would be co-opted by bourgeois society. Eventually Kaprow published an essay titled "Impurity," in which he directly challenged the major tenets of formalist critics such as Greenberg, who advocated a purist art that could be related to the historically determined purism of artists such as Mondrian. Kaprow turned the tables on the formalists by pronouncing Mondrian, Barnett Newman, Pollock, and others "impure":

> Thus the impure aspects of pure painting like Mondrian's is not some hidden compositional flaw, but rather the psychological setting which must be impure for the notion of purity to make any sense at all. The success of a visionary like Piet Mondrian was due to the vividness with which he made the conflict manifest in every picture and at every stage of his career.[50]

Kaprow as artist assumed responsibility for interpreting his own work; Kaprow as critic/educator veered away from the formalism that dominated the writings of Greenberg and others, and called for an aesthetic of regular experience.

After he left the Rutgers College faculty in 1961, Kaprow remained a part of the Rutgers community. In 1963, for example, he returned for an arts festival on the Douglass campus, and participated in Al Hansen's *Car Happening or Carcophony*. In May 1963 he staged another Happening at George Segal's farm as part of the Yam Festival (plate 22). By the time of the 1965 exhibition *Ten from Rutgers* at the Bianchini Gallery, Kaprow was firmly established as an *éminence grise* at Rutgers, a founder of a new approach to art pedagogy, and a theorist of major importance to performance art and related art forms.

Among his Rutgers students, Kaprow's charismatic personality and cogent thoughts on the direction of art stimulated various art forms. The intellectual, interdisciplinary experiences on a college campus produced young artists who were prepared to defy the limits of conventional art making and to explore the new art. Initially Robert Whitman made constructions, then turned to performance art; Lucas Samaras transformed the mundane, plumbing his personal history and experiences for art making.

LUCAS SAMARAS

Kaprow's stellar student, Lucas Samaras, was born in Macedonia and came to the United States at age eleven, in 1947. He joined his father in West New York, New Jersey, and attended public schools there. In 1955 Samaras enrolled at Rutgers on a scholarship, awarded to him on the basis of his watercolors and pencil drawings of the Crucifixion.[51] While attending Rutgers College, Samaras took art classes with Kaprow, but also studied literature and theater. Of his instruction with Kaprow, Samaras recalled: "Kaprow was very useful to me at that time because he introduced me to ideas that the Hansa Group was involved with, and also things about Rauschenberg. . . . I mean Kaprow did know his work, so that it was available to us, and also, Kaprow had a show of Hofmann's work at the college gallery."[52]

During his college years, Samaras acted in a number of plays at the Queen's Theater, was a member of the Varsity Rifle Club, wrote poetry, and became art director for the *Anthologist*, also publishing his poetry in issues of the literary journal. Samaras attended afternoon sessions of the Art Club (also called the Sketch Club) where George Segal gave instruction. In 1958, as an exceptional student of Kaprow, he met artists associated with the Hansa Gallery. Probably with Kaprow's help, Samaras had two solo exhibitions at the Jewish Community Center in Highland Park, New Jersey, while he was a student at nearby Rutgers College. For the second of these shows, the college junior showed twenty-one oil paintings, nine pastels, and three drawings completed during the previous two years. Subjects ranged from still life paintings to portraits and abstractions.[53]

Samaras began working in pastels while in high school, and his figure studies and abstractions continued in college. The immediacy of the medium and the vivid hues suited his temperament and art practice (plate 9). Pastels "functioned for him as a kind of stylistic, iconological and emotional laboratory."[54] Abstract patterns, opulent colors, and complex spatial relationship can be related to Byzantine mosaics and to the rich decorative reliquaries and sacred books found in Greek

Orthodox churches. Samaras was encouraged to identify with his Byzantine heritage by Kaprow, but the young immigrant was also attracted to contemporary artists exhibiting in New York.

Alternating between figurative and abstract compositions, Samaras made pastels and oils, often with erotic or fiercely personal strategies. He became close friends with George Segal, and admired his work. In a practice similar to Segal's use of his own image, Samaras initiated a series of paintings of male nudes, which were undoubtedly all self-portraits.

In March 1958, a solo exhibition of four oils and five pastel drawings by Samaras was shown at the Art House on the Rutgers College campus. A student reviewer in the *Rutgers Daily Targum*, the campus newspaper, notes that three of the oil paintings are male nudes, including one with a "satyric, barbaric pose." Although all of the oils on canvas show intense concentration and careful paint application, the pastels are all beautifully colored and appear as spontaneous renditions of still life subjects.[55] Samaras's nude *Self-Portrait* (plate 10) is a response to Segal's autobiographical canvas (fig. 15). Of the early figure studies produced by Samaras, many are self-portraits, and presage his "phototransformations" of the following decades, where the camera replaces brush and canvas, and autoerotic references abound. During his four years at Rutgers, Samaras experimented with many materials, including glass, tinfoil, metallic paints, and wax. He made a folding screen using metallic pigments that featured interlocking rectangular patterns (plate 24).[56]

Samaras was the art director for the *Anthologist* in 1957 and 1958. His cover designs included the "Freshman" issue of 1958. In March 1958 Samaras established the Rutgers Co-op Gallery in the house where he lived—at 82 Somerset Street in New Brunswick. The gallery had space for about ten paintings, which were installed by undergraduates biweekly.

For his senior honors project—under the Henry Rutgers Scholar Program, which included a stipend for research expenses—Samaras decided to combine his involvement with art and poetry. Under the supervision of Allan Kaprow, his adviser, Samaras wrote an autobiographical honors thesis that included photo-

OFF LIMITS

12

PLATE 1. Allan Kaprow, *Woman Out of Fire,* 1956.
Tar over plaster.
40" x 32" x 24"
Collection of the artist.

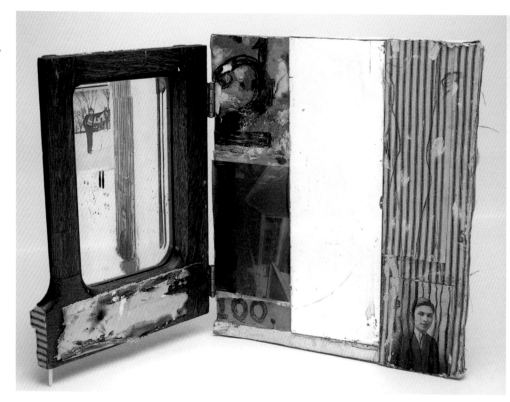

PLATE 2. Allan Kaprow,
Grandma's Boy, 1957.
Assemblage: mattress ticking,
broken furniture, mirror,
found snapshot.
18 1/2 " x 27 " (front).
Collection Robert Delford
Brown, Houston.

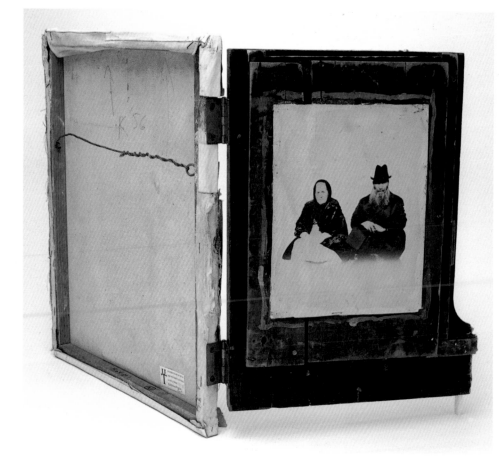

PLATE 3. Allan Kaprow,
Grandma's Boy, 1957.
Assemblage: mattress ticking,
broken furniture, mirror,
found snapshot.
18 1/2 " x 16 " (back).
Collection Robert Delford Brown,
Houston.

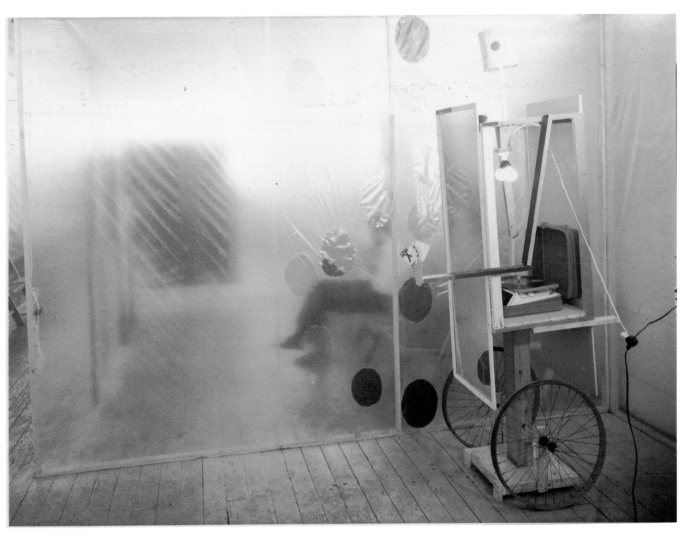

PLATE 4. Allan Kaprow, *18 Happenings in 6 Parts,* 1959,
at the Reuben Gallery, New York.
Photograph by Scott Hyde.

PLATE 5. Allan Kaprow, *Yard,* 1961 (aerial view).
Environment installed at Martha Jackson Gallery, New York.
Used tires, tar paper mounds, barrels; dimensions variable.
Photograph by Robert McElroy.

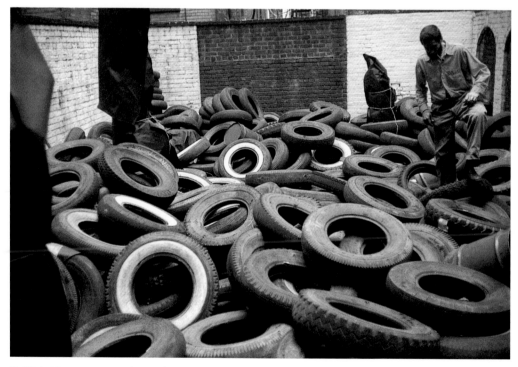

PLATE 6. Allan Kaprow, *Yard,* 1961 (detail, with artist). Environment installed at Martha Jackson Gallery, New York.
Used tires, tar paper mounds, barrels; dimensions variable. Photograph by Robert McElroy.

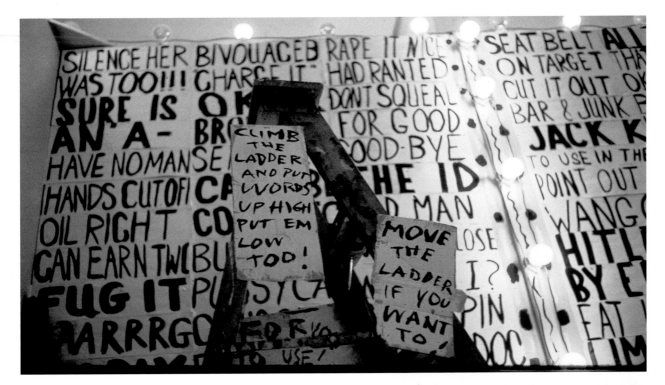

PLATE 7. Installation view of Allan Kaprow's *Words,* 1962.
Environment at the Smolin Gallery, New York.
Photograph by Robert McElroy.

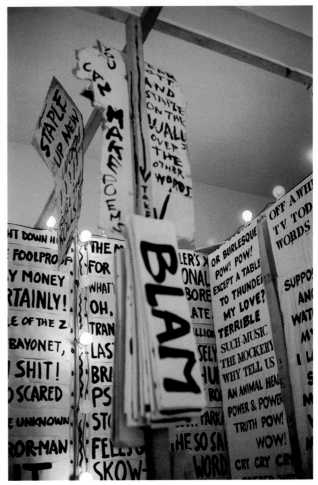

PLATE 8. Installation view of Allan Kaprow's *Words,* 1962,
Smolin Gallery, New York. Photograph by Robert McElroy.

PLATE 9. Lucas Samaras, *Untitled,* 1958.
Pastel.
18" x 12"
Private collection.

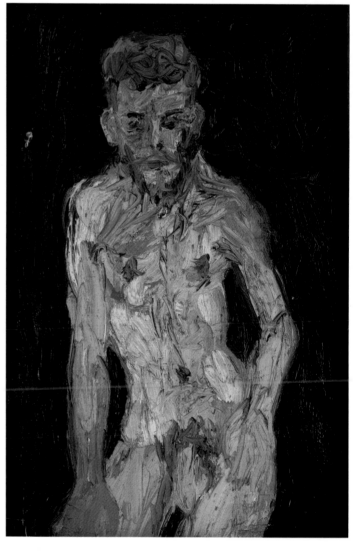

PLATE 10. Lucas Samaras, *Self-Portrait,* ca. 1958.
Oil on masonite.
30" x 21 1/2"
Private collection.
Photograph by Ellen Page Wilson,
courtesy of PaceWildenstein.

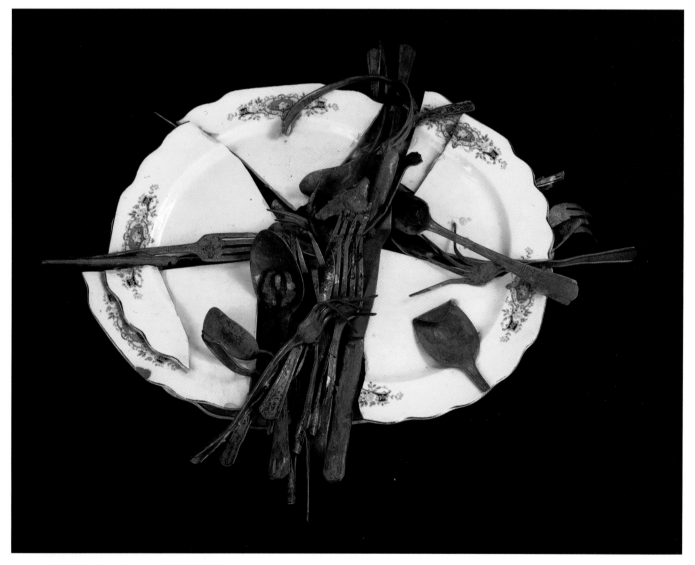

PLATE 11. Lucas Samaras, *Untitled*, 1961.
Smashed plate and bent flatware.
18 1/4" x 15 3/4" x 3"
Private collection.
Photograph by Ellen Page Wilson, courtesy of PaceWildenstein.

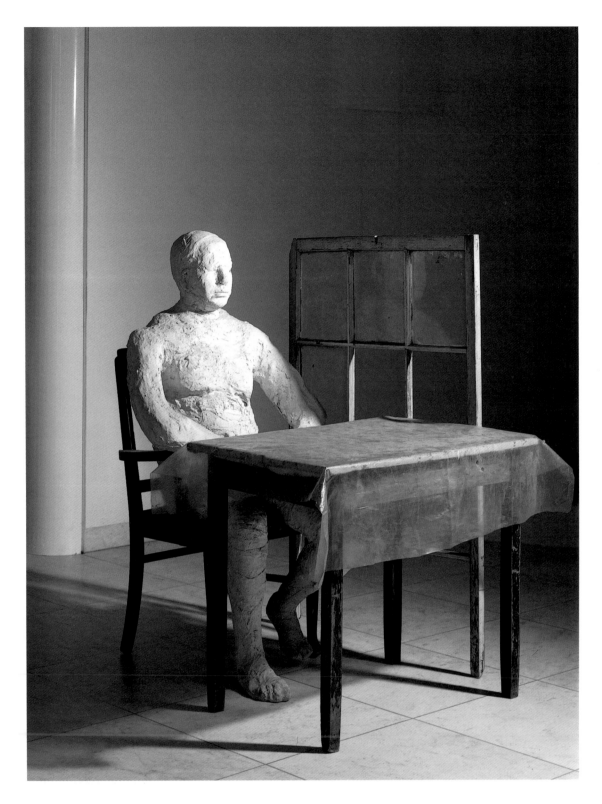

PLATE 12. George Segal, *Man Sitting at a Table,* 1961.
Plaster, wood, glass.
53" x 48" x 48"
Städtisches Museum Abteiberg Mönchengladbach, Germany.
Photograph by Ruth Kaiser. © George Segal/Licensed by VAGA, New York.

graphs of his work and poems of single-syllable words. Repetitive use of certain words was intended to indicate his state of mind, and ranged from a single line of "tsiktsiktsik" to an entire page of "fuck" with a single "you" at the lower right corner as the conclusion. Although Dada poetry and other avant-garde literary forms may have been an influence here, a more immediate source can be found among the contemporaneous collages of Kaprow featuring repeated words or fragments. Kaprow's collage *Hysteria,* for example, featured the repeated "HaHaHa" across the canvas.

When Samaras read some of his poems at a seminar to celebrate the honors projects, and the text was displayed in the dean's office, administrators took umbrage. Apparently the use of state funds to sponsor this offensive material was not considered acceptable. Kaprow remembers that Samaras could have been expelled from Rutgers, and that he pleaded with the administration to allow Samaras to graduate.[57] Although Kaprow did not lose his job at that time, in 1961 he was denied tenure at Rutgers, despite the support of the art department.

After his graduation from Rutgers in 1959, Samaras remained closely involved with Bob Whitman, Kaprow, Segal, and others he had known in New Brunswick. Like his mentor, Kaprow, Samaras enrolled in the art history program at Columbia, and soon joined Segal, Kaprow, Whitman, Claes Oldenburg, George Brecht, and Jim Dine at the Reuben Gallery, which showed "perishable . . . urban industrial subject matter for its own sake."[58]

When he was at Columbia, Samaras considered becoming an actor, and attended Stella Adler's drama school. He was a natural for active participation in the early Happenings of Kaprow, Whitman, and Oldenburg. Beginning with Kaprow's *18 Happenings in 6 Parts* at the Reuben Gallery, Samaras became a "regular" in performance art, appearing in Whitman's *American Moon* (fig. 13) and in many of Oldenburg's Happenings, including *Fotodeath* of 1961 and *Store Days* of the following year. Participation in Happenings encouraged Samaras to practice different approaches to acting, through which he could develop his own gestures and constructions of the role.

FIGURE 7
Lucas Samaras, *Untitled,* 1960–61.
Assemblage: wood panel with plaster-covered feathers, nails, screws, nuts, pins, razor blades, flashlight bulbs, buttons, bullets, aluminum foil.
3" x 19" x 4"
The Museum of Modern Art, New York.
Larry Aldrich Foundation Fund.
Photograph © 1998 The Museum of Modern Art, New York.

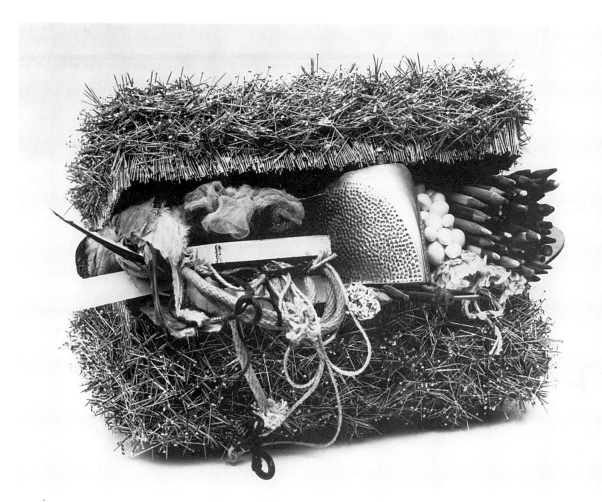

FIGURE 8
Lucas Samaras, *Box #1*, 1962.
Pencils, pins, rope, stuffed bird.
9" x 14" x 9 1/2"
Private collection.
Photograph by Eric Pollitzer, courtesy of PaceWildenstein.

Samaras, rather than creating his own Happenings, had his artwork take him into a more private realm.[59] His rich fantasy life, which had first been seen in the poetry and art of his student years, was transformed into a series of narratives about elementary bodily functions. Stories titled "Shitman," "Dickman," and "Killman" featured characters and situations that Samaras described: "I was in a sense doing Happenings, but they were only for myself."[60] Closely related to his fantasy characters was the creation of plaster-rag dolls that were intended as illustrations for his stories (fig. 6). Usually male and

female images, these simple, expressionistic figures seem related to the early plaster and chicken wire sculptures of his teacher George Segal, and Kaprow's *Woman Out of Fire* (plate 1) and a life-size male nude that Kaprow constructed in the same year (1956).[61] The overt sexuality of Samaras's plaster dolls is startling; they are sublimations of the artist's fantasies.

In 1961, Samaras was included in *The Art of Assemblage* at the Museum of Modern Art. His untitled relief (fig. 7) appears to be a parody of the Renaissance and Baroque paintings that certain art history students would deeply admire. Substituting

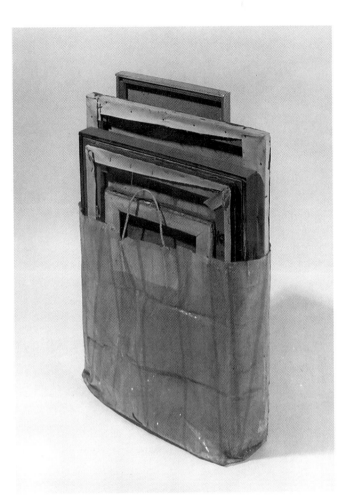

radical materials for the ornate gilded frames of old master paintings, Samaras used plaster-covered feathers to frame a composition of everyday objects: flashlight bulbs, buttons, razor blades, bullets, nails, mirrors, and aluminum foil. This work, among others by Samaras of the time, includes objects that are potentially dangerous. Like Rauschenberg, in his sculptures of the early 1950s, where he includes knife blades and nails in small wooden boxes, Samaras used nails, bullets, and razor blades for their expressive content. Recalling Kaprow's direction that Samaras should explore his Byzantine identity,

his untitled books and boxes are reminders of the sacred books and reliquaries of the Orthodox Church, and elicit meanings associated with the anguish of the Crucifixion of Christ and with religious martyrdoms. In *Box #1* (fig. 8), Samaras enshrined the body of a small bird in a "reliquary" box covered with straight pins.

Another fitting homage to the New Art advocated by his Rutgers mentor is Samaras's *Paper Bag #3* (fig. 9), which is filled with canvases that he had produced during his student years: the bag becomes the work of art, not the individual paintings contained within it. Samaras was ready to move on to constructions and assemblages, though he continued to make pastels and paintings. His imagery was fixated particularly on the kitchen—where disturbing juxtapositions of eating utensils, razors, tacks, and knives evoke associations between death and food consumption (plate 11). Food imagery becomes central to Pop Art in the 1960s, and can be found in selected works by Lichtenstein (fig. 23), Oldenburg, Kaprow, Watts (plate 28), and Segal. Samaras's performance in Happenings by Kaprow, Whitman, and Oldenburg related closely to the development of his domestic/kitchen imagery of the early 1960s.

—

ROBERT WHITMAN

—

Known primarily for performance art and sculpture, Whitman entered Rutgers in 1953 and graduated with a degree in English literature. During his last two years at Rutgers College, he attended classes at the extracurricular Sketch Club, where George Segal taught and where Lucas Samaras was also enrolled. Whitman admired the work that Samaras had exhibited on campus, and the two became fast friends. While at Rutgers, they both wrote poetry and designed covers for the *Anthologist,* and later Samaras was featured in Whitman's early events in New York.

Born in New York City in 1935, Whitman grew up on Long Island and attended a private school in New Jersey. The choice of a major in English stemmed from Whitman's strong admiration for Walt Whitman, whom he considered a spiritual ancestor. Given the development of certain ideas in his later

work, the attraction to the American poet is evident. Barbara Rose observed about Bob Whitman that "many of his themes—the essential unity of man and nature, a pantheistic view of religion, the visionary view of the artist, and the epiphany reached through extremes of self-revelation—are directly related, not only to Walt Whitman, but to the whole of the transcendental tradition in American thought and literature as well."[62]

When Whitman enrolled at Rutgers College, one of his intentions was to avoid serving in the army. He was not intellectually sophisticated at the time, and did not consider himself a good student. Then he was startled by his attraction to the discourse of his instructors. For example, Francis Fergusson, renowned professor of comparative literature, had a profound influence on Whitman, not only in college, but throughout his life.[63] At Rutgers, Fergusson taught a course on Dante, which was taken by

Whitman and Samaras. Because of his interest in Dante, Whitman studied Italian for four years and made drawings based on Dante's *Earthly Paradise*. Whitman remembered that Francis Fergusson was also a playwright and had ideas about the American theater developing independently of the "market."[64]

While at Rutgers College, Bob Whitman served as president of the Art History Club and treasurer of the Sketch Club, and worked at the campus radio station, among other activities. A change to an involvement with the visual arts came about in 1956, when in Whitman's third year at Rutgers, he met Samaras and took a modern art course with Kaprow. Through Kaprow's teaching, Whitman realized that contemporary painting offered some of the most dynamic and creative art forms of the period. Kaprow emphasized new approaches to art, including new media. While Kaprow did not force his artistic vision on others, he supported students in their personal approach and insisted on their pursuit of an individual artistic identity. In 1956 Whitman was included in a show of twelve Rutgers University students and faculty at the Studio Gallery, 94 Albany Street.

Apparently Whitman took to heart Kaprow's directives regarding the use of everyday experiences and materials, the idea of change, and the emphasis on resisting commodification. In keeping with the self-effacement encouraged by Cage and others involved with Zen Buddhism in the 1950s, Whitman created a truly ephemeral art. His early constructions and most of his installations and performances were made of impermanent materials. Only a few of his drawings and early sculptures survive.

Whitman's close association with Kaprow, Samaras, and Segal constituted the immediate community that set the course for his personal aesthetic, but the university provided other sources of stimulation for the young artist. He recalls, for example, attending a dance performance by Paul Taylor at Douglass College in March 1958.

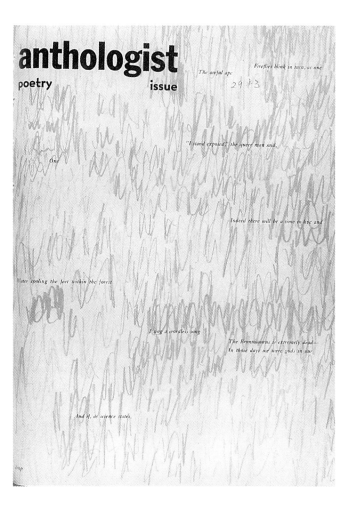

FIGURE 10
Robert Whitman, cover for the *Anthologist* vol. 29, no. 3 (Poetry Issue), 1958.

Among Whitman's contributions to the *Anthologist* is a two-page spread for a special art issue published during his senior year. The combination of painting and prose featured two gestural compositions. On the left page, a hammock or bed appears in broadly applied passages, while the lower section features a loosely rendered checkerboard pattern that will recur in his early constructions; the untitled work on the page opposite is nonobjective.[65]

After Whitman's graduation in 1957, he remained closely involved with Rutgers, participating in campus exhibitions and publications. For example, he was the first to have a solo exhibition at the Art House at 126 College Avenue, in March 1958.

Other contributions included a cover design for the "Poetry" issue of the *Anthologist* in 1958 that featured his "scribble drawing" and a short poem (fig. 10).

At Columbia University, Whitman attended the graduate program in art history in 1958, but he stayed for only one year, later insisting that he enrolled only because he had not decided on a direction.[66] While in graduate school during the 1958–59 academic year, Whitman had his first exhibition at the Hansa Gallery, where he showed a cubical construction of hanging sheets of plastic (fig. 11), and other constructions of cellophane, aluminum foil, plastic, wood, and colored lights.

FIGURE 11
Robert Whitman, *Construction,* 1958.
Wood, aluminum foil, plastic,
Scotch tape, paper.
72" x 72" x 72"
Installation view of solo exhibition at
Hansa Gallery, New York, January 1959.

This show in January 1959 received decidedly mixed reviews. Fairfield Porter noted that Whitman's "first exhibition shows constructions of fragile, ordinary modern materials (such as Rauschenberg made familiar several years ago). . . . The most elaborate exhibit contains red and blue blinking lights in cubbyholes against aluminum foil. . . . What is in store for next year?"[67] Porter was correct to mention Rauschenberg here, for Whitman had indeed met Rauschenberg through Kaprow, and had purchased a small collage. Whitman was undoubtedly attracted to Rauschenberg's skillful use of found objects.

Shortly after the Hansa show, Whitman had another exhibition at Rutgers Co-op Gallery,[68] and his large construction featured at Hansa was installed at the Art House and reproduced in the *Anthologist* with his statement. In part, Whitman's remarks suggest his indebtedness to Kaprow:

The making of a work and its experience are part of the same thing. But the work exists as any object by itself. . . . To make another work means not to make a thing that has anything to do with something done. . . . As one grows he goes beyond the things done, which, if they have any validity, are deeply involved with a moment in time and experience which can never be recaptured. Any work of intensity and value is involved with the experiences during its creation. Laws of entropy forbid these experiences from happening again.[69]

By the time of his first show at the Reuben Gallery in November of 1959, Whitman made constructions of varying materials (fig. 12). Among the many objects to be included, *The Sofa* combined the back seat of a car, a twisted bumper, and strips of chrome suspended from the ceiling. A huge muslin-draped wooden frame formed the shape of a sofa. A reviewer noted:

FIGURE 12
Installation view of Robert Whitman's solo exhibition at the Reuben Gallery, New York, November 1959.

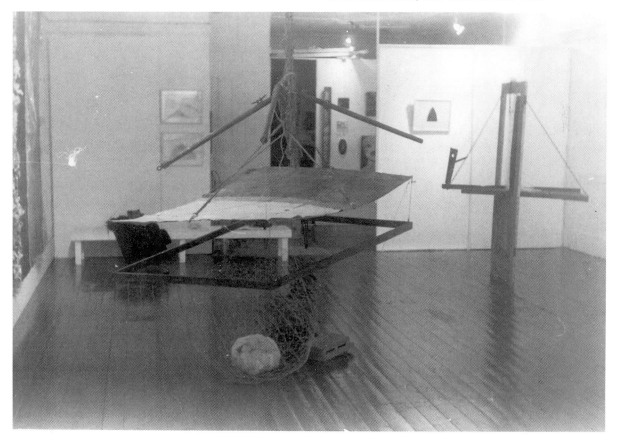

FIGURE 13
Lucas Samaras and Robert Whitman
on the set of Whitman's *American Moon*
at the Reuben Gallery,
New York, 1960.
Photograph by Robert McElroy.

Robert Whitman makes hanging constructions out of automobile wreckage, chicken wire, twine, steel wool and dirty rags; he covers vast canvases with a collage of shredded tissue, polyethylene and foil, and smears the whole with paint. The result is pathetic, a pity when one considers Whitman's talent for pastel and drawing.[70]

The 1960 show at the Martha Jackson Gallery titled *New Forms, New Media* was the first group exhibition to feature a substantial number of artists working in the new direction of junk sculpture, and included Whitman, George Brecht, Red Grooms, Jasper Johns, Kaprow, Claes Oldenburg, Robert Rauschenberg, and Richard Stankiewicz.

Whitman's *Cape Canaveral* appeared as a melted or flattened construction made of cardboard, fabric, wood, and glass.[71] Many of Whitman's early constructions have not survived.

By late 1960, Whitman had decided that he was primarily interested in performance art; he presented a theater piece titled *American Moon* for ten nights in November and December at the Reuben Gallery. One phase of the performance involved six sheets of plastic to which rectangular papers were attached. A movie was projected onto each screen, showing figures, colored shapes, and an autumnal landscape. Lucas Samaras appeared on a wooden swing above the audience (fig. 44).[72]

FIGURE 14
Detail of set of Robert Whitman's *Mouth,* 1961,
at the Reuben Gallery, New York.

John Cage and Kaprow were both important to Whitman's creation of performance art. Whitman is considered an innovator in staging "events" because of the "coherence of their structure and lasting dramatic impact of their imagery."[73] He rejected the term "happening," perhaps to separate himself from Kaprow's trajectory, or to put some distance between his own direction with performance art and that of his former teacher. Whitman performed in *18 Happenings in 6 Parts* at the Reuben Gallery. But he also was attracted to Paul Taylor's dance performances and to Red Grooms's *Burning Building,* which was staged in 1959 and expanded the frame of reference of those involved in staging events.

Although Dine, Brecht, and Oldenburg were also interested in performance art, critics noted that

in contrast to the other artists, Whitman made a serious and long-term commitment to performance and produced some of his most exciting works of the 1960s in this genre. Whitman viewed the theater projects as a legitimate art form, but of other artists he observed, "For most people it was a way to launch themselves into the art world. . . . there was no full-scale commitment to the form in itself."[74]

Performances by Whitman can be distinguished from Kaprow's when one considers the differences in methods. According to Kirby, Whitman did not prepare a "script" for his performers, but made notes, sketches with verbal notations.[75] Rehearsals were held for Whitman's events; careful practice of sections in order of occurrence was his method. His theater pieces were presented on several nights with the same

cast, props, and staging, although there is no plot or narrative. Time is key to the theater works. Whitman stated in an interview:

> The other thing I'm involved in very consciously is time. When I first started doing things, I thought of time as a material that these works were made out of, as a sculptor might make something out of a rock. I thought of time as real and substantial. . . . All of my work has a kind of rhythmic structure.[76]

In 1960 Whitman performed *Small Smell* in Oldenburg's *Ray Gun Spex* at the Judson Church in New York City, along with Kaprow, Dine, Higgins, and Grooms. Whitman's performances continued in 1961 with, for example, *Mouth* (fig. 14) at the Reuben Gallery, and *Ball* at the Green Gallery.

A great innovation in Whitman's performance is his use of film to explore aspects of time. Like Rauschenberg, Whitman joins art with life in his work. From George Segal's sculptural installations of figures observed at private moments, Whitman evolved his own films. *Shower*, for example, includes an actual metal showerhead with water running, while a film of a nude woman bathing is projected on a closed shower curtain.

Through his interaction with Kaprow, Segal, and Samaras at Rutgers, Whitman developed the freedom to explore his own artistic vision.

—

GEORGE SEGAL

—

Segal's first appearance at Rutgers College was in 1942 when he was briefly enrolled; then he took an art foundation course at Cooper Union in New York City. In 1947 he attended Pratt Institute, and two years later he graduated from New York University with a degree in education. In 1953 Segal bought a chicken farm in South Brunswick, and he found that Allan Kaprow, new on the Rutgers faculty, lived nearby. Since Segal had little enthusiasm for raising chickens, he began teaching art and English at New Jersey high schools.[77] As his friendship with Kaprow developed, Segal came to be included in many exhibitions and events at and around Rutgers University. For example, the two friends frequented the Z and Z Kosher Delicatessen in New Brunswick, and they

arranged an exhibition there in 1956. (Kaprow's idea was to evoke the artists of the nineteenth century, who traded artworks for food, leaving café owners to display the traded items on their walls.)

Beginning in 1956 Segal taught drawing and composition in the extracurricular Art Club (or Sketch Club) at Rutgers College, for which he was paid fifteen dollars a week. In October of that year, Segal's paintings were exhibited at the Art House,[78] and in November, he showed paintings at the Studio Gallery on New Brunswick's Albany Street in *Twelve Rutgers University Artists*.

Segal began exhibiting at the Hansa Gallery in 1956. He attended some of John Cage's classes at the New School in 1958, at Kaprow's behest. Although Segal had not studied with Hans Hofmann—as had many of the Hansa members—he greatly admired Hofmann as a teacher and an artist. Summers in Provincetown gave Segal some awareness of Hofmann's instruction there, and he was impressed with an exhibition of Hofmann's work that Kaprow arranged at Rutgers.

Not only was Segal an important presence at Rutgers in the 1950s and early 1960s, but his involvement with Kaprow, Samaras, and Whitman stimulated his own creativity. As did many others in regard to their own work, Segal considered Kaprow a major catalyst in the development of his sculpture. Art historian Martin Friedman observed: "During the period of critical self-analysis, Segal and Kaprow had endless discussions and vehement arguments about the creation of a popular new art. . . . The art form of the future, they asserted, would be a total experience; movements, sounds, even smells would be welcome."[79]

Although Segal flirted with abstraction in his paintings of the 1950s, he was drawn to the figure as a vehicle of personal expression. Every year Segal showed his paintings at the Hansa Gallery, beginning in March 1956. In the first couple of years he exhibited "vigorous oils cued practically by . . . Kaprow and theoretically by Hofmann's color school."[80] In February 1958, Segal exhibited *Man with Dead Chicken around Neck* (fig. 15). This figure of a nude male seems to be an autobiographical work, given Segal's ambivalence about raising chickens and

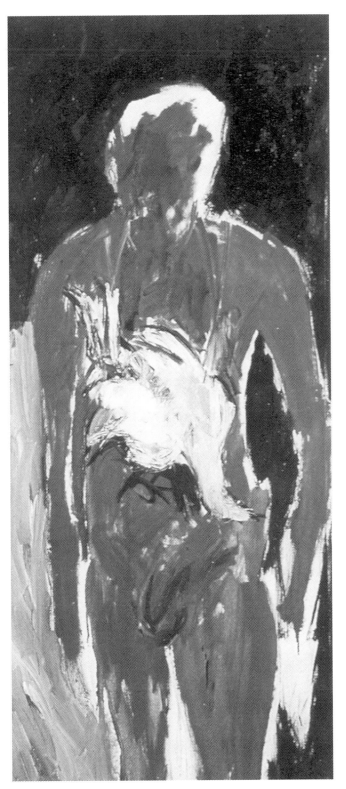

FIGURE 15
George Segal, *Man with Dead Chicken around Neck,* 1957.
Oil on canvas.
68" x 30" Location unknown.
© George Segal/Licensed by VAGA, New York.

his decision to remove all of the chickens from his farm and to use the chicken coops for studio space and storage.

Segal's 1958 exhibition of figurative paintings was reviewed as offering "un-morbid expressionist paintings of nudes in country interiors. . . . The figures are powerfully situated in space, sometimes swung into the canvas like an axe, cleaving it into two areas of hot, contrasting color."[81]

Within months following the 1958 Hansa show, Segal had taken his art literally "off the wall" by introducing figures of plaster and chicken wire that stand separate from the canvas. Kaprow's own exploration of sculpture, such as his *Woman Out of Fire* (plate 1), had some impact on Segal's new direction. For Segal "Kaprow was a catalyst. . . . He had a lot of influence and provoked a lot of ideas."[82] Recalling his move to sculpture, Segal explained that the reason for it was "my dissatisfaction with all the modes of painting that I had been taught that couldn't express the quality of my own experience."[83] When Segal discovered how department store mannequins were actually fabricated, he realized that it was possible to use materials readily available to him.[84] Initially these figures were made of burlap or plaster.

In February 1959, Segal included life-size sculptures along with the paintings in his annual Hansa show (fig. 16). A critic noted, "There are three life-size figures made of strips of burlap dipped into wet plaster, over armatures of shaped chicken wire: a standing man, a figure lying down thrashing, a woman seated in a broken old chair. Their effect is of swiftly improvised immediacy."[85]

While he was teaching at Rutgers, Segal began making sculpture—rather crudely—in plaster. In July 1961, he refined his methods when a student who was married to a chemist at nearby Johnson & Johnson brought newly devised medical bandages to him. Segal discovered that "more definition" was possible in his sculptures when he made life casts using these plaster-filled bandages.

Not too surprisingly, given the encouragement he received from Kaprow, Segal included his Rutgers colleague and former students among his earliest subjects—in addition to himself and his wife, Helen. *Man Sitting at a Table* (plate 12), Segal's self-portrait,

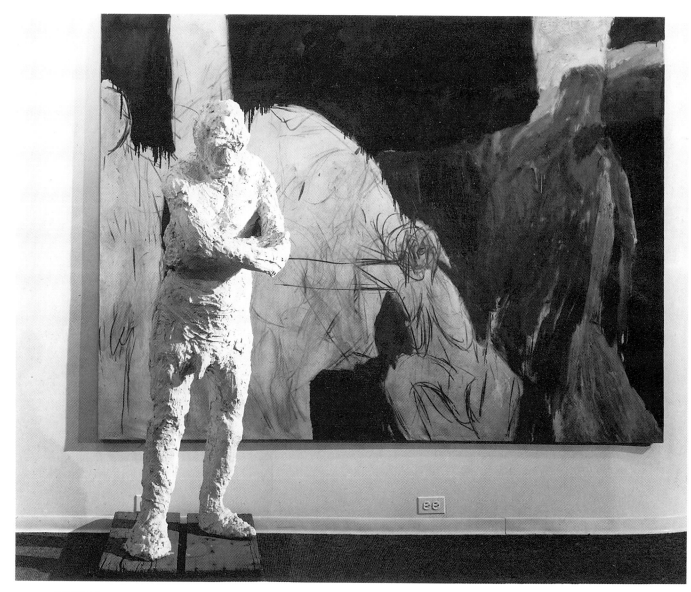

FIGURE 16
George Segal, *Legend of Lot*, 1958.
Oil on canvas, plaster, wood, chicken wire.
72" x 96" x 40"
Collection of the artist.
Photograph by Alan Finkelman, courtesy of the Sidney Janis Gallery, New York.
© George Segal/Licensed by VAGA, New York.

was the first figure cast from life. The artist, seated at a table in his kitchen, posed for this work while his wife wrapped him in the Johnson & Johnson bandages. This piece was followed by more ambitious projects, such as *The Dinner Table* (fig. 17), in which the artist explored both spatial relationships among the figures and their personal interactions. In *The*

Dinner Table, Segal achieves his first effort at combining plaster casts into a compositional-theatrical grouping. Not only does he include close friends Allan Kaprow, Vaughan Kaprow, Lucas Samaras, and Jill Johnston, but also his own likeness (holding a coffeepot) and that of his wife, Helen (standing with arms crossed). And he explores

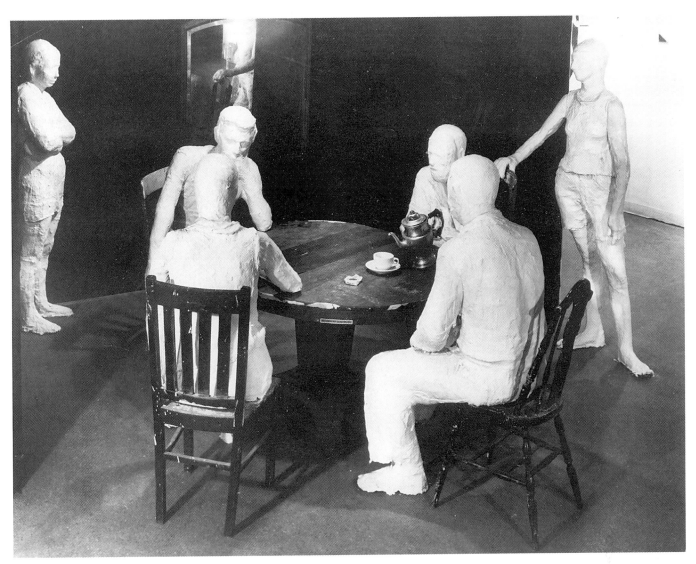

FIGURE 17
George Segal, *The Dinner Table*, 1962.
Plaster, wood, metal, ceramics.
72" x 120" x 120"
Private collection.
© George Segal/Licensed by VAGA, New York.

the interrelationships of these individuals, giving full expression to the dramatic component of this installation.

Through Kaprow, Segal learned that real objects could assume the qualities of "art," and that life experiences could be registered in plastic forms. Through Kaprow's Happenings, Segal was initiated into the theatrical possibilities of his own sculptural groups. Segal's chicken farm was the setting for some of Kaprow's early Happenings. Artists from the Hansa

Gallery enjoyed picnics there, and his open fields and vacant chicken coops eventually proved to be the perfect setting for Happenings and Fluxus events.

Because Segal was not interested in space/ time issues (or performance per se) in his own art, his tableaux (fig. 18) offered an opportunity to move beyond the canvas and create a form of "environment."

Kaprow supported his friend by writing one of the earliest full-scale articles on Segal, providing the

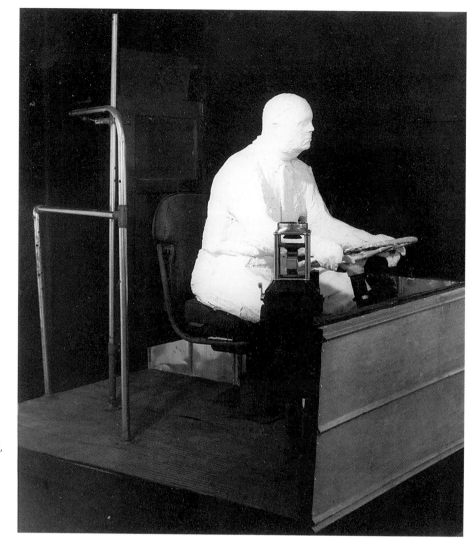

FIGURE 18
George Segal, *The Bus Driver,* 1962.
Plaster over cheesecloth (figure);
bus parts, including coin box,
steering wheel, driver's seat, railing,
dashboard.
Figure: 53 1/2" x 26 7/8" x 45"
Overall dimensions:
7'5" x 51 5/8" x 6'4 3/4"
The Museum of Modern Art, New York,
Philip Johnson Fund.
Photograph © 1998 The Museum
of Modern Art, New York.
© George Segal/Licensed by VAGA,
New York.

theoretical basis for situating his sculptures within the New Realism:

> George Segal's "presences" (I do not know whether I should call his assemblings of plaster people and real objects "sculptures" or "environments") emerge precisely when Abstract Expressionism has lost the sharp focus of its issues. Their somber and massive corporeality affects us doubly because they confront us against an artistic background of violent gestures and intangible veils of color. Directly, they cause us to question once again the nature of art (is it an abstraction or a resemblance?), and since these figures with their ready-mades are impressions or objects taken from life, they force us to ask further whether life is more real than art.[86]

Segal decided to give up high school teaching entirely. In 1962, he enrolled in the M.F.A. program at Douglas College and exhibited his paintings in the Douglass Art Gallery with other graduate students.[87] He received a Walter K. Gutman Foundation grant that enabled him to attend graduate school full time. When he finished the program two years later, Segal no longer had to teach; he had a flourishing career as an artist.

—

ROBERT WATTS

—

Watts began teaching art at the Douglass campus of Rutgers in 1953. Although his radical introduction of technology to art practice was the exception among the art faculty there, Watts eventually had a strong impact on the curriculum. Geoffrey Hendricks was

hired in 1956, and was supportive of Watts's innovative approaches to art pedagogy and art making. Joining tradition-bound instructors such as Robert Bradshaw, Watts would become something of a firebrand at Douglass College. In 1960 Roy Lichtenstein was hired at Douglass College, and brought his own innovations to the art fundamentals course. By the early 1960s, therefore, Watts and Hendricks, who began as an abstract painter, had pioneered many avant-garde events at Douglass College. In the same years, Watts participated in some of the most progressive artistic developments of the period, launching many proto-Fluxus activities with his friend George Brecht.

The women's college of Rutgers University, Douglass College, was a progressive institution, and Watts and Hendricks shared in the spirit of innovation. Under the leadership of Mary Bunting, dean of Douglass from 1954 to 1959, the women's college introduced new programs, including a multilingual course in world poetry and special opportunities for part-time study by married women.[88] Interdisciplinary programs were encouraged at Douglass, and the Voorhees Assemblies, with attendance required of all students, introduced a rich variety of programs. In the spring semester of 1958, Bob Watts served on the Voorhees Assembly Board, and helped to arrange an exciting series of events for Douglass students. Watts and Kaprow, who collaborated on the program, came up with the theme of "communication." The second-semester events at Douglass included a poetry reading by John Ciardi, and a lecture/performance by John Cage and David Tudor.[89] Paul Taylor's dance group performed in March, and Allan Kaprow's first Happening took place in April 1958.[90]

In Recitation Hall, where the art department had offices, classrooms, and studios, a gallery often featured exhibitions of recent developments in art; works by faculty members were also shown. Geoff Hendricks noted that approaches to art pedagogy at Black Mountain College were seriously considered as a model for the curriculum.[91] Not coincidentally, Black Mountain artists John Cage, David Tudor, as well as Paul Taylor—who was a Merce Cunningham soloist—were invited to the Douglass campus and

highly revered by some of the faculty. In addition, the works by Rauschenberg, another Black Mountain alumnus, were exhibited on campus, and his combine paintings and sculpture were greatly admired. Douglass art faculty challenged students with their own high standards of professionalism. Exhibitions combining faculty works with those of leading contemporary artists were organized for the art gallery at Douglass.[92] For example, a series of shows was arranged by Geoff Hendricks and Bob Watts titled *Group 1*, *Group 2*, and *Group 3*. In the third of the series, shown in November–December 1959, the exhibition included Rauschenberg's *Factum I* and *Factum II*, with constructions by George Brecht, Allan Kaprow, Jean Follett, and Robert Watts.[93] Other opportunities were offered to students to encourage them to learn about recent developments in art; they were urged to see art exhibitions and performances in New York. A Douglass student reviewing a 1959 Faculty Art Show noted the diverse approaches, handling of surface effects, and spatial relationships of the work:

> The demonstration of the range of possibilities of contemporary art has special significance because it indicates that the philosophy of the department allows the students a great deal of freedom to develop his [sic] own style, being influenced but not restricted by those of his [sic] instructors.[94]

At the core of the most radical changes in the art curriculum at Douglass, and some of the most outrageous events, was Bob Watts himself. Born in Burlington, Iowa, Watts studied mechanical engineering at the University of Louisville. During World War II, he served in the United States Navy as an engineer on aircraft carriers. After his discharge in 1946, Watts moved to New York, where he took classes in painting, drawing, and sculpture at the Art Students League. At Columbia University he studied art history (including pre-Columbian and Northwest Coast art) and drawing, and was awarded a master's degree in 1951.

After teaching at the Institute of Applied Arts and Sciences in Brooklyn in 1951, he was hired the following year at Rutgers to teach engineering. In 1953 he joined the art faculty at Douglass College, where he remained until his retirement in 1984.

FIGURE 19
Robert Watts at the Douglass College Art Gallery.
Solo exhibition, February 1957.
Photo courtesy of The Robert Watts Studio Archive, New York.

FIGURE 20
Robert Watts, *Construction with Random Light,* 1957–58.
Painted wood, foil, glass, flashing electric lights.
32" x 10 1/2" x 5 1/2" (approx.)
Location unknown.
Photograph courtesy of The Robert Watts Studio Archive,
New York.

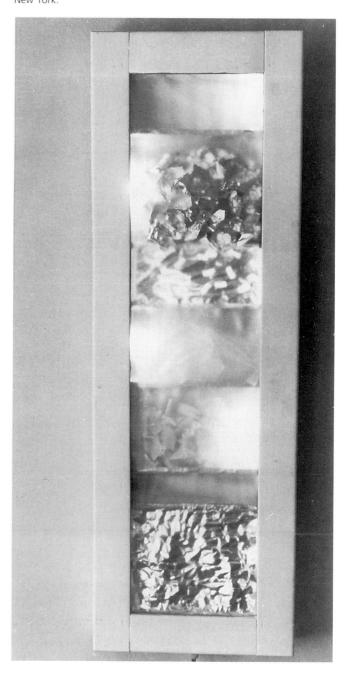

Watts taught both studio courses and the art of Africa and Oceania. In the early 1950s his own work was related to Abstract Expressionism: his paintings were generally small, linear compositions. The 1957 solo exhibition of Watts's work at Douglass (fig. 19) featured expressionist paintings, but Watts noted: "My engineering background has not gone to waste. Besides the practical aspect which helps me in changing fuses and such, engineering has been very valuable to me as an artist and designer."[95]

In 1957, Watts also began working with electric lights, wire, and live plants. *Construction with Random Light* (fig. 20) of 1957–58 included aluminum foil and flashing Christmas lights. His use of light related to his interest in the "magic lanterns" of his grandfather's movie house, which he remem-

bered seeing as a child. Later he recalled passing Newark Airport on his way to Rutgers and being impressed by the sequential lights used on the runway.[96] First Watts made constructions in his cellar that featured electric bulbs programmed by a switch sequence attached to a phonograph turntable. This device was followed by others, and Watts noted that "one day in July 1958, I stopped painting."[97] Also in 1958, Watts designed the "randomly sequenced lighting" for Kaprow's "Total Art" environment at Hansa Gallery. According to interviews with Larry Miller and Geoff Hendricks, Brecht, Watts, and Kaprow made an Environment on the Douglass campus in the spring of 1958. Kaprow called this a proto-Happening, and it included a large collage with flashing lights and an audiotape. Near an entrance, Watts made a mechanical moving hand, which emerged from a box filled with straw. The hand featured a glove with lights, and the box included a flashing blue light.[98]

Among the collaborations of Kaprow, Brecht, and Watts in 1957–58 was an unpublished document titled "Project in Multiple Dimensions." This proposal was circulated as an attempt to secure funding for a program of activities that would take place during the academic year. (Actual programs organized for the spring 1958 Voorhees Assemblies seemed to be closely related.)[99] In November, for example, "a group of events" was to be presented by Kaprow, Watts, and Brecht. In January, an evening of music by John Cage would be followed by a discussion by the composer. During the spring semester, "events" were to be presented by Watts and Brecht, and in March, music by "Advanced Contemporary Composers" would include musical compositions by Morton Feldman and Karlheinz Stockhausen.[100] The introduction of "Project" mentions the idea of "multi-dimensional media," or the use of more than one media in the creation of art, such as the use of sound and light. The authors propose experimenting with new electronic equipment for "creative expression." New techno-logical advances to be explored by the artist were the use of sound and light, and included devices such as pyrotechnics, explosives, audience-activated devices, and synthetics.[101]

For his contribution to this proposal, Watts wrote about his exploration of various "time-space-movement situations." He proposed that the relation of objects to environments through light, sound, and movement might cause objects and environments to "merge." The art he describes "reflects fundamental aspects of contemporary vision, by examining it in terms of space-time, inseparability or observer-observed, indeterminacy, physical and conceptual, multi-dimensionality, relativity and field theory."[102]

Watts, when he attended Cage's class at the New School (probably in 1958 or 1959), must have been fascinated with Cage's use of sound derived from everyday life and his fusion of electronic media. Not only did Watts encourage avant-garde activities at Rutgers, but he produced some of his own: his first works to join sound, light, motion, and electronic components with audience participation were shown on the Douglass campus.[103]

Watts's innovative constructions, such as *Goya's Box* (fig. 67) of 1958, can be considered a miniature museum, with stamps substituted for such famous works of art as Whistler's portrait of his mother and Goya's *Naked Maja*. *Pony Express* of 1960 (plate 13) includes motorized parts, and is a lively assemblage of disparate materials. The title suggests Watts's interest in mail delivery, a recurring theme in subsequent years.

In 1960 Watts prepared a score for *Magic Kazoo*, which was to be a twenty-seven-hour event to take place first in various locations in New York City; second, in transit to New Jersey; and third, by the ocean in southern New Jersey. "Casting" included a "Zen master, a wounded Vet, a Prostitute, a Little Girl, and a Murderer"; clothing and props were described for each; and a sequence of events was detailed. One event was the dropping of a key in a mailbox, hinting at projects such as the *Delivery Events* that he developed later with George Brecht. *Magic Kazoo* culminated in several members of the cast slowly walking into the sea.[104] Watts later acknowledged that such performances included the participation of Rutgers students.[105]

Watts wrote instructions that were like scores for Fluxus events. *Casual Event* (ca. 1961) involves a trip to the filling station, inflating a tire until it blows

up, and then replacing the damaged tire with a spare. Often no particular audience is specified, nor are performers predetermined.

In 1961, Watts made his first stamps, *Safe Post/ K.U.K. Feldpost/Jockpost* (plate 14), and used regulation postage-stamp dispensers. This involvement with postage and mail delivery is significant for correspondence art, which would be developed by Ray Johnson and others. For Watts, stamp art was developed from several previous experiences, including his interest in stamp collecting in his youth, and his substitution of stamps for famous artworks in his seminal *Goya's Box* of 1958 (fig. 67). He devised *Safe Post/K.U.K. Feldpost/Jockpost* (plate 14), which featured W. C. Fields's image; later stamps featured images of nude women, musical notes, and gas cans and other devices.[106]

Stamp art was meant to be participatory, but also had a subversive aspect. As a protest against the United States government—particularly certain policies of the early 1960s, Watts "borrowed" official stamp dispensers and loaded them with his stamps (fig. 21). When placed on view in an exhibition, the work encouraged audience participation: stamps could be bought by inserting coins in the dispenser. The score for *Mailbox* (probably 1964) reads simply "Mailbox event/open mailbox/close eyes/remove letter of choice/tear up letter/open eyes." The event resulted from Watts's experience of tearing up a letter by mistake. He re-created the letter in brass, and returned it to the original mailbox.

Watts evolved other subversive or controversial issues in his work, including references to policies of the United States government. In his 1962 exhibition at the Grand Central Moderns Gallery in New York, the inclusion of a U.S. marshal's badge was explained as a reference to his middle name, Marshall. This exhibition featured Watts's display of stamp machines, which offered the visitor stamps of the artist's own devising, and Watts produced *Dollar Bills* (fig. 22), which aroused suspicion that he was involved in counterfeiting operations. The bills were printed in large quantities and distributed freely.

Art involving stamps or dollar bills can be related to Fluxus, an international movement of the early 1960s. Watts, Brecht, and Geoffrey Hendricks

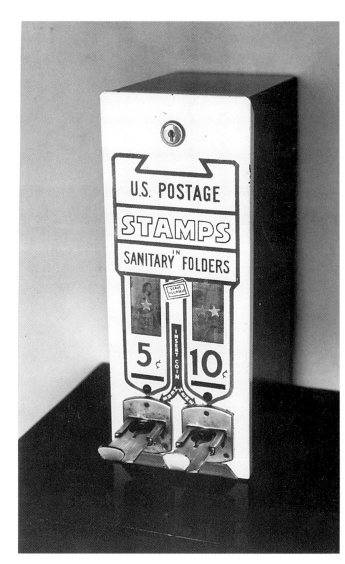

FIGURE 21
Robert Watts, *Stamp Vendor*, 1961.
Commercial stamp dispenser, with artist's stamps
(offset on gummed paper), cardboard folders.
14 1/2" x 5 3/4" x 5" (approx.)
Photograph courtesy of The Robert Watts Studio Archive,
New York.

came to be identified with this development that was meant to purge the world of "dead" art forms and unite the efforts of a cultural, social, and political revolution. Fluxus activities included performances and events. With Watts, the stamp's official function and regulatory function had been subverted; he usurped the official government role as stamp maker,

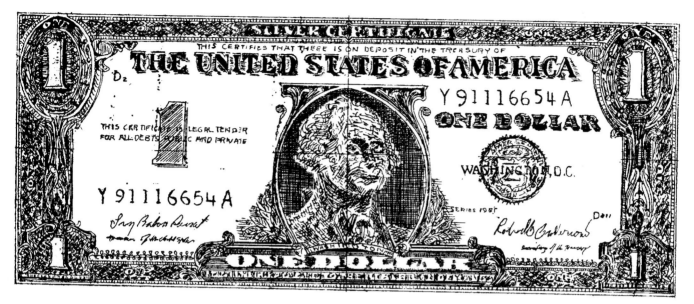

FIGURE 22
Robert Watts, *Dollar Bill,* 1962.
Drypoint etching.
10" x 7 1/2"
Offset versions were printed in quantities, trimmed to dollar size,
and distributed at performances, used as admission to events,
and sent aloft by helium balloons.
Collection of the Robert Watts Estate.
Photograph courtesy of The Robert Watts Studio Archive,
New York.

and substituted his zany designs. Although the stamps
are a bona fide project and are not counterfeit, when
people attached them to envelopes in the position of
official government postage stamps they violated
counterfeit laws. Watts's other projects were similarly
subversive: fake dollar bills, and a sticker that could be
attached to a parking meter so that twenty minutes
appeared to remain. Although Watts viewed these
works as harmless pranks, his projects often
challenged municipal or federal regulations.

In the 1960s Watts made works involved with
another theme: food consumption. The food objects
are indicative of an iconography shared with colleague
Roy Lichtenstein (fig. 23) and Claes Oldenburg.
Watts's food items were cast and chrome plated,
and made of plaster or Formica (figs. 69, 70). The
industrial methods transformed ordinary food
products into iconic, but also unappetizing,
commodities. In the 1960s Watts created chrome-
plated chocolates in a real candy box (plate 20),

chrome bread and butter, chrome eggs in a carton
(fig. 69). There were tin TV dinners, and laminated
dinner tables with photographs of food.

According to Lawrence Alloway, in 1964 Watts
attempted to register the title Pop Art with the
United States government, thereby removing the
term from the art market and preventing its use for a
variety of products. A series of documents resulted
that attest to the extensive use of the term by art
critics. Therefore the generic term could not be
officially trademarked by an individual.[107]

Like George Maciunas, the self-proclaimed
"leader" of the Fluxus artists, Bob Watts had an
interest in making multiple editions that could be
sold to the public.[108] Although the Fluxshops on
Canal Street in New York failed to sell their wares,
the cynical advertising for these products and the
initiation of a mail-order warehouse were a perversion
of all art world values and the false pretenses of
commodification.

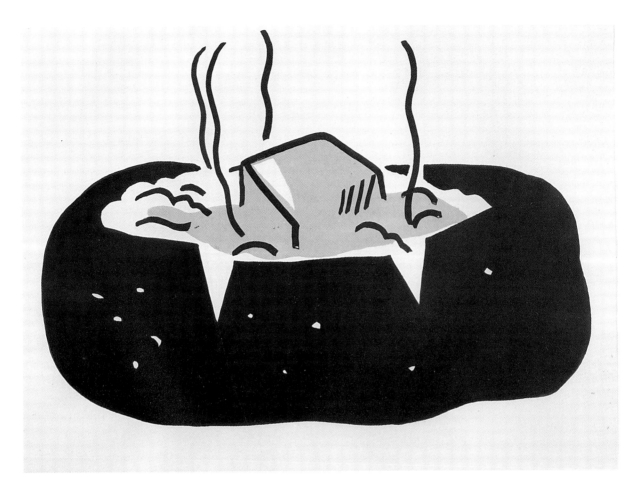

FIGURE 23
Roy Lichtenstein, *Baked Potato,* 1962
Ink and synthetic polymer paint on paper.
22 1/4" x 30 1/8"
The Museum of Modern Art, New York.
Gift of Abby Aldrich Rockefeller (by exchange).
Photograph © 1998 The Museum of Modern Art, New York.

ROY LICHTENSTEIN

Lichtenstein was always forthright in his acknowledg-
ment of Allan Kaprow's importance to the direction
of his art in the early sixties. Lichtenstein's years
as an assistant professor at Douglass College,
1960 to 1963 (fig. 24), were the last of his teaching
before he was propelled into acclaim as a leading
proponent of Pop Art. Key developments at Rutgers
include Lichtenstein's creation of the first large-scale
paintings to introduce Pop imagery, his acceptance
of Kaprow's concepts that "art doesn't need to look

like art,"[109] and his introduction (through
Kaprow's efforts) to Ivan Karp at Castelli Gallery.
Lichtenstein put together an innovative basic course
for visual art students, and taught other art classes
in design at Douglass College. He showed his
work on the Douglass campus, and became friends
with Robert Watts and other faculty members who
encouraged his involvement with avant-garde
concepts.

Given his commercial-art background and his
proclivity for sardonic commentaries on popular
culture, Roy Lichtenstein might have seemed the
perfect choice as a new faculty member to teach

FIGURE 24
Roy Lichtenstein at Douglass College, 1962,
as illustrated in *Quair* (Douglass College yearbook).

design in a department that was seeking innovative approaches to art making.

Lichtenstein recalled, however, that when he was asked by Douglass art department chair Reginald Neal (whom he met on the State University of New York, Oswego campus) to come to Rutgers for an interview, it was Neal's belief that he would work in a more conventional manner than Bob Watts and others at Douglass. Later, Lichtenstein felt that Neal must have been surprised by the direction taken in his use of cartoon imagery after coming to Rutgers.[110]

Lichtenstein was born and raised in New York City, where he attended private schools. In his youth he had an interest in radio shows such as *Flash Gordon* and other science fiction features. After attending Saturday classes at the Parsons School of Design, when he was a teenager, Lichtenstein studied with Reginald Marsh at the Art Students League. When his parents insisted that he pursue a college degree, Lichtenstein enrolled at Ohio State

University, in 1940. Hoyt Sherman, who developed experimental approaches to art instruction, was a lasting influence on him. In 1943, a year before his graduation, Lichtenstein was drafted into the army. He trained as a pilot and served in France and England. During his years in the military, he was assigned to *Stars and Stripes,* enlarging cartoon images for this newspaper. After the war, Lichtenstein returned to Ohio State University for his Bachelor of Fine Arts degree.

In the early 1950s Lichtenstein explored a long-standing interest in American themes and parodies of famous artists. He joined a fascination with media images from television and advertising with his interest in the fine arts by reinterpreting works by nineteenth-century painters. In 1951, for example, he produced a humorous version of Emanuel Leutze's *Washington Crossing the Delaware* (plate 15), which Lichtenstein described thus: "It's as though Paul Klee did Washington. . . . The influence is Picasso, but it's Picasso's influence on Miró or Klee.[111] American themes appear early in his work and lead to the playful Pop images of the sixties (fig. 25). In 1956, Lichtenstein made a lithograph titled *Ten Dollar Bill* (fig. 26), which makes a humorous, Cubist abstraction of the currency. Other works of the 1950s included paintings of the Old West and popular American folklore. Until 1957, Lichtenstein also held commercial art and design jobs, including the design of furniture, in Cleveland, Ohio. He exhibited works both in Ohio and in New York City. In 1957, with his first teaching position at the State University of New York in Oswego, his style changed to abstraction. While living in upstate New York he worked in a late Abstract Expressionist style. "Rag paintings" were made by the use of a torn bedsheet, saturating the material with paint and drawing it across the canvas. Ribbonlike passages of color or multicolored stripes resulted. Other canvases combined blank areas with sections of hatched strokes. Although somewhat expressionistic, these paintings featuring primary colors and thick, black lines seem to presage the outlines and limited palette of the comic-strip paintings.

When Roy Lichtenstein arrived at Rutgers, with paintings strapped to the roof of his car, he was

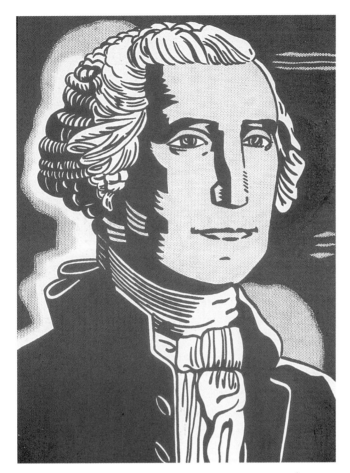

FIGURE 25
Roy Lichtenstein, *George Washington*, 1962.
Oil on canvas.
51" x 38"
Collection Jean-Christophe Castelli, New York.
© Estate of Roy Lichtenstein, 1998.

primed for even more radical changes of direction in his work. While teaching at Douglass, and developing friendships with Kaprow, Segal, Watts, and Hendricks, Lichtenstein moved beyond the expressionism of the Abstract Expressionists. During his transition to Pop imagery, Lichtenstein witnessed exhibitions of Kaprow, Watts, and Segal at Rutgers and saw important shows in New York. He recalled, for example, the *New Forms, New Media* exhibitions at the Martha Jackson Gallery, and mentioned being impressed with Claes Oldenburg's work.[112]

While his cartoon images were not directly influenced by Happenings, he was aware of Jim Dine's, Oldenburg's, and Kaprow's projects, and he

recalled, "Happenings used more American subject matter than the Abstract Expressionists used. Although I feel that what I am doing has almost nothing to do with environment, there is a kernel of thought in Happenings that is interesting to me."[113]

In January of his first year of teaching at Douglass, Lichtenstein had a solo exhibition of his rag paintings at Douglass College (plate 16) as an introduction of his art to students and faculty alike. The campus newspaper reported, "An exhibit of oil paintings by Roy F. Lichtenstein, a new member of the Douglass College art faculty who has exhibited in New York City and Cleveland, will go on display on Wednesday (Jan. 11) at the Douglass Art Gallery."[114]

While exhibiting abstract paintings at Douglass, Lichtenstein had privately turned to experimentation with cartoon imagery. Kaprow recalls going to his home for dinner one summer evening, and speaking with Lichtenstein in his studio. Piled everywhere were abstract paintings, "rather heavily painted squiggles and sort of parallel lines," but the conversation with Kaprow turned to cartoon images, whereupon Lichtenstein "walks over to this stack of striped paintings, that I thought were very nice. . . . Underneath around three or four layers, there was this canvas about yea big with Donald Duck casting a fishing line into the water [*Look Mickey*]. So, I look at this, and I start to laugh. Not out of criticism, but out of sheer pleasure. This is it. I knew."[115] Having encouraged Lichtenstein to continue his efforts, Kaprow also arranged for him to meet Ivan Karp (whom Kaprow had known at the Hansa Gallery; Karp was now gallery director at Leo Castelli Gallery). When Leo Castelli saw Lichtenstein's paintings, he decided to give the young artist a show at his gallery.

Look Mickey (plate 17) is generally considered to be Lichtenstein's first painting to feature cartoon imagery. Yet cartoons of Disney characters appear in his sketches of the 1950s, and there were several abstract paintings of 1958 that had Donald Duck, Mickey Mouse, or Warner Bros.' Bugs Bunny appearing among the expressionistic passages of his oils. At the same time, Lichtenstein was making drawings for his children based on bubble gum wrappers. His involvement with Rutgers faculty, and

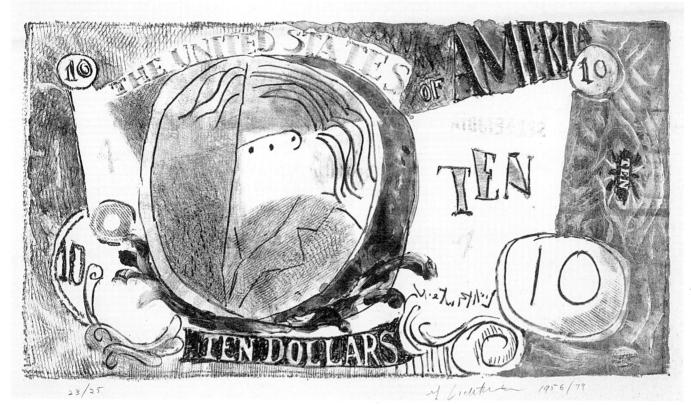

23/25 y Lichtenstein 1956/79

FIGURE 26
Roy Lichtenstein, *Ten Dollar Bill,* 1956.
Lithograph.
19" x 24"
Private collection.
Photograph by Robert McKeever.
© Estate of Roy Lichtenstein, 1998.

particularly the emphasis placed on everyday
experience, provided the incentive to make full-scale
paintings based on the mechanical drawings of
cartoon characters. Lichtenstein's previous experience
in commercial art and illustration must have helped
ease the transition (fig. 27, plate 19). Ileana Sonna-
bend also found out about Lichtenstein's paintings,
and she quickly arranged to buy several of them.

In 1962, Roy Lichtenstein was included in
the Faculty Art Show. A review of the show notes
that his paintings "parody commercial art." In the
same exhibition, which included Lichtenstein's
The Engagement Ring (plate 18), Hendricks showed
paintings, and Robert Watts exhibited stamp
machines and mailboxes. The student reviewer
commented, "By the strange content of his work,
Watts is forcing us to focus our attention on the

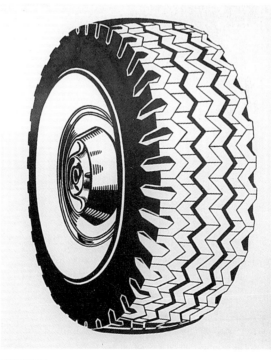

FIGURE 27
Roy Lichtenstein, *Tire,* 1961.
Oil on canvas. 68" x 56"
Private collection. Leo Castelli Gallery, New York.
Photograph © Estate of Roy Lichtenstein, 1998.

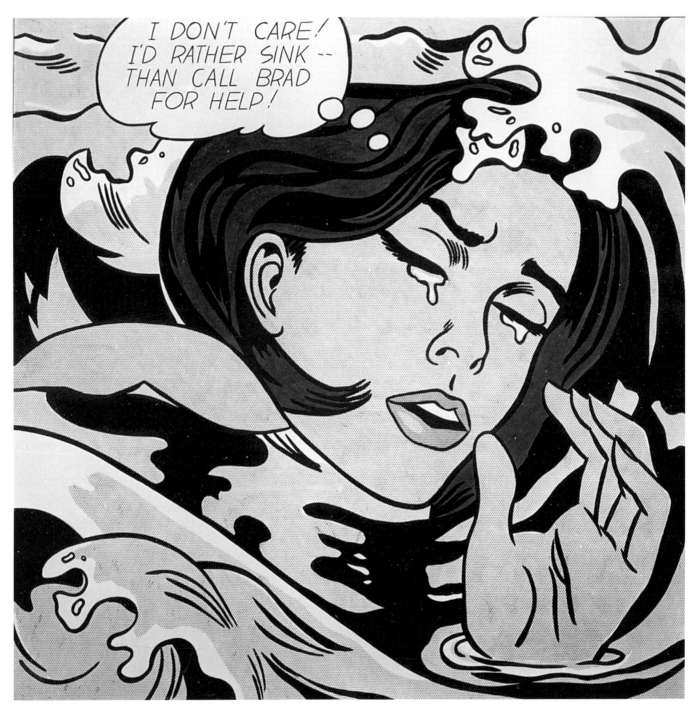

FIGURE 28

Roy Lichtenstein, *Drowning Girl*, 1963.

Oil and synthetic polymer paint on canvas.

67 5/8" x 66 3/4"

The Museum of Modern Art, New York.

Philip Johnson Fund and gift of Mr. and Mrs. Bagley Wright.

Photograph by Rudolph Burckhardt.

© 1998 The Museum of Modern Art, New York.

almost hidden aspects of art in everything around us . . . and two paintings by Lichtenstein should be viewed in the same light."[116]

In September 1963, Lichtenstein took a leave of absence from Douglass. According to Geoff Hendricks, Lichtenstein hoped to teach painting at Douglass, rather than the design classes and fundamentals course that he had initially been assigned. But Reginald Neal, who was teaching painting, would not offer Lichtenstein a painting class, and the newly successful Pop artist resigned his position.[117] Lichtenstein's career was in high gear, and he could afford to move to New York, where he continued to produce his renowned Pop images (fig. 28).

Lichtenstein returned to Douglass in April 1964 for a symposium during Junior Arts Weekend. The event was moderated by Billy Klüver and included Lawrence Alloway, Roy Lichtenstein, and Rudolf Arnheim. The speakers intended to discuss Pop Art as a burgeoning style, and specifically "to explore changes in attitude which have led artists such as Robert Indiana, Roy Lichtenstein and Andy Warhol to adopt the images and methods they are presently using."[118] Lichtenstein has remained a central figure in any consideration of Pop Art in the United States.

—

GEOFFREY HENDRICKS

—

Currently Hendricks is the Rutgers art department faculty member with the longest history there. He began teaching in 1956, and is still a part of the Visual Arts Program, serving twice as graduate director in recent years. Hendricks assumed a role in the development of the Douglass art department, particularly the planning of the M.F.A. program. Beginning in the 1960s, he was involved with Fluxus, and made a contribution to the advancement of Fluxus ideas at Rutgers. Frequently citing concepts based on the pedagogy of Black Mountain College, he has shaped the graduate curriculum, and introduced students to contemporary artists active in New York.

Hendricks was first hired at Douglass College after graduating from Amherst College, studying

sculpture at Smith College, and attending Cooper Union, where he produced sculpture and paintings. In 1951 Hendricks attended a lecture by John Cage at the Artist's Club in New York City, and his admiration for Cage continued in subsequent years.

Having been assigned responsibility for the Douglass College Art Gallery program, Hendricks organized exhibitions, beginning in the fall of 1957. With the intention of featuring "new art," Hendricks installed *Group 1* at the Douglass Art Gallery, and included works by Robert Motherwell, Franz Kline, Joan Mitchell, and James Brooks. The following year *Group 2* was devoted to innovative sculpture. In 1959, Watts and Hendricks were co-curators of *Group 3*, which featured Rauschenberg, Bruce Conner, Brecht, Kaprow, Jean Follett, and Motherwell, among others.

In 1958, while teaching at Douglass College, Hendricks also began studying art history at Columbia University. He took classes with Rudolf Wittkower, Meyer Schapiro, and Julius Held. (Influenced by Kaprow's enthusiasm for Schapiro, Whitman and Samaras were also students at Columbia in the 1950s.) In 1960 Hendricks prepared a thesis on Baroque ceiling paintings; the illusionistic views of clouds would soon find their way into his art.

Hendricks's paintings of the 1950s were inspired by nature, particularly skies, and the effects of light. In 1962, a dramatic change occurred as he sought new means of expression. Having attended Happenings and performance events at the Reuben Gallery and the Judson Church, Hendricks began making constructions of found objects, such as *Picturesque America* (fig. 29) of 1962. From the beginning there were leitmotifs; car tires, wooden boxes that could be opened like altarpieces, and references to the sky are examples. Most of Hendricks's performance activities took place after 1963, and therefore are beyond the scope of this project. Hendricks is a productive and influential teacher and Fluxus activist who continues to be part of the Rutgers Visual Arts Program. He was included in the 1965 *Ten from Rutgers* show at the Bianchini Gallery. Thereafter, Hendricks's cloud paintings and objects were shown at Bianchini and elsewhere. In 1969, his performance *The Sky's the Limit* took

FIGURE 29
Geoffrey Hendricks
with *Picturesque America*
at his solo exhibition at
the Douglass College Art Gallery,
March 1962.

place in Voorhees Chapel. Hendricks brought George Maciunas to campus in 1970 for a controversial event, the *Fluxmass,* and also introduced performance artist Herman Nitsch to Douglass College in 1971. As a contemporary shaman, Geoffrey Hendricks has gained international recognition for his performance art.

—

GEORGE BRECHT

—

When he was working at Johnson & Johnson in New Brunswick, George Brecht began to experiment in the visual arts. Trained in mathematical theory, Brecht also studied statistics, random numbers, and chance, and wrote an essay exploring the connections between art and chance, which he sent to John Cage in 1956. He began to make paintings and drawings based on these ideas, including works done by "taking Cartesian coordinates and choosing the points using random numbers for the x and y coordinates, then connecting the dots. . . . Or rolling marbles dipped in ink over plywood, so that irregularities in the surface appeared in the resultant form."[119]

After producing abstract paintings in a 1950s version of Abstract Expressionism, Brecht moved on to objects related to the laws of chance. He

recognized that Pollock's improvisational compositions constituted one response to the incorporation of chance, but Brecht's scientific study, including random-number tables and statistics, opened other possibilities for using chance in works of art.

Beginning in 1955, Brecht made what he called "sheet paintings" that were produced by spraying a crumpled bedsheet with water and ink and letting the stains bleed together. When the sheets were untangled and stretched, many variations appeared: sharp edges to more blurred forms resulted from the moisture remaining in the sheets before they were unfurled. Although these works may have been the beginnings of an exploration of chance, they still appear indebted to Abstract Expressionism.

But Brecht soon discovered Dada artists, particularly Marcel Duchamp, and he was then able to articulate his ideas fully. In 1966 he published *Chance Imagery*, recalling a number of classic Dada works, including Duchamp's *Three Standard Stoppages* and Jean Arp's *Collages Arranged According to the Laws of Chance*, which were undoubtedly related to his ideas.[120] Conceptually, Brecht's works of the period seem inspired by Arp's collages, or possibly Max Ernst's *Decalcomania*.

Brecht wrote a letter to John Cage about his researches and ideas concerning chance. When Cage came to New Jersey to search for mushrooms, he visited Brecht and they "passed a fantastic evening together."[121] Having heard of Cage's course at the New School from Kaprow, Brecht joined the class in 1958. His artwork changed dramatically; with the encouragement of Cage, Brecht introduced radical new explorations of chance and indeterminacy.[122] Brecht recalled what impressed him about the class:

> On the one hand [there was] Cage's personality, his way of living, and on other there was the general atmosphere of the course, which was attended by exciting people like Al Hansen, Dick Higgins, Allan Kaprow and others. It was a context in which I could really do something. At the end of each meeting—after discussing the subject—Cage would give a theme, for example a composition for five portable radios and the following week you'd come back with five radios and six different proposals. Afterwards we'd play them and everybody would discuss them.[123]

Within the rubrics of "experimental music" Cage had shown that a musical composition could be "composed" of random, ambient sound. In addition, musical "instruments" could be unconventional ones such as toys or eating utensils. A piano could be used in various ways, not simply by touching the keyboard. Brecht's works created during the late 1950s, including his events, resulted from ideas developed in Cage's class. For example, *Drip Music, Time-Table Music* of 1959, and *Motor Vehicle Sundown* of the following year show the artist's interest in sound.

Among the most interesting of his events is *Time-Table Music*, which was meant to be performed in a train station without the event being announced. Each performer was intended to use train schedules to "time" his or her noise; participants independently chose timetables, resulting in a random composition. The ambient noise within the station also altered the piece.

In *Motor Vehicle Sundown* (fig. 63) the performers follow instructions on randomly ordered cards and execute a series of actions, including turning on car headlights, honking horns, rolling down windows, and so on.

Fluxus notions of democratization—by eliminating the need for a virtuoso performance—were based on Brecht's concepts. By subverting the artist's authorship (as Duchamp had once "chosen" the Readymade), there was no emotional valence in the work. As Fluxus artists would also believe, the artistic activity cannot be differentiated from everyday acts. The depersonalization of the art-making process accomplished the most pointed rejection of the physicality and gesturalism of Abstract Expressionism. Brecht's works form situations that define themselves, without the intervention of the artist: there is no personal expression, interpretation, or explanation.

In Brecht's works, such as the *Three Chairs Event* (fig. 51) shown at the Martha Jackson Gallery in 1961 in *Environments, Situations, Spaces*, a wicker rocking chair was placed in the gallery and could be sat upon and moved around the space (fig. 50). Of this work Brecht wrote:

> [Chairs] interest me since they can pass unnoticed: you can't tell if they're works of art or not. One

day . . . I showed three chairs . . . one black, one white, one yellow.[124]

Expanding his idea of the Readymade beyond that of Duchamp, Brecht not only selected an object from his environment, but let it retain its functionality. While Duchamp might have transformed the Readymade, put it on a pedestal, or adjusted it to eliminate its functionality, Brecht simply installs a chair in a gallery.

Other works by Brecht are more participatory. For example, *The Cabinet* (plate 21) was intended to be rearranged or radically altered by his audience. Objects could be removed and rearranged. Certain objects could be shaken or knocked together to create sounds. In *Repository* (fig. 30), Brecht invited the viewer to remove objects and exchange them for others. In this instance, the experiment failed when people took away objects and left nothing in return. Brecht's attempt to activate the spectator and break down the conventional relationship between artist and audience was not practical. But the idea of removing pedestals from artworks and eliminating traditional boundaries was part of his redefinition of art-making processes that joined him with others at Rutgers.

In 1963 Brecht and Watts organized the *Yam Festival*, which can be viewed as a Fluxus homecoming; while Brecht's *V TRE* paper was also published in this period.

By 1963, when the *Yam Festival* events were taking place at George Segal's farm, in New York City, and elsewhere, the graduate program was well

FIGURE 30

George Brecht, *Repository,* 1961.

Wall cabinet containing pocket watch, tennis ball, thermometer, plastic and rubber balls, baseball, plastic persimmon, "Liberty" statuette, wood puzzle, toothbrushes, bottle caps, house number, pencils, preserved worm, pocket mirror, lightbulbs, keys, hardware, coins, photographs, playing cards, postcard, dollar bill, page from thesaurus.

40 3/8" x 10 1/2" x 3 1/8"

The Museum of Modern Art, New York,

Larry Aldrich Foundation Fund.

Photograph © 1998 The Museum of Modern Art, New York.

established on the Douglass campus at Rutgers. In early April, an arts festival was organized at Douglass titled "An Experiment in the Arts," and the program included a keynote address by Allan Kaprow; an art exhibition; experimental music; Fluxus works by Dick Higgins, Joe Jones, Alison Knowles, and others; one-act plays; and two Happenings by Al Hansen. His *Parisol 4 Marisol* was staged in the old Douglass gymnasium,[125] and Hansen also presented experimental music for cars in a Happening called *Car Happening or Carcophony*. The campus newspaper reported: "Approximately fifteen cars will participate in this automotive happening which will attempt to explore and utilize the musical qualities inherent in the automobile."[126] The faculty panel discussion featured Roy Lichtenstein and Bob Watts, and an art exhibition was installed in the conference rooms of the student center.[127]

YAM FESTIVAL EVENTS

The *Yam Festival* had its birth probably in 1961, when Robert Watts and George Brecht met weekly for lunch at Howard Johnson's—their favorite haunt—in New Brunswick, and put together a sequence of events that was to take place over many months and culminate in a month-long celebration in May 1963. The name "Yam" was "May" written backward, but also relates to a lithographed label for a crate of yams that Watts found in 1961 and used in a collage (fig. 93). Brecht wrote:

> It all started with this performance we were supposed to do and we tried to find, among the 28 flavors [of Howard Johnson's ice cream] a title for it. . . . We decided to do a program of events to cover the whole month [May]. We invited everybody to take part. There were street, subway, all kinds of events. The Kornblee and Smolin Galleries lent spaces too. . . . I remember one of the most fantastic shows I've ever seen, which was not by me, but arranged by Alison Knowles. It was a hat show held at the Smolin Gallery as part of MAY-YAM. Alison invited various people to make a hat and come with it to the show. There must have been 50 hat people.[128]

The name *Yam Festival* refers, therefore, to a number of events occurring from 1962 to May 1963.

Not all of the events were realized. Watts referred to the *Yam Festival* as a "loose format that would make it possible to combine or include an ever expanding universe of events."[129] The *Delivery Event* was one of the first, and offered products for delivery at bargain prices (fig. 31).

George Segal's farm was the setting for an afternoon of Happenings in 1963. Segal recalled many children participating in events, which included a *Sculpture Dance* created by sculptor Chuck Ginnever; Dick Higgins staged an event called *Lots of Trouble*, Yvonne Ranier danced on the roof of Segal's chicken coops, and La Monte Young played music.[130]

Allan Kaprow's Happening titled *Tree* (plate 22) involved many participants; the artist wished to bring in bulldozers to push bales of hay in a mock "battle" against "actors" wielding tree limbs, but Segal eliminated these vehicles out of concern for the safety of all participants and the protection of his fields.[131] Cars were substituted for the bulldozers, and bales of hay were pushed toward a waiting army (plates 30, 31) This Happening was realized more successfully than the 1958 event at Segal's farm. Al Hansen noted the seriousness of Kaprow's event:

> In a flat field at George Segal's farm, he arranged a huge hill of hay bales, on top of which he stuck a tree. On the bales sat La Monte Young playing his sopranino saxophone. . . . A line of autos slowly approached the hill, each auto knocking down stacks of hay that had been placed in its way. People from the cars got out and restacked the bales only to have them knocked down again. . . . On the other side of La Monte an army of men, women and children hid behind detached leafy branches. At a signal from their bearded leader, Kaprow himself, this ragged phalanx moved forward. . . . When the army reach[ed] the musician, Kaprow fought him for supremacy of the hay mound, vanquished him and cut down the tree.[132]

Kaprow's score for *Tree*, which was distributed at the Happening, gave specific instructions:

> This is a kind of war-game. One, however, which is neither won or lost. There will be no spectators at this event. At the sound of a loud, slow, booming beat coming over a public-address loudspeaker, everyone will gather around the hay mound for

YAM FESTIVAL PART 5

DELIVERY EVENT

by subscription

R. WATTS and or G. BRECHT
will assemble a work
and arrange delivery
to you
or an addressee of your choice

upon receipt of either

(A) $1 2 3 5 8 13 21 34 55 etc.

or

(B) a number of $ equal to the date of the month
 on which the work is subscribed to multiplied by
 the number of food items consumed by the sub-
 scriber on that day.

To subscribe, address:
YAM FESTIVAL, P.O. Box 412, Metuchen, N. J.

FIGURE 31
Robert Watts and George Brecht,
Yam Festival Delivery Event, 1962. (Announcement card.)
10" x 4 1/4"
Courtesy of Jon Hendricks. Photograph by Dan Dragon.

preliminary instructions. . . . From the start of this action, the forest people begin creeping gradually toward the pole, and when it goes down, they scream defiantly for about three seconds, quieting down as quickly as the shouting started. They move forward in this crouching position, tree upright, until they reach the spot of the demolition and the tree man becomes once more part of the forest. Following a few moments, this whole action is repeated again and again, until the forest has crept up to the hay mound and the tree man has struck down the last pole.[131]

The *Yam Festival* included many other events and paralleled Fluxus activities in the United States and Western Europe.

—

CONCLUSION

—

The contribution of Rutgers artists to major artistic developments such as Pop Art and Happenings has never before been fully documented. Likewise, innovations of Rutgers faculty in art training have remained unrecognized. In Carl Goldstein's book *Teaching Art: Academies and Schools from Vasari to Albers,* the Rutgers art program is not mentioned.[134] But he gives importance to art pedagogy at Black Mountain College, which was the acknowledged model for the Rutgers art program. In a section titled "The University Art Department: The New Academy?" Goldstein notes that artists prominent in the mid-1960s held B.A. and B.F.A. degrees, while those of previous decades attended art schools but did not receive degrees.[135] The shift to university art departments threatened a return to "academic" styles or to a strict adherence to the tenets of modernism, but this has not been the result among the best of the postwar university programs.

At Black Mountain College, Josef Albers taught, and Robert Rauschenberg was his seemingly rebellious student, in the early 1950s. If Black Mountain is accepted as a paradigm for art instruction in this period, the interaction of this teacher and student warrants examination: Albers may have presented a structured approach to art making, but he also encouraged students to be sensitive to visual experience and to learn the

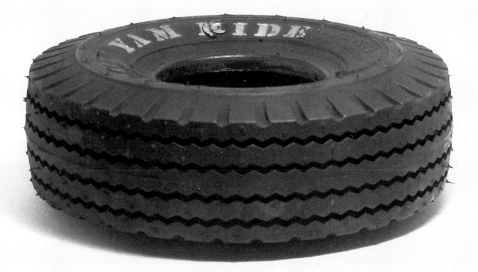

FIGURE 32
Robert Watts, *Yam Ride*, 1962–63.
Spray paint on tire.
Approximately 10 1/2" diameter and 3" deep.
The Gilbert and Lila Silverman Fluxus Collection, Detroit.
Photograph courtesy of The Robert Watts Studio Archive,
New York.

properties of materials, including such everyday examples as razor blades or burlap. With the encouragement of John Cage and others who taught at Black Mountain, Rauschenberg pushed Albers's ideas to the limits, introducing ever more radical materials and forms that seemed to fuse art and life.

The Rutgers art program was fully in accord with these ideas. The faculty rejected the notion of high art and accepted the random and the ordinary. Separating themselves from the modernist legacy, Rutgers students and faculty pushed on to a previously "off-limits" zone by exploring the connections between performance and art objects—incorporating sound, smells, and other stimuli.

After Black Mountain College closed, Josef Albers joined the faculty at Yale University; other avant-garde artists such as Ad Reinhardt began teaching at Brooklyn College. At Rutgers there were Allan Kaprow, Bob Watts, Roy Lichtenstein, Geoff Hendricks, and others to assure that Black Mountain concepts would continue to hold sway. Rutgers artists gave primacy to radical approaches to materials and art-making processes.

Although some university programs may have produced students who could only mimic the work of their instructors, the Rutgers art program encouraged independence and experimentation.[136] At Rutgers, the faculty continues to believe that the problems of society, personal identity, and the realities of life itself are essential components of innovative art making.

NOTES

Special thanks are offered to Joseph J. Seneca, Vice President for Academic Affairs, and Richard Foley, Dean of the Faculty of Arts and Sciences, Rutgers University, for their generous support of this publication. My thanks also to the artists who willingly shared recollections of their Rutgers years, particularly to Allan Kaprow, Geoffrey Hendricks, Roy Lichtenstein, Letty Lou Eisenhauer, George Segal, Lucas Samaras, and Bob Whitman. This essay was also supported by grants from the Office of Research and Sponsored Programs, Rutgers University. I am grateful to the Metropolitan Museum of Art for the Jane and Morgan Whitney Senior Fellowship, which provided released time to complete this publication and other research projects. The staff of the Watson Library at the Metropolitan Museum has been a continuous source of support.

1. From 1955 George Segal was the instructor for the Art Club (or Sketch Club), an extracurricular activity at Rutgers College. Even though he was not a regular member of the Rutgers faculty in the 1950s, Segal was included in many faculty exhibitions. In 1962, he enrolled as a graduate student in the art department (located at Douglass College), and was awarded a Master of Fine Arts degree in 1963.

2. Black Mountain College, a small experimental institution in the mountains of North Carolina, operated from 1933 to 1956 and attracted such artistic and literary figures as Josef Albers, Willem de Kooning, Robert Rauschenberg, John Cage, Merce Cunningham, and Buckminster Fuller. See Martin Duberman, *Black Mountain: An Exploration in Community* (New York: Dutton, 1972); Mary Emma Harris, *The Arts at Black Mountain College* (Cambridge: MIT Press, 1987).

3. Several of the artists on the Rutgers faculty have discussed avant-garde developments at the university during the 1950s. For example, Geoffrey Hendricks, in a statement for a Fluxus publication, wrote: "New Brunswick was no stranger to Fluxus or performance art. Seminal activity took place in that New Jersey city as early as events in Wiesbaden or anywhere else." In a note, Hendricks mentioned several of the key faculty members and events. See Geoffrey Hendricks, "Fluxriten," in *Wiesbaden Fluxus, Eine kleine Geschichte von Fluxus in drei Teilen* (Berliner Kunstlerprogramm des DAAD: Harlekin, 1982), 151–157.

4. Lucy Lippard, *Pop Art* (New York: Praeger, 1966), 74.

5. Barbara Haskell, *Blam! The Explosion of Pop, Minimalism, and Performance 1958–1964* (New York: Whitney Museum of American Art, 1984), 77.

6. Ibid., 113n121.

7. Allan Kaprow, introductory essay in *Ten from Rutgers University* (New York: Bianchini Gallery, 1965), n.p. This exhibition, which appeared December 18, 1965, to January 12, 1966, at the Bianchini Gallery, 50 West Fifty-seventh Street, New York, included George Brecht, Geoffrey Hendricks, Allan Kaprow, Gary Kuehn, Roy Lichtenstein, Phil Orenstein, George Segal, Steve Vasey, Robert Watts, and Robert Whitman. This retrospective of the early years at Rutgers included several artists, notably Kaprow, Lichtenstein, and Whitman, who were no longer affiliated with Rutgers in 1965.

8. During the interviews conducted for this project with Allan Kaprow, George Segal, Robert Whitman, Lucas Samaras, and Roy Lichtenstein, the mutual recognition, esteem, and awareness among the artists was noticeable. George Segal, for example, has retained close ties with Lucas Samaras, who appears in several of his works, including the renowned *Sacrifice of Abraham and Isaac.* Lichtenstein openly acknowledged the importance of Allan Kaprow to his early development of paintings based on cartoon images in the early 1960s and Robert Whitman counts among his closest associates several of these artists.

9. Until 1955 Douglass College was called the New Jersey College for Women. Only female students register as Douglass College students, but they are permitted to take courses on any campus of Rutgers University.

10. The art department was located in the "Art House," at 126 College Avenue in New Brunswick. The building, which housed a small classroom, faculty offices, and an art gallery, was torn down in 1966 during the construction of the Rutgers Student Center.

11. Interview with Allan Kaprow, Newark, New Jersey, December 8, 1995. Letty Eisenhauer, who was an undergraduate at the Women's College from 1953 to 1957, recalled that women could take courses at Rutgers College if the course was not offered at the other colleges (Interview with Letty Eisenhauer, New York, April 26, 1996).

12. "This Instructor is Different; He Welcomes Sharp Criticism," *Daily Home News* (August 4, 1955).

13. Calvin Tomkins, *Off the Wall: Robert Rauschenberg and the Art World of Our Time* (New York: Doubleday, 1980), 150.

14. Allan Kaprow used the term "New Art" in connection with Jackson Pollock, in "The Legacy of Jackson Pollock," *Art News* 57 (October 1958): 24–25. In other essays Kaprow also referred to a "new art," though not always with capital letters. See, for example, "The Demi-Urge," in which Kaprow states, "I have always dreamed of a new art, a really new art." *Anthologist* 30 (1959): 4.

15. Kaprow, "Legacy of Pollock," 26. According to Kaprow, the article was submitted to Tom Hess, editor at *Art News,* late in 1956, but Hess held the article for more than a year before scheduling it for publication. Interview with Kaprow, New York, March 4, 1998.

16. Kaprow, "Legacy," 26, 55.

17. Ibid., 56–57.

18. Grover Foley, "Vigor or Violence: An Analysis on Contemporary Painting," *Anthologist* 26 (1955): 6.

19. Irving Sandler, *The New York School: The Painters and Sculptors of the Fifties* (New York: Harper and Row, 1978), 198.

20. Interview with Kaprow, Newark, New Jersey, December 8, 1995.

21. Ibid.

22. Details about this work were supplied in an interview with Kaprow, New York, March 4, 1998.

23. "12 RU Artists Hold Showing," *Caellian,* November 29, 1956, 4. Among Rutgers faculty in the exhibition were Helmut von Erffa, Allan Kaprow, Sam Weiner, and George Segal, instructor for the Art Club. Eight undergraduate art majors were also in the show. As noted in the article, "Art majors exhibiting works are Andrew Ferenchak III, Robert Garlick, Arthur Gisser, Alfred Gruenert, William Kleiner, Lucas Samaras and Benjamin Whitmire. Ivan Kaiman is a sociology major."

24. There are some discrepancies in the dating of Allan Kaprow's participation in the John Cage class at the New School. Kaprow met Cage in the early 1950s, and came to the composition class at the New School specifically to solve problems with sounds that he was using for his Environments. In Kaprow's own curriculum vitae, he lists the years of study with John Cage as 1956–58. However, in recent conversations, Kaprow has talked of his participation in the class in 1958, probably beginning in the spring semester. Interview with Kaprow, New York, March 4, 1998.

25. In John Cage's composition class at the New School for Social Research were Allan Kaprow, Jackson Mac Low, George Brecht, Al Hansen, and Dick Higgins. George Segal was invited by Allan Kaprow to attend. Calvin Tomkins wrote about Cage's class: "The students in his experimental music class were for the most part young, impressionable, and

aesthetically ambitious. Allan Kaprow, George Brecht, and Al Hansen were practicing artists; Jackson Mac Low and Richard Higgins were poets; the only musician in the class was a Japanese student named Toshi Ichiyanagi. Cage's teaching method was to introduce them to the point he had reached in his own work, following a brief general survey of modern music, and then to try to find out where they were and do what he could do to stimulate them to experimental action." See Calvin Tomkins, *Off the Wall: Robert Rauschenberg and the Art World of Our Time* (New York: Doubleday, 1980), 149. See also Al Hansen, *A Primer of Happenings and Time/Space Art* (New York: Something Else Press, 1965), 91–102.

26. According to Kaprow, Cage described the Black Mountain event involving Merce Cunningham, Rauschenberg, David Tudor, and several poets to the students in his composition class (Interview with Kaprow, New York, March 4, 1998). Regarding the Black Mountain event, Martin Duberman wrote: "Taking into account the resources of talent in the community, [Cage] outlined various time brackets, totalling forty-five minutes. . . . To fill the time brackets, Cage invited Olson and Mary Caroline Richards to read their poetry, Rauschenberg to show his paintings and also to play recordings of his choice, David Tudor to perform on the piano any compositions he wanted, and Merce Cunningham to dance. Each person was left free, within his precisely defined time slot, to do whatever he chose to do." See Martin Duberman, *Black Mountain: An Exploration in Community* (New York: Dutton, 1972), 370. For another description of this event, see RoseLee Goldberg, *Performance Art* (New York: Abrams, 1988), 126–127.

27. Interview with Allan Kaprow, December 8, 1995.

28. *Re-Arrangeable Panels,* in other orderings of the individual panels, is known as *Kiosk* when it forms a four-sided structure, or *Wall* when the panels are installed end to end on the wall. Interview with Kaprow, March 4, 1998.

29. Kaprow's essay "Notes on the Creation of a Total Art" has been reprinted from the catalog in Allan Kaprow, *Essays on the Blurring of Art and Life,* edited by Jeff Kelley (Berkeley and Los Angeles: University of California Press, 1993), 10–12.

30. A reviewer noted, "As one wove at leisure among the even rows, one had phantasmal glimpses of other visitors doing the same—that is, absorbing courteously, with every available nerve, the sensation of being abstracted from the ordinary world to one where musique is as *concret* as abstract art, and both are heroically anti-Muzak." See "Allan Kaprow," *Art News* 57 (March 1958): 14.

31. Conversation with Geoffrey Hendricks, New York, May 17, 1998.

32. Allan Kaprow, "Notes on the Creation of a Total Art," in Allan Kaprow, "Environment" (brochure), (New York: Hansa Gallery, 1958).

33. *Environments, Situation, Spaces,* Martha Jackson Gallery and David Anderson Gallery, May 25–June 23, 1961. This show presented the work of six artists, and was the first group exhibition of artists creating environments that required viewer participation. In addition to Kaprow's *Yard,* the individual events were George Brecht's *Iced Dice,* Jim Dine's *Spring Cabinet,* Walter Gaudnek's *Unlimited Dimensions,* Claes Oldenburg's *The Store,* and Robert Whitman's *Untitled.*

34. Allan Kaprow, "Piet Mondrian, A Study in Seeing" (master's thesis, Columbia University, 1952).

35. Allan Kaprow, "Rub-a-Dub, Rub-a-Dub," *Anthologist* 29 (1957): 16.

36. Ibid.

37. In April 1958 an article in the *Caellian,* the Douglass College newspaper, announced Allan Kaprow's "lecture" to be given in Voorhees Chapel on the Douglass Campus. Kaprow is described as a member of the Rutgers faculty since 1952, and a founder of the Hansa Gallery in New York City. See "Allan Kaprow, Roy Wilkins to Speak Here," *Caellian,* April 16, 1958, 1.

38. The literature of performance art and most art history books give incorrect information about the first Happening. In many sources Kaprow's *18 Happenings in 6 Parts* at the Reuben Gallery in October 1959 is considered the first Happening. See, for example, Goldberg, *Performance Art,* 128–130; and Michael Kirby, *Happenings: An Illustrated Anthology* (New York: Dutton, 1966), 10. Geoff Hendricks recalls an event staged by Kaprow in his garage in North Brunswick, which predates the public Happening on the Douglass campus. Conversation with Hendricks, May 17, 1998.

39. Interview with Kaprow, New York, March 4, 1998.

40. Thanks to Allan Kaprow for supplying the original score of *Pastorale.* The text reads in part:
 Alas, she talked too much, too soon.
 Let us speak of beauty. We may. Let us gather our bodies' forces. We shall be reborn or die. We shall clutch our bellies, twirl garlands of flowers, floating veils. We might be nervous. Chew ashes. We could accompany the dying fall. We could throw ourselves amongst the flames, become a fire extinguisher. . . . There are gray situations everywhere.
 —Or take a step forward, we'll lean on an arm, smile into the wind. Here are four notes to listen to. . . . Do you love the sun? Have you ever counted sunspots?
 Kaprow refers to Miles Forst, who was a painter in New York, and a jazz musician. Conversation with Kaprow, July 17, 1998.

41. Interview with George Segal, South Brunswick, New Jersey, January 27, 1998.

42. Allan Kaprow, "The Demi-Urge," *Anthologist* 30, no. 4 (1959): 4–24. The issue also contained a statement by Robert Whitman and poetry by John Ciardi and Horace Hamilton. Federico Garcia Lorca's "Brief Theater" was also published in this issue.

43. "Gallery Shows Kaprow's Art," *Caellian,* September 25, 1959, 5.

44. For a useful statement by Kaprow and descriptions of four Happenings by him, see Kirby, *Happenings,* 44–117.

45. Kaprow, "The Demi-Urge," 4, 17. Following this essay is the complete text of his "something to take place: a happening" (12 pp.)

46. Allan Kaprow, *Assemblages, Environments, Happenings* (New York: Abrams, 1966), 184.

47. Allan Kaprow, "Some Observations on Contemporary Art," *New Forms, New Media I* (New York, Martha Jackson Gallery, 1960), n.p.

48. Allan Kaprow, "The Principles of Modern Art," *It Is,* no. 4 (1959): 51.

49. Kaprow, "Legacy of Pollock," 9.

50. Allan Kaprow, "Impurity," *Art News* 62 (January 1963): 30–33. See Kaprow, *Essays on Blurring,* 34–35.

51. Kaprow recalls that he was acting chair in 1955, and recommended Samaras for a scholarship that was seldom given for fine arts projects. Interview with Kaprow, March 4, 1998.

52. Allan Solomon, "An Interview with Lucas Samaras," *Artforum* 5 (October 1966): 40.

53. "Samaras Offers Second Art Exhibition at Highland Park Jewish Center," *Targum,* January 7, 1958, 1.

54. Peter Schjeldahl, *Lucas Samaras Pastels,* (Denver: Denver Art Museum, 1981), 6.

55. Rubin Rabinowitz, "Samaras Shows Oils and Pastels," *Targum,* March 5, 1958, 1.

56. This screen, recently restored, is owned by the Zimmerli Art Museum, Rutgers University.

57. Interview with Kaprow, January 1996. Apparently, administrators were unhappy about the language used by Samaras in his thesis. However, Kaprow's students had also installed "junk" sculptures on

the front lawn of the Art House. The sculptures were festooned with toilet paper and vandalized. Neighbors along College Avenue complained about the unsightly appearance of these student works. Conversation with Geoff Hendricks, May 17, 1998.

58. Lippard, *Pop Art*, 74.

59. In 1964, after moving to New York City, Samaras created *Room #1* at the Green Gallery. This installation, replicating in full scale the artist's bedroom in New Jersey, could be considered Samaras's personal response to creating an Environment.

60. Solomon, "Interview with Samaras," 40–41.

61. This male nude figure remains in the collection of the artist in Encinitas, California.

62. Barbara Rose, "Considering Robert Whitman," in *Projected Images* (Minneapolis: Walker Art Center, 1974), 38.

63. Interview with Whitman, New York, December 15, 1995.

64. Doris E. Brown, "American Theater Still Growing, Authority at Rutgers Believes," *Sunday Times* (New Brunswick, N.J.), March 18, 1956.

65. See illustrations and poetry by Robert Whitman in the *Anthologist* 27, no. 2 (1957): 16–18.

66. Richard Kostelanetz, *The Theater of Mixed Means* (New York: Dial Press, 1968), 226.

67. Fairfield Porter, "Robert Whitman [Hansa; Jan. 12–31]" *Art News* 57 (January 1959): 18.

68. "Alumni Artist to Give Show," *Targum*, January 30, 1959. The article reads in part, "The art department is planning an exhibition of work by Robert Whitman, a noted modern painter and alumnus of the University at the Art house, 126 College Avenue. . . . Since his graduation in 1957 Whitman has become one of the most advanced artists of his generation. His work, which includes huge constructions made of unusual materials like plastic, tin-foil and blinking lights, moves in a direction that appears to bypass painting and sculpture for the making of 'things.'"

69. Robert Whitman, "A Statement," *Anthologist* 30, no. 4 (1959): 25.

70. "Robert Whitman [Reuben: to Dec. 17]" *Art News* 58 (December 1959): 20.

71. *New Forms, New Media I* (New York: Martha Jackson Gallery, 1960), no. 73. Essays by Lawrence Alloway and Allan Kaprow. Whitman's *Cape Canaveral* is priced at $750 in the catalog.

72. For a complete description of *American Moon*, see Kirby, *Happenings,* 137–147.

73. Rose, "Considering Robert Whitman," 41.

74. Ibid., 41.

75. Kirby quoted from an interview, ibid., 137.

76. Kostelanetz, *Theater of Mixed Means,* 226.

77. Segal taught at Jamesburg High School, 1957–58; then at Piscataway High School, 1958–61. While he was in graduate school at Douglass College he taught at Roosevelt Junior High School, 1961–64.

78. "RU Displays Work of Abstract Artist," *Caellian,* October 4, 1956, 6. The article states in part: "Recent paintings of George Segal, advisor to Rutgers Art club, are on display at Rutgers Art House."

79. Martin Friedman, *Segal Sculpture,* 11.

80. "George Segal [Hansa; to Mar 10]" *Art News* 55 (March 1956), 58.

81. "George Segal [Hansa; Feb 17–March 8]," *Art News* 56 (February 1958), 11.

82. Phyllis Tuchman, *George Segal* (New York: Abbeville, 1983), 15.

83. Jan van der Marck, *George Segal* (New York: Abrams, 1975), 17.

84. Ibid., 16.

85. "George Segal [Hansa; Feb 2–21]," *Art News* 57 (February 1959): 16.

86. Allan Kaprow, "Segal's Vital Mummies," *Art News* (February 1964): 31–32.

87. The student reviewer noted in regard to Segal's paintings: "By far, the best paintings in the gallery [are] two large canvasses by George Segal. These evocative paintings, both portraying nude figures. . . . His neon colors are excitingly interrupted, on one of these oils, by a black ground—with a bright yellow square. Along with these, he has offered a large structure which seems to dominate at least half of the room. This amazingly grotesque piece consists of a stark white sculptured figure surrounded by four doors of various surfaces." See Beth Ann Weiner, "Graduate Students Exhibition 'Art,'" *Caellian,* April 14, 1961, 2.

88. For additional information on Mary Bunting, see Karen W. Arenson, "Mary Bunting-Smith, Ex-President of Radcliffe, Dies at 87," *New York Times,* January 23, 1998, D20.

89. For the text of John Cage's lecture at Douglass College, see John Cage, *Silence* (Hanover: Wesleyan University Press, 1961), 41–56. The text, titled "Composition as Process," is subtitled "Communication" and features a long series of questions.

90. An evaluation form for "Voorhees Assemblies, Second Term 1958" indicates that events of the spring semester involved John Ciardi (January 28), John Cage (March 11), Paul Taylor Dancers (March 18), and Allan Kaprow (April 22). My thanks to Geoff Hendricks for

sharing his personal records of Douglass College events.

An article in the Douglass newspaper noted that choreographer Paul Taylor appeared in the Little Theater at Douglass with dancers Donya Feurer and Toby Glanternik. Original dance creations to the music of John Cage were to be featured. Taylor was "soloist for the Merce Cunningham and Anna Solok Companies." See "Chapel Will Present Choreographer, Alumna," *Caellian,* March 13, 1958.

91. Interview with Geoff Hendricks, January 22, 1998.

92. For example, a 1957 faculty show in Recitation Hall included Geoffrey Hendricks, Robert Watts, Ka Kwong Hui, Evelyn Burdett, and Robert Bradshaw. See "Exhibit Offers Department Art," *Caellian,* September 19, 1957, 4.

93. The *Group 3* exhibition at the Art Gallery, Douglass College, took place from November 30 to December 16, 1959. The show presented works by Alfred Leslie, Robert Motherwell, Conrad Marca-Relli, Bruce Conner, George Brecht, Esteban Vincente, George Ortman, Allan Kaprow, Robert Watts, Joseph Cornell, Alberto Burri, Robert Rauschenberg, and Jean Follett. Thanks to Geoff Hendricks for supplying the brochure from his files.

94. Bette Colby, "Reviewer Praises Variety, Freedom in Douglass Faculty Art Exhibition," *Caellian,* October 9, 1959, 4.

95. "Watts States Views on Expressionist Art," *Caellian,* February 7, 1957. The brochure for Robert Watts's painting exhibition includes a brief statement by the artist, and another by Theodore Brenson, chair of the art department at Douglass.

96. Robert Watts in an interview with Larry Miller, ca. 1981, Robert Watts Archives, New York.

97. Colin Naylor, ed., *Contemporary Artists* (Chicago: St. James Press, 1989), 1014.

98. Larry Miller, interview with Watts, on file in the Robert Watts Archives, New York.

99. Allan Kaprow recalled that Bob Watts had a friend who worked for the Carnegie Corporation. Although this project was not funded, Watts did receive a grant from Carnegie in 1964 to set up an experimental workshop. See "Rutgers is Granted $15,000 to Spur Innovation in Art," *New York Times,* November 5, 1964. The article notes: "Present student projects include construction of a series of windows, the combining of photographic images to suggest other images, and evocation of changing images and emotions through the use of common-

place objects such as food, make-up and clothing."

100. "Project in Multiple Dimensions" by Watts, Kaprow, and Brecht was made available by the Robert Watts Estate. My thanks to Larry Miller and Sara Seagull for supplying materials from the Watts Archives.

101. Ibid., 2.

102. Ibid., 8.

103. Benjamin H. D. Buchloh, *Robert Watts* (New York: Leo Castelli Gallery, 1990), 5.

104. Special thanks to Larry Miller and Sara Seagull, who provided a copy of the *Magic Kazoo* score from the Watts Archives.

105. Naylor, *Contemporary Artists,* 1014–1015.

106. See *Robert Watts/Artistamps/ 1961–1986* (San Francisco: Stamp Art Gallery, 1996). This publication was made available by the Watts Archives.

107. Lawrence Alloway, *American Pop Art* (New York: Collier, 1974), 1. See also essay by Sid Sachs in Lafayette College Art Gallery, *Robert Watts* (Easton, Pa.: Lafayette College, 1991), n.p.

108. Fluxus is an international movement whose name was coined officially by George Maciunas in 1962. The first Fluxus festival took place in 1962, in Wiesbaden, Germany. Fluxus artists worked in Germany; later Fluxus festivals took place in Paris, Copenhagen, Amsterdam, London, and New York. Fluxus events feature simultaneous mingling of various art forms. Performances, concerts of electronic music, and street art are related to earlier Happenings in the United States. See Simon Anderson's essay in Elizabeth Armstrong and Joan Rothfuss, eds., *In the Spirit of Fluxus* (Minneapolis: Walker Art Center, 1993).

109. Interview with Lichtenstein, New York, March 27, 1996.

110. Interview with Lichtenstein, March 27, 1996.

111. Interview with Lichtenstein, New York, March 27, 1996.

112. Interview with Lichtenstein, March 27, 1996.

113. John Coplans, ed., *Roy Lichtenstein* (New York: Praeger, 1972), 56–57.

114. "Gallery Exhibits Oil Paintings," *Caellian,* January 13, 1961, 1.

115. Interview with Allan Kaprow, December 8, 1995.

116. Denise Flaccavento, "Faculty Art Show," *Caellian,* October 12, 1962, 6.

117. Interview with Geoff Hendricks, New York, January 22, 1998.

118. Carol Busanovich, "Jr. Arts Weekend to Feature Artists, Musicians, Scholars," *Caellian,* April 3, 1964, 1, 6.

119. Michael Nyman, "George Brecht," *Studio International* 192 (November/December 1976): 262. Quotes taken from an interview with Brecht in Cologne, Germany.

120. George Brecht, *Chance Imagery* (New York: Something Else Press, 1966).

121. Irmeline Lebeer, "George Brecht," *Chroniques de l'art vivant* 39 (May 1973); translated by Henry Martin in *An Introduction to George Brecht's Book of the Tumbler on Fire* (Milan: Multhipla, 1978), 83.

122. Henry Martin states: "Brecht himself prefers to say not that Cage influenced him but rather that Cage 'changed' him." See Martin, *An Introduction,* 7.

123. Irmeline Lebeer, interview with George Brecht, translated in Martin, *An Introduction,* 83.

124. Martin, *An Introduction,* 87.

125. *Parisol 4 Marisol* was later performed at the Gramercy Arts Theater in New York City (August 8, 1963). Hansen recalls

that the event involves the artist and a woman tearing off each other's shirts, and ends when a pie is thrown into his face. See Al Hansen, *A Primer of Happenings,* 16, 24–25.

126. Denise Flaccavento and Harwood, "A. Kaprow Slated for Music, Arts Weekend," *Caellian,* March 15, 1963, 1.

127. "Arts Festival Scheduled; Allan Kaprow to Lecture," *Rutgers Daily Targum,* March 21, 1963.

128. Robin Page interview with George Brecht, in Martin, *An Introduction,* 103.

129. Quoted in Larry Miller, "Robert Watts: Scientific Monk," *Kunstformen Internationale* 115 (September/October 1991). My thanks to Larry Miller for supplying the original typescript of his article.

130. Interview with George Segal, South Brunswick, New Jersey, January 28, 1998.

131. Interview with George Segal, South Brunswick, New Jersey, January 27, 1998.

132. Hansen, *A Primer of Happenings,* 33–34.

133. Allan Kaprow, original score for *Tree.* Thanks to Jon Hendricks for supplying this documents from his archives.

134. Carl Goldstein, *Teaching Art: Academies and Schools from Vasari to Albers* (New York: Cambridge University Press, 1996), 280–299.

135. Ibid., 280.

136. See, for example, Harold Rosenberg's criticism of university-trained artists as working in the method of their teacher: "For instance, Josef Albers' impacted color squares have become the basis of impacted color rectangles, chevrons, circles, stripes—works bred out of works, often with the intervention of a new vision." Quoted in Goldstein, *Teaching Art,* 280.

Since the dawn of the twentieth century, if not earlier, many artists on both sides of the Atlantic have repeated the same mantra. The artist's main task, they have insisted, is to break down the barriers between art and life. Manifestos from the 1880s to the 1960s, from Paris to San Francisco to New Brunswick, New Jersey, have contained a common rallying cry: Bring art from the salon to the streets. The idioms have changed from modernist high seriousness to postmodern ironic detachment. But the message has been constant—away with the effete Victorian idea that art should occupy a separate sphere. Blur the boundaries, cross the border, close the gap between art and life. (The problem that has usually gone unexamined has been how to define "life.") By the second half of the twentieth century, the slogans of barrier-breaking had been repeated often enough to constitute an avant-garde tradition.

The artists who clustered around Rutgers during the late 1950s and early 1960s worked within that tradition even as they challenged some of its assumptions. This essay aims to locate their work at a particular moment in American history—those few decades between V-J Day and the OPEC embargo, when it looked like an affluent-consumer culture was here to stay, and when a subtle but far-reaching shift in artistic sensibility began to redefine the relations between art and life. A Modernist belief that life must be dredged from the artist's inner emotional depths gave way to a postmodern notion that life could be skimmed from the surfaces of consumer culture, no matter how banal they seemed. The Rutgers artists were on the cusp of this change.

OUT OF CONTROL

—

ART AND ACCIDENT

IN A MANAGERIAL AGE

—

JACKSON LEARS

Yet labels such as "modernity" and "post-modernity" obscure as much as they illuminate. There were continuities as well as breaks. On either side of the postmodern divide, American artists remained preoccupied with capturing spontaneous experience in a society that seemed bent on subduing it. Recoiling from fears of a regimented existence, they created an aesthetic of accident—a devotion to the use of chance in art that altered as it crossed the postmodern divide but retained its fundamental character as a protest against an overorganized society.

The aesthetic of accident was shaped by the managerial cast of American culture at midcentury. As every textbook acknowledges, the postwar era witnessed an unprecedented growth in economic security and spending power for the middle classes. What is less widely discussed is that mass consumption depended on the triumph of a managerial commitment to efficiency and productivity—an ethos that spread beyond factories and offices into a variety of arenas, including public policy debate, mass entertainment and advertising, even domestic life.

The managerial ethos was an updated version of Victorian self-control, and it, too, provoked a nearly uniform hostility among artists and intellectuals. Most were still haunted by the specters of fascism and communism; to them consumer culture seemed merely a kinder, gentler version of totalitarian social conditioning. Dostoyevsky's tale of the Grand Inquisitor became a popular parable. Small wonder that many sensitive souls, from existentialist philosophers to Beat poets and Abstract Expressionist painters, became preoccupied with the spontaneous gesture as a declaration of independence from managerial authority—or that, given their avant-garde tradition, they sometimes justified their outlook as part of a broader agenda: the merger of art and life.

But it was hard to make spontaneity—and still harder to make chance—into an artistic program. The aesthetic of accident raised a host of difficult questions. Self-contradiction pervaded its adherents' pronouncements. The marriage of art and life was frequently proposed but only fitfully consummated. Difficulties deepened during the 1960s and 1970s,

after the postmodern turn. Artists traded anguish for irony; managerial culture became progressively hipper, disengaged from the button-down organizational styles of the 1950s, and incorporated aesthetic rebellion as a marketing tool. Still, certain artists and writers withstood self-contradiction and incorporation. The work of George Brecht and Robert Watts, among others, revealed an important alternative vision. It also suggested that the idea of art as a separate sphere might be a useful fiction, after all.

—

Textbook accounts to the contrary notwithstanding, post–World War II consumer culture was not simply constituted by an upsurge of leisure and abundance. Rather it could be described as a rebalancing of tensions that had characterized market society in the United States since the early nineteenth century— the balancing act that might be called the stabilization of sorcery. The market's potentially anarchic promise of magical self-transformation, perpetual novelty and fluidity, had constantly to be contained by the broader social need for stability, regularity, predictability. Through the nineteenth century, moralists posed this conflict in its classic forms: sybaritic consumption against virtuous production, aristocratic luxury versus republican morality.[1]

But by the early twentieth century, managerial thinkers believed that they had come up with a new formula for orchestrating those tensions. In *The New Basis of Civilization* (1907), the economist Simon Nelson Patten departed decisively from previous moral commentary on political economy. He argued that expanding consumption would not undermine labor discipline but would reinforce it. Workers would embrace productive habits in order to buy more things and make a better way of life for themselves and their families. Good consumers would make good producers as society moved from agrarian scarcity to mass-produced abundance. Experts such as Patten would bring their managerial skills to the overseeing of the dynamic, upward spiraling equilibrium between production and consumption. American society would become a busily humming, ever expanding "social system," as a later generation of social scientists would call it. Frederick Winslow Taylor, the

originator of scientific management, and Henry Ford, the pioneer of the five-dollar day, were having similar thoughts at about the same time. But no one else's vision was as grandiose as Patten's.[2]

Several decades, two world wars, and a Great Depression later, Patten's vision was finally realized—more or less—in the post–World War II United States. It was the Fordist moment, the fulfillment of the managerial dream of orderly economic development. The dream was limited and problematic even for the white middle classes, but it was deeply rooted in popular yearnings for safety and stability, longings for refuge from depression and war.[3]

Those longings underlay the cultural continuity between the 1930s and the 1950s. They can be seen in the persistent hovering presence of the American Way of Life, a collective mythology born in the 1930s under vaguely populist auspices, and gradually transmuted into a filiopietistic nationalism that was perfectly consistent with the resurgent corporate apologetics of the war years and after. The American Way of Life seemed larger than the individuals who pledged allegiance to it. It acquired a life and causal potency all its own.[4]

This tendency toward reification pervaded social science as well as popular thought during the midcentury decades. Academic theorists implicitly denied individual or group agency, transforming members of society or culture into autonomous, omnipotent beings. Talcott Parsons's "social system" was the most egregious example, but even more empirically minded thinkers sometimes yielded to similar temptations. In *People of Plenty* (1954), the historian David Potter chose the abstraction "abundance" as the deus ex machina to explain the peculiarities of "American national character." "As abundance raised the standard of living," Potter wrote, "*it* did far more than multiply the existing types of goods. *It* caused us to use new goods, new sources of energy, new services, and by doing so, *it* transformed our way of life more than once every generation." Americans were passive, abundance active.[5]

Here as elsewhere during the postwar years, one sees the emerging sense that American society had become a machine that would run by itself. "Who

really runs things?" David Riesman asked in 1950. "What people fail to see is that, while it may take leadership to start things running or to stop them, very little leadership is needed once things get underway. . . . The fact that they do get done is no proof that there is someone in charge."[6] Everything was under control, though no one (or at least not Riesman) was quite sure how or why. Indeed the faith in managerial competence was strained daily by the accelerating pressures of the Cold War and the nuclear arms race; the constant atmosphere of crisis, of impending chaos beyond ordinary citizens' control or even knowledge, made the notion of a smoothly functioning social system all the more appealing—if not altogether believable.

The vision of society as a self-regulating mechanism was related to the rise of the blank, impersonal face of modern authority. By the 1950s, college sophomores had learned to call their epoch "Kafkaesque." Universities, government bureaucracies, and corporations were all among the sorting and categorizing institutions engaged in what the philosopher Ian Hacking has called the taming of chance. Statistical thinking tamed chance by acknowledging indeterminacy in the universe, by giving up the dream of universal, mechanical causality and settling for a probabilistic conception of natural law. From the statistical perspective, chance became little more than the predictably unpredictable occurrence, the standard deviation. In the actuarial tables of insurance companies, the risk-assessment studies of government planners, the market research of major corporations, a new conception of the cosmos emerged. It was all the more orderly because it acknowledged and aimed to manage the occasional eruption of disorder. And it was well suited to managerial visions of a controllable, predictable social universe.[7]

Everything, somehow, fit into the functionalist framework of managerial sociology. Even the apparently unproductive suburban family had a role to play: it was an institution, Talcott Parsons decided, that was made for "intimacy maintenance."[8] From this perspective, play became *recreation*—re-creating the individual's capacity to perform where it counted, in the workplace. An older idiom of morality gave way

to a newer one of normality—itself a statistical construction. An eclectic psychology of adjustment, using shreds and patches of theory from behaviorism to psychoanalysis, expressed the hegemony of the normal.

Under this regime, a fascination with chance could be a social disease. Films such as *The Lady Gambles* (1949) revealed the thumbprints of Freudian orthodoxy, pressed into the service of the status quo. A newlywed woman (Barbara Stanwyck) gambles compulsively, losing constantly, despite the entreaties of her husband (Robert Preston). Finally it is revealed that she feels irrational guilt over the death of her mother in (her own) childbirth. Her cold, stereotypically mannish, and suspiciously unmarried sister has encouraged this delusion of guilt in an attempt to break up the heroine's marriage and keep her to herself. In the end good sense triumphs through the cooperation of the husband and a wise psychoanalyst: the unmarried sister is vanquished, the man and woman reunited. In such a well-managed universe, it should come as no surprise that the devotee of chance—especially the female devotee of chance—was marked as a dangerous deviant, particularly by therapists, who condemned gambling as pathology rather than immorality.[9]

The dominance of managerial norms did not mean that most people conformed to them. Americans still managed to enjoy themselves in idiosyncratic ways. But the culture of normality was pervasive enough to provoke the widespread conviction that conformity had become a national problem. For subtler critics, conformity was more than a matter of taste; it signified surrender to an empty managerial cult of efficiency, an abandonment of one's authentic self. Consider a scene from J. D. Salinger's *The Catcher in the Rye* (1951). Holden Caulfield, prince of maladjustment, holds forth (from a psychiatric hospital), against "phonies" as he recalls his bangings around Manhattan. To kill time he went to the movies at Radio City Music Hall, that glittering monument to Fordist gigantism. "I came in when the goddam stage show was on," he says. "The Rockettes were kicking their heads off, the way they do when they're all in line with their arms around each other's waist. The audience applauded like mad,

and some guy behind me kept saying to his wife, 'You know what that is? That's precision.' He killed me."[10] Holden Caulfield's bemused perception caught the cultural moment: a vacuous reverence for "precision" as an end in itself epitomized the merger of mass entertainment and managerial norms.

A comparable connection could be seen in corporate advertising from the 1930s to the 1950s. Far from simply celebrating the pleasures of consumption, advertisers were engaged in a war of culture against nature, a systematic (but still panicky) effort to control biological processes ranging from yellowing teeth to "smelly hands." These preoccupations were justified by market analysis based on lumbering statistical surveys and manipulative motivation research—the sorting and categorizing institutions at work in the service of corporate sales. The rhetoric of advertising tended toward manic repetition; to justify it, the executive Rosser Reeves coined the term "Unique Selling Proposition"—fast, *fast,* FAST relief from the tablet that consumes forty-seven times its weight in excess stomach acid (fig. 33). In advertising as in other areas of the dominant culture, Depression-bred longings for security came to rest in a monochromatic style.[11]

In its hierarchical organization and earnest vacuity, the advertising industry typified the managerial ethos of control. It also made an easy target. Well before Vance Packard's alarums in *The Hidden Persuaders* (1957), advertising had provoked the parodies of *MAD Magazine* (founded in 1952). The *MAD* men were mostly representatives of the New York Jewish subculture. They taught gentile boys (the readership was mostly male) about nebbishes, *veeblefetzers,* and axolotls. They captured the hysteria behind the bland sociability of managerial culture, and brilliantly dismantled its technological fetishes (figs. 34–36). In some ways, the *Mad* men resembled the artists and writers who were drawn toward an aesthetic of accident during the postwar era. They were outsiders, ethnically or regionally alienated from the northeastern WASP elites who retained much cultural power. They were drawn to Romantic/modernist conventions—such as the notion that those officially dubbed crazy by an insane society might actually be sources of insight. But the

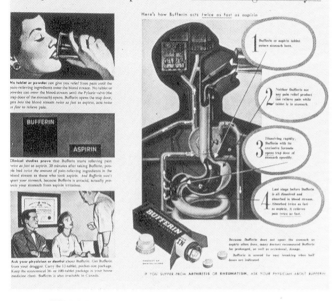

Mad men were out for laughs, and the artists were serious even when they wanted to play. Alongside their fascination with spontaneity and accident, Abstract Expressionists and Beat poets preserved a belief that they were making something apart from random dailiness, a sense of the artist as a seer with the power to penetrate and transform the banalities of everyday existence.[12] By the 1960s and 1970s that exalted sense of the artist's role would come to seem too great a burden; a younger generation would use irony to dissolve distinctions between art and life; the aesthetics of accident would gradually dissipate amid slogans of postmanagerial entrepreneurship. But not before a lot of paint and ink had been spilled.

—

Midcentury chance-imagists looked toward the Surrealist movement for inspiration. George Brecht

used Surrealist pronouncements as epigraphs for his pamphlet *Chance Imagery* (1957). The poet Tristan Tzara set the tone. "Art is not the most precious manifestation of life," he announced. "Art has not the celestial and universal value that people like to attribute to it. Life is far more interesting."[13] This sort of assertion was squarely in the barrier-breaking tradition of the avant-garde.

But the avant-garde did not invent the aesthetics of accident. Its lineage predated Surrealism by centuries. Tzara and his contemporaries liked to quote Leonardo: "When you look at a wall spotted with stains, or with a mixture of stones, if you have to devise some scene you may discover a resemblance to various landscapes . . . or, again, you may see battles and figures in action, or strange faces and costumes or an endless variety of objects, which you could reduce to complete and well-drawn forms. And these appear on such walls promiscuously, like the sound of bells in whose jangle you may find any name or word you choose to imagine."[14]

Tzara and his contemporaries took these words to heart. Tzara composed poems by drawing words from a hat; Marcel Duchamp dropped threads on a canvas and glued them in the configurations they formed when they fell; Max Ernst created "the decalcomania of chance" by spilling ink between two sheets of paper, then spreading them apart. Surrealists transformed Leonardo's advice into a self-conscious program.[15]

The collage tradition supplied them with concrete examples. In forms as diverse as Georges Braque's Cubist *papiers collés* and Kurt Schwitters's assemblages, collage embodied the link between chance and play in art. "Before it is anything else, collage is play," Robert Hughes writes. "The rules of the game are subsumed in what is available—the mailing paper, matchboxes, cigarette packs, chocolate wrappers, stickers, and other stuff in the unstable flux of messages and signs that pass through the flux of a painter's studio. Pushing them around on the paper is pure improvisation, a game with educated guesses played out until the design clicks into some final shape." Joseph Cornell's work may have embodied some of this playfulness, as he translated European Surrealism into his own American idioms.[16]

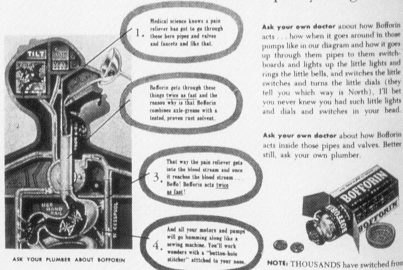

But Cornell was an idiosyncratic offshoot from the early aesthetics of accident. Rather than playing with chance, Abstract Expressionists embraced it as a path to dark truth. As early as 1942, the critic Edward Renouf, commenting on "the relative dourness of American painters," observed that "the more spontaneously, the more quasi-automatically they worked the more their work expressed the emotional disintegration and desperation that lurked concealed and inhibited behind the compulsive optimism of industrial civilization."[17] Mixing heady drafts of Freud and Jung, some early Abstract Expressionists believed that by allowing their unconscious impulses free rein they could re-create the mythic forms—the embodiments of mystery and magical self-transformation—buried beneath the blandness of a managerial society.[18]

This was the rationale behind the pictographs that Adolph Gottlieb painted in the early 1940s.

Gottlieb acknowledged that "there was an element of accident to what association, what image would pop into my mind and I would put it down, try to put it down without revision or without thinking it over too much, so that there would be no self-consciousness and there would be a free play." The idea that one was expressing an inner world devalued academic craft traditions. "I don't work from drawings," Pollock said in 1950. "I don't make sketches and drawings and color sketches into a final painting. Painting, I think, today—the more immediate, the more direct—the greater the possibilities."[19]

By midcentury, artistic possibilities were popping up in unpredictable ways. Pollock started out

FIGURE 35
"Howdy Dooit,"
MAD Magazine no. 18,
February 1956.
MAD Magazine and all related elements are trademarks of E.C. Publications, Inc.
© 1998 All rights reserved.
Used with permission.

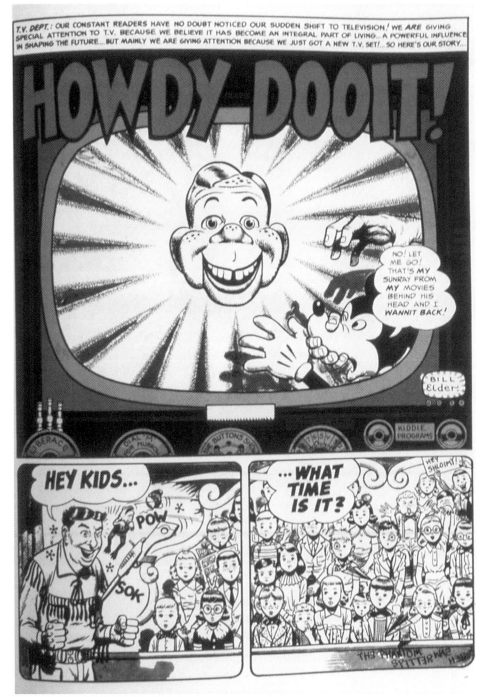

FIGURE 36
"Howdy Dooit,"
MAD Magazine no. 18, February 1956.
MAD Magazine and all related elements are trademarks of
E.C. Publications, Inc.
© 1998 All rights reserved. Used with permission.

as a mythmaker, along with Arshile Gorky. But in 1949 he spun out the spontaneous gesture to its logical conclusion. He began the flailing dance of drip painting (fig. 37). Not long afterward, Robert Rauschenberg left his lower-Manhattan apartment, took a walk around the block, and returned with an armload of junk, whatever forlorn and fascinating object that happened to catch his eye—the first load of trash he would use to make his "combines" (fig. 38).

Impulses toward spontaneity informed literary experiment as well. Jack Kerouac, Allen Ginsberg, and other Beat writers were inspired by improvisational bebop jazz to produce what Kerouac called "spontaneous bop prosody." As Charlie Parker and other bebop musicians reemphasized polyrhythmic jazz against the highly orchestrated big-band sound of swing, Beat poets played with words and sounds, hoping to hear them separate from the organized apparatus of conceptual thought. As Kerouac wrote, "great words in rhythmic order all in one archangel book go roaring through my brain, so I lie in the dark also seeing also hearing the jargon of the future

worlds—damajehe eleout ekeke dhdhkdk dldoud, . . . mdoduldltkdip—baseeaatra—poor examples, because of mechanical needs of typing, of the flow of river sounds, words, dark, leading to the future." The poet Charles Olson coined the term "projective verse" to characterize his poetry's emphasis on the syllable—"to engage speech where it is least careless—and least logical." One is reminded of James Joyce's decision to conclude *Finnegans Wake* with the word "the."[20]

Despite their reverence for spontaneity, the midcentury writers and artists were no more willing than Joyce to abandon meaning in art. Like William Carlos Williams, some (especially the poets) assumed that the spontaneous gesture ensured both sincerity and democracy in art: the abandonment of self-conscious craft, from this view, democratized access to cultural authority. Others, less prone to populism, preferred to envision the artist as shaman, creating and interpreting an augury. This was the posture of the mythmakers among the Abstract Expressionists, and also of the writer William Burroughs, whose composition technique included cutting up and folding together fragments of printed prose. "I would

say," Burroughs wrote, "that when you make cut-ups you do not get simply random juxtapositions of words, that they do mean something, and often that these meanings refer to some future event."[21] It was hard to surrender the search for meaning, even amid the aesthetics of accident.

Despite their tendency toward anti-intellectualism, devotees of chance in art developed various philosophical rationales for their work. One was Zen Buddhism, as interpreted for American audiences by the influential Zen master Daisetz Suzuki. Particularly important for poets and artists

FIGURE 37
Jackson Pollock in his studio, 1950.
Photograph by Rudy Burckhardt.

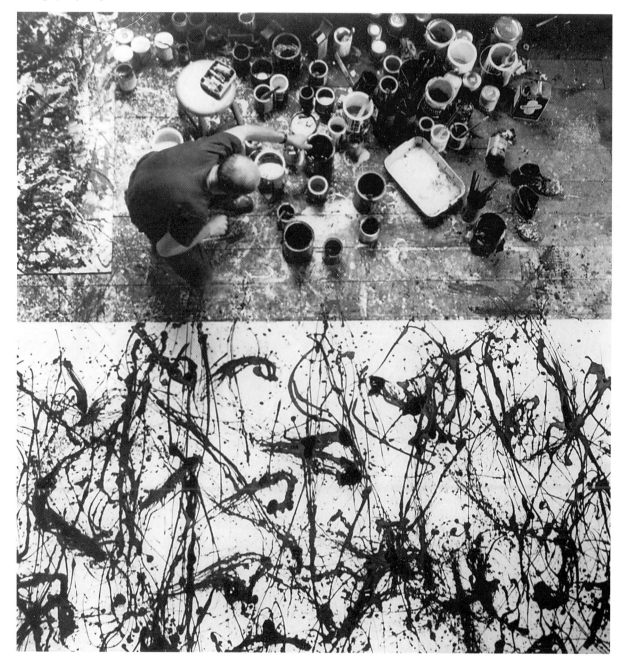

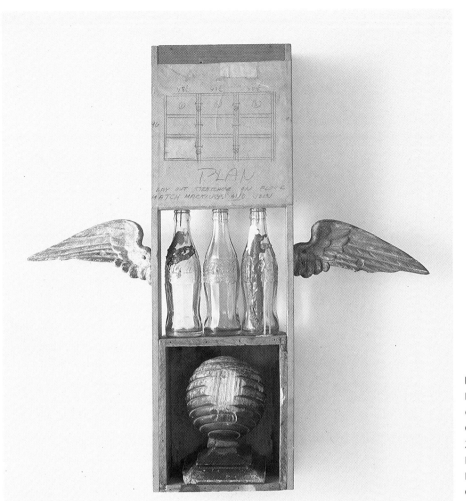

FIGURE 38
Robert Rauschenberg,
Coca-Cola Plan, 1958.
Combine painting.
26 3/4" x 25 1/4" x 4 3/4"
Museum of Contemporary Art,
Los Angeles, The Panza Collection.
© Robert Rauschenberg/Licensed by
VAGA, New York.

was the Zen idea of *prajna,* which according to Suzuki meant "immediacy, absence of deliberation, no allowance for intervening propositions, no passing from premises to conclusions. *Prajna* is pure act, pure experience."[22] The apotheosis of "pure experience" suggested some common ground between this version of Zen and the pragmatist philosophical tradition inspired by William James.

Whatever challenged the objectivist epistemology behind the managerial worldview was congenial to the aesthetics of accident. By the 1940s, quantum physics provided increasingly powerful weapons with which to attack body-mind dualism and materialist metaphysics. We live, the Dutch surrealist Wolfgang Paalen wrote in 1942, "at a time when science has given up thinking of matter otherwise (to speak popularly) than as a transitory

state of energy. . . . Perhaps it was necessary to possess the conclusive proofs of contemporary physics to comprehend *objectively* the perfect, irrefutable reciprocity between causes and effects, in order to know definitely that every separation between cause and effect is arbitrary and erroneous."[23] This was the overblown prose of the scientific autodidact, ironically replicating the objectivist certainties he set out to refute.

It is not always easy to penetrate Paalen's sort of pronouncement, but one conclusion to be gleaned from it is that he, like other advocates of spontaneity, believed that the artistic process was more important than the artistic product. From this view, to ignore process was to separate means and ends in accordance with outmoded physics (and metaphysics); it was also to overlook an essential part of Pollock's achievement

in his drip paintings, or Burroughs's in his cut-ups. Alfred North Whitehead's "process philosophy," which interpreted quantum physics with considerable care, provided a more coherent rationale than Paalen's for the melding of means and ends.[24]

But few midcentury artists cared all that much about their philosophical antecedents, and the group in and out of Rutgers was no exception. They knew that quantum physics had vindicated the idea of indeterminacy in the universe, and that even before then Surrealists had made chance imagery central to their work—as George Brecht observed in *Chance Imagery*, citing authorities from Tzara to Heisenberg. They also knew that Jackson Pollock, for whom the act of painting often seemed to be more important than the painting itself, had dramatically elevated process over product.

The trick was to capture the playful improvisation in the process, as Allan Kaprow observed in 1958. "Employing an iterative principle of a few highly charged elements constantly undergoing variation (improvising like much Oriental music), Pollock gives us an all-over unity and at the same time a means continuously to respond to a freshness of personal choice," Kaprow wrote. Pollock's large paintings, from Kaprow's view, created "environments" that subverted the everyday world and yet remained oddly resonant with our own (unconscious) experience.[25]

The coexistence of ordinariness and transcendence struck Brecht as a key characteristic of chance imagery. Chance is a mundane, inescapable experience. Yet the very labeling of it as such, proclaiming its universality, elevates it to a transcendent level, so that chance imagery reunites humans with nature and all that is beyond human. Chance imagery, by breaking down the barriers between art and ordinary life, might also serve paradoxically to reconstitute the relationship between art and transcendence. But maybe only if one granted the artist the shaman's role that Kaprow implied was Pollock's.

Kaprow's immediate debt to Pollock was clear. "I developed a kind of action-collage technique, following my interest in Pollock," Kaprow recalled in 1965.

These action collages . . . were done as rapidly as possible by grasping up great hunks of varied matter: tinfoil, straw, canvas, photos, newspapers, etc. I also cut up pictures which I had made previously, and these counted as autobiographical fragments, as much as they were an intended formal argument. The straw, the tinfoil, occasional food, whatever it was, each of these had, increasingly, a meaning that was better embodied in the various non-painterly materials than in paint. Their placement in the ritual of my own rapid action was an acting-out of the dramas of tin-soldiers, stories, and musical structures, that I had once tried to embody in paint alone.[26]

Kaprow's action-collages were prototypes for his later Environments and Happenings. Pollock cast a long shadow across the participatory art of the 1960s.

But it was a shadow. Pollock's brooding high seriousness seemed out of step with the high jinks of Happenings. Brecht and other devotees of chance imagery, including those associated with the transatlantic Fluxus group, gradually turned for inspiration from the canvases of Pollock to the musical compositions of John Cage. It was a postmodern turn. Cage's *Imaginary Landscape No. 4*, to take one of many possible examples, required twelve radios tuned to different stations, playing all at once. The shift from Pollock to Cage signified a broader movement in the aesthetics of accident—from psychic automatism to mechanically induced chance, from modernist depths to postmodern surfaces.[27]

In the 1960s and 1970s, the aesthetics of accident would become more theatrically inclined. The brooding loner gave way to the band of merry pranksters. Fluxus artists created toys and games—more self-conscious and cerebral than Cornell's—and staged "events" that became indistinguishable from the trivialities of ordinary existence. Consider the *Flux Snow Event,* held in New Marlborough, Massachusetts, in January 1977. A participant, Brian Buczak, recalled:

My favorite event was the search in the snow for Jean Brown. Next came that great shopping trip with all those pickles. Jean Brown's snow search piece was a perfect prelude to my get lost, you're all wet piece which I had planned for the next day. All went perfectly. I wasn't found and the ice gave way just as I had thought I had crossed the pond without falling

in. . . . In a similar tone since then, I have performed two new pieces called "Falling Down on the Icy Sidewalk," parts one and two. They consist in slipping and falling down on the sidewalk when least expecting to do so.[28]

The mix of ordinariness and transcendence, which Brecht had envisioned hopefully, somehow evaporated in the chill air of New Marlborough. The marriage of art and life, rather than transfiguring the commonplace, transformed art into banality. The aesthetics of accident consumed itself. The more thoughtful midcentury artists and writers gradually came to understand the difficulties involved in leaving things to chance.

—

A primary difficulty might be called the problem of consciousness, which led in two directions. One was self-consciousness, the staged quality of so many allegedly spontaneous Happenings. I remember a countercultural friend announcing in 1969: "I've made up my mind that from now on I'm going to be spontaneous in everything I do." There was an internal contradiction involved in the deliberate courting of accident.

The second direction was toward the unconscious, where apparent spontaneity was actually obedience to immutable drives. The tradition of psychic automatism assumed that random doodles appeared in accordance with mysterious but inescapable psychic laws—Freudian fate, or Jungian, in Pollock's case. Pollock, who was in Jungian analysis for years, insisted in 1950 with respect to his drip paintings that "I don't use the accident—'cause I deny the accident." The problem with painting images from the unconscious was one of abdicating aesthetic responsibility. As Pollock's contemporary Robert Motherwell observed, the unconscious offered "none of the choices which, when taken, constitute an expression's form. To give oneself over completely to the unconscious is to become a slave." It was more helpful to think of automatism as simply "a plastic weapon with which to invent new forms." From Motherwell's view, the artist had to acknowledge that he (or she) was more than a passive vehicle for random associations.[29]

Apart from the self-contradictions involved in the problem of consciousness, there were other obstacles confronting the devotees of chance in art, pushing them toward the managerial culture they despised. Zen spontaneity had a way of meshing with American speed—anything to avoid calculation, craft, or thought. Peter Voulkos, the Abstract Expressionist potter, put it this way: "You try to keep the spontaneity. You can't sit there and think about it for long. You don't have that kind of time with clay." The material itself provided a rationale for Voulkos, but the emphasis on speed subsumed all the arts, even writing. Suzuki quoted the Zen master Tenno Dogo, who stopped a disciple from pondering his advice by saying: "No reflecting whatever. When you want to see, see immediately. As soon as you tarry [that is, as soon as an intellectual interpretation or mediation takes place], the whole thing goes awry."[30]

It was left to Olson to translate Zen into the idiom of scientific management. "ONE PERCEPTION MUST IMMEDIATELY AND DIRECTLY LEAD TO A FURTHER PERCEPTION," he asserted in 1950, "at *all* points (even, I should say, of our management of daily reality as of the daily work) get on with it, keep moving, keep in speed, the nerves, their speed, the perceptions, theirs, the acts, the split second acts, the whole business, keep it moving as fast as you can, citizen."[31] Olson would no doubt bristle at the comparison, but the disdain for reflection, the obsession with movement, energy, and dynamism as ends in themselves, all placed him alongside managerial ideologues whose social views he abhorred.

The turn toward irony posed difficulties more diffuse than the mingling of spontaneity and speed. After Pollock's high seriousness gave way to the antics of Cage, an ironic sensibility pervaded the aesthetics of accident. Far from fostering resistance to managerial culture, irony promoted acceptance of it. Chance imagery was a way of jettisoning the ponderous alienation of the Abstract Expressionists, of playfully accepting the existing social universe—including the overstuffed commodity civilization of the midcentury United States. To those who felt engulfed by the Sargasso Sea of American stuff, the

ironist advised: let it wash over you, while remaining bemused and detached.

Deploying this attitude, Jasper Johns produced two artisanally burnished ale cans in *Painted Bronze* (1960) (fig. 39). According to Cage, Johns taught artists the right attitude toward the larger society: "The situation must be yes and no, not either or. *Avoid a polar situation*."[32] The avoidance of polar situations suggested a weariness with seriousness, an understandable desire to escape the self-destructive isolation embodied by Pollock's death.

It was only a short step, as Johns demonstrated, from acceptance to replication of consumer culture (fig. 40). Pop Art's most celebrated exemplar, Andy Warhol, was famously opposed to spontaneity (among his mantras were "I want to be a machine" and "Frigid people really make it"), but he also aimed to challenge the distinction between art and life. In a further ironic turn, Pop Art proved the ultimate museum art, unable to survive in the sea of floating signifiers outside the museum walls, as pale by comparison to the real thing as Warhol's ghostly face

FIGURE 39
Jasper Johns. *Painted Bronze,* 1960.
Painted bronze.
5 1/2" x 8" x 4 1/4"
Collection of the artist.
© Jasper Johns/Licensed by VAGA, New York.
Photograph by Rudy Burckhardt; courtesy of Jasper Johns.

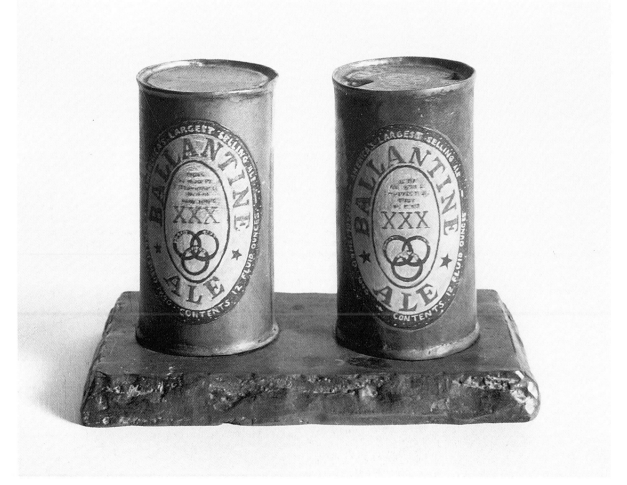

to George Hamilton's. After Pop, the Photo Realist turn offered an embrace of random sights but with a method that could only make the viewer comment, "Now, that's precision." In that respect, at least, Photo-Realism mirrored Fordist values.

During the 1960s and 1970s, as the managerial ethos loosened, artists found it easier to inhabit and even celebrate consumer culture—as well as ironically to replicate it. Advertising became hipper; gray flannel gave way to blue denim, at least among the

FIGURE 40
"J. Walter Thompson Company,
P. Ballantine & Sons Gold Award
in Metal-Container Division of 1935,
All American Package Competition,"
as reproduced in *Printer's Ink* (February 27, 1936).

People go better refreshed. The never-too-sweet taste of Coca-Cola gives that special zing...refreshes best.

things go
better
with Coca-Cola
Coke

1964

FIGURE 41
Advertisement, Coca-Cola, 1964.

"creatives." Advertisers signaled their discovery (or invention) of youth culture even before the Pepsi Generation campaign of 1964 (fig. 41; Coke ad dates from 1964). More important than this scrubbed vitality was the embrace of irony as a preferred cultural style. Ironic understatement was a key feature of what advertising's in-house historians reverently term the "Creative Revolution." Doyle Dayne Bernbach's early-1960s campaigns for Volkswagen (fig. 42) epitomized a witty, even apparently self-deprecating alternative to the ridiculous earnestness of the Unique Selling Proposition. Clever guys in jeans were harder to parody than stiffs in gray flannel suits.[33]

The triumph of irony made advertising more entertaining, but it also had more diffuse and

FIGURE 42
Advertisement, Volkswagen, 1962,
Volkswagen United States/DDB Needham Worldwide.

potentially sinister consequences as it seeped into much of mass culture. Mark Crispin Miller, identifying irony as the quintessential idiom of the TV sitcom in the 1980s, observes that

> the "comedy" almost always consists of a weak, compulsive jeering that immediately wipes out any divergence from the indefinite collective standard. The characters vie at self-containment, reacting to every situation of intensity, every bright idea, every mechanical enthusiasm with the same deflating look of jaded incredulity. . . . TV seems to flatter the inert skepticism of its own audience, assuring them they can do no better than to stay where they are, rolling their eyes in feeble disbelief. And yet such apparent flattery of our viewpoint is in fact a recurrent warning not to rise above this slack, derisive gaping.[34]

TV irony pervades news reporting as well as sitcoms; militance appears as madness, and violence rooted in ancient political or economic grievances seems a form of insanity. The aim of TV irony, in Miller's view, is not to promote any particular ideals (the mythical "liberal bias") but to discredit all ideals by urging viewers "to live up, or down, to the same standard of acceptability that TV's ads and shows define collectively," to turn themselves into models of blasé self-containment.

So we are left with a form of domination that seems at once archaic and peculiarly modern—one that is dependent not on the imposition of belief but on the *absence* of belief, the creation of a void in which only power matters. The deadpan ironic idiom became a universal solvent in the symbolic universe of managerial culture. The spread of that idiom coincided with dramatic changes in political economy during the 1970s and since—the erosion of consumer culture's institutional base, a well-paid working population, as the United States lost its hegemonic role in the world economy. Multinational corporations exported jobs overseas and downsized others; the welfare state was gradually reduced to a thing of shreds and patches.

By the 1980s and 1990s the midcentury Fordist consensus had collapsed. As corporate behemoths struggled to acquire a leaner, meaner look, the old preoccupations with predictability and control yielded to a resurgent mythology of entrepreneurial risk. The new entrepreneur was cooler by far than his predecessors; he incorporated hip styles and even hip metaphysics—a metaphysics that not only drew on the familiar cult of dynamism ("WE EAT CHANGE FOR BREAKFAST!") but that also celebrated spontaneity and chance, using catchphrases culled from Zen masters and quantum physicists. Tom Peters compares the new entrepreneurship's crusade against Taylorized scientific management with the triumph of quantum mechanics, which "has trumped Newtonian physics." Bill Boisvert summarizes Peters's argument: "Newton's orderly, calculable landscape of billiard balls and tidily orbiting satellites has given way to the misty flickering world of wave-particle duality, where companies are both solvent and bankrupt until you do an audit. Thus, any attempt to

plan and stabilize the corporate world defies the laws of nature *at the subatomic level*."[35] At this point we have surely reached the fullest incorporation—as well as the reductio ad absurdum—of the apotheosis of chance.

—

Amid the maniacal babble of postmodern entrepreneurship, it is important to return to the Rutgers artists. Despite their disdain for aesthetic tradition, their work reveals that the fascination with chance in art could be combined with Romantic assumptions: a belief in the artist's transformative powers; a hope that art could serve as a refuge, however imperfect, from the random brutalities of everyday life.

Consider the art of George Brecht and Robert Watts. Their work was most interesting when it was least "spontaneous." Yet it still constituted a sardonic subversion of technocratic hubris; it repudiated the obsession with precision and predictability at the heart of managerial culture. And it celebrated the flotsam and jetsam cast off by a commodity civilization in search of constant newness.

A few examples suggest some recurrent concerns of their implicit cultural critique. Watts produced boxes of rocks divided into separate compartments by weight, titled *Rocks Marked By Weight;* drafted proposals for potato Jello, disposable jewelry, and disintegrating shoes; cranked out deft counterfeits of money and stamps; and created the elaborate *Flux Timekit,* composed of various

instruments for measuring time. This parallel universe of things posed an implicit challenge to the "real world" created by Monsanto, General Motors, and the United States government—though that challenge remained vulnerable to the self-canceling force of its own irony.

Brecht, meanwhile, designed games and puzzles (among other things) with deliberately mystifying intent. His *Bead Puzzle* was a box that contained a scallop shell (no beads) and the instructions "Arrange the beads in such a way that the word C-U-A-L never occurs."[36] His *Deck* consisted of cards with enigmatic figures and inexplicable scenes, designed to allow the player to make up his or her own game. Brecht took the problem-solving/play-by-the-rules mentality, the nerve center of the managerial ethos, and reduced it to absurdity.

Whatever their rhetorical claims, the work of Brecht and Watts was not simply an attempt to erase the boundaries between art and the rest of experience. Like their Abstract Expressionist predecessors, these artists preserved a persistent sense that they were making something apart from random dailiness. Tricksters rather than seers, they nevertheless clung to some faith in their own capacity to transfigure the banalities of everyday existence. Even for these pioneers of postmodernism, the old Romantic verities still preserved some power. Maybe they were on to something. Maybe art and life were still better off separated, some of the time.

NOTES

1. I have discussed this process in my *Fables of Abundance: A Cultural History of Advertising in America* (New York: Basic Books, 1994), esp. chaps. 2, 3.
2. Simon Nelson Patten, *The New Basis of Civilization* [1907] (Cambridge: Harvard University Press, 1967). Also see Lears, Fables, 113–117.
3. See Warren Susman, *Culture as History* (New York: Pantheon, 1984), 150–210, for a brilliant emotional history of the 1930s.
4. I have discussed these developments in "A Matter of Taste: Corporate Cultural Hegemony in a Mass Consumption Society," in Lary May, ed., *Recasting America: Culture and Politics in the Age of Cold War* (Chicago and London:

University of Chicago Press, 1989), 38–57.
5. David Potter, *People of Plenty: Economic Abundance and American National Character* (Chicago and London: University of Chicago Press, 1954), 68. Emphasis mine.
6. David Riesman, with Nathan Glazer and Reuel Denney, *The Lonely Crowd: A Study in the Changing American Character* [1950], 3d ed. (New Haven and London: Yale University Press, 1969), 220.
7. For an excellent introduction to this huge subject, see Ian Hacking, *The Taming of Chance* (New York and Cambridge: Cambridge University Press, 1990). See also Jackson Lears, "'What If

History Was a Gambler?'" in Karen Halttunen and Lewis Perry, eds., *Moral Problems in American Life* (Ithaca and London: Cornell University Press, 1998).
8. Talcott Parsons, *The Social System* (Glencoe, Ill.: Free Press, 1951).
9. For a symptomatic, psychoanalytic example of clinical disapproval, see Edmund Bergler, *The Psychology of Gambling* (New York: International Universities Press, 1958).
10. J. D. Salinger, *The Catcher in the Rye* (New York: Little, Brown, 1951), 137.
11. A fuller version of this argument is in Lears, *Fables*, chap. 8.
12. For a sensitive and comprehensive overview of midcentury countercultural

aesthetics, see Daniel Belgrad, "The
Social Meanings of Spontaneity in
American Arts and Literature,
1940–1960," 2 vols., Ph.D. dissertation
in American Studies, Yale University,
1994. Belgrad's exhaustive research has
provided scholars with an uncommonly
useful guide to the sources. For a quirky
recent example (though dating back to
Vienna in the 1920s) see J. L. Moreno,
The Theatre of Spontaneity (Ambler, Pa.
[privately printed], 1983). For a contem-
porary celebration, see Stephen
Nachmanovitch, *Free Play: Improvisation
in Life and Art* (New York: Putnam,
1990).

13. Tristan Tzara, "Lecture on Dada"
[1922], in Robert Motherwell, ed., *The
Dada Painters and Poets: An Anthology*
[1951] 2d ed. (Boston: G. K. Hall,
1981), 248, quoted on title page of
George Brecht, *Chance Imagery* [1957]
(New York, 1966).

14. Leonardo quoted in Robert Hughes, *The
Shock of the New* (New York: Knopf,
1980), 225.

15. Brecht, *Chance Imagery*, 3–5.

16. Hughes, *Shock of the New*, 161. For a
fuller discussion of Cornell's relationship
to postwar American mass culture, see
Lears, *Fables*, 403–414.

17. Edward Renouf, "On Certain
Functions of Modern Painting," *Dyn* 2
(July–August 1942): 20.

18. Three excellent general treatments of
Abstract Expressionism are Irving
Sandler, *The Triumph of American
Painting* (New York: Harper and Row,
1970); Michael Leja, *Reframing
Abstract Expressionism: Subjectivity and
Painting in the 1940s* (New Haven and
London: Yale University Press, 1993);
and Stephen Polcari, *Abstract
Expressionism and the Modern Experience*
(New York: Cambridge University Press,
1990).

19. Adolph Gottlieb, unpublished transcript
of interview with Martin Friedman, 24,
Adolph and Esther Gottlieb Foundation,
New York; Jackson Pollock; interview
with William Wright, 1950, in Ellen
H. Johnson, ed., *American Artists on
Art, from 1940 to 1980* (New York:
Harper and Row, 1982), 6–7.

20. Jack Kerouac, *The Subterraneans* [1958]
Black Cat ed. (New York: Grove, 1971),
57; Olson quoted in Belgrad, "Social
Meanings," 112.

21. Burroughs quoted in Warren Motte,
"Burroughs Takes a Chance," in John
Kavanagh, ed., *Chance, Culture, and the
Literary Text* (Ann Arbor: University of
Michigan Press, 1990), 215.

22. Daisetz Suzuki, *Studies in Zen,* edited by
Christmas Humphrey (New York: Dell
Books, 1955), 64. See the thoughtful
discussion of Suzuki's influence in
Kristine Stiles, "Between Water and
Stone," in Elizabeth Armstrong and Joan
Rothfuss, eds., *In the Spirit of Fluxus*
(Minneapolis: Walker Art Center, 1990),
62–99.

23. Wolfgang Paalen, "The New Image,"
Dyn 1 (spring 1942), 10–12.

24. For Whitehead's influence, see Belgrad,
"Social Meanings," chap. 5.

25. Allan Kaprow, "The Legacy of Jackson
Pollock," *Art News* (October, 1958),
24–26, 55–57. Quotation at 55.

26. Allan Kaprow, quoted in Michael Kirby,
ed., *Happenings: An Illustrated
Anthology* (New York: Dutton, 1966),
44–45.

27. On Cage's influence, see, for example,
Brecht, *Chance Imagery,* 15; Catherine
Cameron, *Dialectics in the Arts: The Rise
of Experimentalism in Modern Music*
(New York: Praeger, 1996), 40–42; Noel
Carroll, "Cage and Philosophy," *Journal
of Aesthetics and Art Criticism* 52 (winter
1994): 93–99; Douglas Kahn, "The
Latest: Fluxus and Music," in Armstrong
and Rothfuss, *In the Spirit of Fluxus,*
103; Andreas Huyssen, "Back to the
Future: Fluxus in Context," in
Armstrong and Rothfuss, *In the Spirit of
Fluxus,* 146.

28. Letter from Buczak to George Maciunas,
February 12, 1977, Archiv Sohm,
Staatsgalerie Stuttgart, quoted in Owen
Smith, "Fluxus: A Brief History," in
Armstrong and Rothfuss, *In the Spirit of
Fluxus,* 36.

29. Jackson Pollock, interview with
William Wright, 1950, in Johnson,
American Artists on Art, 8; Robert
Motherwell, quoted in Hughes,
Shock of the New, 260.

30. Rose Slivka, *Peter Voulkos: A Dialogue
with Clay* (Boston, 1978), 52; Daisetz
T. Suzuki, *Zen and Japanese Culture*
(New York, 1959), 15. Bracketed phrase
in original.

31. See Charles Olson, "Projective Verse," in
Donald Allen, ed., *The New American
Poetry* (New York: Grove, 1960),
386–399. Quotation is at 387–88

32. John Cage, quoted in Hughes, *Shock of
the New,* 356.

33. For a spirited and critical account of the
Creative Revolution, see Thomas Frank,
The Conquest of Cool (Chicago and
London: University of Chicago Press,
1997).

34. Mark Crispin Miller, "Big Brother is You,
Watching," in his *Boxed In: the Culture
of TV* (Evanston: Northwestern
University Press, 1987), 325–326.

35. Bill Boisvert, "Apostles of the New
Entrepreneur," *Baffler* no. 6, 75–76.

36. Jon Hendricks, *Fluxus Codex* (New York:
Abrams, 1988), 201.

In 1959, they crashed New York. *They* were the "New Jersey school," as Claes Oldenburg once referred to Allan Kaprow and the New Brunswick artists around him—George Segal, George Brecht, Bob Whitman, Bob Watts, Lucas Samaras, Geoffrey Hendricks, and Roy Lichtenstein.[1] With the exception of Brecht, all were affiliated with Rutgers University. Although by no stretch of the imagination an organized group, these friends, acquaintances, teachers, and students had a great impact on contemporary art through a presence in New York that was dramatic in every sense of the word. At one level, their art had a dramatic impact because it was so radical, especially in the use of new media: Kaprow exhibited Environments, Segal put white plaster figures in environments of found materials, Samaras displayed razor blades threateningly projecting from wood and metal printing plates covered with paint and toilet paper (plate 23), Watts presented assemblages of flashing lights and moving parts that required visitor participation (fig. 43), and Brecht challenged his audience by presenting card games that allowed the players to make up the rules. But the most dramatic works were the performance pieces of Kaprow, Whitman, Brecht, and Watts, which are the focus of this essay. Instead of quietly hanging on a wall or sitting on a pedestal, this art exploded in the gallery and, because it was theater, in time as well. It was drama as visual art, or visual art as drama, but it was certainly not theater in the traditional sense of the term. Composed of people, sound, lights, and mixed media of all sorts, this art that blew in from New Jersey had no fixed name. Although most often referred to as Happenings, its aliases included "theater pieces," "events," "intermedia," and "plays."

CRASHING NEW YORK
À LA JOHN CAGE

—

JOSEPH JACOBS

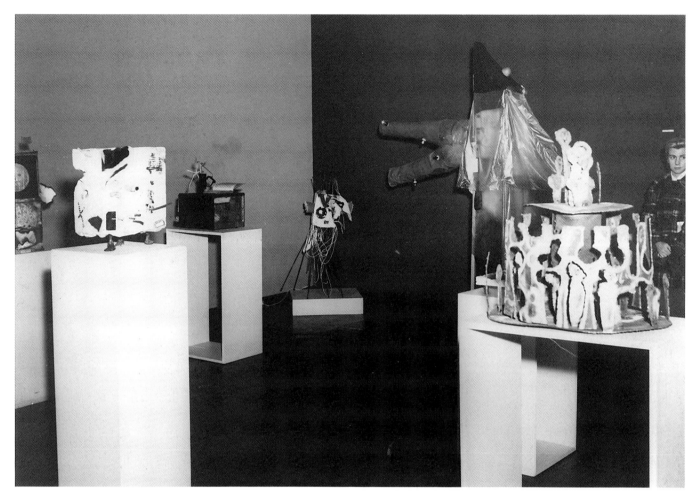

FIGURE 43
Installation view of Robert Watts's solo exhibition
at Grand Central Moderns Gallery, New York,
December 20, 1960–January 14, 1961.
Photo courtesy of The Robert Watts Studio Archive, New York.

The "exhibitions" were more like programs, with
many performances scheduled for a single evening,
and the same program scheduled for several evenings.
These evenings were themselves events or
happenings, something that the New York art world
had to experience, occasionally even as participants.
For a brief moment in time in the late 1950s and
early 1960s, the Rutgers group transformed the art
gallery into an energy center, and in so doing injected
both art and the art world with a new dynamic—
symbolized by a much reproduced photograph of
Lucas Samaras swinging through the air in Robert
Whitman's *American Moon,* presented at the Reuben
Gallery in 1960 (fig. 44).

CAGE'S CLASS

This dramatic transformation of the art world
was spawned not in New Brunswick, but in New
York City itself, specifically in a course titled
"Composition" (1956–58) and "Experimental
Composition" (1958–60) offered in the evenings by
John Cage at the New School for Social Research
from 1956 to 1960.[2] Students included Allan
Kaprow, George Brecht, Dick Higgins, Al Hansen,
Jackson Mac Low, Toshi Ichiyanagi, Florence Tarlow,
and Scott Hyde. Most arrived independent of the
others from 1957 to 1959, and almost all attended

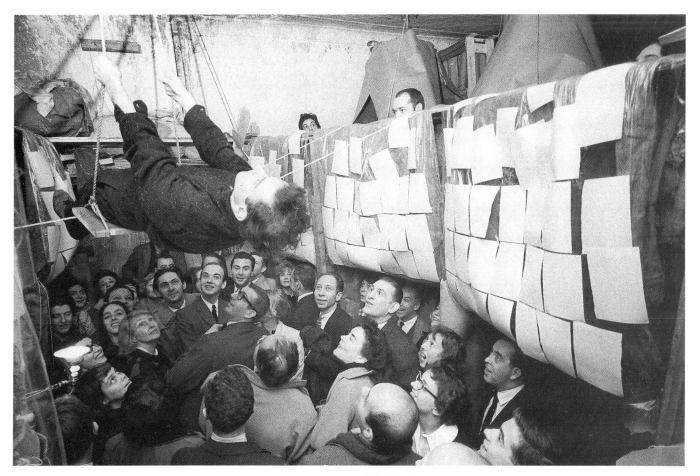

FIGURE 44
Robert Whitman, *American Moon,* 1960
(with Samaras on swing) at the Reuben Gallery, New York.
Photograph by Robert McElroy.

during the summer of 1958. George Segal tagged along with Kaprow on several occasions, and also showing up from time to time were Robert Whitman, Robert Watts, and Larry Poons. Most were not officially enrolled in the course, instead having been personally invited by Cage. Almost everyone had little or no background in music. Kaprow, for example, was there because he wanted to learn how to improve the sound for his Environments, which he was generating with windup toys, bells, and other noise-producing objects. He wanted to produce more complex, random sound using magnetic tapes, at which Cage was expert. When Kaprow approached Cage for advice in late 1957 or early 1958, the composer suggested stopping by his class, after which they would talk. Kaprow enjoyed the evening so much,

he stayed in the course, taking it several times.[3] In contrast, Hansen's motivation for taking the course in the summer of 1958 had nothing to do with music. He signed on because his wife had enrolled in a philosophy class scheduled at the same time at the New School. On the first day, Cage patiently probed Hansen to find out about his musical background, becoming increasingly delighted as he learned that his student had never studied music or learned to play a musical instrument.[4] By Juilliard School standards, Cage had a class of misfits, many of whom would become leading avant-garde artists within five years.

Clearly, Cage was not offering a traditional music course. The composition he was teaching was his own avant-garde music, which was based on found sound (i.e., sounds made in life and not by

instruments) and chance. Recent works included *Water Music* (1952), for which "a solo performer plays not only piano but also siren whistle and radio, and is called on to shuffle and deal seven playing cards, blow a duck call in a bowl of water, and prepare the piano on the spot with four objects in just over thirty seconds."[5] *Imaginary Landscape No. 4* (1952) consisted of twelve RCA Victor radios set on the stage and broadcasting live programs, the volume and tuning periodically changed by the performers. *Imaginary Landscape No. 5* (1952) was electronic music—magnetic tapes, randomly cut up and spliced together. *4'33"* (1952), inspired by Robert Rauschenberg's *White Paintings,* which captured the shadows, dirt, and reflections of the gallery space, called for the performer to open and close the cover of a piano keyboard three times in a period of four minutes and thirty-three seconds, one time for each of the three movements—the music was the ambient sound. *Winter Music,* composed in 1957 and dedicated to Rauschenberg and Jasper Johns, allowed the performer to determine the composition. All of this music was produced using chance, often with the *I Ching,* the Taoist book of divination.

While the music world often failed to embrace Cage or even take his work seriously, he was greatly admired in art, literary, and dance circles, which appreciated the philosophical underpinning of the work, which encompassed the visual component of his music as well (*4'33"* is also about the visual act of starting the timer and opening and closing the keyboard). His radical music was not made just to expand the boundaries of music (which it did); nor was it produced as a formalist exercise. The driving principle behind it was Cage's desire to reconcile listeners with modern life, which could be accomplished by breaking down the distinction between art and life, and presenting daily life, in other words, ordinary sounds, as art.[6]

For Cage, life was largely perceived from a Zen perspective, much of which he acquired directly from Daisetz Suzuki's course on Zen Buddhism at Columbia University. Expressed in simplest terms, this perspective embraced the idea that the universe is composed of limitless things and beings, each of which is unique. To use Cage's own language, each

element is "at the center" and thus is "the most honored one of all." Simultaneously "each one of these most honored ones of all is moving out in all directions, penetrating and being penetrated by every other one no matter what the time or what the space."[7] The focus of this uniqueness and inter-penetration is the present moment, and for humans, the objective is simply experiencing the moment, which is unique and cannot be replicated. There are no values attached to the objects or the experience, which is not to say that Zen is without moral principles. Nor are there explanations, since there is no cause and effect in Zen. What happens just happens. Life is simply an endless succession of events happening in time and space. Music was merely one of these events, and it should be as random and indeterminate as any other event.

Cage's class consisted of describing his own music and philosophy, although he mentioned several major twentieth-century composers and contemporaries, such as Arnold Schoenberg, Anton von Webern, Karlheinz Stockhausen, Morton Feldman, Richard Maxfield, and Earle Browne (Feldman and Maxfield even occasionally substituted for Cage). Each week he gave an assignment to produce a short score, which would be presented and discussed in the next class. The assignment usually had specific instructions, such as to create a piece that is thirty seconds long, is restricted to radios, or uses a classmate's abstract paintings as a score. As a result of these exercises, Kaprow, Brecht, Higgins, and Hansen produced what some claim to be their first Happenings or Events. All four were present in the historic summer class of 1958.

When recently interviewed, however, Kaprow referred to his works produced in Cage's class as *prototypes* for his Happenings, and not actual Happenings.[8] He describes them as "prototypically musical," although instead of writing the music using traditional notes and staves, he scored the work in the modern sense of listing an object that is to make a sound, along with the duration of that sound. Typical of these first pieces is an untitled and undated work consisting of four parts, in which Kaprow called for a fork, a rattle, a piano ("B above B above mid-C . . . strike hard"), and a clock for part 1;

a screen, a blue bottle ("blow" "strike"), a green bottle ("strike"), and a knife for part 2; a dog, a voice ("saying 'tock,' uninflected"), an Easter egg, a match ("strike evenly"), and a sign ("hold red side up" and "turn over to 'AH'") for part 3; and again a clock ("ring alarm"), wood blocks, a rubber duck ("lift up foot to release squeak"), bell ("strike hard and sustain"), and another clock ("start ticking and sustain") (fig. 45). Performers were given time fields, probably determined by chance means, within which they could work, but they could decide themselves when to produce the sound and how to shape it within Kaprow's restrictions. While this work was basically audio, it had a visual component as well. The dog rolling over or the knife vibrating from its

FIGURE 45
Score by Allan Kaprow from John Cage's class at the New School for Social Research, New York, ca. 1958. Collection of the artist.

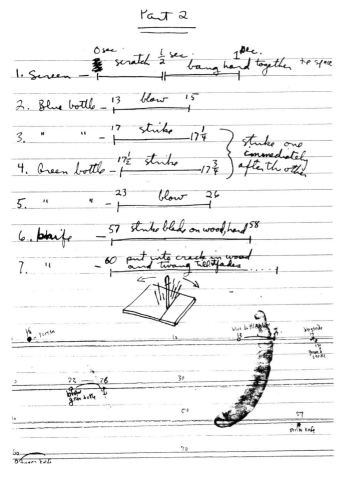

point stuck in a board was to be seen as well as heard. In another work produced for the class, the performers move about while making sounds. In another score, Kaprow instructed a performer to go into the hall and drink from a fountain. Restricted by the musical content of the course and by the classroom itself, Kaprow's work was conceptually similar to Cage's. It was not until he combined the lessons of Cage's class with the Environments he was exhibiting at the Hansa Gallery that he would produce the revolutionary art for which he would become famous.

Brecht's first works for Cage's class were also conceived in audio rather than visual terms. Brecht's published notebooks place him in the course by June 24, 1958, the day the summer course began.[9] The notebooks are a gold mine of information about Cage's class, as well as about Brecht's own projects. His entry for June 24, 1958, ends with a quote: "'Events in sound-space,' (J.C.)," Cage's definition of music that emphasizes action or experience occurring in time rather than just sound, and a concept that would drive much of Brecht's work, to the point that he would call his work Events.[10] This quote is followed by a description of the "1st piece performed in Cage class," which is a score that Brecht wrote for cellophane (which would be crinkled), voice, and mallet, occurring in three sections, with the duration and frequency determined by chance.[11] Although the notebook is not clear, the score seems to be a complicated chart of letters and numbers indicating instrument, starting time, and duration. A note indicates that the "performer fills alternate intervals with sound, choosing amplitude at will."

Brecht's next pieces experimented with the system for triggering the sound or music, but the end product is similar. In Confetti Music, tiny colored cards (confetti) were dropped on a grid of fifteen floor tiles, three in one direction, five in another. Each floor tile represented twenty seconds, and the four performers, each sitting on one side of the grid, would read the grid in a designated order, taking his or her cue from the color-coded card in the grid. The instruments were a Japanese gong, a tom-tom, an Indonesian xylophone (probably all available in a classroom closet), and a prepared piano (the one

musical instrument always present in the room).[12] For his next work, *3 Colored Lights,* the performers took their cue from colored lights. At first Brecht used flashlights with red, blue, and yellow lights to signal the performers, but over the course of the summer he developed an electronic device of lights mounted on a box of switches. Each performer had a score, a single card with vague directions for the duration and amplitude of his instrument when a colored light was lit. The "conductor," working in a darkened classroom, turned the three colored lights on and off following Brecht's score, which had been determined by a table of random numbers, as were the instructions on the performer's cards, or scores.

Brecht took the course again in the summer of 1959, and his music changed significantly, allowing more freedom for the performer, perhaps, in part, a response to Cage's complaint that he "never felt so controlled before" as when he played prepared piano for *3 Colored Lights.*[13] In *Candle Piece for Radios* (fig. 75), Brecht called for one and a half radios per person. The radios were scattered around a darkened room, plugged in, with the volume set on low. On each radio sat a stack of instruction cards and a birthday candle, and at a signal from the conductor, the candles were lit and the piece began. The performers followed the directions on the top card, such as "volume up" and "volume down," or "R" and "L," referring to tuning changes to the right or left. The performer then buried the instruction card at the bottom of the stack and went to any unoccupied radio and followed the directions of the top card. The performance ended when the last candle burned out. This work obviously relates to Cage's *Imaginary Landscape No. 4,* which called for twelve radios, and was made in response to a class assignment to produce a score for radios. *Candle Piece for Radios,* which would become one of the more often performed Brecht scores of the 1960s and a favorite at the early Fluxus festivals, had a greater visual component because of the burning candles and the performers constantly moving about the room. It also had a sense of greater freedom, since the performers proceeded from radio to radio at will.

With *Time-Table Music,* introduced to the class on July 14, Brecht did away with "instruments,"

allowed the performers to determine how to make their sound, and transformed the "music" into an event, which in effect could encompass everything visual, audio, and sensory taking place during the piece, although the emphasis would be on the sound component. The following is the complete score:

> TIME-TABLE MUSIC
> The performers enter a railway station, and obtain time-tables.
> They stand or seat themselves so as to be visible to each other, and, when ready, start their stop-watches simultaneously.
> Each performer interprets the tabled time indications in terms of minutes and seconds (e.g., 7:16—7 minutes, 16 seconds). He selects one time by chance to determine the total duration of his performing. This done, he selects one row or column, and makes a sound at all points where tabled times within that row or column fall within the total duration of his performance.

The most radical aspect of the work is that it is not designed for the classroom or a stage. Instead it is to be presented in a train station, where the art commingles with life. The notebooks contain several similar drafts of this event, one of which instructs that "a public place" can be used instead of "a railway station." Just as *Time-Table Event* was performed in Cage's class, it could be performed anywhere, a concept for which Brecht makes a point of crediting Al Hansen in his notebook.[14]

If anyone in the class would make such a suggestion, it would be Hansen. He was probably the most adventurous and outrageous member of the class, the one for whom anything went, both for himself and anyone else. His unrestrictive scores and laissez-faire attitude were in direct contrast to Brecht's and Kaprow's rigidly controlled pieces of 1958. This free playful spirit is paramount in *Alice Denham in 48 Seconds,* the work created for the 1958 summer class and one of Hansen's most famous Happenings. Alice Denham, the person, was, according to Hansen, "an author and model" who impressed him at the time.[15] He transformed her name into numbers using Cage's system of assigning a number to a letter, such as 1 to A, 2 to B, and so on, so that her name became 1, 12, 9, 3, 5, 4, 5, 14, 8, 1, 13, which became the score for the work. The

first number determined the sound or "instrument" (each instrument was given a number), the next number designated the duration, the next the sound, the next the duration, and so on. The score was written on an enormous paper and hung over the blackboard. Toys were then distributed to the class (fig. 46). Hansen describes the confusion that his minimal score presented the musicians:

> We tried *Alice Denham* the first time using toys. . . . I had a preference for toys that made noises. If anything made a noise that was cyclical—like the little ratchety sparkler or sirens or army tanks that you wound up or rubber mice—these were distributed to the class.
>
> Cage enjoyed this very much. Several people in the class didn't seem to know how to begin the piece. I think he asked me how it began and I said "At the beginning." So Cage said, "Let's all consider it a picnic. When one arrives at the picnic site, he then proceeds to do whatever one does at a picnic and after a while goes home or goes away or isn't there anymore." So everyone could begin at any part he wanted of the big number notation on the wall and proceed from there in any direction The only static part of the piece is the notation; it is merely a doorway or a springboard for the performer. The performer has complete freedom to move in any way he wants through the number chain or even consciously to ignore it.[16]

The score for *Alice Denham* was nothing more than a pretext to make something happen that could then be called art. It was a prescription for anarchy. Everything was negotiable—the instruments, the duration, perhaps even the place. The artwork was indeed "a happening," to use the word in its non-art-historical sense, since it was so unpredictable. It consisted not only of the sound, but actions and visual effects as well. Everything that took place in space and time was part of the piece. While Cage may very well have enjoyed *Alice Denham*, he would never have relinquished so much control over his own work.

By the end of the summer of 1958, Cage must have been nudging the students out of the course, which several seem to have taken a few times. As expressed by Hansen, "We realized that one couldn't stay in the course forever. . . . Each week, after class, Dick Higgins and I and others would meet . . . and

discuss ways to continue the contacts made and the work being done in the class after the course was over."[17] The problem was how to present their work outside of the classroom. Kaprow was first to do so, which he did while attending the class. As discussed in Joan Marter's essay in this book, he experimented with his new vision in New Brunswick, presenting an untitled performance at Douglass College on April 22, 1958, and a work called *Pastorale* at a Hansa Gallery picnic on George Segal's farm that summer (the latter was disrupted by rowdy drunks led by Aristodemus Kaldis, who were under the impression they were at a party—which they were—and not an art event).

During the winter of 1958–59, Hansen and Higgins discovered a New York venue, the Epitome Coffee Shop, owned by Larry Poons with two partners and located on Bleecker Street in Greenwich Village.[18] The Epitome opened in January 1959 and closed in early 1960, and on most Friday and Saturday nights, Higgins, Hansen, and Poons could be found there performing.[19] They were joined by poets Allen Ginsberg, Joel Oppenheimer, Ray Bremser, Ted Joans, William Morris, and Diane DePrima, who were invited, in part, to help attract an audience. According to Higgins, "I did various concertos and read from *Orpheus Shorts* and *Machines in the Wind* and various of my poems. We did lectures and read dada, lettriste and Iliazd texts."[20] The performances at the café were largely based on language, or as expressed by Hansen, there was "a predilection for vocal works."[21] Hansen read his own poetry.

The Epitome Coffee Shop, however, was not just a Beat hangout featuring avant-garde poetry, for some of the work had visual and musical components. One of Hansen's favorite performances was *Requiem for W. C. Fields Who Died of Acute Alcoholism*, for which, as Hansen describes, "I projected W. C. Fields movies—flipped upside down and backwards—on my white shirted chest. The movies were spliced with newsreels and different things."[22] Poons made a work that can best be associated with music. It was titled *Tennessee*, and according to Hansen, it

> involved a motorcycle, an electric guitar and a blue basketball. There was one or two other sections in his

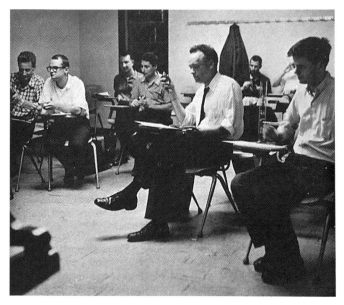

FIGURE 46
John Cage's experimental composition class
at the New School for Social Research,
New York, summer 1958.
Above left, George Brecht is in the center
foreground and Allan Kaprow is in the
background (near coat).
Above right, Al Hansen gives instructions
to Brecht and Kaprow.
Photographs by Harvey Gross.
Right, Robert Whitman, Kaprow, and Brecht
in Cage's class at the New School
on August 5, 1959.
Photograph copyright © by Fred W. McDarrah.

mad orchestra. The idea was to have several groups of people; Group I consisted of as many people as could be gotten around an electric guitar on a stand, and (let's say there were four) one would tighten and loosen the strings, another would pluck the strings, another would work one control, another would work another control, and they would move about the guitar in some fashion. Group II was involved with the motorcycle—starting and stopping it and beeping its horn and whatnot—and, I remember, one person was to bounce the blue basketball and cough. Or perhaps there was another group that just coughed at one moment or another. The piece was one minute long.[23]

While the visual component was strong in *Tennessee* (as it is in theater), it was more a by-product of the sound-making component, the thrust of the piece. In general, the work produced at the Epitome Coffee Shop was audio, and most was based on language rather than music.

Hansen, Higgins, and Poons called themselves the New York Audio Visual Group, and on April 7, 1959, they made their concert-hall debut: they performed in "A Program of Advanced Music" at the YM-YWHA Kaufman Theater on 92nd Street. The students were now on the same bill with their teacher, for the program included *Music of Changes* by John Cage. Also listed was Christian Wolff's *Suite*, which, like the Cage piece, was performed by David Tudor. Al Hansen opened the evening with *Alice Denham in 48 Seconds*, and the evening concluded with *Six Episodes* from Dick Higgins's *Aquarian Theater*. Both *Alice Denham* and *Six Episodes* were performed by the Audio Visual Group, which that evening included Hansen, Higgins, Poons, Florence Tarlow, Robert Braverman, Harry Koutoukas, and a man named Ivor.[24] All the work was described as music, not Happenings or Events, and was reviewed by the major newspapers, negatively, as music.[25]

Despite the bad press, the concert created a media sensation, so much so that the New York Audio Visual Group was invited later that spring to show off its new art form on television, on the *Henry Morgan Show*. They presented an episode from Higgins's *Aquarian Theater*, *The escape of the goose from the wild bottle*.[26] Hansen describes the performance:

Dick Higgins entered wearing a terry cloth robe and a dunce cap, opened the robe revealing old fashioned swimming trunks, stepped into the big colonial tin bathtub, blobbed himself with green paint or ink and then slowly got out of the tub and flopped himself about on a huge sheet of paper, creating a two-dimensional work in green ink—hand and foot and body prints. At the same time, David Johnson was shaking the dice, writing his answers on the blackboard, holding the little slate up so we all could see it. Then he would clean the slate and prepare to roll the dice again while we did what he said for one minute. He moved one hand from his side to overhead to provide a sort of metronomic effect for us to gauge the minute with.

When it was over Henry Morgan asked Dick Higgins what it was all about.

Dick said, "It's about art."

"Well, what did you end up with?"

Dick pointed to the thing on the floor.

Morgan said, "Well, you're the New York City Audio Visual Group, and I can see that this is a painting, but does it make any sounds?"

As he said this, I took one of the flower pot shards and tossed it so that it went just over his shoulder and crashed in the middle of Dick's painting on the floor which gave everyone a laugh—here was the sound. Then Morgan came over to me and asked me whether I considered this music and I said, "It is the music of our time."[27]

The pot-shard incident is a classic example of how in Hansen's aesthetic a script or score was nothing more than a device to trigger an event to occur in space and time. It also reflects the humor of his work, the degree to which art cannot be taken too seriously, and how indistinguishable a spontaneous, ordinary action in life, such as throwing a pot shard, can be from art.

No one knew what to call the new phenomenon, which seemed to be most closely identified with music, although, as Henry Morgan noted, Higgins's piece was more visual than audio. The name New York Audio Visual Group was an attempt to deal with the two main components of the work, the audio and the visual. Although the visual component was often very strong, as it is in theater, the sound component appeared to get much of the attention. The fact that the work took place on a stage also linked it to music and performance, especially theater. John Cage's classroom, the

Epitome Coffee Shop, the Kaufmann Theater, and a television studio did not help to link the work to the world of visual art. Allan Kaprow changed that.

—

THE REUBEN GALLERY AND ITS AFTERMATH

—

It was Allan Kaprow who was responsible for introducing the Happening to the art world and having it identified as a fine arts medium. He had been making Environments when he started attending John Cage's class, and when he introduced the performer of Cage's work into his Environments, he gave birth to a new art form, one that was distinctively visual, especially when put in a gallery context. He unveiled his creation to the New York art world at the Reuben

Gallery, which he inaugurated on October 4, 6, 7, and 8, 1959, with what, because of its title, would become his most famous Happening, *18 Happenings in 6 Parts*.[28] Kaprow was instrumental in starting the gallery, located in a third-floor loft in the East Village, downtown New York, at 61 Fourth Avenue at Ninth Street (fig. 47).[29] He had been approached by artist Renée Miller, whose sister, Anita Reuben, had been interested in opening an art gallery. Would he schedule artists for the space? The timing could not have been better, since the Hansa Gallery, an artists' cooperative that Kaprow had cofounded with others in 1952, had just closed. Hansa had been the principal venue for Kaprow, Whitman, Samaras, and Segal. It was here, from 1957 to early 1959, that the group showed its first experimental work—Kaprow his first Environments, Whitman his early constructions, Segal *Legend of Lot* (fig. 16), and

FIGURE 47
Anita Reuben entering the Reuben Gallery building at 61 Fourth Avenue, New York, ca. 1959–60. Photograph by Robert McElroy.

Samaras his radical pastels. Its demise left the Rutgers artists without a New York showcase.

Kaprow agreed to Miller's request to be a consultant for programming, and the rest is history.[30] The lineup of artists for the first season reads like a Who's Who of contemporary art: in addition to Kaprow, the gallery artists included Brecht, Whitman, Samaras, Oldenburg, Jim Dine, Red Grooms, and Rosalyn Drexler. A December group show, *Below Zero,* also included Robert Rauschenberg, George Segal, and Al Hansen. Other gallery artists were Renée Miller, her close friend Martha Edelheit, and Herb Brown.[31] These last three artists shared the radical exploration of mixed media found in the work of many of the better-known gallery artists.

Despite the overlap in artists, the Reuben Gallery was very different from the Hansa Gallery, or, for that matter, any gallery that had come before. The Reuben Gallery was not just an art gallery. As stated in the introduction to this essay, it was an energy center, and was recognized as such even by its detractors, who spoke of the commotion coming from the space.[32] Even the first group show, *Below Zero,* had a kaleidoscopic intensity. It had no Happenings, Events, or even Environments, but instead consisted mostly of mixed-media assemblages, many made out of inexpensive, disposable materials, and presented in a densely packed installation. Kaprow, for example, exhibited a mountain of crumpled paper (fig. 48); Rauschenberg, *Coca-Cola Plan;* Segal, a "crude and unwieldy" plaster figure on a real bicycle; Whitman, *Small Cannon* ("an assemblage of rubble resembling a cannon"); and Hansen, a "giant machine sculpture called the *Hep Amazon,* composed of guiding motors and electricity and micro-switches

FIGURE 48
Allan Kaprow, *Untitled (Mountain),* 1959.
Crumpled paper, dimensions variable. As reconstructed for the 1993 exhibition *Neo-Dada,* for the American Federation for the Arts.

and lights and shavers and hair dryers and vacuum cleaners."[33] To the uninformed eye, the show must have looked more like the deposit of a street sweeper than art. Instead of making illusionistic images or abstract act, the artists were mostly re-presenting everyday life, especially that of the street. Their assemblages captured the cacophony of contemporary urban living, in which one had to navigate filth and decay. Some work, such as Hansen's *Hep Amazon,* made noise and moved. This penchant for action surfaced in Dine's one-person show in March 1960, for which the gallery played rock music records, as announced in the show's press release.

But the work that was most explosive and for which the gallery became renowned were Happenings. Happenings were active; they were events taking place in space and time. Kaprow's *18 Happenings in 6 Parts* made this clear, and it defined the gallery and set its aesthetic values, although the performance art of his colleagues was often quite different, as will be discussed later. While the name Reuben Gallery became virtually synonymous with Happenings, Kaprow himself became disenchanted with the term, since the word would be applied to a broad range of work, much of which had little to do with his.[34] The label was popularized by Max Baker, Anita Reuben's husband and the co-owner of the gallery. Baker was in advertising, and he recognized the marketing appeal of the word, which jumped out at him from the title of Kaprow's piece, and which Kaprow himself used to describe his score, titled "something to take place: a happening," which he published in a 1959 issue of the *Anthologist,* the Rutgers literary magazine.[35]

The label made its debut for a program of Happenings scheduled for January 8–11, 1960, at the Reuben Gallery. It appeared on the gallery poster, in the *Art News* and *Arts* calendars, and in an *Art News* review, and it lives on to the present day, much to the chagrin of the artists who, with the exception of Hansen, reject the term, many because they find misleading the word's implication that Happenings are not highly structured or carefully organized works of art. The poster announced "Happenings by Grooms, Kaprow, Whitman" and the program consisted of *The Magic Train Ride, The Big Laugh,* and *Small Cannon,* respectively.[36] Programs with

numerous events scheduled for one evening (modeled, in part, on concert programs) became the fashion. Oldenburg, who had been present on Segal's farm in 1958 to witness the aborted *Pastorale* and showed with Dine at the Reuben Gallery from December 4 to 11, 1959, created a lengthy evening program for the Judson Gallery, a space he had opened with Jim Dine, Dick Tyler, and Phyllis Yampolsky the year before at the Judson Memorial Church in Greenwich Village at 239 Thompson Street, not far from the Reuben Gallery.[37] Called *Ray Gun Spex* and presented February 29 and March 1 and 2, 1960, the program consisted of an evening of Happenings and was designed as a sampler to give the audience an idea of the broad range of styles offered by the new medium.[38] The Happenings included Oldenburg's *Snapshots from the City,* Dine's *The Smiling Workman,* Higgins's *Edifices, Cabarets & Einschlusz,*[39] film projections by Hansen, Kaprow's *Coca-Cola, Shirley Cannonball?,* and Whitman's *Duet for a Small Smell.* The Reuben Gallery followed with a major program on June 11: "An evening of Sound Theatre—Happenings," which included Dine's *The Vaudeville Show,* Kaprow's *Intermission Piece,* Whitman's *E.G.,* Brecht's *Gossoon,* and Richard Maxfield's *Electronic Music.* As the title for the evening indicates, Happenings were on the same program with music, a reflection of the close relationship between the two art forms. The music included Maxfield's performance and Kaprow's *Intermission Piece,* the latter randomly spliced tapes— parts of which had originally been used for Kaprow's 1958 Hansa Gallery Environment—coming from speakers located in the four corners of the gallery.

For the 1960–61 season, the Reuben Gallery presented an unbroken succession of Happenings. A poster boldly headlined "new happenings at the Reuben Gallery" and announced that "the Reuben Gallery will devote its 1960–61 season exclusively to a series of evening exhibitions of art in a new dimension." The artists decided to change the format, however, and, for the most part, preferred to present only one performance at a time, thus allowing several weeks to prepare the space for the Happening, which would then occur for a full week. Jim Dine performed *Car Crash* November 1–6

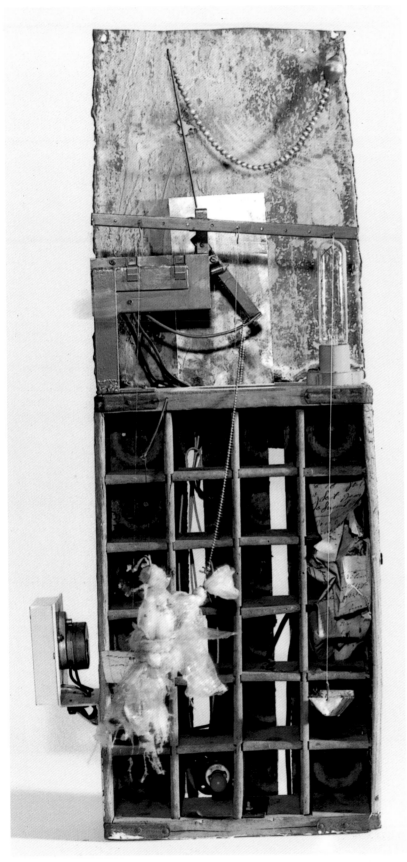

PLATE 13. Robert Watts, *Pony Express,* 1960. Motorized kinetic construction with electric lights, metals, polyethylene, glass, ink on paper (pages from a Pony Express account book) mixed objects, wood crate.
34" x 15" x 20"
Moderna Museet, Stockholm.

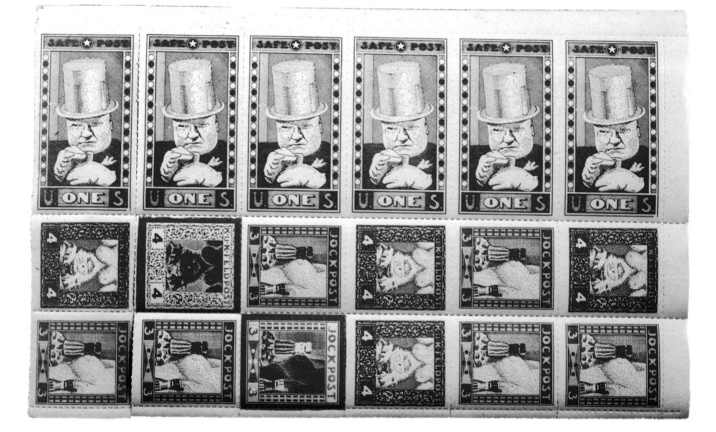

PLATE 14. Robert Watts, *Safe Post/K.U.K Feldpost/Jockpost,* 1961 (detail).
Sheet of 30 stamps, offset print, gummed and perforated.
4" x 10 1/2"
Collection The Newark Museum, Purchase 1998 The Members' Fund.
Photograph courtesy of the Robert Watts Studio Archive, New York.

PLATE 15. Roy Lichtenstein,
*Washington Crossing
the Delaware I,* 1951.
Oil on canvas.
26" x 32"
Private collection.
Photograph by Robert McKeever.
© Estate of Roy Lichtenstein,
1998.

PLATE 16. Roy Lichtenstein, *Untitled,*
1959–60.
Oil on canvas.
41 1/8" x 56 1/8"
Private collection.
© Estate of Roy Lichtenstein, 1998.

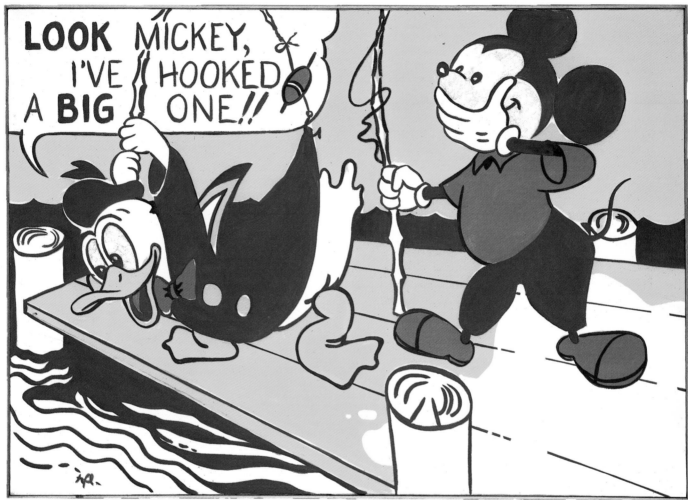

PLATE 17. Roy Lichtenstein, *Look Mickey,* 1961.

Oil on canvas.

48" x 69"

Dorothy and Roy Lichtenstein: Gift (partial and promised) of the Artist,

in Honor of the Fiftieth Anniversary of the National Gallery of Art, Washington, D.C.

© Estate of Roy Lichtenstein, 1998.

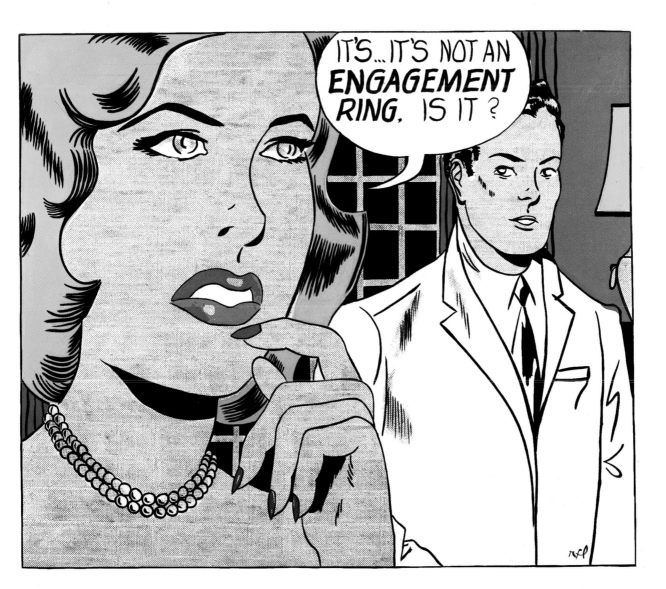

PLATE 18. Roy Lichtenstein,
The Engagement Ring, 1961.
Oil on canvas.
67 3/4" x 79 1/2"
Private collection.
Exhibited at the Faculty Art Show,
Douglass College, October 1962.
© Estate of Roy Lichtenstein, 1998.

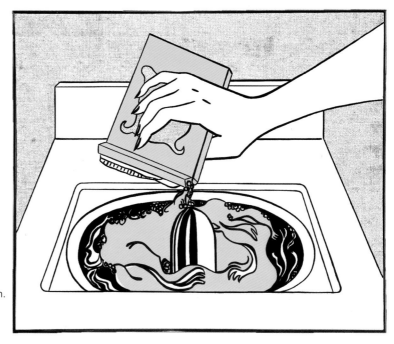

PLATE 19. Roy Lichtenstein,
Washing Machine, 1961.
Oil on canvas.
56 1/2" x 58 1/2"
Yale University Art Gallery, New Haven.
Lent by Richard Brown Baker, 1935.
© Estate of Roy Lichtenstein, 1998.

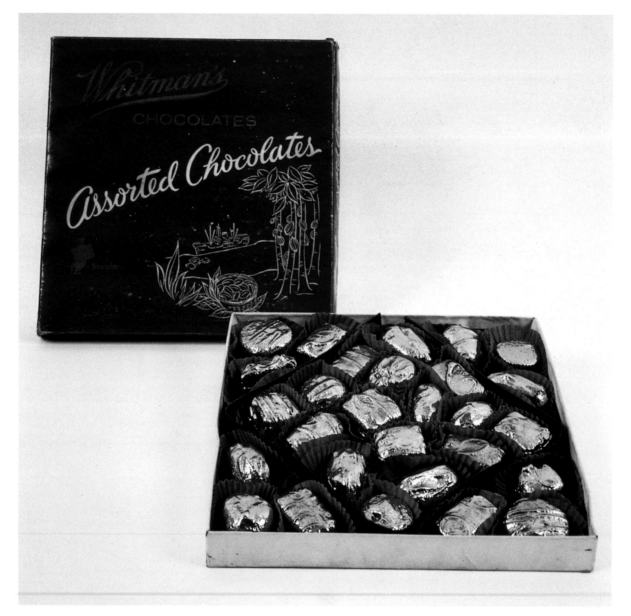

PLATE 20. Robert Watts, *Whitman's Assorted Chocolates,* 1963.
Candy box and chrome plate on bronze.
1" x 8 1/4" x 8 1/4"
The Philadelphia Museum of Art, gift (by exchange) of Mr. and Mrs. R. Sturgis Ingersoll.
Photograph courtesy of the Robert Watts Studio Archive, New York.

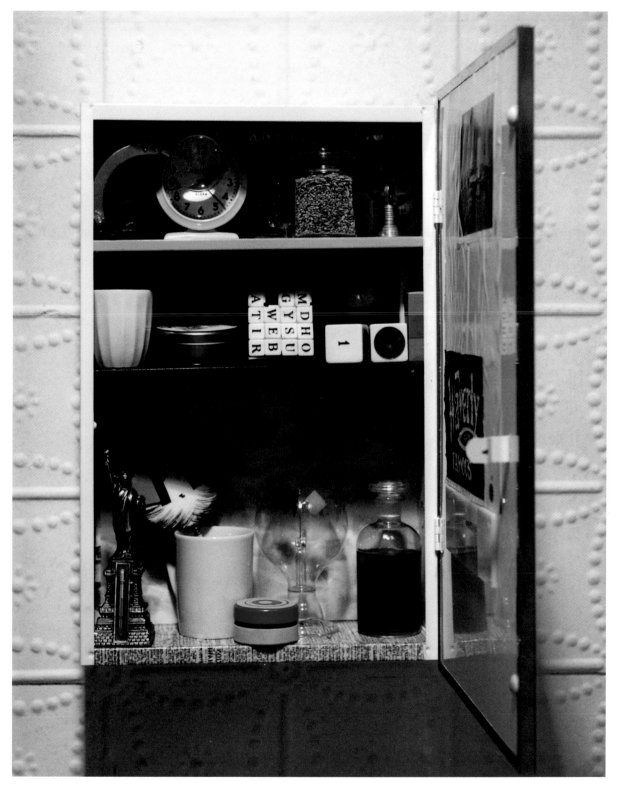

PLATE 21. George Brecht, *Cabinet,* 1959.

Mixed media.

14 1/2 " x 11 1/2 " x 4"

Location unknown. This work is shown as installed in Brecht's *Toward Events* exhibition, Reuben Gallery, 1959.

Photograph by Scott Hyde.

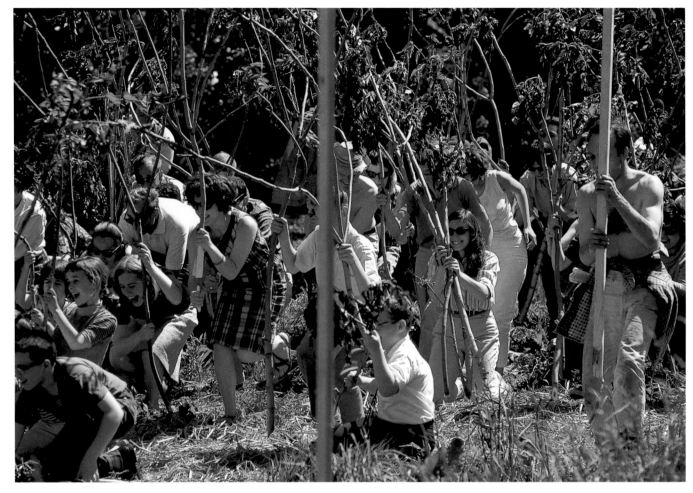

PLATE 22. Participants in Allan Kaprow's *Tree,* 1963,
a Happening at George Segal's farm,
South Brunswick, New Jersey.
Photograph by Robert McElroy.

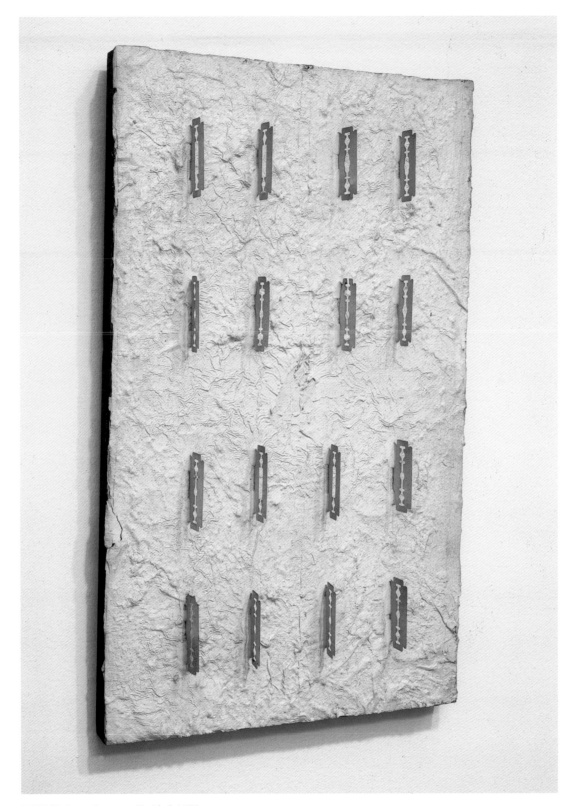

PLATE 23. Lucas Samaras, *Untitled*, 1959.
Wood, metal, printing plate, toilet paper, razor blades and paint.
15 1/4" x 14" x 9"
Private collection.
Photograph by Ellen Page Wilson, courtesy of PaceWildenstein.

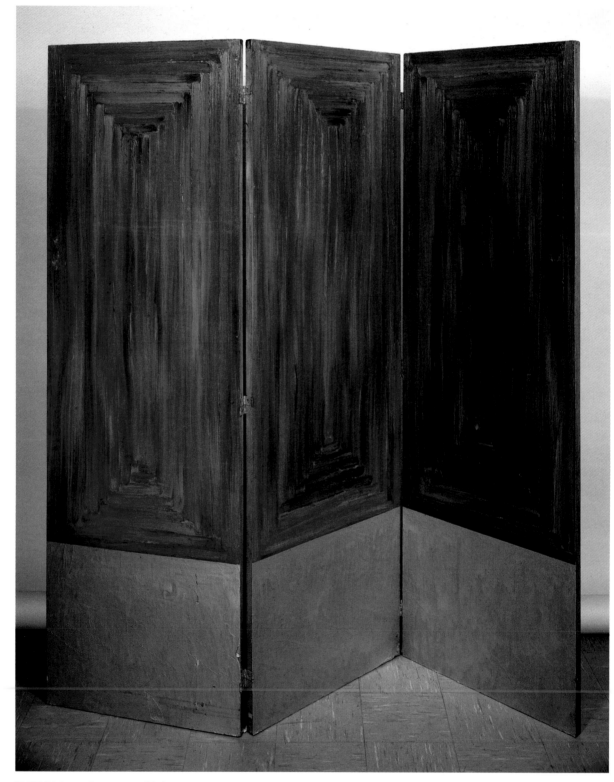

PLATE 24. Lucas Samaras, *Untitled,* ca. 1958.
Painted masonite screen with aluminum foil.
69" x 69" (23" each panel)
Jane Voorhees Zimmerli Art Museum, Rutgers, The State University of New Jersey, New Brunswick.
Gift of the artist.

PLATE 25. George Brecht, *Koan,* 1959.

Mixed media.

Location unknown. This work is shown as installed in Brecht's *Toward Events* exhibition, Reuben Gallery, 1959.

Photograph by Scott Hyde, courtesy of Barbara Moore.

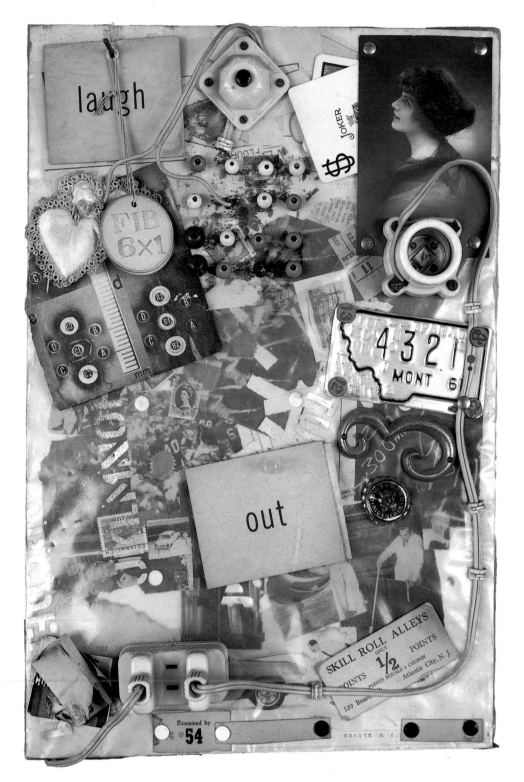

PLATE 26. George Brecht, *Bulletin Bored* (*Laugh*), ca. 1963–64.
Found objects on board.
23" x 13 1/2" x 3"
The Gilbert and Lila Silverman Fluxus Collection, Detroit.

PLATE 27. Robert Watts, *Hot Sculpture,* 1960.
Heated nichrome wire, mirrors, metal, plaster.
approx. 30" x 24" x 24"
Location unknown.
Photograph courtesy of the Robert Watts Studio Archive, New York.

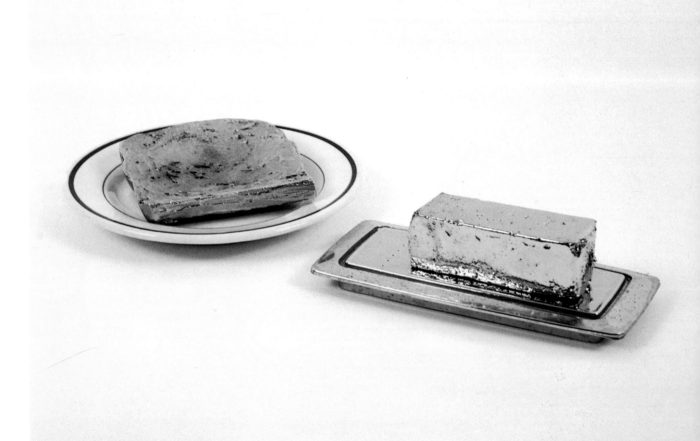

PLATE 28. Robert Watts, *Bread Slice* and *Butter*, 1963–64.
Bread: chrome plate on brass, wire, solder and ceramic dish, 1 1/4" x 4" x 4".
Butter: chrome plate, plastic cover, 2 1/4" x 6 3/4" x 2 3/4".
Photograph courtesy of the Robert Watts Studio Archive, New York.

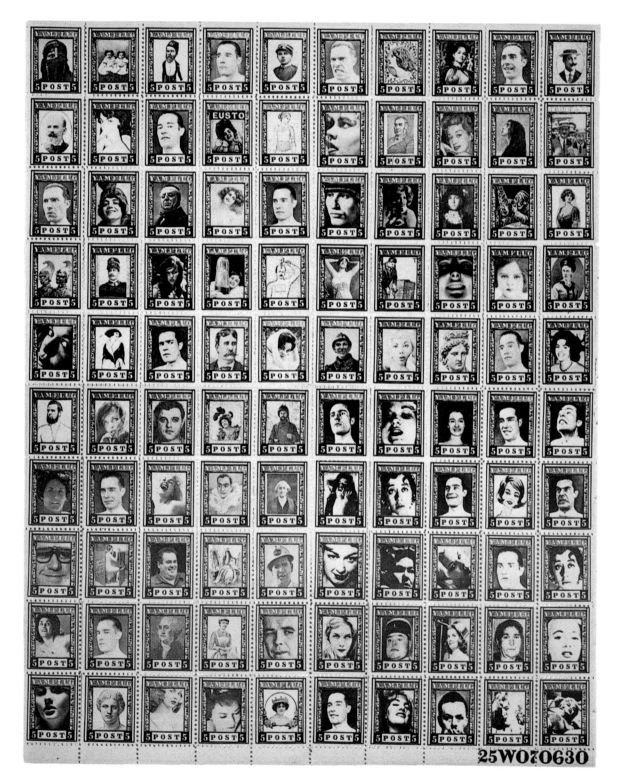

PLATE 29. Robert Watts, *Yam Flug 5-Post-5,* 1963.
Sheet of one hundred stamps, 10 3/8" x 8 1/4"
Published by the artist in 1963 in several ink colors.
Photograph courtesy of the Robert Watts Studio Archive, New York.

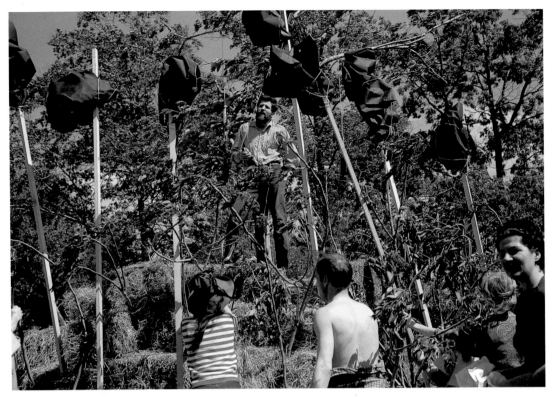

PLATE 30. Allan Kaprow on top of a haystack as part of his Happening *Tree*, a *Yam Festival* event at George Segal's farm, South Brunswick, New Jersey, May 1963. Photos, top and bottom, by Robert McElroy.

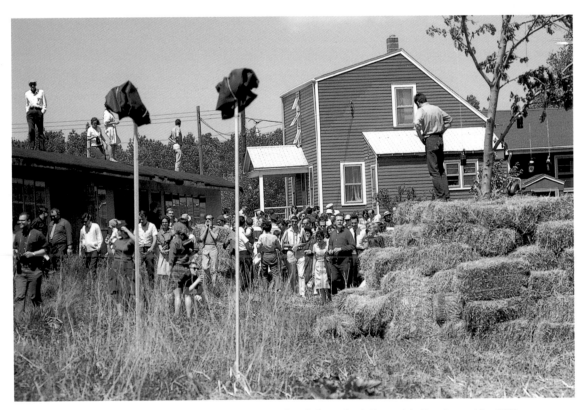

PLATE 31. Allan Kaprow's *Tree*, a *Yam Festival* event at George Segal's farm, South Brunswick, New Jersey, May 1963.

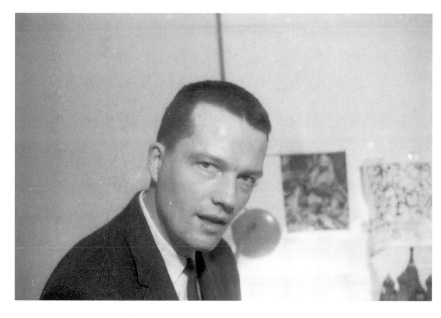

FIGURE 49
Portrait of George Brecht, 1960.
Photograph by Scott Hyde.

and Whitman followed with *American Moon*
November 29–December 4. The calendar year
ended with a bang December 16–20 with a multi-
performance show called *Varieties*, which included
Dine's *A Shining Bed*, dancer Simone Morris's
(Simone Forti) *See-Saw and Rollers*, and Oldenburg's
*Blackouts (Chimney Fire/Erasers/The Vitamin
Man/Butter and Jam)*. The momentum continued in
1961 as the Reuben Gallery scheduled Oldenburg's
Circus (Ironworks/Fotodeath) in February, Kaprow's
A Spring Happening on March 22, and Whitman's
Mouth April 18–23. In May, Anita Reuben closed the
gallery, which she was forced to support for two
years, since she rarely had anything she could sell.

The Reuben Gallery may have been gone, but
Happenings were still alive and well, at least until the
end of the decade. Even before the Reuben Gallery's
demise, various kinds of performance art, not
necessarily considered Happenings per se, were
appearing with a fair degree of regularity in many
different spaces.[40] While these spaces would have
undoubtedly materialized on their own, the Reuben
Gallery was the first to appear and was the catalyst
that helped spark the other venues. Like the Reuben
Gallery, these spaces were energy centers, for they
presented dynamic, lengthy, evening programs of
avant-garde performance. Sometimes the work had a
strong orientation toward the visual arts, sometimes
toward music, and sometimes toward dance and

theater, but in general, much of the work was a
combination of these art forms. The unifying
ingredient was the human presence activating the
piece in space and time.

In most instances, these events were presented
on a stage, instead of a gallery, and were more directly
related to the audio pieces of Cage than to the visual
art of Kaprow. The Living Theater, which was located
on the Avenue of the Americas in Greenwich Village
near the Judson Church and opened in late 1958 for
avant-garde theater, presented programs of "New
Music" organized by the energetic Hansen on March
14 and August 1, 1960. The evenings included work
by Hansen, Higgins, Brecht, Kaprow, Cage, and
Maxfield. Hansen arranged a similar program at
Memorial Hall at the Pratt Institute on May 2.
He also operated the Third Rail Gallery of Current
Art, which existed wherever he was living and was
open when he presented one of his Happenings.[41]
In 1961, the gallery was at 104 Hall Street in
Brooklyn, and by 1963, it was in different locations
in the Lower East Side, including 49 East Broadway
and 220 Second Avenue. The name of the gallery is a
reference to the electrified third rail that powers the
city's subways, and, in part, it was selected by Hansen
to underscore how Happening galleries had become
energy centers electrifying the art world.[42]

Other performance centers were Yoko Ono's
loft at 112 Chambers Street, where salons, organized

by La Monte Young, were held from January to May 1961 featuring word performances by Jackson Mac Low, dance by Simone Morris and Robert Morris, and music by Maxfield, Young, and Ono. From March into July of the same year, George Maciunas's AG Gallery at Madison Avenue at Seventy-third Street (one of the few uptown spaces) served as a forum for the work of Trisha Brown, Cage, Walter de Maria, Henry Flynt, Higgins, Ray Johnson, Ichniyanagi, Mac Low, Robert Morris, Simone Morris, and Yvonne Rainer. No one worried about what to call the work, although the programs were variously described in press releases, announcements, and posters as "a festival of electronic music," "concerts of new sounds and noises," or "literary evenings"—terms that seem to apply more to Cage's circle of influence than to Kaprow's. Many of the artists from Ono's and Maciunas's salons would become key participants in the Fluxus movement, born in Europe in 1962 when Maciunas, then abroad, coined the term and dubbed many of the artists Fluxus artists. Ironically, the term "Fluxus" could be seen as a solution for what to call some of the diverse art that was presented in these circles; unfortunately, the word said little about the work, although it spoke to the spirit, which was playful to the point of seeming not to take itself, or the concept of art, too seriously.[43]

The Judson Church also continued to be an active center for performance, with Kaprow programming the Judson Gallery and, with Phyllis Yampolsky, the Hall of Issues from mid-1960 through 1961.[44] The church was further activated by the birth of Yvonne Rainer's Judson Dance Company in 1962. The Green Gallery, located uptown on Fifty-seventh Street, partially filled the void left by the closing of the Reuben Gallery by presenting in 1962 Happenings by Oldenburg and Whitman and one-

person shows of Lucas Samaras and George Segal. The downtown scene had already made an uptown appearance when in May and June 1961 the Martha Jackson and David Anderson galleries presented *Environments, Situations, Spaces,* an exhibition including Environments by Kaprow, Whitman, Oldenburg, and Dine and Events by Brecht and Walter Gaudnek.[45] For the exhibition, Kaprow made *Yard,* a Jackson-Pollock-all-over piece of used tires completely filling the backyard of the gallery's town house, and Brecht's *Three Chairs Event,*[46] consisting of three chairs: one white, dramatically lit in the gallery like a work of art (fig. 50); one black, in the bathroom, which probably went unnoticed; and one yellow, which was placed on the sidewalk (fig. 51). As far as Brecht was concerned, "the most beautiful event" to occur in this piece was "when I arrived

FIGURE 50
George Brecht, Chair inside gallery for *Iced Dice,*
a realization of *Three Chairs Event*
at the Martha Jackson Gallery, New York, 1961.
Photograph by Robert McElroy.

there was a very lovely woman wearing a large hat comfortably sitting in the [sidewalk] chair and talking to friends. . . . It was Claes Oldenburg's mother."[47]

From February 23 to 26, 1962, Oldenburg, in cooperation with the Green Gallery, operated the Ray Gun Manufacturing Company in an empty storefront at 107 East Second Street in the East Village, where he presented the *Ray Gun Theater,* a program of ten of his Happenings. In 1962, Whitman opened a performance space at 9 Jones Street, where, in March, he presented *Flower* approximately twenty times over the course of four weekends. The Living Theater continued to be a major performance venue, introducing environments and theater by Carolee Schneemann, sometimes on the same program with Dick Higgins and La Monte Young. Meanwhile, the New York Poets Theater at the Maidman Playhouse

presented performances by Kaprow, Whitman, Brecht, Johnson, Young, and others. Kaprow's *A Service for the Dead* took place in the boiler room.

Beginning in 1962, Kaprow, Whitman, Oldenburg, and Hansen were performing Happenings across America. Ann Arbor, Chicago, Dallas, East Hampton, Los Angeles, Philadelphia, Washington, and Woodstock are just a few of the places in which they received commissions. Furthermore, they often took their performances out of the confines of the art gallery and into the world itself, for example, into hotel courtyards (Kaprow's *Courtyard,* 1962, Mills Hotel, New York) (figs. 52, 53), forests (Kaprow's *Sweepings,* 1962, Woodstock, New York), and parking lots (Oldenburg's *Autobodys,* 1963, American Institute of Aeronautics and Astronautics, Los Angeles).

FIGURE 51
Chair placed on sidewalk as part of George Brecht's *Three Chairs Event* in the exhibition *Environments, Situations, Spaces* at the Martha Jackson Gallery, New York, 1961. Photograph by Robert McElroy.

FIGURE 52
Allan Kaprow, *Courtyard* (Happening at the Mills Hotel, New York), 1962
(view from above).
Photograph by Robert McElroy.

FIGURE 53

Allan Kaprow, *Courtyard* (Happening at the Mills Hotel, New York), 1962
(view from below, with Letty Lou Eisenhauer on ladder).
Photograph by Robert McElroy.

Also in 1962 and 1963, work by Brecht, Watts, Higgins, Alison Knowles, Mac Low, Emmett Williams, Ichiyanagi, Ben Patterson, and Nam June Paik (whose first performance, *Homage à John Cage*, took place in Düsseldorf in 1959) was being performed in Düsseldorf, Wiesbaden, Amsterdam, Copenhagen, London, and Paris, often in Fluxus festivals and alongside the work of their European counterparts, such as Wolf Vostell, Ben Vautier, and Robert Filliou. For the most part, this work was presented on a stage in a concert format and was associated more with music than with visual art.[48]

By 1965, books were being written about the phenomenon, Happenings were being covered by national magazines and on television, and the term was a household word. In October 1966, Rauschenberg, Whitman, and Bell Labs electrical engineer Billy Klüver took Happenings to an even grander level when they presented *9 Evenings: Theatre and Engineering* at the cavernous Twenty-fifth Street Armory in New York. Extravaganzas in terms of scale, equipment, and number of performers, the ten separate performances on nine evenings by artists Rauschenberg, Whitman, Oyvind Fahlström, musicians John Cage and David Tudor, and dancers Lucinda Childs, Alex Hay, Deborah Hay, Steve Paxton, and Yvonne Rainer were designed to attract huge audiences and open up new avenues for artists by allowing them access to scientists and sophisticated technology. But by the late 1960s, the opposite had occurred—Happenings by visual artists had virtually disappeared. Grooms had stopped performing by 1960,[49] Dine by 1962, and Oldenburg by 1966. Whitman's new pieces were few and far between after 1966, not from a lack of desire, but because he found it difficult to find anyone willing to present them. The fad was fading, replaced by numerous new styles such as Pop Art, Minimal Art, Conceptual Art, and Earth Art. The demise of Happenings was hastened by the fact that they were expensive and labor intensive, and ultimately produced no object that could generate sales.[50] Performance was the natural domain of musicians, dancers, and the theater, not the art world. Of the original group that showed at the Reuben Gallery in 1959–60, only Allan Kaprow continued to produce Happenings on a regular basis. By 1969, he

was living in California, and while his work was presented around the world, it was rarely seen in New York.[51] By the end of the sixties, the energy that had exploded from the Reuben Gallery in 1959 and ignited so many New York venues through the mid-1960s was gone, absorbed into the vast expanse of the United States and Europe and lost among the many styles and isms that evolved throughout the decade.

—

THE WORK

—

This partial listing of performance highlights in the early to mid-1960s does little more than relate the tremendous amount of performance occurring at the time, and does little to qualify this energy and excitement. The label "Happening" was applied mainly to the artists of the Reuben Gallery: Kaprow, Whitman, Grooms, Oldenburg, and Dine. Hansen, the only self-proclaimed Happening artist, never performed at the Reuben Gallery, but he, too, is always associated with the word. On occasion, Rauschenberg, who was in the *Below Zero* show at the Reuben Gallery, has been lumped together with this group.[52] A second circle of artists were those who were eventually involved with Fluxus: Brecht, Watts, Higgins, Mac Low, Young, Ichiyanagi, Flynt, Patterson, and Yoko Ono, to mention but a few. Brecht was the only artist to show and perform at the Reuben Gallery who was absorbed into Fluxus. It was not until the birth of Fluxus in Europe in 1962 that Watts's works were performed on a regular basis, and, prior to 1963, this was done almost exclusively abroad, often in Fluxus programs of "New Music."[53] While Cage can be viewed as the springboard for both groups, the direction each took was quite different, despite their common ground. Although this may be an oversimplification, Kaprow and Brecht can be seen as characterizing the two poles. The work of the Happening circle can be described as environmental, with an emphasis on the work as visual art. While also visual, the Fluxus group can be portrayed as theatrical and conceptual. Almost symbolizing their differences is the fact that Happenings have to be orchestrated by the artists, while the Events of the

Fluxus circle could, like music, be performed by anyone who had the score, and often was. Furthermore, the Happening artists, while still working in galleries, generally built the environments or sets for their works, which were an essential component of their art; the Fluxus artists usually just required props.

Kaprow's *18 Happenings in 6 Parts* embodies many of the characteristics of the Happening circle. Performed at the Reuben Gallery in October 1959, it had an elaborate set and script. The work was one of the most complicated and by far the most controlled of his oeuvre. This was in part because he had an usually large amount of time to prepare the piece and think about it. The Reubens signed a lease for the gallery space in the spring, and Kaprow had the entire summer to create the work. Undoubtedly, putting additional pressure on him was the awareness that *18 Happenings* was to launch the gallery and mark his New York debut in this new medium.

The numbers in Kaprow's title suggest how calculated the work was. The piece was composed in six parts, much as a symphony is divided into movements. Kaprow separated the Reuben Gallery into three contiguous rooms, each constructed of semi-translucent materials allowing the audience to have some idea of what was going on in each of the rooms. The materials, not only in keeping with Kaprow's art but also of the period, were cheap, disposable, and expressionistic. Stylistically, they relate directly to his constructions and Environments, to the point that Kaprow even incorporated *Re-Arrangeable Panels*, a screenlike assemblage of found objects from 1957–59, into *18 Happenings* (plate 4 and figs. 54, 55).

Upon arriving, spectators were given instruction cards directing them to seats in one of the three rooms. At the end of every two parts, a bell rang, and the audience went to the next room assigned on the card. During each part, the audience heard record players, tapes, and performers moving in the rooms and speaking, usually mechanically delivered fragments of sentences, or non sequiturs. They smelled paint being brushed on canvas (by George Segal, Red Grooms, Robert Thompson, Alfred Leslie, Robert Rauschenberg, or Jasper Johns,

depending on the evening)[54] and oranges squeezed into orange juice. All of these activities were performed according to a score, although the performers, who rehearsed for weeks, were given considerable leeway, typical of Kaprow.

The spectator was subjected to a barrage of sensory experiences in *18 Happenings in 6 Parts*—smells, sound, and light. Furthermore, there was a constant procession of events—of someone squeezing oranges, projecting slides, painting, or exercising—although the actions never coalesced into a story, or even a suggested story. The entire work was quite literal in its presentation of life, assaulting the viewer with *real* smells, *real* sounds, *real* light, and *real* events—nothing could be interpreted as illusionistic or representational. A broad range of experience—life itself—was presented to the audience, often many experiences at one time, as in a three-ring circus.[55] As a result, the perception of these eighteen Happenings presented in six parts was different for each spectator, as was the meaning. However, no meaning is affixed to these events. Kaprow describes himself as a formalist, and at one level his Happenings can be seen as an abstract collage of life, the artist's materials including visual, audio, and olfactory components, as well as space and time.

With *18 Happenings in 6 Parts*, Kaprow moved well beyond Cage and the work produced in his class. It was a natural outgrowth of his Environments exhibited at the Hansa Gallery. The Environments were collages of life, and now Kaprow simply added to his collage the human being and human activity he found in Cage's class. The total visual and sensory environment that he created, and that Whitman, Oldenburg, Dine, and Grooms designed as well, was new. Cage had never thought of his work as total environment, and because his interest was in sound, he placed less emphasis on the visual component of his pieces.[56]

Kaprow along with Whitman invited artists who shared their interests to join some of the other Rutgers artists at the Reuben Gallery. Dine, Oldenburg, and Grooms were likewise working expressionistically with found objects, making assemblages, collages, and even Environments.[57] All three become known for their Happenings, but

Grooms was the only one to perform a Happening prior to the opening of the Reuben Gallery: *A Play Called Fire* in the summer of 1958 and *The Walking Man* in September 1959, both at the Sun Gallery in Provincetown, Massachusetts. Grooms was in part encouraged to do these performances when he heard about Kaprow's aborted Happening at Segal's farm in 1958, as well as through direct contact with Kaprow himself in Provincetown in the summer of 1959.[58] He made his New York debut with *The Burning Building*, performed at his Delancey Street Museum on the Lower East Side December 4–11, 1959, followed shortly thereafter by *The Magic Train Ride*, presented at the Reuben Gallery the following January. His brief, punchy performances packed

tremendous energy and were universally admired by his colleagues, especially by Dine, Oldenburg, and Whitman.[59] Whitman, who presented *Small Cannon* on the same program as *The Magic Train Ride*, probably spoke for many of his contemporaries when he described the magic of Grooms's piece in a recent interview. His recollection of details may be hazy, but his remembrance of the impact is still fresh:

> I recall a poetic work about people and a train, maybe a circus train, or some kind of train, stopping in the forest. I remember you see a shadow play of people rehearsing their circus performances. And then crazy woodmen come and drive them out, charging through the audience with axes, and yelling, with this great hullabaloo. Someone shouts "Get on the train. Get on the train. Get on the train." There

FIGURE 54
Allan Kaprow and Robert Whitman at the Reuben Gallery, August 1959, during the construction of the set for *18 Happenings in 6 Parts*. Photograph © by Fred W. McDarrah.

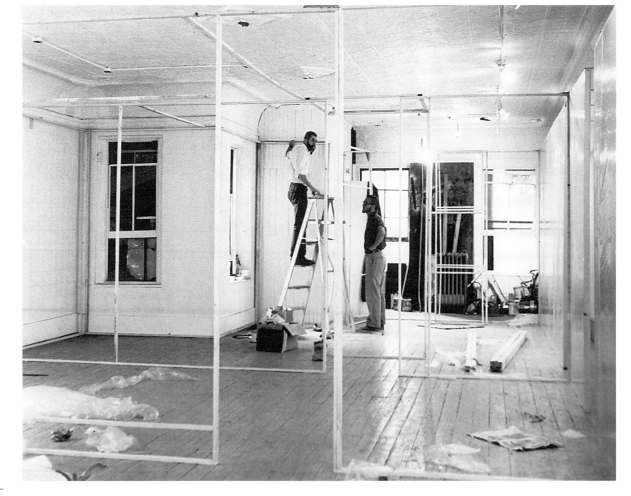

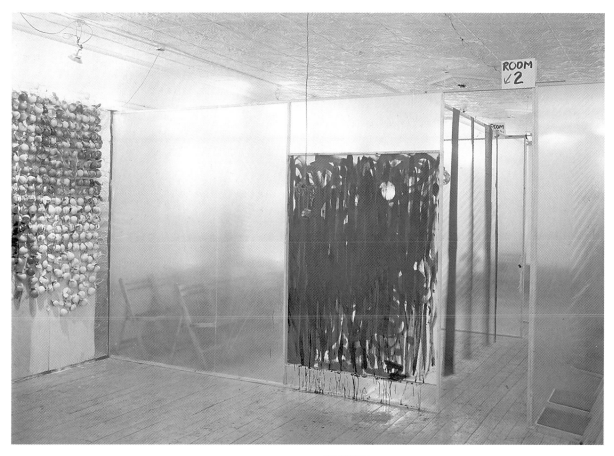

FIGURE 55
Set for Allan Kaprow's *18 Happenings in 6 Parts*
at the Reuben Gallery, New York, 1959.

was also a typical Red Grooms cardboard cutout of a train. Red has his arm out the window, and he's got an engineer's cap on, I think. All of the people on the train, who I think are circus people, they're making the train go, and they're stomping their feet to the rhythm of a train. Then, they go through the woods. And they chant, "We're going through the woods." And then here comes Bob Thompson, pushing a baby carriage full of Christmas trees sticking out, and he's got tin cans all over everything, and it's kind of jingling, and he's pushing this by the train, going through the woods. And as I remember, the end was something like Red screaming out, "The tunnel. The tunnel." And the light goes out.

There was a kind of naive wonderfulness about what Red was doing, and some kind of magic. There was this kind of exuberance and spirit to it. It's the past, never to be seen again.[60]

The nostalgia of Whitman's last statement reflects his awareness of the timely impact that Grooms's perfor-

mances had. Despite their influence, the performances had a conservative side. Because of their narratives, however disjointed and irrational, Grooms's works were closer to theater, almost children's theater, than to visual art, and Grooms himself called his works plays, not Happenings.[61] Furthermore, Grooms's plays involved a distinct separation of stage and audience, although, as in *The Magic Train*, the actors run through the audience. Rather than citing theater as a source, Groom cites the circus, the outrageous caricaturing, boisterous zaniness, and dazzling visual fireworks of the big top undoubtedly having made an indelible impression on him as a boy.[62]

With *The Burning Building* and *The Magic Train*, Grooms offered an alternative to the intellectual tradition of Cage. His work was filled with passion, and his "primitive energy" to quote Barbara Haskell, was provocative.[63] Whitman, whose

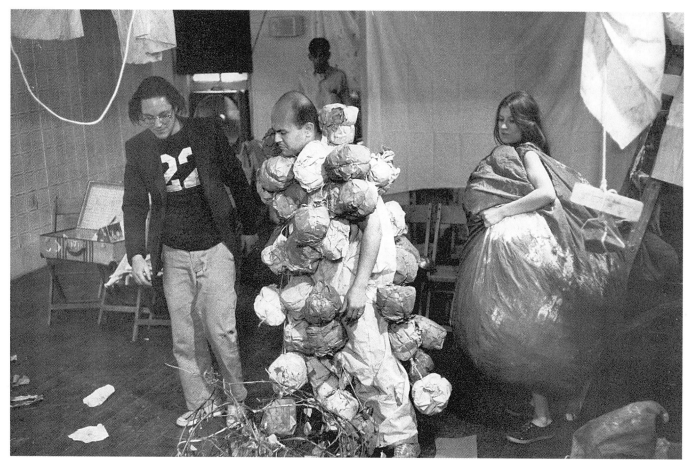

FIGURE 56

Jim Dine and Patty Oldenburg preparing for a performance
of Robert Whitman's *E.G.* at the Reuben Gallery, New York,
June 11, 1960. Whitman is on the left.
Photograph by Robert McElroy.

assemblages at the time were already headed in a
less controlled, more expressionistic and personal
direction, identified with the fervor of Grooms's
work, although he respected the abstract
formalism of Kaprow. Whitman had studied
theater at Rutgers College and had been considering
creating theater of some kind after being awed
by a Paul Taylor performance at Douglass College
in the spring of 1958. His first realizations were
structured walks through the woods in the
company of Grooms and Kaprow in the winter of
1959, although he now does not consider these
pieces artworks. But Grooms's *The Burning
Building* had a determining impact on him, to the
extent that he returned to see it several times,

bringing Robert Rauschenberg and dancer Jimmy
Waring with him.

Whitman's first performances, which he calls
theater pieces, were *Small Cannon* and *E.G.*,
presented at the Reuben Gallery in January and June
1960, respectively. The works were filled with
expressive, violent action. In *Small Cannon*, Patty
Oldenburg innocently swings on a swing not
knowing when an ax-wielding performer (the artist,
who did not like to appear in his works but felt
compelled to take what he considered undesirable
parts) will cut the ropes suspending her and send her
crashing to the floor. In *E.G.*, the audience was almost
immersed in the piece, since they sat to either side of
the performance space (fig. 57). There they saw Lucas

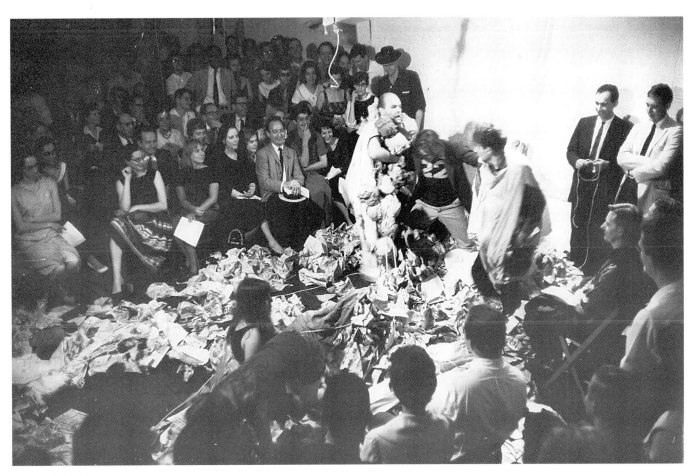

FIGURE 57
Finale of Robert Whitman's *E.G.*, June 11, 1960,
with Jim Dine in center of rubble (wearing balls),
Robert Whitman in center (wearing no. 22 sweatshirt and leaning on Lucas Samaras),
and Claes Oldenburg in center rear (in charge of cutting strings),
at the Reuben Gallery, New York.
Photograph by Robert McElroy.

Samaras, dressed in vines, put cartoon limbs made of fabric on two women dressed in cloth balls stuffed with paper. Jim Dine, dressed in multicolored paper-bag balls, then illusionistically tore the women apart, violently throwing their costumes and arms about, creating a snowstorm of paper and fabric (fig. 57). Players streaked through the space and slammed into the wall, when suddenly Claes Oldenburg, unseen and on cue, cut a string that sent rocks, hidden above near the ceiling, crashing to the floor, followed by the dropping of a muslin curtain, which blocked the audience's view. Moments later, another set of rocks smashed to the floor, taking down the curtain. The action was fast paced, and accompanied by taped music of voices.

With *American Moon*, performed in December 1960 at the Reuben Gallery, Whitman totally immersed his audience in the work, although he simultaneously toned down the violence and action. The work was assembled with the same kind of expressionistic, inexpensive, disposable materials used for his mixed-media constructions shown at the Hansa and Reuben galleries in 1958–59: cloth, paper, clear plastic, cellophane tape, and wood. The structure of the piece was six kraft-paper tunnels radiating out from a circular performance area. After

entering a foyer that set the tone for the theater piece (fig. 58) members of the audience were ushered to seats in the tunnels, six to eight people in each (fig. 60). Because they entered through a temporary tunnel removed when the work began, the spectators had no sense of the entire environment—only their tunnel and the one directly across.

During the performance, the audience saw piles of colored cloth gradually rise in the dimmed performance space and make inhuman movements and sounds. Plastic curtains partially covered with a grid of white paper were dropped at the mouth of each tunnel (fig. 44), enclosing each and becoming a screen for a movie. During the simultaneous projection of the movie, lights occasionally flashed in the tunnels, interfering with the viewing of the film. Performers periodically manipulated the plastic curtains, causing them to ripple and distort the film image. When the film ended, the screens were removed so that spectators across the way were brightly illuminated by the light from their projector. Then the cloth roofs of the tunnels were pulled back, allowing spectators to see large yellow cones above. The lights went out, and when turned on again, the spectators discovered large, clear, paper-filled, plastic balls stuffed in the openings of their tunnels. When removed, figures could be seen rolling by on the floor, followed by the roar of a vacuum cleaner pumping air into an enormous plastic balloon directly in front of tunnels. A man and a woman then tried to cope with the balloon as they moved around, under, and over it (figs. 59, 60, 61). The lights went out, the balloon was removed, and when the lights came back on, there was Whitman standing in the center space urging the spectators to join him. Above him, they saw a man swinging on a trapeze inches above their heads and expressionless faces eerily peeping at them from catwalks above. Flashbulbs started going off, and when they gradually stopped and the last face disappeared, the performance ended.

Because the audience was physically immersed in Whitman's piece, it experienced rather than just witnessed the continuous changes in light, sound, movement, and space, all of which evoked a variety of associations and emotions, none of which was clear or definite. Ultimately, Whitman's work, like

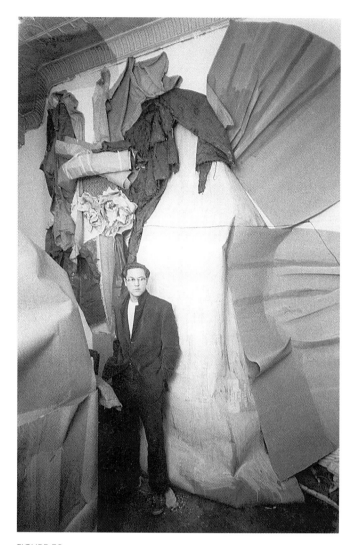

FIGURE 58
Robert Whitman standing at the entrance to his *American Moon,* Reuben Gallery, New York, 1960. Photograph by Robert McElroy.

Kaprow's, defied interpretation and had to be read as a formalist arrangement of abstract images and sound occurring in time—"abstract theater," to use the artist's own description. Even Whitman's figures tended to be abstractions; they were not fire fighters, woodmen, or people making orange juice. Like Kaprow and Grooms, Whitman sees the circus as a distant relative to his work, admiring its physical, nonverbal qualities and the way in which many things occur simultaneously.[64]

In the wake of Grooms and Whitman, Kaprow increased the degree of energy in his work, forcing the spectator to experience the piece more directly.

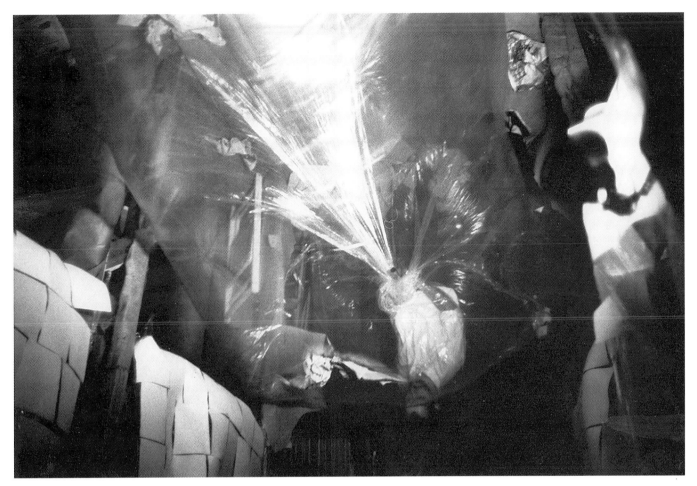

FIGURE 59
Inflation of plastic balloon in
Robert Whitman's *American Moon,*
Reuben Gallery, New York, 1960.
Photograph by Robert McElroy.

Jill Johnston, in an *Art News* review, describes the dramatic impact of *Spring Happening,* presented at the Reuben Gallery on March 22, 1961:

> Allan Kaprow left no doubt in anyone's mind about the part he expected his audience to play at his Spring Happening [fig. 62]. After chatting idly in the chilly area just inside the doorway the innocents were politely ushered into a long narrow dark train. "Be my guest," an invisible devil seemed to say, and there was no time to resist what was about to happen. . . . By way of a coup he has forced the audience into a position of participation. Not only by the claustrophobic cattle-car device, but through the tantalizing slits on either side of you which makes vision an effort and only partially satisfied it, and through the onslaught of sights and sounds which grip the senses from beginning to end. The waiting passengers are first treated to an unnerving racket of careening metal barrels. Lights flash, thunder strikes, paper shakes, smoke appears, at one point a cellophane drop is lowered over your slit-windows and quickly washed down with soapy water. The trapped spectators are clearly in a vortical chamber where the primal elements are in the throes of an agonizing realignment. The air is pregnant with expectation. A man walks by ringing a bell, a girl twists and turns in a shadow play behind a dropped sheet; a naked girl—a lovely symbol of innocence—searches through the area with quiet desperation until felled by a smothering blanket. At last and perforce the spectators are set free, released, "created," purged, when the walls of their train-tomb-womb can no longer contain them, as a thunderous power lawn

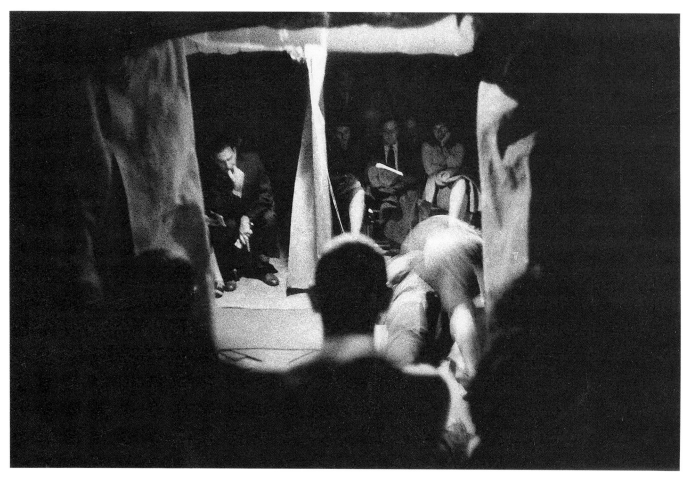

FIGURE 60
Audience seated in tunnels in
Robert Whitman's, *American Moon*,
Reuben Gallery, New York, 1960.
Photograph by Robert McElroy.

mower appears at one end and the sides give way to the ground allowing the spectators to step out with massive relief. This is a tour-de-force.[65]

While Kaprow was increasing the drama in his work, Brecht was lowering the intensity of his. His work could be energetic and active, but, in Zen fashion, his energy was paradoxical; it was quiet energy, or contained energy, to be activated and controlled in many instances by the viewer, not by the artist. His October–November 1959 show at the Reuben Gallery did not include a Happening. Titled *Toward Events,* the show was described in the announcement as "an arrangement." Most, if not all, of the work called for visitor participation. *The Case, The Dome,* and *The Cabinet* all followed the same

premise. Inside each of these different containers were objects that the viewer was instructed to remove and activate. Brecht provided the following instructions for *The Case*:

> *The Case* is found on a table. It is approached by one to several people and opened.
> The contents are removed and used in ways appropriate to their nature.
> The case is repacked and closed.
> The event (which lasts possibly 10–30 minutes) comprises all sensible occurrences between approach and abandonment of the case.

The contents of these works were such unremarkable small items as wood blocks, small tin containers, yo-yos, golf balls, bells, tea balls, marble

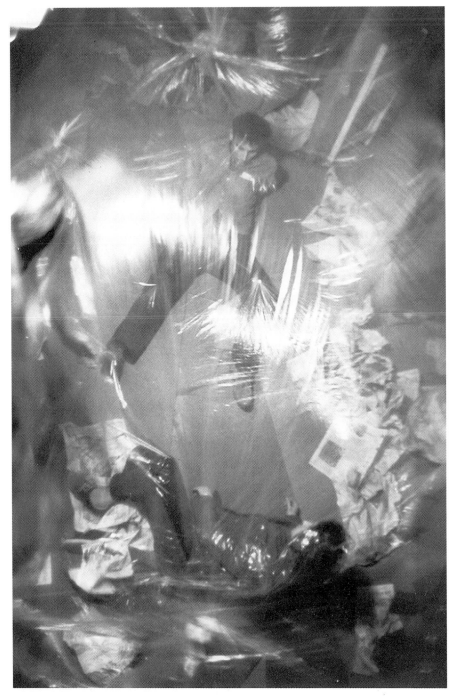

FIGURE 61
Lucas Samaras under the
plastic balloon in Robert Whitman's
American Moon, Reuben Gallery,
New York, 1960.
Photograph by Robert McElroy.

eggs, postcards, and so on. As the instructions
indicate, an event occurs when the visitor activates the
contents of each container; the event ends when
everything is returned and the container closed. The
objects are not necessarily the artwork—the event is,
although the artist leaves this issue ambiguous. In
some instances, the visitor was permitted to take away

components, although they had to be replaced (they
never were, much to Brecht's displeasure).[66] Unlike
the Happenings of Kaprow and Whitman, these
Events could be solitary, with a single visitor able to
activate the piece. One work in the show was even
titled *Solitaire,* which was a "unique set of 27 cards
based on the variables [of] number, size, and

FIGURE 62
Steve Vasey pushing a lawn mower
in Allan Kaprow's *Spring Happening,*
at the Reuben Gallery, 1961.
Photograph by Robert McElroy.

color."[67] The rules were a variation on the traditional game of solitaire.

By 1960, Brecht's work was getting increasingly simple, abstract, and less controlling. In a later card game that had sixty-four cards, all with images taken from an encyclopedia, there were no rules at all; they were to be made up as the players went along.[68] In 1960–61, Brecht began hand-writing his event scores on slips of paper and mailing them to friends and acquaintances. It was only in 1963 that a full set of event cards, now offset printed on heavy card stock, was published in a Fluxus edition called *Water Yam.* By circulating work based on words, Brecht, in a single gesture, created Conceptual Art and helped popularize Correspondence Art. One of the first scores that he mailed was *Motor Vehicle Sundown* (Event) (fig. 63), published in the spring/summer of

1960. The work, which is dedicated to John Cage, calls for the performers to make sounds using cars as their instruments. Following randomly distributed instruction cards, musicians would manipulate the wipers, sound the horn, or roll down a window.

By 1961, Brecht's scores became shorter and less restrictive. *Time-Table Event,* which was conceived in conjunction with Cage's class in the summer of 1959, was reduced that year to the following:

> TIME-TABLE EVENT
> to occur in a railway station
> A time-table is obtained.
> A tabled time indication is interpreted in minutes and seconds (7:16 equalling, for example, 7 minutes and 16 seconds).
> This determines the duration of the event.

FIGURE 63
George Brecht, *Motor Vehicle Sundown* (Event score),
spring/summer 1960.
22" x 8 1/2"
Photograph by Dan Dragan.

Musicians are no longer instructed to produce sounds
in a train station based on the random numbers
found in a schedule. Now the event is the real life
that is observed during the seven-minute-and-sixteen-
second period that had been randomly selected by the
viewer, and only one person need observe the event.
Using chance method, Brecht has simply framed a
segment of time as a work of art.

In 1961, the instructions on the event cards
became even more minimal, to the point of being
almost abstract and wide open to any interpretation.
Three Aqueous Events, dated summer 1961, consisted
of just the title at the top of the card followed by a
column of three words, "ice," "water," and "steam,"
each preceded by a bullet (fig. 64). This mysterious
and poetic card evokes a range of responses. Brecht's
realization of the piece was to mount a glass of water
on a white board with the word "ice" in the upper
left corner and "steam" in the lower right. Allan

FIGURE 64
George Brecht, *Three Aqueous Events* (Event score),
summer 1961. From *Water Yam* edition, 1963.
Photograph by Dan Dragan.

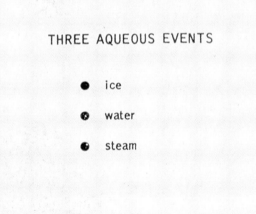

Kaprow's response was "to make ice tea."[69] Brecht even reduced the event card to a single word. One example is *Exit,* which would be one of the events favored by Fluxus artists, who often used it to end Fluxus festivals, as is discussed by Simon Anderson in his essay in this book.[70]

The event cards posed the question, What is a work of art? Was it the card, which in the case of *Exit* was a beguiling object with its bullet and one word floating on a field of white paper? If so, the cards were clearly Conceptual Art *avant la lettre.* Was it the event, that is, the execution of the card's instructions? Was it the object, if there was one, produced by the event (e.g., ice tea)? If there is an object, as in *Three Chairs Event* (figs. 50, 51), who is the artist if the chairs are not selected and arranged by Brecht? And how authentic is the artwork? And does the concept of authenticity have any relevancy or meaning? The event cards raise the issues of authorship, uniqueness, and value, and question the identity and function of art.

Brecht took the implications of Cage's class in a direction never imagined by Cage, who, for all of his emphasis on randomly appropriating the sounds of life, never conceived of art that was so conceptual, and so far removed from a musical context. Brecht's work is more complex and encompassing.[71] By 1961, it was certainly more random and uncontrolled. It is almost impossible to identify Brecht's art, which became a series of events, objects, and ideas steeped in the swiftly flowing river of life, to the point that the boundary between art and life appears almost completely blurred. His art seems to defy definition, unlike Cage's, which is basically steeped in music.

The *Yam Festival* epitomizes this ambiguity. Hatched by Brecht and Watts in a Howard Johnson's in downtown New Brunswick in 1961 or 1962, the *Festival* defies definition as it, too, blurs the boundaries of art and life. As discussed in Anderson's essay, the *Yam Festival* included such conceptual works as the *Delivery Events* and *Lantern Cards.* There were also *Yam Lectures* by Watts and Brecht, *Hat Day,* Robin Page's *Guitar Piece,* and numerous other performances, tours, auctions, and events in New York and on George Segal's farm. At one point, the *Yam Festival* was to have been kicked off by a

performance that played on the twenty-eight flavors of ice cream offered by Howard Johnson's, the artists' favorite lunchtime restaurant. As defined by Watts in the notes for the *Yam Lecture,* "Yam Festival was conceived by [us] as a loose format that would make it possible to combine or include an ever expanding universe of events."[72] To this day, no one is quite sure when it began and what it consists of, other than "an ever expanding universe of events."[73]

—

THE MEANING

—

While Brecht's work may have an entirely different character from Cage's, the meaning or content is the same: there is none. In the case of both, there is no fixed meaning, since Brecht, like so many of his contemporaries, is not concerned with values or meaning—just with presenting what is, just with presenting life, and letting each viewer use the presentation as needed for that moment, which includes attaching value and meaning. Speaking of his objects, such as *The Cabinet* or *The Dome,* Brecht has said, "I don't think at all it's an aesthetic matter."[74] He goes on to say:

> My impression is that these objets got together in the same way that dust moves in the streets. If we said that one object had a greater value than another and that it therefore got into the piece, well, I don't think that would be appropriate. I don't see it as a matter of choice. I don't choose an object to use. The fact that an object is used is a natural process of which I am only a part. It just arrives.[75]

Brecht continues by saying that he does not consider as art the objects that he makes. He explains that "they're just things to have around, like everything else. And they're researches."[76]

Brecht's language and position is philosophically very close to Zen Buddhism. Brecht had discovered Zen well before meeting Cage, whom he credits with simply reinforcing his interest. Brecht's notebooks are filled with references to Zen, some reflecting comments that Cage made in class. There are also references to Zen in his works, such as *Koan* (plate 25), a work exhibited in his *Toward Events* exhibition. To quote the dictionary, *koan* is "a

paradox to be mediated upon that is used to train Zen Buddhist monks to abandon ultimate dependence on reason and to force them into gaining sudden intuitive enlightenment."[77] But Brecht has disavowed any strong relationship between his work and Zen. In a 1967 interview with Henry Martin, he said, "I have no real connection with Hindu thought or with Zen. I mean I simply do what I do and that's it. In fact, I wouldn't like it if someone tried to find a correspondence between what I do and Oriental thought. It wouldn't be appropriate. Because a glass of water is a glass of water."[78]

In part, Brecht's statement is itself very Zen, since it is paradoxical and a rejection of a cause-and-effect relationship as an explanation for an event. But his disavowal of Zen as a direct influence on his art probably stems from the fact that Zen is just one part of a much larger worldview that he held, a worldview that is conditioned by thinking that is similar to Zen but comes from many different, unrelated sources and disciplines, such as quantum physics, to which his scientific background would have introduced him. His preoccupation with a worldview that spanned disciplines, continents, and time must have led him in 1959 to attend courses at the New School for Social Research taught by Giorgio Tagliacozzo, "The World of Modern Knowledge" or its sequel, "The Modern Study of Man and Society," or both. As described in the prospectus for "The World of Modern Knowledge," the course was an attempt to present a worldview that spanned the humanities and the sciences and combined "the essentials of modern knowledge into a significant picture of its entire structure," one that "integrates specialized fields and disciplines." The course syllabus, which Brecht pasted in his notebook, is revealing:

> October 27 and November 3: Non-Euclidean geometry: a death blow inflicted upon the Euclidean world view. Basic feature: *Freedom from absolutes*;
> November 10: *Freedom from absolutes* as a feature of the world of modern knowledge: relativity of linguistic, biological, psychological, cultural, ethical, economic, aesthetic categories;
> November 17: The theory of relativity. Basic feature: *space-time*;

> November 24: Space-time as a feature of the world of modern knowledge. Space-time in modern art;
> December 1: Quantum theory. Basic feature: *discontinuity-uncertainly*;
> December 8 and 15: Discontinuity-uncertainty as a feature of the world of modern knowledge: modern theory of infinity; certainty as an illegitimate concept (Gödel); quantum and life; the observer as part of what he observes; chance in modern art;
> December 22 and January 5: Philosophy in the world of modern knowledge: symbolic logic; unity of logic and mathematics; analytical philosophy; existentialism and Zen; toward a gestalt philosophy?[79]

Tagliacozzo's course mirrors the thinking of the period, as discussed by Jackson Lears in his essay in this volume, and to varying degrees that of the artists involved with Happenings. Most of the artists were not as steeped in philosophy as was Brecht. Kaprow is the exception, and he even has a strong academic background in the discipline. For example, his emphasis on making experience the essence of art stems in part from John Dewey's *Art as Experience,* which he first read in 1949.[80] At the other extreme is Hansen, who can perhaps be described as a sidewalk philosopher who had unbridled enthusiasm for Zen.[81] Echoing Kaprow, Hansen has written that "at the core of happening theory, and central to the thinking and philosophy of the happening people, is the idea that there is a fusion of art and life. Like life, the happening is an art form of probability and chance."[82] And what is the meaning or context of a Happening? "Right now the message of my happenings is fairly simple, to the point of being trite—the meaning in meaninglessness, the meaninglessness in meaning."[83]

Regardless of the philosophical source, most of the artists emphasized experience in their work, and perceived their work as events occurring in time and space. Most were reluctant to impose meaning or value on the work, which is not to say that the work could not be expressionistic and suggestive. As expressed by Oldenburg in a 1967 interview with Richard Kostelanetz: "The people in my audience are like spectators at an anatomy—a medical theatre. I throw up images one after another or on top of one

another and repeat them until it is evident I am asking, 'What are they, or what do you think you are watching?' My theatre is therefore undetermined as to meaning."[84]

In the same interview, Oldenburg states that "it's characteristic of all my pieces to want to put the responsibility upon the individual eye. You see whatever you choose to see. People are always saying, 'Look over there,' while someone else is looking somewhere else."[85] Kostelanetz elicited a similar statement from Kaprow, who remarked in his interview, "Well, I've always been impressed by the fact that I wasn't able to experience anything completely, only indirectly or in part."[86]

Contemporaries understood this neutrality of Kaprow, Whitman, Brecht, and many of their contemporaries, and the fact that they were formalistically serving up slices of life for viewer experience and interpretation. Critic Dorothy Gees Seckler specifically dealt with these issues in the introduction to her article about the upcoming New York art season in a fall 1961 issue of *Art in America,* spurred by the then soon to open *Art of Assemblage* show scheduled at the Museum of Modern Art (which, in effect, was the upshot of the Reuben Gallery exhibitions as popularized at the Martha Jackson and David Anderson galleries). She makes a point of distinguishing the assemblage and Happening artists from their Dada predecessors, noting that the latter is "anti-culture" and negative, while the former has

> no political ax to grind. Rauschenberg points out that dada had a program of exclusion—cutting all ties with previous culture and tradition—in contrast to his own group's belief in "inclusiveness."
>
> The neo-dadaist may be interested in mysticism, occultism, or like Rauschenberg, in Zen Buddhism, but he is indifferent to Marx and seems to have no quarrel with nationalism. The American flag that turns up in the work Jasper Johns neither affirms nor protests.
>
> Paradox, not satire, is the aim. The object—fender, razor blade or torn nylon—does not lose its identity—it acquires an ambiguous one. . . . The combine-artist does not select and abstract from life,

he identifies his object with life. It comes down off the museum wall, gets extended into space by incorporating chairs and step-ladders. . . .

> One end-result is theatre. At the Reuben Gallery a group of young experimenters actually pursued this extension into time and space to a logical conclusion in the "happening"—assemblage plus audience participation. . . .
>
> It is difficult to document some of the intangibles that have shaped attitudes: the strong focus on "what is" coming from existentialism or the urge to create that paradoxical moment, exalted in Zen philosophy, when the real is the most unreal.[87]

Seckler ends her introduction by quoting Kaprow from the catalog for *Environments, Situations, Spaces,* the summer exhibition that had just closed at the Martha Jackson Gallery: "Among the things I have felt to be important in the conception of my work is the idea that it could be called art, or ordinary nature. I devote great effort to balancing what I do as precariously as possible on this tightrope of identities. . . ."

Balancing art and life almost served as the leitmotif for the art world in the early 1960s. To varying degrees, chance, anonymity, paradox, insignificance, temporality, and freedom were components of the new art. These values seemed to be everywhere, percolating in Japan, Europe, and California, and not just in New York.[88] But it was John Cage who seemed to become the symbol for these values and the hero for the era. Kaprow summed up Cage's role in a 1995 interview:

> Cage was more of a mentor to the arts in general [than to just music], and particularly in the art world, the visual art world, than anyone else. Certainly the dividing line between the neo–de Kooning group, which was increasingly conservative . . . and the possibility of an avant-garde . . . was inspired by Cage. Cage seemed to many of us, and certainly to me, to be offering a way out that was not nihilistic. It was philosophically positive. It emphasized all of the clichés of the day of freedom of choice. It was anti-authoritarian at a time which seemed, from our vantage point, to become increasingly authoritarian on the government level. Cage seemed to be the way.[89]

NOTES

1. In response to a question about being influenced by Kaprow, Oldenburg responded with, "I didn't live in New Jersey, and I wasn't part of the New Jersey school, of which Kaprow was the leader." Richard Kostelanetz, *The Theatre of Mixed Means* (New York, Dial Press, 1968), 138. Of the Rutgers artists, Oldenburg mentions Whitman, Samaras, Segal, and Lichtenstein. The eight artists from Rutgers were inextricably linked together as late as the mid-1970s; Lawrence Alloway discusses them as a group in *American Pop Art* (New York, Collier Books, 1974), 20.

2. For a brief history of the impact of Cage's class on contemporaneous art, see Barbara Moore, "New York Intermedia: Happening and Fluxus in the 1960s," in Christos M. Joachimides and Norman Rosenthal, eds., *American Art in the Twentieth Century* (London: Royal Academy of Arts and Prestel, 1993), 99–106.

3. There is some question about when Kaprow first entered Cage's course. Kaprow is sure it is before he and Watts invited Cage to perform at Douglass College on March 11, 1958. It is conceivable that he was in the class by late 1957, since by 1959, he had a reputation for taking the course more often than most of the students. According to Scott Hyde, Cage one day kidded Kaprow in class by offering him a lifetime scholarship for the course (Scott Hyde, telephone interview with the author, February 18, 1998). Kaprow confesses that Cage was nudging him to "graduate" in 1959 (Kaprow, conversation with the author, New York, March 3, 1998).

4. Al Hansen, *A Primer of Happenings and Time/Space Art* (New York: Something Else Press, 1965), 91–94. On a more serious note, Hansen admits that he also attended the course because "I wanted to know who to get for sound tracks for my experimental films," ibid., 91.

5. David Revill, *The Roaring Silence: John Cage, A Life* (New York: Arcade, 1992), 160.

6. For a discussion of Cage's philosophy, see ibid., 107–125.

7. Ibid., 111.

8. Allan Kaprow, interview with Joan Marter and the author, Newark, New Jersey, December 8, 1995.

9. George Brecht, *Notebooks* 3 vols., edited by Dieter Daniels with Hermann Braun (Cologne: Verlag der Buchhandlung Walther König, 1991). Brecht knew of Cage by 1951, and met him about 1956, when Cage looked him up in New Jersey after Brecht had sent him an early draft of his essay "Chance Imagery." See Henry Martin, *An Introduction to "Book of the Tumbler on Fire"* (Milan: Multhipla Edizioni), 83, 91, 148.

10. Cage called his famous 1952 Black Mountain Happening *The Event*. See Calvin Tomkins, *Off the Wall* (New York: Penguin Books), 74–75.

11. Brecht, *Notebooks*, 1:5–6.

12. Brecht uses the word "gamelan" instead of "xylophone."

13. Martin, *An Introduction*, 115.

14. Brecht, *Notebooks*, 3:105.

15. Hansen, *A Primer of Happenings*, 96. Dick Higgins describes Alice Denham and the creation of the work a bit differently. Hansen had "found three or four sets of numbers on the street all of which happened to add up to 48. He wrote them on a piece of paper in a square. In his hand he had a magazine. It had a pretty nude in it, a red-head by the name of Alice Denham. It also had a very fine short story by her." Dick Higgins, "Postface," in Dick Higgins, ed., *The Word and Beyond*, (New York: The Smith, 1982), 50–51.

16. Hansen, *A Primer of Happenings*, 98.

17. Higgins, "Postface," 52.

18. Higgins, Hansen, and Kaprow continued to attend Cage's classes from time to time through the summer of 1959.

19. This is according to Dick Higgins, telephone conversation with the author, December 12, 1997. Hansen claims that the group met on Sunday mornings. See Hansen, *A Primer of Happenings*, 103.

20. Higgins, "Postface," 52.

21. Hansen, *A Primer of Happenings*, 103

22. Ibid., 105

23. Ibid., 103–104

24. Dick Higgins, telephone conversation with the author, January 8, 1998.

25. Higgins, "Postface," 52.

26. The script or score for this work is in Dick Higgins, *foew&ombwhnw* (New York: Something Else Press, 1969), 255. Hansen's description of the performance makes it sound as though the group simultaneously presented a second work, which was similar to *Alice Denham*. A conductor rolled dice to determine which of the toy pianos, toy xylophones, or windup toys would be played and for how long, and the numbers were posted on a blackboard. See Hansen, *A Primer of Happenings*, 107.

27. Hansen, *A Primer of Happenings*, 108–109.

28. Actually, Kaprow first introduced the concept of Happenings to a New York audience on the *Henry Morgan Show* in September 1959. Kaprow was asked because he was making similar work that he was going to present the following month to launch the Reuben Gallery. Kaprow came to the television studio armed with wood, hammer, and nails to erect a small structure that he would then dismantle as part of his performance. He discovered just before the live broadcast that he was not allowed to build anything because of union rules. Without a prop and co-performers, he was hard pressed to fill his one minute of airtime, and in his panic, he forgot to mention the Reuben Gallery and his upcoming performance. Dick Higgins also performed on this same program. Allan Kaprow, telephone conversation with the author, December 3, 1997; and Dick Higgins, telephone conversation with the author, May 20, 1998.

29. For the 1960–61 season, the gallery moved around the corner to 44 East Third Street to take advantage of a street-level storefront space.

30. In part because Kaprow lived in New Jersey and often was not available, the gallery was frequently run more like an artists' co-op, with the artists and Anita Reuben and her husband determining the programming, often on an ad hoc basis. Allan Kaprow, telephone conversation with the author, December 3, 1997.

31. The importance of the Reuben Gallery was recognized by the Solomon R. Guggenheim Museum when it presented *Eleven from the Reuben Gallery*, January 6–28, 1965.

32. For example, Sidney Tillim, in the June 1960 issue of *Art News*, wrote the following about the Reuben Gallery: "Some of the noises coming from the vicinity of Tenth Street, and the Reuben Gallery in particular, with its 'happenings' and what have you, sound suspiciously like a kindergarten supervised by Alfred Jarry." Sidney Tillim, "Claes Oldenburg," *Art News* 59 (Summer 1960) 4: 53.

33. Segal and Hansen quotes from Hansen, *A Primer of Happenings*, 60; Whitman quote from telephone interview with the author, January 8, 1998.

34. Kaprow selected "Happenings" and "Environments" to describe *his* art, and he specifically chose these labels because he did not want to use words that were associated with the history of art. "I wanted to introduce value-free terms that would at least initially signify a new kind of art and then eventually no kind of art," terms that would "not evoke Shakespeare or Picasso." Allan Kaprow, interview with Joan Marter and the author, Newark, New Jersey, December 8, 1995.

35. Allan Kaprow, "something to take place: a happening," *Anthologist* 30 (spring 1959): 4.

36. The poster for the evening lists Grooms's piece as *Fireman's Dream.* The title, and probably the work as well, was changed.

37. Oldenburg based the Judson Gallery on Red Grooms's City Gallery. See Kostelanetz, *The Theatre of Mixed Means,* 138.

38. On the poster for the program, Oldenburg did not use the term "Happening" to describe any of the events. Instead, he just used the title *Ray Gun Spex,* Spex referring to the word "spectacle," or "film."

39. The title of Higgins's performance varies from source to source, including the poster, announcements, and his own later publications.

40. For brief history of Happenings and performance art, see Barbara Moore, "New York Intermedia," and Barbara Haskell, *Blam! The Explosion of Pop, Minimalism, and Performance, 1958–1964* (New York: Whitney Museum of American Art in association with W. W. Norton, 1984), 31–67. For discussions of performance that also include West Coast and international manifestations occurring about at this same time, see Susan Hapgood, "Neo-Dada," in her *Neo-Dada, Redefining Art, 1958–62* (New York: American Federation of Arts in association with Universe), 11–66; and Richard Kostelanetz, *Theatre of Mixed Means,* especially his chapters on Ann Halprin, 64–77, and La Monte Young, 183–218.

41. Hansen describes many of his Happenings in his *A Primer of Happenings,* 125–138.

42. See Heike Hoffmann, "Biographie: Life as Art. Art as a Way of Life," in Heike Hoffmann, ed., *Al Hansen: An Introspective* (Cologne: Kölnisches Stadt Museum, 1997), 230–236.

43. Fluxus has yet to be satisfactorily defined. In a 1972 interview, Brecht made the following comment about FLUXUS: "I say let it go. After all, FLUXUS is a Latin word Maciunas dug up. . . . If it hadn't been for Maciunas nobody might ever have called it anything. We would have gone our own ways and done our own things: the only reference-point for any of this bunch of people who liked each other's works, and each other, more or less, was Maciunas. So Fluxus, as far as I'm concerned, is Maciunas." Martin, *An Introduction,* 103. For a discussion of Fluxus and its meaning and history, see Simon Anderson et al., in Janet Jenkins, ed., *In the Spirit of Fluxus* (Minneapolis, Walker Art Center, 1993).

44. The Hall of Issues was a kind of social-protest bulletin board. A November 1961 poster announced that "the Hall of Issues will be open every Sunday afternoon from 2 to 5 o'clock to anyone who has any statement to make about any social, political, or esthetic concern . . . who would bring that statement, - in the form of painting or poems or posters or essays or a sentence or a sculpture or a newspaper clipping or photos or an assemblage . . . and . pin-it-tack-it-or tape-it,- hang-it-or set-it-up . . . anywhere in the hall he chooses until the space is filled, or until 5 o'clock. . . And at 6 PM on Sunday the exhibit will be opened to the public and it will be open 6 to 10 every evening Sunday thru Wednesday . . . and at 8:30 every Wednesday evening there will be a meeting so that issues can be discussed and action can originate." See H. Sohm, *Happenings and Fluxus* (Cologne, Kölnischer Kunstverin, 1970), unpaginated.

45. The Martha Jackson Gallery had already taken its cue from the Reuben Gallery when, in June and September 1960 it presented two back-to-back exhibitions called *New Forms, New Media* (I and II). The shows featured assemblages and were similar to the Reuben Gallery *Below Zero* exhibition of the previous December. Like *Environments, Situations, Spaces,* the exhibitions were partially organized by Rolf Nelson and Steve Joy, who worked for Martha Jackson and were friends of Kaprow and regulars at the Reuben Gallery. The importance of assemblage by the early 1960s was confirmed by the *Art of Assemblage* exhibition at the Museum of Modern Art in the fall of 1961.

46. Recent literature refers to this piece as *Chair Events.* See Hapgood, *Neo-Dada,* 26.

47. Martin, *An Introduction,* 87.

48. The musical association is reflected in the titles for many of the 1962 performances, for example, "Neo-Dada in der Musik," Düsseldorf, June 19, 1962; "Fluxus Internationale Festspiele neuester Musik," Wiesbaden, September 1–23, 1962; and "Parallele auffuehrungen neuester Musik," Amsterdam, October 5, 1962. In 1963, the concerts were generally called Fluxus festivals, or "Festum Fluxorum Fluxus." For a relatively comprehensive listing of Happenings, Events, and performances from 1951 to 1970, see Sohm, *Happening and Fluxus.*

49. Grooms made two films, however: *The Unwelcome Guests* (8 mm), July 1961, Florence, Italy; and *Shoot the Moon,* (16 mm), 1962, New York City.

50. Fluxus Events, which often required less preparation, coordination, and expense, as will be discussed below, continued to be popular.

51. Kaprow's Happenings changed dramatically as the 1960s unfolded. In part influenced by George Brecht, he gradually eliminated the audience as well as theatri-cal and musical devices as the works took place in nonart spaces and were executed almost privately by the performers. This change is discussed in Kristine Stiles's essay in this book.

52. Rauschenberg was included in Richard Kostelanetz's *The Theatre of Mixed Means,* along with Kaprow, Oldenburg, and Whitman. Rauschenberg and Whitman are also close friends, because of their similar interests, which also led them to found with Billy Klüver Experiments in Art and Technology, the organization that sponsored *9 Evenings.*

53. In 1960, Watts performed a twenty-seven-hour work titled *The Magic Kazoo.* It consisted of three parts—*New York City, That Night and In Transit,* and *The Sea*—and had fifteen performers, who had such roles as Prostitute, Zen Master, Delinquent, Automobile, and Crucifixion. Traveling in cars and motorcycles in New York and New Jersey, and mysteriously meeting and delivering and exchanging objects, some of which are ritualistic, some very commercial (e.g., four thousand Rockefeller campaign buttons), the participants end up on the beach in New Jersey, where they enact a mysterious ceremony on a sand altar that includes cutting the heads off of dolls while Zen Master throws darts at a target, radios play, and Delinquent and Crucifixion make a collage by pasting photographs all over Priest. It is no longer known who participated in this work. All that remains is a twenty-six-page manuscript/script/score in the Robert Watts Studio Archive, New York.

54. The program lists the painters as "Sam Francis, Red Grooms, Dick Higgins, Lester Johnson, Alfred Leslie, Jay Milder, George Segal, Robert Thompson—each of whom paints."

55. Kaprow himself draws a parallel between his work and the circus, which he often discussed with John Cage. Allan Kaprow, interview with Joan Marter and the author, Newark, New Jersey, December 8, 1995.

56. It is not until Cage worked with Rauschenberg, Whitman, and Klüver in 1966 to create *Variations VII* for *9 Evenings* that he made a total Environment with sound. Kaprow, thinking like a sculptor, had already created a sound Environment with his 1960 *Intermission Piece,* pirated from his untitled 1958 Hansa Gallery Environment.

57. All three had shown at Grooms's City Gallery, a radical downtown space that was replaced in 1959 by Grooms's Delancey Street Museum, which in turn closed at the time of the opening of the Reuben and Judson galleries.

58. For a discussion of Grooms's plays—as he preferred to call his Happenings—and

his relationship with Allan Kaprow, see Barbara Haskell, *Blam!,* 35–36.

59. For a discussion of Grooms's influence on Oldenburg and Dine, see Haskell, *Blam!,* 36. Oldenburg describes Grooms's influence in Kostelanetz, *The Theatre of Mixed Means,* 138.

60. Robert Whitman, interview with Joan Marter and the author, Warwick, New York, March 14, 1996.

61. When asked by Michael Kirby to comment on the use of the word "Happenings," Grooms gave a non-committal response: "Now to the delicate word 'Happenings.' In pre-historic times when I put on my play, *The Burning Building,* I was groping in the dark without that valuable word. Therefore, I must humbly bow to M. Allan Kaprow for the total invention of the word; and look with awe at the repercussions that it has caused." Michael Kirby, *Happenings: An Illustrated Anthology* (New York: Dutton, 1966), 120.

62. See Kirby, *Happenings,* 119–120. Grooms reveals his theatrical intent in his statement to Kirby: "What I was a kid, the big influence on me was Ringling Brothers, Barnum & Bailey, and the Cavalcade of Amusement which would roll in every year for the Tennessee State Fair. After that, I put on my own shoes in the back yard. *The Burning Building* on Delancey Street was an extension of

my backyard theatre. I wanted to have some of the dusty danger of a big traveling show. And the chicken-coop creakiness of a backyard extravaganza. And the mysteries of the operations behind the proscenium."

63. Haskell, *Blam!,* 36.

64. Robert Whitman, telephone conversation with the author, March 14, 1996.

65. Jill Johnston, "Reuben Gallery Review," *Art News,* 60 (1960) 4: 61–62.

66. See Martin, *An Introduction,* 94.

67. See the announcement for the show, illustrated in Sohm, *Happening and Fluxus.*

68. Martin, *An Introduction,* 95.

69. Allan Kaprow, interview with Joan Marter and the author, Newark, New Jersey, December 7, 1995.

70. Robert Watts's event *2″* was a favorite to start Fluxus festivals. The work consisted of cutting a ribbon in two.

71. Even a simple work such as the event card for *Exit* is extremely complicated. While it consists of a single word, and is therefore deceivingly minimal, the implications of the word are endless, suggesting a never ending interpretation and execution of the piece.

72. Robert Watts, "Yam Lecture— Oakland Version," unpublished document in the archives of the Silverman Collection, New York City. As expressed by Brecht, the "Yam Festival was an on-going series of

objects and performances." Martin, *An Introduction,* 101.

73. Perhaps the most comprehensive listing of the *Yam Festival* appears in Jon Hendricks and Barbara Moore, *Yam Festival* (New York: Backworks, 1979), a photocopy publication.

74. Martin, *An Introduction,* 77.

75. Ibid., 77.

76. Ibid., 80.

77. Henry B. Woolf, ed., *Webster's New Collegiate Dictionary, 150th Anniversary Edition* (New York: Merriam, n.d.), 634.

78. Martin, *An Introduction,* 82.

79. Brecht, *Notebooks,* 2:118.

80. See Jeff Kelley, introduction to Allan Kaprow, *Essays on the Blurring of Art and Life* (Berkeley and Los Angeles: University of California Press), 1993, xi–xix.

81. Hansen, *A Primer of Happenings,* 123–124.

82. Ibid., 85.

83. Ibid., 87.

84. Kostelanetz, *The Theatre of Mixed Means,* 154.

85. Ibid., 152–153.

86. Ibid., 123.

87. Dorothy Gees Seckler, "Start of the Season—New York," *Art in America* 49 (fall 1961), 86.

88. See Hapgood, "Neo-Dada."

89. Allan Kaprow, interview with Joan Marter and the author, Newark, New Jersey, December 8, 1995.

One of the most remarkable phenomena to occur around Rutgers at the end of the fifties was a dynamic collaboration between Robert Watts and George Brecht, a partnership between two ordinarily reserved characters that engendered a firm friendship lasting up to Watts's death in 1988. Robert Watts was in his early thirties when he met George Brecht, and had been teaching at Rutgers since 1953. Brecht, two years his junior, was working locally as an engineer at Johnson & Johnson, and here lies their first connection: Watts's first official schooling had been in mechanical engineering, and he had been an engineer in the U.S. Navy. The differences—Brecht was an inventor and research chemist—are as important as the similarities, but both men turned away from an early career in the sciences, and brought to their art a particular kind of analysis, which is visible in both separate and cooperative creative productions.

Brecht had seen Watts's work in an exhibition at Douglass College, and was sufficiently impressed to telephone and invite him to a show of his paintings in New Brunswick. The two men then met weekly, and, over lunch at Howard Johnson's, they dreamed up a number of fascinating projects across a wide range of activity, between them generating ideas that played a vital part in the cultural revolution of the 1960s.

Their combined efforts helped to create a community, and cemented some long-term affinities within the experimental arts. A number of the artists they included in the *Yam Festival* of 1963 reappeared together the following year at the "Monday Night Letters," a weekly series they organized at New York's Cafe à Go Go. The participants in these evenings of music, events, happenings, lecture-demonstrations,

LIVING

IN MULTIPLE

DIMENSIONS

—

GEORGE BRECHT

AND ROBERT WATTS,

1953–1963

—

SIMON ANDERSON

dance, and indescribable intermedia amount to a roster of American Fluxus, with a number of additions from the spectrum of the New York avant-garde.

The Festival was conceived as an extended performance, taking place in the New York area beginning in May 1963—thus creating a priceless pun that typified the spirit of their intent ("May" being "Yam" spelled backward). More ambitious than a straightforward series of actions and events, *Yam Festival* was a long and multifarious celebration: it lasted, according to Brecht, about two years; "the idea was . . . to keep things going. Everybody who wanted to could contribute."[1] As with their other collaborations, *Yam Festival* was more than simply an administrative convenience. They took on and mixed a number of forms; acts of imagination, visual innovations, creative design and straightforward organization. *Yam Festival* was a potent, amusing, and clever idea that helped to produce unique forms of art, but that must have also required a good amount of the kind of logistical activity that many of us call work.

It was generated partly at the invitation of Bob Whitman, who had been chosen to curate an exhibition; the show never happened, but Watts and Brecht developed *Yam Festival* into a multitude of jokes, surprises, games, lectures, mail-order art, and simple occasions made festive by a gathering of like minds in playful mood.

Yam Festival activities included *Water Day, Box Day, Clock Day*, and two days of a *Yam Hat Sale*; there were openings, poetry, performance, exhibitions, and parties; there were tournaments offered daily, with intermissions and prizes (fig. 65). Information on this miscellany was spread by a

FIGURE 65
Al Hansen auctioning a hat by Joe Jones from the Smolin Gallery, New York as part of the *Yam Festival,* May 11–12, 1963. Photograph © 1963 by Peter Moore.

printed calendar, whose disjointed graphics are typical of Brecht's design. It featured advertisements for *An Anthology* and *Fluxus I* amid a lively plethora of event scores and jokes. *Yam Day* itself consisted of an endless and continuous program of performance beginning "about noon on Saturday through evening and Sunday."[2] This marathon was advertised as featuring the work of a wide and international array of artists, with events by a spectrum of Fluxus associates from Mac Low to Maciunas. There was an afternoon of Happenings, music, and dance at George Segal's farm with a roster that presents a new slant on artist affiliations in the early sixties. Dick Higgins, Wolf Vostell, and La Monte Young, all fellow Fluxists, were joined by Allan Kaprow, Yvonne Rainer, and sculptor-dancer Chuck Ginnever. This concert-picnic was presented by the Smolin Gallery, which chartered buses for the trip to South Brunswick.

At one point the *Yam Festival* involved Watts in a two-hour "presentation" at a symposium on primitive and contemporary art at Michigan State University. This *Yam Lecture* was a variation on an already flexible frame: two readers picked random texts from envelopes while a disconnected series of images was projected onto a wall.[3] Watts himself described the *Yam Festival* as a vehicle that involved a range of "material that ordinarily is not so directly useful for art or has not yet been so considered."[4]

One important aspect of *Yam Festival* was the subscription event, a mail-order artwork in which a sometimes unknown and randomly chosen audience was offered an unspecified object in return for a self-chosen amount of money (fig. 32). This participatory program, titled *Delivery Event*, involved a range of things that give a considerable clue to the joint interests of the two organizers: food, pencils, soap, photos, actions, words, facts, statements, declarations, puzzles, and so on. It is a poetic list that includes household articles of the most mundane, even prosaic kind; the very stuff of "life"—if and when one has chosen to separate Art from Life. That Brecht and Watts both saw a need to deliberately but purpose-lessly erase this theoretical fracture is one clue to the longevity of their collaboration—if not their longer-lasting friendship—and a certain hint at their involvement with another mail-order catalog, *Fluxus*.

These shared enthusiasms can be better understood in light of their individual approaches to art making and their relationships to the art object. Since the mid-1950s, Brecht had been educating himself and writing an unofficial dissertation on chance imagery (later published as a Great Bear Pamphlet by Dick Higgins), while Watts experimented with mark making. These interests were to lead both men to the margins of Abstract Expressionism, and in the case of Watts, to an early association—at least in the minds of some art critics—with Neo-Dada.

After World War II, Watts switched from engineering to the arts, and enrolled at the Art Students League before moving on to Columbia University, where he studied art history. His experience left him with an interest in Aboriginal culture, particularly Inuit art, and this attention is reflected in the stark lines of his mostly monographic abstractions. His early work had consisted of hybrid abstract paintings, and had often included nature studies; there are, for instance, birds portrayed in a series of small paintings using a calligraphic style that distorted them and could not help—given the era of their production—but be identified with trends then current in American Abstract Expressionism.

By 1956 Watts had begun to experiment with cut-up paintings and seemingly random collections of imagery, but around 1958, he shifted from abstract painting to sculpture and assemblage. By 1959–60 he was building with found objects and assembling ersatz machines: *Monuments* (see fig. 66), for instance, was a series of sculptures consisting of found objects and texts embedded in plaster, sometimes acting as maquettes for very large proposals. After he experimented with these, and with a series of mechanical toys—he had shown evidence of technical ability at an early age—his artistic boundaries widened exponentially to include film, events, and Happenings; the whole range of possibilities open to the intermedial artist. Within this range, however, can be seen a recurrent tactic; he subjected materials to a succession of fantastic or seemingly inappropriate processes, and thus discovered a potential for new and surprising objects or events. Furthermore, Watts's investigations across all media were always colored by his playful view of the world, which

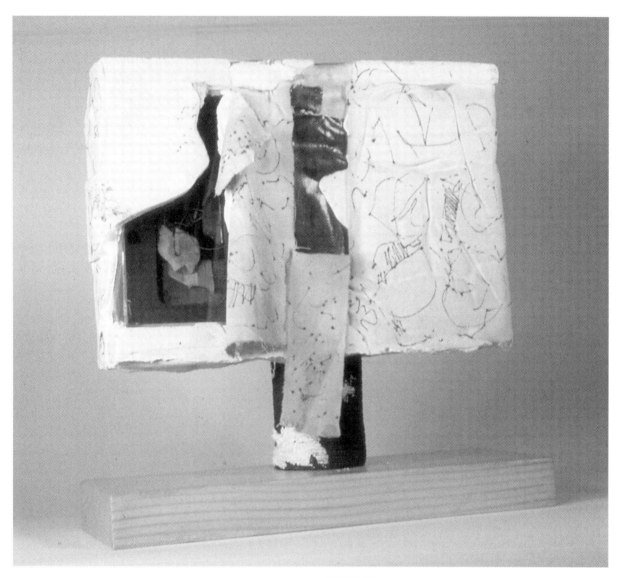

FIGURE 66
Robert Watts, *Model for Monument,* 1960.
Ink and paint on plaster castings and cloth with embedded metal foil, glass, string, ribbon, mirror, metal button, and photograph.
11 1/2" x 12 1/4" x 4" (without base)
Collection of the Robert Watts Estate, New York.
Photo courtesy of The Robert Watts Studio Archive, New York.

inevitably led to comparisons with Dada—the previous explosion of anarchy and irony.

Throughout the 1960s a majority of reviews of Watts's exhibited work relied on the unhelpful but vaguely familiar term "Neo-Dada." It was almost universally so labeled from the first exhibition in the winter of 1960. Like those Dadaists who saw too clearly the follies of their age, and who exposed them

with a laugh, Watts was often misunderstood; "barely transformed rubbish," wrote one cruel journalist, later adding for compensation that Watts did, at least, construct "authentic" examples of the genre.[5] A couple of reviews of his show at the Grand Central Moderns Gallery mentioned his *Goya's Box* (fig. 67) in a favorable light. This small sculpture featured postage stamps illustrating Goya's *Naked Maja,*

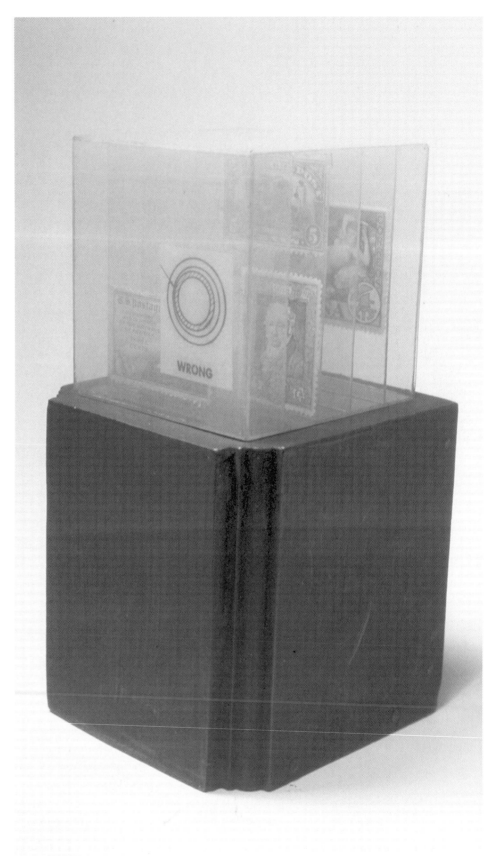

FIGURE 67
Robert Watts, *Goya's Box,* 1958.
Plastic, wood, electric light,
postage stamps, printed matter.
6" x 3 1/4" x 3 1/4"
Spanish issue of
Goya's *Naked Maja*
and U.S. issues of
Whistler's Mother
and "Mail Train."
Collection of the Robert Watts
Estate, New York.
Photo courtesy of
The Robert Watts Studio Archive,
New York.

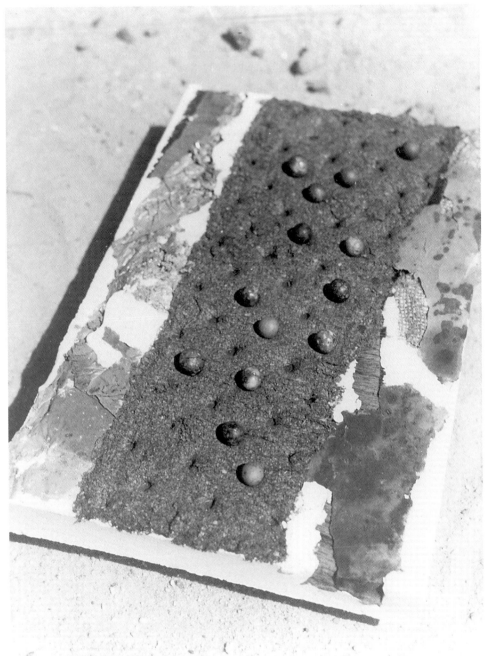

FIGURE 68
Robert Watts, *Game*
(or *Game without Rules*
or *Marble Game*), 1960
(exhibited at Grand Central
Moderns Gallery, 1960).
Plaster, marbles, metal foil.
13 1/16" x 15 1/2" x 10"
Collection of Letty Lou Eisenhauer.
Photograph courtesy of
The Robert Watts Studio Archive,
New York.

among other miniature graphic items, revealing Watts's lifelong interest in aspects of philately, and offering a hint of his later importance to the history of correspondence art.

His early, often kinetic, sculpture elicited comments on his very evident technical ability, whether or not critics agreed on his use of that talent. One, for instance, praised him as an "entertainer," and while the *New York Herald Tribune* agreed that his work was "uproarious," their reviewer later described it as "rooting onlookers out of any attitudes of complacency they possess, and showing that art galleries needn't be the solemn places they are supposed to be but on the contrary repositories of great curiosity."[6]

Certainly, Watts's own mechanical and philosophic curiosity prompted his visual and formal investigations, fields of inquiry that transformed and

remade simple ideas into extended multilayered themes, seen most clearly, perhaps, in his uses of light.

Watts's grandfather ran a movie theater, for which, as a child, the artist made his first graphic works, and it was there that he gained his interest in light: "I used to make advertising slides for the movie house and it was thrown onto the screen with the 'magic lantern,' the projector. It was just unbelievable—no kidding—huge and very bright light. Very interesting."[7] He began experimenting with light again around 1957–58, in a collage with randomly activated decorative lights, which were then a novel Christmas item. His continuing use of electricity can be seen in *Hot Sculpture* (1960) (plate 27) which contains a wire heated to red hot, along with mirrors, and stuff embedded in plaster.

He used reflected light again in *Marble Game* (fig. 68), where light played off metal foil; and this early impulse to reflect continued with his famous collections of chromium bread, fruit, vegetables, and chocolates (fig. 69 and plate 28), shown most appropriately in the delicatessen-style exhibition *American Supermarket*, held at the Bianchini Gallery October 6–November 7, 1964, where he offered reasonably priced multiples—part of a large series of cast objects, mostly food. The frisson provoked by chrome stayed with Watts almost to the end of his life and is seen most notably in a series of Ashanti sculptures replicated in chrome. Producing them generations before Koons's seaside caricatures, Watts was able to protest and make personal issues out of cultural pretension, consumerism, and

FIGURE 69
Robert Watts, *Box of Eggs,* 1963.
Chrome plate on metal.
13" x 8" x 5 1/2"
Collection Leo Castelli.
Photograph courtesy of the Robert Watts Studio Archive, New York.

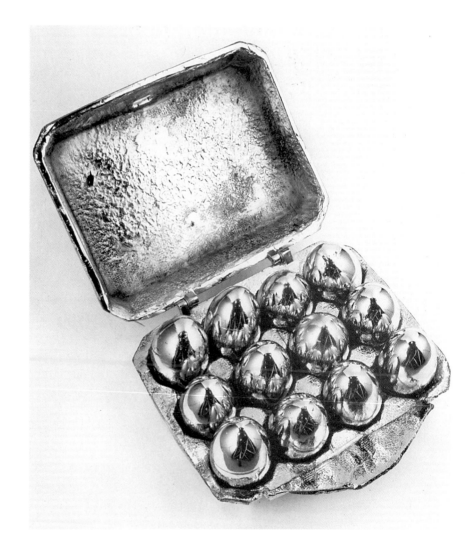

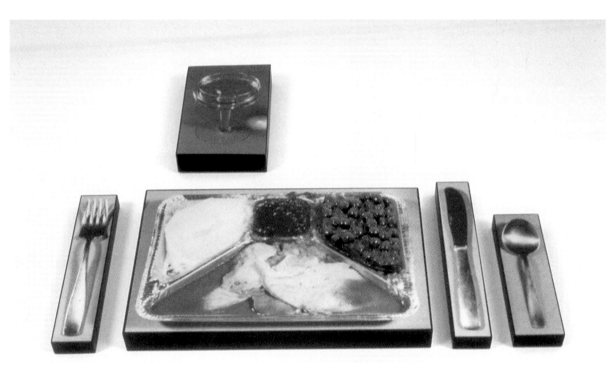

FIGURE 70
Robert Watts, *TV Dinner*, 1965.
Photograph laminated on wood, plastic cast.
1 3/8" x 20" x 11" overall, installed.
Collection Walker Art Center, Minneapolis,
T. B. Walker Acquisition Fund, 1993.
Photograph courtesy of The Robert Watts Studio Archive,
New York.

coca-colonization, which collide in a symbolic fetish wherein observers can literally reflect on their own situation in the surface of the object.[8] His repeated use of food as a motif also often amounted to social comment: his eerily beautiful *TV Dinner* (fig. 70) is an indictment of the twentieth-century isolation of individual life, whose solitary, illusory, and ultimately inhuman units arrogate for themselves the luxury of civic grouping.

It may be true, as has been suggested, that his preference for reflective surfaces was partly stimulated by the mischievous challenge it offered to photographic documentation,[9] and if indeed his intent was as much subversion of commodification as it was celebration of illumination, then it merely emphasizes a continuing thread throughout his oeuvre; from fake pork or lamb chops to *Fluxstamps* (plate 29), and from "Implosions" to *Yam,* Watts knowingly played with the many-faceted conventions of commodity and

distribution: the egg is surely the original multiple, yet selling red-white-and-blue-flocked eggs—by the dozen—in a contemporary art gallery reaches deep into questions of social organization.

Perhaps less deliberately, Watts's use of chrome reflected real variety into his palette, which was largely monochrome and otherwise naturally muted or colored by industrial design. After his mostly black-and-white paintings, he moved into sculptures in which color was often totemic, like the aforementioned eggs in national colors. While hardly the mark of a colorist, this was a presciently Pop solution, with obvious American connotations that appealed to Watts—who made early use of other Pop icons, such as brand names, neon light, and fast food. Works such as *Great American Lover* (1963) (fig. 71) only confirm Watts's inclusion into the canon of early Pop.

As if to confirm his connections with the Pop world, he tried, in vain, to gain legal control over the

word itself, but soon afterward he cut loose from the stable, into the dark underbelly beneath those bright and sexy consumer-friendly art forms such as Pop, Op, and Kinetic art. He forms part of the sinister band who shadow the sixties of media memory: like Wolf Vostell, Ray Johnson, Gustav Metzger, and La Monte Young, among others, who carried the issues celebrated by Pop into unpopular areas less suitable as advertising for American-style capitalism, Watts took on the commodity fetish with subtle wit and savage gusto, which he combined with the thoroughness of an engineer.

His play—like that of Brecht—involved the multilayered use of humor in many forms; from the comically surreal to the slyly ironic. He was not above the vulgarity of the sight gag—as can be seen in the witty series of photographic illusions on a dinner theme—and his equally weird sense of slapstick endeared him to the heart of Fluxus. His *F/H Trace* of 1962—in which the bell of a French horn is filled with small objects or fluid, spilling to the floor when the soloist performs the customary preliminary bow to the audience—has became a concert classic; one of those select events whose hilarious simplicity and bold intermedial exchanges has enabled them to be remodeled to suit the variable occasion. Maciunas had early taken to Watts as a result of some correspondence pieces they exchanged while the former was in Germany. Watts sent the ever sickly Maciunas "get-well" postcards—embedded with

FIGURE 71
Robert Watts, *Untitled (Great American Lover),* 1960.
Fabric, lightbulbs, plastic, ball bearings, Plexiglas box.
9" x 12 1/16" x 2 1/2"
Collection of the Robert Watts Estate, New York.
Photo courtesy of The Robert Watts Studio Archive, New York.

FIGURE 72
Robert Watts, *Star Chief*, 1962.
Pontiac dashboard with working radio, speedometer,
and so on, altered by the artist. Location unknown.
Photograph courtesy of The Robert Watts Studio Archive,
New York.

toy-size explosives—and thereby launched a sporadic collaboration that saw the publication of many varied editions by Watts, including a business partnership, "Implosions," whose line of temporary tattoos have again become a fashion item in the 1990s.

Part of Watts's power lay in his ability to playfully combine scourging wit with razor-deep cuts of profundity, and he brought to this combination an unique and appealing aesthetic. From the fully operative automobile dashboard of *Star Chief* (1962)

(fig. 72), to the literalist reading of a feather dress (*Feather Dress* [1965]), and from the neon-light artist-signature series to his many illusory laminated photo-objects, Watts happily subjected seemingly random objects and ideas to the precise and thorough machinations of his playful imagination.

In the anonymous works for Sissor Bros. Warehouse (fig. 73) he formed part of a trio that out-Fluxed George Maciunas's contemporaneous efforts at collectivity and alternative commodity distribution.

FIGURE 73
Robert Watts, George Brecht, Alison Knowles, and Letty Lou Eisenhauer
modeling their installation for the *Sissor Bros. Warehouse* exhibition, 1963.
Later shown at Rolf Nelson Gallery, Los Angeles.
Photograph © 1963 by Peter Moore.

Not only was Watts subjecting his identity to the eponymous corporation—along with Brecht and Alison Knowles—but all the goods upon which they silk-screened their tripartite design were generally cheap and industrially made. The mass-produced quality of the objects is disturbingly complementary to their standardized treatment. A wide range of ordinary things, from bijouterie to tool chests, were overprinted with an anonymous and chance-produced assemblage, and then sold for little more than their street value. The coordinator of the warehouse project, the dealer Rolf Nelson, was even quoted as claiming, "We'll take orders—stencil anything anyone wants with BLINK." The stencil he referred to consisted of a square with three discernible strata. Across the top, Watts had contributed a photographic image of seminaked celebrants at a Balinese wedding, replete with esoteric tattoos. Alison Knowles—

principal printer of the three—occupied the lower register of the yellow cube with three scissors in gradual stages of opening, and Brecht's event score *Blink* provided a meditative hiatus between them. *Sissor Bros. Warehouse* also included a variegated advertising flyer reminiscent of *V TRE* and the *Yam Newspaper.* Combining the classic Fluxus characteristics of collaboration, randomness, humor, and antiart irony, the show was at first labeled "a protest that could well end all protests." In the conclusion to the piece containing this remark, however, reviewer Art Seidenbaum admits that the protest here was "more obscure" than the issues he imagined they were against.[10]

In reality, Watts was hardly obscure: cryptic maybe, but rarely was his work designed to disappear into the background. George Brecht, on the other hand, has described his ideal event as coming close

to a natural occurrence, as *BLINK* exemplifies—effectively erasing the difference between artwork and happenstance. Certainly, he started his inquiries from the singular position of not caring whether they did or would ever constitute "art," yet the result of his endeavors—especially the "natural event"—is exactly that of endowing the insignificant with a range of new, even meaningful possibilities. His cavalier attitude to the status of his works extends to many other conventional concepts, a rejection of the limitations that he feels attach themselves to things and ideas already named: as he has admitted, he prefers to have "all the possibilities" of life remain open to him.

Brecht has made his disdain for history clear on many occasions, pleading a poor memory, or arguing that any individual's contemporary research on the spot is better than academic inquiry. He has, for instance, at least three different published places of birth, including the poetic "Halfway, Or.," whose qualified ambiguity points to the fact that all memory is essentially fictional. Both artists seem to have reinvented themselves consistently through their lives, and both have celebrated the constant flux of duration in their art, but Brecht appears to have additionally refused to see the value of the conventional kind of fact gathering that generally accrues to artists of his stature. Like fellow Fluxartist Eric Andersen, among others, he cares less—or seems to—about the actuality of his past than about the range of possible ramifications of the kind of ideas he was having, or is now having. The only notebook he cares about is the one next to his table, now. This has not prevented the publication of his notes, but it has made him an evasive interviewee; one who seems often to dissemble or obfuscate, although it is more likely that he strives to reemphasize the fluidity of experience, the fickleness of remembrance, the arbitrary nature of circumstance.

By 1958, Brecht had begun to see his life as a series of interactions with the uninterrupted connectedness of the world, rather than as a set of specific occurrences, itemized by date. Later wishing to see over and through the predictable system of scientific—at least, numeric—order, he rewrote the calendar in terms of individual experience. The ubiquitous universality of his arrangements, for example, *Day of the Bird,* are—as in our present calendar—equaled by their arbitrariness, which may well be the point.

The period circumscribed for the Rutgers group marked a tremendous period of change for Brecht; in his official career as a chemist, as well as in his personal life, the kinds of advances that are seen in his work are visible in outline. Between his 1953 move to Johnson & Johnson, where he began as quality control engineer, and his departure for Europe in the middle sixties, Brecht had revolutionized his ideas about art, and the way he should be in the world. Allan Kaprow has recalled that Brecht's habitat changed markedly within the space of three weeks: from benign suburban to bohemian stark, and it was around the same time that he engineered a part-time position at work, a freelance consultancy with built-in time for research—study that was to became a philosophical experiment on his life. This time marks a particularly expanded and expansive manner of thinking for him, when the several directions of his conceptual life ran parallel enough for there to have been fascinating interchanges between these normally separate modes of thought. His knowledge of the history and philosophy of science was easily parlayed into the sphere of music, and thence art, where his explorations in chance, fueled by science but colored by Zen Buddhism, led to new developments in performance art. Although he described himself as having "survived" an education in chemistry, an experience that it apparently took him six months in Mexico to overcome, he was able to assimilate his interests in science with these other concerns, and use them productively.

At the time of Brecht's first connection with Watts, he was living in New Brunswick with his wife and child, working as a chemist, immersing himself in history, philosophy, and art, and making paintings that were almost textbook exercises in chance imagery. They were produced by dripping paint over crumpled paper, which he smoothed out and over-painted according to his taste. He described these as "corrected abstract expressionism," but then, "in 1955, in the summer, while lying on the beach in Atlantic City, it came to me that starting with

LIVING IN MULTIPLE DIMENSIONS

dripping was ended. And what to do. I started a notebook of possibilities of making works by other chance methods."[11]

Soon, in collaboration with Watts and Allan Kaprow, he was to give shape and form to this search, in a collaborative text titled "Project in Multiple Dimensions."

"Project in Multiple Dimensions" was a grant application jointly proposed by the three men; written sometime between 1957 and 1958, it is a ten-page document that lays out a case for support of "an examination of contemporary technological advances for the purpose of discovering new forms for creative artistic expression." The text includes, apart from a budget, an introduction to the very notion of new areas of art activity; a schematic explanation of the avant-garde; thoughtful personal statements from each artist; and a proposed six-month concert and event series, with an individual event offered by all three. The "Proposed Program" was rather vague, with repeated use of the embryonic term "event"; but the budget was precise, including an amount for lumber and welding supplies. One-third of the total was for individual reimbursement, and another third for publicity and printing costs.

As an application, "Project in Multiple Dimensions" was not a success, although in 1964, Watts was to prove successful in gaining a Carnegie Foundation award for a course at Douglass College. On behalf of Rutgers University he was awarded fifteen thousand dollars toward a course that would encourage new kinds of research into new kinds of art. "Project in Multiple Dimensions" surely provided the seeds for this venture, and additionally the document represents an informed and careful analysis of experimental art and art education at the time.

In places, "Project in Multiple Dimensions" has the air of a Futurist manifesto: using lists, comparisons, and appeals to technology; like Marinetti, Russolo, et al., they declared a search for materials and methods that had yet to become available to artists. The phraseology is somewhat corporate—referring to people as "the human organism," and yet despite its occasionally earnest tone, the document is prescient in parts, arguing, in the introduction, for experimental sound productions

that have subsequently begun to occur. The enigmatic language in the section listing examples of these new concepts might almost be read as presaging the concerns of dematerialized art, situationist Happenings and Land Art, with references to new and unexplored forms of "non-space," "synthetic space," and "natural space."

The section titled "Background" continues in an idealistic vein, reflecting a celebration of the hegemony of American capitalism. Displaying feelings of liberation from the bondage of European cultural standards, the rebellion implicit in "Project in Multiple Dimensions" typified an element of the postwar American experience: there was a "loosening of forms" across a wide social front. The three artists argued that daily experiences had become fragmented, and that there was widespread trans-formation of thinking and acting, giving as one example the recent change in newspaper design, whose traditional regular columns had been replaced by "asymmetrical groups of type" in no apparent order. Given that Brecht was to first make a collaged newspaper for the *Yam Festival* with Watts, and then go on to create another *V TRE* newspaper for himself and thence for Fluxus, it is perhaps no surprise that the daily-news analogy should be used to illustrate a journey from restrictive rationality to the chaos of modern collage. The fate of *V TRE* was to mirror this modernist analogy, slowly shifting from a random collection of astonishing tidbits to a performance catalog of efficiently modular design. The newspaper additionally represents a continuation of Brecht and Watts's interests in ephemeral experience and quotidian popular culture; concerns shared by Kaprow, of course, who wrote in the "personal" section of the piece that he "proceeded from the everyday situation rather than from art."

This third section of "Project in Multiple Dimensions" contains three texts that reveal one more shared trait: a struggle to name their art. Kaprow's detailed description of the elements within his Happenings—what he called "some kind of synthesis of elements that belong to several arts," is ultimately reduced to negativity; "there is no 'script' or 'story,' no 'dance' score, no 'set,' no 'music,' no 'stage,' no 'audience' really." Watts, also, was clearly

searching for an appropriate term with which to describe his activities: in anticipation of Dick Higgins's exquisite appropriation of the term "intermedia" he assembled his varied interests as an "exploration of various time-space-movement situations through the use of both electro-mechanical devices and selected synthetic and natural materials." Brecht, perhaps influenced by his growing interest in Zen, manages to be specific and yet say little: "My art is the result of a deeply personal, infinitely complex, and still essentially mysterious, exploration of experience. No words will touch it."[12]

As early as June 1958, Brecht had evidenced a fascination with Buddhist views of the world, and no doubt his interest in Eastern thought was stimulated further by John Cage's affinity for the teachings of Dr. D. T. Suzuki. Both Kaprow and Brecht had attended Cage's classes at the New School for Social Research, where Cage most probably advertised Suzuki's lecture at Columbia University in September 1958. Brecht made a note of it and it may be that he went to listen to him. In an article for *Evergreen Review* in 1958, titled "Aspects of Japanese Culture," Suzuki had written very clearly about the alogical nature of understanding, and the uselessness of rational interpretations of existence, positing a proposition that may have appealed to Brecht: "Life itself is simple enough, but when it is surveyed by the analyzing intellect it presents unparalleled intricacies."[13]

In this article, Suzuki also makes comments that surely have some bearing on the shape of Brecht's earliest event works, particularly *Water Yam*, the collection of event scores that he produced for *Yamfest*, which were published as one of the first Fluxus editions. Not only did Brecht acknowledge the importance of pure intuition as a creative force in some of the scores, he later admitted to not necessarily understanding all of his work. Other pieces, including solutions to real problems, occurred to him in dreams.

Although his ideas, according to one interview, "just come, without motive, without any reason, without logic,"[14] it might be possible to trace the genesis of one particular event; *Two Durations* (fig. 74), through some of Suzuki's comments.

TWO DURATIONS

● red

● green

FIGURE 74
George Brecht, *Two Durations* (1961).
Photograph by Dan Dragan.

"One of the commonest sayings in Zen," he wrote, "is 'Willows are green and flowers are red.'" By this he meant that facts of experience are to be accepted as they are, neither positively nor nihilistically, although "when he says that the willow is green and the flower is red, he is not just giving a description of how nature looks, but something whereby green is green and red is red. This something is what I call the spirit of creativity."[15]

Prior to this, his notebooks for Cage's class reveal that Brecht had been toying with durations, indicated by flashlights, showing green and red light. By the time of *Water Yam*, however, the durations were registered simply by the names of the colors: "Red" and "Green." This represents a shift away from the imposition of a particular experience upon the audience to a text that is little more than an invitation to the universe of possibilities—as Brecht put it—that any individual audience member might choose.

Whether or not he had read Suzuki, and whether or not he consciously applied what he saw in Cage to his own ideas—for it is quite evident that he and Cage are very different kinds of artist—Brecht, in the years he was associated with Watts, helped to forge the medium of the event as a site in which the individual could find a universal, or through which the universal could be individualized.

CANDLE-PIECE FOR RADIOS

1. There are about one and one-half times as many radios as performers. The radios are placed about the room and turned on at lowest volume. A stack of instruction cards from a shuffled master-deck is dealt, face-up, at each radio.

2. The room lights are turned out. (Birthday) Candles are lighted and given to the performers, each of whom places one candle by each of the instruction card stacks. After doing this, each performer finds himself at a radio. He performs the instructions given on the top card, places the card at the bottom of the deck, and proceeds to another, unoccupied, radio.

3. Each performer, then, finds himself performing a card instruction and going to another radio. He does this until he finds either that a card is unreadable, or that the candle at a radio is out completely. In either event, he turns off that radio, and, when no more radios are available, returns to his seat.

4. Instruction card notation is as follows:
Pause 3 means pause for a slow count of 3.
Volume up means raise volume to audibility.
Volume down means lower volume as far as possible without turning the radio off.
R and L apply to tuning changes, R-3 meaning right about 3 cm. on the dial, L-5 meaning left on the dial about 5 cm. If the direction brings the dial indicator as far as it can go to the end of the dial, then the distance remaining is to be made up in the opposite direction.
1/2sec(ond), applied to volume or tuning changes, is a convention denoting the shortest practical duration.

5. The instruction card universe is constructed as follows:
a. An equal number of cards of type I and II are made up.
b. Type I follows the form:
"Pause (0-9), vol up 1/2sec, (L or R) (1-9), vol down, pause (0-9)."
Type II follows the form:
"(L or R) (1-9), pause (0-9), vol up 1/2sec, vol down, pause (0-9)."
There are an equal number of L and R cards of each type. Numerical values in parentheses are chosen from the indicated range, using a table of random numbers.

George Brecht
Summer, 1959

FIGURE 75
George Brecht, *Candle Piece for Radios* (Event score), 1959. Photograph by Dan Dragan.

In *Two Durations*, for instance, the open structure of the event score makes the piece portable, flexible, open to modulation and transformation. No longer is the redness of red limited to the feeble power of a flashlight, but to the richness of the human imagination. It can be experienced everywhere and anywhere, from traffic lights to botanical gardens; from museums to the dinner table: in a 1972 Fluxus concert, Takehisa Kosugi indicated the pair of elements by drinking red wine and eating green salad.

Two Durations offers a salutary example of Brecht's ability to synthesize, or rather correlate, thoughts, instead of simply analyzing them or subsuming them in larger concepts. For Brecht, whose position, as already noted, stemmed from Asian ideas almost as much as from Western science or philosophy, duration was both infinitely measurable and simultaneously unknowable from outside. His early versions of *Drip Music* were painstakingly calculated, using burettes and other such scientific devices; as with *Two Durations*, the score was later distilled almost to a pure—though not necessarily platonic—essence of water, musically accumulating in one's choice of situations. Like the philosopher Henri Bergson, perhaps, whose meditations on time are so crucial to any grasp on Fluxus, Brecht realized that such "off-the-peg" concepts as are provided by language will always be insufficient to describe the continuous flow of internal duration. Brecht, in switching from the calculated measurement of time, matter, and space to a metaphysical understanding of duration, experience, and intuition, gave the minimal gestures of the event a potential for enormous personal effect.

This shift became evident in formal terms; at some point between 1959 and 1962, during the production of *Water Yam,* Brecht managed to slough off most if not all excess content in his work, leaving only the minimum necessary for delivery. Initially, around 1959, he had created event scores such as *Candle Piece for Radios* (fig. 75), a printed text that necessitated complex notation devices and enumerated explanations; Brecht himself admitted that it generated too many instruction cards. Like a recipe, the score offers precise instructions, arriving at strict mathematical randomness, and making evident Brecht's scientific training. Just as Kaprow's earliest Happenings are characterized by deliberate inversions of his own exact analysis of the work of art—randomly juxtaposing generic activities from ideally envisioned and discrete concepts such as "life,"

"play," "work," and so on—so Brecht used the sharp and accurate tools of science to construct a scrupulously indeterminate music:

"In the Spring of 1960, standing in the woods in East Brunswick, New Jersey, where I lived at the time, waiting for my wife to come out of the house, standing behind my English Ford station wagon, the motor running and the left-turn signal blinking, it occurred to me that a wholly 'event' piece could be drawn from this situation."[16]

In the summer of 1961, he was still playing with complex orchestration, as in *Mallard Milk* (fig. 76), a collaboration with Dick Higgins—who provided a marvelously poetic and evocative libretto for Brecht's sound score. Requiring players to wield toys and common objects in addition to their chosen instrument, he further elaborated a complicated

FIGURE 76
George Brecht, *Mallard Milk,* 1961.
Photograph by Dan Dragan.

MALLARD MILK

Sound-score: G. Brecht

There are three players and a reader.

Each player has three instruments: a conventional musical instrument, a toy, and a common object or set of objects.

Each player selects, by a chance method, one of the following counting schemes : 1-3-5, 1-5-3, 3-1-5, 3-5-1, 5-1-3, 5-3-1.

A player's performing (by the first counting scheme, for example) comprises: counting to his age in years by units of 1, followed by the making of a sound with one instrument; counting by 3's to the multiple of 3 nearest his age and making a sound with a second instrument; and counting by 5's to the multiple of 5 nearest his age, then making a sound with the third instrument.

At a signal, the performance begins, each player performing as above. The reader is silent until the first sound made by a player, at which time he counts to either 2, 4, or 6, and begins reading.

(Summer, 1961: gb)

mathematical scheme involving some undefined chance procedure and the performers' age. Earlier that year, however—according to the skeletal dating system of *Water Yam*—he had honed the event to a monosyllable, in one of his most enduring works; *Word Event* (fig. 77). There is a contrast between these almost contemporaneous works; *Mallard Milk,* like its predecessor *Motor Vehicle Sundown* (fig. 63), adopts a strict system and a sharp tone to ensure the best attempt at chance: the planned escape from intention requires an elaborate score. The laconic *Word Event,* however, with its bulleted "EXIT," offers the absolute minimum: a single word.

Paradoxically, this Spartan form manages to contain a very high degree of inevitability. Everyone exits: it may be done badly, but it can't be done wrong. The exact nature of each replay of *EXIT;* how, when, and why each performer completes the piece, is, of course, an entirely aleatory matter, and whether it is noticed, applauded, or even consciously rehearsed, the artist has succeeded in freeing himself from the burden of intent, using the most limited structure imaginable.

Brecht's contribution to the genesis of Minimalism should not be understated. Despite his claim never to have studied Latin, the motto *multum in parvo* appears in his notebook of spring 1959, and, in an even earlier, more formal setting, he had written, "The primary function of my art seems to be an expression of maximum meaning with a minimal image, that is, the achievement of an art of multiple implications, through simple, even austere, means."[17] Another facet of this drive toward nothing is the spare, formal presentation of his ideas; *Water Yam,* for instance, is usually published as a plain box of white cards, with instructions or event scores simply printed in the condensed sans serif font favored in early Fluxus publications.

The majority of events in *Water Yam* tend to be terse, even to the point of impenetrability: *Concert for Clarinet* offers a single word, "nearby," and *Concert for Orchestra* simply consists of a mysterious and parenthetic "exchanging." Other scores vary from brief lists to short statements that seem to be instructions. The lists—often bulleted and carefully placed upon small cards according to precise designs

WORD EVENT

● EXIT

G. Brecht
Spring, 1961

FIGURE 77
George Brecht, *Word Event (Exit),* spring 1961.
Photograph by Dan Dragan.

by Brecht, are presumably activities to perform or notice. *Water,* for instance offers only the following possibilities: coming from, staying, going to. *Piano Piece,* however, assumes an act. Brecht has himself performed this as a simple gesture, placing without stopping, yet the deceptively simple score, "a vase of flowers on [to] a piano," carefully omits any firm directive. This economical form was deliberate, and entailed an increasing level of enigma in formal terms; as he acknowledged in a 1970 statement, later events became "very private, like little enlightenments I wanted to communicate to my friends who would know what to do with them."[18]

Privacy prevails with Brecht, although he remained in sporadic but friendly contact with Watts until the latter's death. His gradual shift into

seclusion did not begin until the later 1970s, after a number of fascinating collaborations; including with Maciunas, on *V TRE,* one among a proliferation of Fluxus publications; with Robert Filliou in the cosmic experiment that was "*La Cedille qui Sourit*"; and with Patrick Hughes in a playfully serious investigation into paradox as a phenomenon.

Similarly, Watts played well with others; apart from numerous group exhibitions such as his 1964 show with Richard Artschwager, Christo, and Alex Hay, at Castelli; and aside from his copublication with Maciunas on a wide selection of Fluxus objects and multiples, of necessity he cooperated with the number of craftspeople needed to produce such a rich diversity of art. Later, he was to co-edit an anthological report with Edmund Carpenter, Christopher Cornford, and Sidney Simon, documenting a yearlong experiment in pedagogy. Published in 1970 as "*Proposals for Art Education,*" it is an exemplary study of creative collaboration between artists and art students.[19]

The careers of Brecht and Watts developed separately, although sometimes in parallel through Fluxus or European gallerists more sympathetic to ephemera. Watts remained an experimental and effective teacher, and an inspiration, through the international postal network of the 1970s and 1980s. Brecht, turning to the production of marvelous objects, redefined his entire oeuvre as an imaginary text, "*The Book of the Tumbler on Fire.*" Theirs was neither a deliberate nor a heroic partnership—Brecht and Watts were not the pioneers of postmodernity, roped together on the slippery slopes of intermedia. Rather, their concerns were revealed as a playful kind of inquisitiveness that was sharpened and maintained by their training in the sciences. Their joint commitment to imagination, invention, and investigation, whether in formal institutions such as Rutgers, or looser affiliations such as *Yam Festival,* was reinforced by combined practices that amount to a kind of 'Pataphysics. Their shared approach to research allowed the mind to travel freely over the conceptual surface of an object; to dissect it in myriad fashions and reconnect the parts in new, more interesting, and always amusing ways. Both men were naturally attracted to a seriously playful view of the world, and the coincidence of these various unpredictable characteristics made their unique collaborations fit seamlessly into the larger community better known now through Fluxus.

NOTES

I would like to thank Larry Miller and Sara Seagull of the Robert Watts Studio Archive, and Herrman Braun for invaluable assistance with research and guidance on Watts and Brecht respectively.

1. "An Interview between George Brecht and Robin Page for Carla Liss (Who Fell Asleep)," *Art & Artists* 7 (October 1972): 29–33.
2. *Yam Festival* calendar of events, n.d.
3. Brecht and Watts gave a *Yam Lecture* in New York on January 21, 1963; Watts's *Yam Lecture* at Michigan State University was given at the Oakland campus on October 4, 1963.
4. *Times Literary Supplement,* August 6, 1964.
5. "Robert Watts at Grand Central Moderns Gallery," *Arts* (February 1961).
6. *New York Herald Tribune,* December 24, 1960.
7. Larry Miller, *Robert Watts: Scientific Monk.* Published in German translation in *Kunstforum International* 115 (Sept./Oct. 1991); quote is from author's original manuscript, in English.
8. *New Light on West Africa,* Rene Block Gallery, New York, 1976.
9. See the essay by Benjamin H. D. Buchloh, "Cryptic Watts," in *Robert Watts* (exhibition catalog, New York: Leo Castelli Gallery, 1990).
10. All quotes regarding *Sissor Bros. Warehouse* from *Los Angeles Times,* October 3, 1963.
11. Letter, 1969, private collection.
12. All quotes and page numbers in this section are from "Project in Multiple Dimensions" (unpublished ms.), Robert Watts Studio Archive.
13. D. T. Suzuki, "Aspects of Japanese Culture," *Evergreen Review,* no. 6, 1958.
14. From "A Conversation about Something Else: An Interview with George Brecht by Ben Vautier and Marcel Alocco," first published in *Identités,* nos. 11–12, 1965. This translation by Henry Martin, from his *An Introduction to George Brecht's "Book of the Tumbler on Fire."* (Milan: Multhipla Edizioni, 1978).
15. Suzuki, "Aspects of Japanese Culture," *Evergreen Review* (1958).
16. From Brecht, "The Origin of Events," reproduced in Harry Ruhe, ed., *Fluxus: The Most Radical and Experimental Art Movement of the 1960s* (Amsterdam: A, 1973).
17. From "Project in Multiple Dimensions."
18. Brecht, "The Origin of Events."
19. Edmund Carpenter et al., eds., *Proposals for Art Education* (funded by Carnegie Corporation, New York, 1970).

Note that *content* cannot break down Religious thought, since this thought is distinguished, characterized by *contentless form*.
—George Brecht

George Brecht jotted down this observation in his notebook on April 24, 1959.[1] On the same page, he also referred to Indian and Persian astrology, Vedic religions, and aspects of the Trinity manifest in Hindu, Hebrew, and Christian religious practices. To the back of this page he fastened the program from a concert on experimental music. *Concert of Advanced Music* had been performed April 7 at the New York YM-YWHA, at 92nd Street and Lexington Avenue, and had included works by Al Hansen (*Alice Denham in 48 Seconds*), Christian Wolff (*Suite*), Dick Higgins (*Six Episodes for the Aquarian Theater*), John Cage (*Music of Changes*), and the New York Audio Visual Group (founded by Higgins and Hansen). Continuing to juxtapose religion, art, and music on the next page of his notebook, Brecht attached two newspaper clippings under a heading he underlined: "*Vedic——Buddhist (500 B.C.——700 A.D.)*" The first attachment featured an advertisement publicizing an upcoming exhibition by Marcel Duchamp at Sidney Janis Gallery; the second was the advertisement for the *Concert of Advanced Music* (figs. 78–80).[2]

 These and other entries in his notebooks suggest not only the manner in which Brecht acquired and specified particular kinds of knowledge, but also how he interwove Eastern and Western philosophy and religion with experimental art and music. This synthetic practice assisted him in

BATTLE OF THE YAMS

—

CONTENTLESS FORM AND THE RECOVERY OF MEANING IN EVENTS AND HAPPENINGS

—

KRISTINE STILES

FIGURE 78

George Brecht, *Notebooks,* vol. 2, April–August 1959, p. 7. Photograph by Dan Dragan.

reformulating diverse kinds of information into alternative structures of associations. By unexpected juxtapositions, Brecht provoked unanticipated and unexplored networks of conceptual relations at the intersection of uncorrelated ideas. As much as his notebooks access the ideational foundations and activities of Brecht's imagination, they also offer a representation of his aesthetic and intellectual processes. Connecting random points of data, without reverting to genealogical modes of linkage, Brecht's creative process highlighted junctures, intermediary medians where concepts, subject matter, and practices of widely diverse peoples and conventions overlapped in nonhierarchical, nonsignifying, hybrid forms that created spaces for the articulation of alternative concepts and— eventually—values.

What interests me in this particular section of his notebooks is the fact that Brecht emphasized "content" and "contentless form," and that while these terms were written as a description of religion, he coded them with the polyvocality of art and music.[3] For the artist seemed to acknowledge how considerations of content fail to reveal meaning in either art or faith. By noting that "*content* cannot break down Religious thought, since this thought is

distinguished . . . by *contentless form*," Brecht emphasized the phenomenological conditions of form beyond the limitations of formalism as a semiotic or purely aesthetic device.

A year or so earlier in his statement "Project in Multiple Dimensions" (1957–58), Brecht attended to the relation between thought and the construction of meaning that inevitably emerges from form. Brecht stated this aim:

> The primary function of my art seems to be an expression of maximum meaning, with a minimal image, that is, the achievement of an art of multiple implications, through simple, even austere, means . . . accomplished . . . by making use of all available conceptual and material resources. . . . [including]

infinite space and time; in constant interaction with that continuum (nature), and giving order (physically or conceptually) to a part of the continuum with which he [an individual] interacts.[4]

The artist's interest in the interrelation between his own developing scores for events and the Happenings of his friends as the locus of art is key, for he had begun to attend to the interrelation between contexts and sites in organizing forms for behavior. For example, in a note to a draft of one of his scores— *Time-Table Music*—Brecht credited artist Al Hansen with understanding the potential simultaneity and multiplicity of sites for the realization of a events: "The piece may be performed in: a classroom, w pencils, pens, erasers, etc., a restaurant, w knives

FIGURE 79
George Brecht, *Notebooks,* vol. 2, April–August 1959, p. 8.
Photograph by Dan Dragan.

FIGURE 80
George Brecht, *Notebooks,* vol. 2, April–August 1959, p. 9.
Photograph by Dan Dragan.

+ forks, etc. I am indebted to Al Hansen for an element of this piece: the nature of the many places in which it may happen." In this regard, events might themselves be understood as contentless forms par excellence. An event—especially as Brecht conceptualized it—focused attention on phenomena and behavior, while the Happening fit together a simultaneous assemblage of objects, people, and occurrences, shaping circumstances that might attribute social value to actions even if the meanings of such behaviors were at the time, and remain today, fundamentally elusive.[5]

Conceptualizing form as an empty container defeating stable meanings, events as artistic medium may be thought of as a contentless form that offers insight into both the *shapes of* the *processes-of-thought* and *processes-of-coming-into-being* with respect to cognition and behavior on the part of both the artist and the participant. For a very brief historical moment (c. 1958–62), artists creating Happenings and events were able *to confuse* the divide between the personal and the social, recuperating distinguished thought (characteristic of both religious and aesthetic reflection) by plunging the *processes* of being and thinking into the undefined shape of the event template.[6] As a contentless form, *artistic actions emerged as meaning that could not be broken down into anything as discrete or contained as a narrative of content.* What differentiated them was a quality of being, distinct from everyday life but contributing to what it might, or at least had the potential to, become.

Such ambiguity regarding the boundaries between ordinary life and aesthetic existence could not last. For where instrumentalism demands meaning for use value, exchange value, or both, content is reified. Several decades later, after various forms of event art had affected an understanding of the possibility of the semipermeability of the social and the aesthetic, the private and the public, French sociologist Pierre Bourdieu could state, "Art's value in modern society derives from [the] play between private subjectivity and social reality."[7] Moreover, Gilles Deleuze and Félix Guattari—tutored by Jean-Jacques Lebel, a pioneer of Happenings in France and Italy who introduced the philosopher and psycho-analyst to event art both in Europe and the United States—could theorize about similar organizations of knowledge as "rhizomorphous."[8] In their book *Mille Plateaux* (1980), Deleuze and Guattari emphasized acentered systems able to produce a variety of "becomings" and "interbeings," resembling the synaptic multiplicity of the human nervous system itself. They juxtaposed the function and properties of the rhizome to Western "arborescent schema" upon which epistemological models of the root are based in binary relations established along biunivocal positions. Drawing directly on typologies of art, Deleuze and Guattari summoned the term "assemblage" to describe both their own textual project as well as aspects of their model of the rhizome as it might encompass a vast range of phenomena: their considerations of "becoming," their notions of "the body without organs," conditions of the book, collective

enunciations, content and expression, deterritorialization, form and matter, incorporeal transformation, language, libidinal conditions, linguistic variations, the machine and war, refrain in song, the regime of signs, the state apparatus, stratification, the subject and subjectifications, and many other notions.[9] My point is that although the theory of artists associated with Happenings and Fluxus has invisibly informed the intellectual foundations of many disciplines for four decades, artists such as Brecht and Kaprow have rarely been acknowledged for the shape their practice has contributed to cultural change, filtered, as it has been, through critical theory.

Such modes of conceptualizing the construction of knowledge recall how Fredric Jameson has described the juxtaposition of "a series of situations, dilemmas, [and] contradictions" as a more dynamic means for unfolding history. He pointed out that historical narratives must include simultaneously "the sense of Necessity, of necessary failure, of closure, of ultimately unresolvable contradictions and the impossibility of the future."[10] These qualities give history its rich texture and require close attention to details that do not lend themselves to the construction of heroic art-historical narratives.

What follows is an attempt to offer insight into the working and behavioral conditions of the artists now being historicized as the "Rutgers group." In keeping with Jameson's sense of history and Brecht's attention to the form of assemblages of knowledge and the processes of juxtaposition that animate them, I shall let Al Hansen report on one of their activities—the *Yam Festival* ("May" spelled backward) held at George Segal's farm in May 1963. From the oblique perspective of Al Hansen's narrative, I hope to make the conditions in which the Rutgers group created art appear more confusing, full of contradiction, and, therefore, much more vivid.[11]

Hansen existed on the periphery, while at the same time he was at the center of the Rutgers group, involved with an international mélange of artists creating Happenings, and he was one of the participants in Fluxus. His tale of the *Yam Festival* is riotous and entertaining. But it is also troubling, an account of the interpersonal dynamics of those who created an art of events that is full of the situations, dilemmas,

and contradictions that shaped their aesthetic forms and undergirded their personal actions in a way that did, indeed, produce unresolvable contradictions. What I hope Hansen's narrative will convey is how the very contentless form of an event or a Happening—filled as it is with personal character—highlights conditions of *actual* experience and demonstrates the dependency of the value of art—all art—on the qualities of behavior. Where conventional art objects, and even the goods of popular culture, veil the demarcation between public and private behaviors (in the differentiation between aesthetic and social forms), the art created by those associated with the Rutgers group makes behavior visible through the very contentlessness of the vessel of events. In this regard, when referring to events, Happenings, Fluxus, or performance art, Brecht's note may be amended as follows: *content* cannot break down *aesthetic* thought, since this behavior is distinguished, characterized, by *contentless form*.

—

Brecht and Robert Watts, two artists associated not only with the Rutgers group but also with Fluxus and Happenings, were the principal organizers of the month-long series of activities that took place in and around New York for the *Yam Festival*. They also created the Yam Festival Press to publish the *Yam Festival Newspaper,* and they edited several broadsides concerned with promoting *Yam Festival* activities. The two principal performance venues planned during the month included activities at the Hardware Poet's Playhouse, and Happenings and other events scheduled for George Segal's farm. In the second issue of the *Yam Festival Newspaper* (with the jaunty heading *New SE pA pay ER*), Brecht and Watts advertised: "AL HANSEN'S THIRD RAIL GALLERY is running a display of THEATER MARQUEES on 42nd St. West of Broadway, in New York."[12] In their four-page calendar of events, *MAYAM TIME,* Watts and Brecht opened with the announcement "THE SMOLIN GALLERY . . . will be a source of information for activities listed on this calendar, will carry publications, scores, and related materials, & will arrange special shows at the gallery throughout the month."[13] A second announcement in the same calendar advised, "AL HANSEN'S

SILVER CITY AT GROUND ZERO will evolve at Canal Street & Broadway, NYC."

For *Yam Day* (May 11–12) at the Hardware Poet's Playhouse, the calendar listed an "endless and continuous program of performances" by dozens of artists, among whom Hansen and Higgins were scheduled to perform Higgins's compositions of *Danger Musics, Celestials,* and *Two for Hami Bay.* Hansen was also invited to serve as auctioneer for a *Yam Festival* fund-raiser held at the Hardware Poet's Playhouse. Given Hansen's spirited storytelling capacities, one can only imagine how raucous his performance might have been. But when it came to being invited to participate in the events scheduled at George Segal's farm on May 19, Hansen had a surprise coming. The *MAYAM TIME* four-page calendar of *Yam Festival* events announced that the Smolin Gallery would present a Happening by Allan Kaprow, *A Dance* by Yvonne Rainer, a "De-coll/age" by Wolf Vostell, *Music* by La Monte Young, and *All Kinds of Trouble* by Dick Higgins. Hansen was not on the program.

Trying to account for why Hansen had been excluded, George Brecht observed:

> The Smolin Gallery was more or less associated with Allan [Kaprow]. The Smolins themselves didn't really know much about what was happening. I didn't go to Segal's farm. I heard about Al's happening. What the Smolins were really interested in was Allan, and Allan's work; and they were suddenly overwhelmed by all this.[14]

Brecht did not attend the festivities at Segal's farm because he "just sensed that something wasn't right." But he was more involved in other *Yam Festival* tasks:

> For Yam festival, we had the whole month that we wanted to fill up (because Yam equals May). So we filled in what we had and then I think probably Bob Watts and Allan—because they were both teaching at Rutgers—worked out the whole thing at Segal's Farm. I wasn't much involved with that. I was involved with the Hardware Poets Playhouse and the other events. I pasted the calendar together. It was chaotic. No wonder no one knew what was going on.

Allan Kaprow remembered things differently. He recalled "play[ing] little, if any, part in its organi-zation—except for approaching George Segal and enlisting his willingness to give over his farm for the occasion." "Otherwise," he continued, "I was an invitee and spent my time preparing my event (with George's help)."[15]

Whatever proved the cause of Hansen's exclusion, it came as a painful surprise:

> In the midst of planning what to do at George Segal's farm I was informed I wasn't on the program. Not on the flyer or the poster. Midnight phone calls, "What's going on?" Uptown (Ira Smolin) had decided I wasn't needed. Well, it's not the Viennese Opera is it? I'll just do a little something anyway. Phone calls. "You can't." Maybe I will. Maybe I won't. More calls. "Absolutely forbidden." Well, shit! A few more calls, condolences, succor. A French girl who pouted beautifully fucked me. Great! More calls. Dick Higgins: "I don't know how you do it, but everyone's talking about you and Ira Smolin says (from uptown) if you so much as show up at Segal's Farm he'll have you arrested by the police." Gee whiz! Wouldn't miss that for the world. Happenings become the academy: take a card . . . and go to jail. Gosh. Wow!

Upset about what he considered a snub, undaunted Hansen followed through on his intention to participate by purchasing material necessary to make an event:

> Early the next morning Joe Jones and I went up by subway to the Port Authority Bus Terminal. We went to a supermarket and I bought 20 or 30 rolls of toilet paper, about 1/2 yellow and about 1/2 pink, as I remember. I insisted Joe go up and get on the bus. I was/had been told I wouldn't be allowed on the bus. I didn't want Bklyn Joe Jones to be kept out of the festivities through association with me. He refused. We went up to the bus together. It was a special bus Ira Smolin had engaged, perhaps there were several. . . . Charlotte Moorman, Alison Knowles, Lette Lou Eisenhauer, Lil Picard, Philip Corner . . . La Monte Young, and it was like a big deal. The Port Authority UPTOWN GALLERY!!!! Bus Terminal. Special Buses—Shit! And they all started yelling, "Hey Al!" "It's Al!!!!" And the Smolin Gallery Guy, Ira Smolin Smiles and Yells, "Hey Al— Gooooooood to see ya." And [he] gave me a big hug! Well, somebody was blowing smoke up somebody's ass and one day it will come out. Hugged, patted and cheered by the very people who were saying, "We mustn't let *him* in." I clenched my buttocks firmly and got on the bus.

Describing his grand entrance, Hansen emphasized the pronoun *him*. For he understood and accepted his own marginality, no matter how cheery a greeting he might receive from those he had been told wished to exclude him. He continued:

> The ride out was uneventful. Several people like Brooklyn Joe Jones and the French gal reminded me of the State Trooper arrest warning. I said, "It's all pussy shit. They're pussy. Nothing's going to happen." The bus finally pulled up at Segal's Farm and we debarked. Mrs. Smolin was there with a clip board manifest list, saw me and squealed with delight—"Ah, good to see you." And kissed me on the cheek. The French girl murmured, "I don't beleev ziss!" We all walked down into Segal's Farm past his house on the left and on the right a long long shed for chickens. . . . Down we walked along the chicken run past some fields and woods on our left always going slightly down hill. We found Alison Knowles down the grassy slope with Philip Corner, Takako Saito and others. There seemed to be a lot of food. We ate and walked around.

Hansen and his French friend began to enjoy the events, most of which he remembered in great detail, especially performances by Higgins, La Monte Young, and Yvonne Rainer and Trisha Brown:

> Dick Higgins did a snake in the grass piece with a fake snake. Some people were upset because they had brought their kids into this ex–chicken farm reverting to country and Dick had (they thought) brought a live snake and it might bite their kids. "Do you know if it was a poisonous snake?" one big-eyed imbecile woman asked.
>
> La Monte Young and Larry Poons did something way off in the fields. There were others. La Monte had a continuous piece that subsequently was performed for horns. As many as thirteen or more. It involved a group humming, vocalizing, or bowing stringed instruments on a particular note continuously. It was pre-psychedelic. It was another aspect of La Monte's video piece of a video monitor screen with a white line in the grey and nothing else. Minimal art formal special precious and totally common ordinary. A found object note or line anyone could have chosen, except La Monte did. I have always liked, to the point of championing, La Monte Young's work.
>
> Yvonne Rainer and Trisha Brown did a long, rambling, gamboling play, a game energy dance on the long roof of the chicken house.

While he enjoyed observing the other artists, Hansen began to think about what he would do:

> I had my shopping bags of toilet paper to festoon a tree or trees. I took a walk and found a bog area with hummocks of grass. It was circular with tall oak and aspen. It wasn't that far from the be-in like doings but the summer heat and the trees insulated me from sound there. Perhaps the muck of the bog helped soundproof the area too. Soon I had Alison, Joe Jones, Lette Lou Eisenhauer, Philip Corner, The French Girl and several others helping me to festoon the trees in an arc with toilet paper streamers. One would throw a roll up on the trees so it unrolled going through the air. This is something Americans do at football games as well. Then one gets it and throws it again. It was instant Camelot. The natural greenery of the bog festooned with the long graceful pennants of toilet paper undulating here and there to a stray breeze became very cathedral like. It was so simply done and effective. I thought Philip Corner was really into it because he was wading around ankle deep in the mud going to get rolls and throwing them up back into play. As we began to run out of toilet paper rolls, Philip suddenly pointed at my shoes and yelled, "You have no mud on your shoes!" He pointed at several other people and said the same thing. "Why don't you have mud on your shoes?" "We've been stepping from grass hummocks to knolls and not going in the mud." Philip is incredibly cerebral like most composers and had been charging around in the muck w/o realizing he had a choice.

Dick Higgins thought the effect of Hansen's Happening "with all the toilet paper in the trees (which resembled ribbons) looked like Fragonard." He added, "But there was no way they could all be cleaned up."[16]

At this point in the events, Hansen seemed to have recovered from his hurt feelings and while he was not on the "official" program, he was, nevertheless, quite content to make his own contribution out in the bog—beyond the frame of the Smolin Gallery. More important, he got to participate—to be one of the gang that belonged to what he believed was a radical new direction in art. It is ironic and moving that two years after his *Yam Festival* experience, Hansen's belief in the social potential of the aesthetic form of Happenings and events was still strongly enough in place for him to write (on the first page of his book *A Primer of Happenings and*

Time/Space Art): "I think of happenings as an art of our time."[17] Later in the text he added:

> The wonderful thing about the happening is that the love is going not only from the stage to the audience but from the audience to the stage and back and forth between the people in the happening to each other. This is my own poetic view. It would be very unique to perform a happening with spectators who were unsympathetic and with performers who were at odds with each other.[18]

It is clear from Hansen's position that a clique was antithetical to everything he valued in the new art form, and to the inclusiveness he tried to practice in his own life. Nevertheless, he was there in the midst of his friends, artists who were not only apparently unsympathetic to his very presence at Segal's farm, but at odds with one another. Hansen continued:

> We went back to Alison's area and had some more chicken and salad. Several people went to look at it. Others found it and came to tell us how beautiful it was. Except for one Allan Kaprow [who] came charging up and began yelling at me: "How dare you do that?" I said, "I just did it."
>
> "You had no right to do that. This is a closed program. It's all arranged. You aren't on the list. How dare you just barge in here and help yourself. You've ruined George Segal's woods. He was good enough to let us use his farm and look what you've done! He's going to be furious. You owe him an apology. Who do you think you are?"
>
> "It was a happening," I said.
> "No it is not!" Allan Kaprow yelled.
> "It's clearly a matter of opinion," I said.
> "You owe us an apology," he roared.
> "I don't feel I owe you a thing, but I'm sorry I upset you so and I will find George Segal and tell him I destroyed his woods with toilet paper."
>
> Allan fumed off as if he would never speak to me again and because of the amazing dimensions he'd presented I didn't plan to go out of my way to talk to him either. The French girl had been standing next to me throughout and her jaw was hanging down.

Kaprow's memory of these events is equally vivid. He insisted that "the toilet-paper event was "not at all *far off* in the boggy woods" (Kaprow's emphasis). Moreover, Kaprow pointed out:

> They were at the edge of the field where I was about to start my work [*Tree*]. As we can see from photos

of a group of about 25 to 30 "forest people," each carrying branches or poles with black tar paper overhead, were to emerge from the forest edges; they were to proceed across the field in front of them, for the rest of the piece [plates 30, 31]. Al's activities with the toilet paper were visibly close and I was annoyed that the two events would get confused! Before this several spectators (early ecological activists) had criticized me for cutting down a tree I had placed in a stack of hay bales, for the happening; and for cutting down saplings for the "forest people." I hadn't done that at all. It was a tree that had been blown down a year before in a storm. And the saplings came from its still half-alive branches! So I was expecting another criticism with Segal involved! Well, I was a bit put-out, and saw those tree-saviors talking to George Segal in the distance. I didn't light into Al as he remembers! Those words aren't my style. But I did tell him that I had to begin my event and would he please finish. He did, everything worked out fine.

Before everything became "fine," Hansen went off to solicit Segal's forgiveness. He found his way back to Segal's house, and noted:

> I have always liked him and Helen his wife, and I felt he must be to some degree as disappointed with me as Allan was. Or, taking another tack [I imagined] George being (for some reason) paper phobic [and that he] was angry with me, and that was the reason for Allan's near apoplexy. [But] they received me very cordially and I proceeded to confess I had led a group of people to festoon some trees around a bog down in his woods with toilet paper streamers. "So what's the problem?" George said. "We don't have any toilet paper if you want more. Maybe a roll." Helen offered to see if there was more. "No." I said [that] I did it and they said you were angry so I thought I should apologize. "Well, that's foolish," George said. "People are doing stuff all over the place. You can't hurt trees in a swamp with toilet paper!" I agreed. "You can come throw toilet paper around in my woods anytime you want to!" Rejoice. I went back to the area. The French Girl came over. "Was he angry?" "No, he likes it," I said. We walked down the slope and Allan was calling for volunteers for his happening which would be next. "There you are you son of a gun," he grinned. "You know you're terrific the way you really go in there and just do things. I wish I could do that." And he gave me a big hug. I said, "Can I be in your piece?" He said, "Of course you can. How could I do it without you?" So I was in it.

Kaprow understood Happenings to be distinguished from Hansen's work because, for Kaprow, the Happening was "poetic" and "quietly exploratory" while

> Al was impulsive, . . . openly adventuresome, . . . a dare-devil who made people admire him but fear him. He picked up on the fear-attraction. We saw it [Hansen's Third Rail Gallery] as a kind of danger metaphor where electrocution was possible at any moment. If he calls his own home a "third rail," he might see the rest of his life with all its changes of forces as a dangerous world.[19]

These distinctions were important especially for Kaprow, who was, even then, moving away from his own more multilayered, physically demanding, and energized, sometimes even Baroque events requiring participation, toward the "activities" that would characterize his work at the end of the 1960s. Kaprow came to associate his extravagant structures with what he eventually called "high jinks," qualities in which he lost interest.[20] He probably associated the toilet paper–strewn forest decorated by Hansen with just such high jinks and even then wanted to distance himself from such activities. Nevertheless, he also appreciated Hansen for his inherent personal qualities. "Al is right in recalling that I invited him and friends to participate, and that I told him I always had admired his work," Kaprow said. "I probably did hug him."

Hansen was thrilled. He, too, deeply admired Kaprow, and he sought Kaprow's acceptance.[21] Hansen was honored to participate in his event, and remembered:

> It was like Robin Hood. A horde of people carrying branches and sticks some of them with bunched clumps of black tarpaper at the top are all in the woods at one point we charge a pile of stacked hay bales atop which La Monte is acting drunk and drinking from a bottle. Cars come down from the other direction and knock over bales of hay. The drivers then stack them up and knock them down again. One of the cars was a Morgan driven by a couple [of] students of Roy Lichtenstein. . . . At some point once we had surrounded La Monte, he began to play a soprano saxophone which looks like a brass clarinet.

Hansen's account of the *Yam Festival* at Segal's farm ended with this reconciliation with Kaprow. But he added one last melancholy comment to his otherwise stirring story:

> The French Girl and I got separated and a few days later she returned to France and I never saw her again. I had given her a copy of my Happening book and years later I found it in a junk book shop for a dollar with the inscription still in it. Telling the story later someone said they wanted *that* book. (It was someone I said could have a copy.) I found it and gave them that book. I don't remember who it was.

Objects can change hands without losing their value if that worth is recuperated elsewhere. Just as Al Hansen, the person, presented his momentary lover an inscribed book that she either gave away, lost, had stolen, or sold; that copy of his book was recovered by an individual who valued it but who Hansen forgot. The process of loss and recovery took place in a linkage of exchanges that moved meaning along time through a book in action. In such slippage, Hansen's book became a mere contentless form distinguished only by sequences of actions. "Hansen couldn't make 'art,'" Carolee Schneemann once observed, "It was too distant from life; *he had to inhabit his art because he was the congealing element.*"[22]

—

Historian Christoph Asendorf observes in *Batteries of Life* that a transfer away from the subjectivity of the individual to a more anonymous objectivity parallels shifts in perception and consciousness in the late nineteenth century. In particular, he argues that urbanization effaced a certain kind of subjectivity that attended to close personal relations characteristic of the preindustrial era, in a period when one had few contacts during the course of the day, but those contacts were often with people one knew. By contrast, in postindustrial urban centers daily contacts multiplied and were often anonymous. Asendorf quotes the Austrian novelist Robert Musil, who, in *The Man Without Qualities,* invented the character Ulrich (the man without qualities) in order to describe one who sees "a world of qualities without a man to them, of experiences without the one who experiences them."[23]

The artists associated with the Rutgers group whose primary form of art was the creation of an event sought precisely to recover qualities of human life as conditions of both experience and art. The contentless form of their events depended entirely on distinguished conditions of behavior to determine their meanings. George Brecht anticipated this understanding in notes he recorded in his notebooks on March 3, 1959. There he identified various categories of human invention as behavior, underlining the term each time he associated the word with a certain discipline of action:

> Art as *Behavior*. Myth as *Behavior*. Language as *Behavior*. (Psycholinguistics.) Science as *Behavior*.[24]

Brecht's emphasis on behavior has its corollaries in the ways in which the space of life is built, destroyed, lost or restored, and recovered.

The art event stresses the interrelation between thought and its objects, behavior and its effects. As a result, art that uses the body as its primary material draws art history back into a study of the life of the artist at the nexus of the social context in which he or she produces art. Nevertheless, art history based in artists' biographies has been held in contempt for more than a decade, accused of not being sufficiently theoretical to explicate the complex institutional, historiographic, and social constructs that shape the reception and understanding of art; this critique of the use of biography has also been coupled with a critique of originality and artistic aura.[25] But examination of artists' lives, especially when lived by those associated with the contentless form of Happenings, should not be ignored; it sheds light on the content of that art and the institutional practices, cultural situations, and political interactions that resulted from it.

The critical point made by Hansen's account of Happenings—and by extension the activities of the Rutgers group—is how integral behavior is to the content of the lived environment in which events take place. His experience requires us to ask, Could an art of events be about *that* much life? To what degree were Happenings and Fluxus able to accommodate the extremes to which some of the artists who practiced them seemed capable of living and working?

Would—indeed, could or should—these artists ride the third rail? If not, why not? How does one go about excluding the extremes of life from the shape of aesthetic events? What is at stake in such exclusions?

By 1961, Kaprow had already begun to move away from what would become his own six "guidelines for happenings," constantly attempting to bring his art practice closer to the interpersonal commitments of his life. He stated:

> To the extent that a Happening is not a commodity but a brief event, from the standpoint of any publicity it may receive, it may become a state of mind [wherein] the artist may achieve a beautiful privacy, famed for something purely imaginary while free to explore something nobody will notice.[26]

But if ever there was ever a person who (1) kept the line between art and life "as fluid, and perhaps indistinct, as possible," it was Hansen. If ever there was (2) a practice whose "source of themes, materials, actions, and the relationships between them [were] derived from any place or period except from the arts, their derivations, and their milieu," it was Hansen's. If a "performance of a Happening should take place over several widely spaced, sometimes moving and changing locales," then (3) Hansen's "third rail" existence/exhibition and performance strategy did so. If "time . . . should be variable and discontinuous," then (4) Hansen's "freak it and party" attitude and way of "disappearing" and then "dropping back in the scene after a year or two to challenge the big cats," materialized this invisible quality of time. If "Happenings should be performed once only," then (5) the Happening quality of every day of Hansen's life made it an art. And, finally, if it is true that we must "finally . . . eliminate entirely" the audience, as Kaprow insisted, then (6) once the focus of its gaze is brought to rest on Hansen's life, we can only be amazed at how well he performed this task, and what a shame it is that so many missed it.[27]

Hansen's lifework and, indeed, *his life itself,* appeared to be a contentless form comprising an assemblage of simultaneous, unrepeatable, and unrelated occurrences and actions that defeated attempts at producing meaning, while at the same time embodying a remarkable coherency and unity that provided a fascinating litmus test for the verity of

the values upheld by those creating events. From Cage the artists associated with the Rutgers group had learned that consciousness is not a thing but a process, that art must entail the random, indeterminate, and chance aspects of nature and culture, that behavioral processes continually inform a work of art, and that "the real world . . . becomes . . . not an object [but] a process."[28] In theory, at least, such a life appeared ideal. But in practice it was quite another thing, as witnessed by the paradox that Cage himself regarded Hansen with distant caution.[29]

Just as the *form* of an abstract thought about some value or belief may be contentless, that form also belongs equally to a dynamic system (from which it cannot be separated) that gives it meaning (content), creating a phenomenological loop along whose circumference a contentless state occurs. This state is, nonetheless, always already in the process of giving way to the recovery of meaning. Where meaning happens, contentless form recovers something.

Recovery is an act of broad implication, insinuating events of restoration, reinstatement, rehabilitation, reorganization, regeneration, rejuvenation, renovation, and also recuperation. When value is attached to recovery it becomes recuperation, a content-loaded act that may lead even to a sacrament linked to redemption. Redemption is the rescue of something worthwhile from an apparent absence of value. Rescue may defer nihilism.

Like a Möbius strip, meaning and value slide, and are simultaneously determined, along a single surface, a line extending from contentless form to recovery and redemption. Artists near to and associated with the Rutgers group devised an aesthetics of recovery in their behavioral acts. Such an aesthetics is usually difficult to find and nearly always *invisible*. But it is also quite beautiful to those who discover its signs of "distinguished thought." For distinguished thought imbues the art of events with value, making visible the aesthetic merit of its contentless form.

NOTES

I would like to thank Joan Marter for her patience and support in bringing this essay to completion. I also want to thank Edward Allen Shanken for his excellent editorial assistance.

1. George Brecht, *Notebooks,* vol. 3, April–August 1959. Edited by Dieter Daniels with Hermann Braun (Cologne: Verlag der Buchhandlung Walther König, 1991), 7.

2. Next to the announcement for the Duchamp exhibition, Brecht penned "ca. 5/2–5/30 [1959]." According to Higgins, members of the Audio Visual Group included "especially in 1959–60, when it was very active—Al, myself, Larry Poons, Donald (= 'Max') McAree, Howard Smythe, Jaimee Pugliese, Reginald Daniels, Ruth Waldinger, Richard O. Tyler, Dorothea Behr, Charles Adams, Florence Tarlow, Robert Braver[man], Herbert Grossman, Lisa Null. Alison Knowles was not yet doing performances." Higgins, letter to the author, July 15, 1997.

3. Although there is no indication in the notebooks about whether Brecht borrowed the quote from a text he was studying, or formulated it himself, his use of the sentence, not its origins, concerns me here.

4. George Brecht, "Project in Multiple Dimensions," (1957–58), reprinted in George Brecht, *The Book of the Tumbler on Fire* (Los Angeles: Los Angeles Country Museum of Art, 1969), unpaginated.

5. An example of how elusive and simultaneously concrete the experience of a Happening may be was vividly conveyed to me in the following example: In 1996, Robert Sikorski, a lawyer and the acting director of the Center for International Studies at Duke University, called me into his office. He explained that he wanted to launch a series of activities—symposia, guest speakers, visiting artists, whatever—that would "change people's lives," and he wanted my help. Daunted, I asked him what he meant by "life changing." He then recounted the following story: "In the spring of 1968 I was a freshman at Kenyon College, a kid from the suburbs. I attended a workshop that changed my life. It wasn't because of what we actually did. We jumped up and down, I think. The point is it was *how* we did it and *that* we could do it in that context. It opened my mind. I've never forgotten it; and I want to do something like that for Duke students. Maybe you

know the artist. Her name was Carol, or Carolee. Have you ever heard of . . ." When he got to this question, I interrupted, "Carolee Schneemann." "Yes!" he said, with excitement, "You know her?"

6. I date the ability of Happenings and Events to confuse the divide between the personal and the social to about 1962 or 1963. One marker of the end of their efficacy is Allan Kaprow's vivid account of the failure of his Happening *Push and Pull: A Furniture Comedy for Hans Hofmann* (1963). There he was unable to gain a committed response by his participants to such playful activities as "eat[ing] your way through the designs [of a Persian carpet made of food], right across the room, making new ones behind you as you went along." When the participants failed to engage in the event in a sufficiently interactive way, Kaprow responded: "From reports, I gather that this arrangement has not worked out optimally. In an exhibition atmosphere people are not geared to enter into the process of art. Hence, this kind of work is much better off away from the habits and rituals of conventional culture." Kaprow, *Assemblage,*

Environments, and Happenings (New York: Abrams, 1966), 314.

7. Bourdieu quoted in Joseph Leo Koerner and Lisbet Koerner, "Value," in Robert S. Nelson and Richard Shiff, eds., *Critical Terms for Art History* (Chicago: University of Chicago Press, 1996), 292.

8. I discuss the connection between Lebel, Deleuze, and Guattari in my forthcoming book, *Uncorrupted Joy: Considering the Social Value of Performance Art Internationally* (Berkeley and Los Angeles: University of California Press).

9. See Gilles Deleuze and Félix Guattari, *Mille Plateaux,* vol. 2 of their *Capitalisme et Schizophrénie* (Paris: Éditions de Minuit, 1980), reprinted as *A Thousand Plateaus,* translated and with a foreword by Brian Massumi. Minneapolis: University of Minnesota Press, 1987.

10. Fredric Jameson, "Architecture and the Critique of Ideology," in Joan Ockman, ed., *Architecture, Criticism, Ideology* (Princeton: Princeton Architectural Press, 1985), 58–59.

11. Unless otherwise indicated, all quotes by Al Hansen in this essay come from his unpublished letters to the author written between 1980 and 1982. I want to thank Kathy O'Dell, who, at that time, typed many of his handwritten letters into manuscript form. Hansen wrote copious, fascinating, and vivid letters regarding the period ca. 1955–80. His memory was prodigious and seems to have been remarkably accurate as I corroborated his story of the *Yam Festival* at Segal's farm with Allan Kaprow, Alison Knowles, Dick Higgins, and Carolee Schneemann. Although he was highly expressive and sometimes exaggerated, Hansen got the essential components of the tale right. I have retained the spelling, syntax, emphases, and language of Hansen's letters, except where adjusted punctuation makes the text clearer.

12. George Brecht and Robert Watts, *Yam Festival Newspaper* 2 (1963), 3. Broadside in the Hanns Sohm Archive, Staatsgalerie, Stuttgart.

13. George Brecht and Robert Watts, "MAYAM TIME," *Yam Festival Calendar of Events* (1963), 1–2. All subsequent quotes from this event come from this calendar, preserved in the Hanns Sohm Archive, Staatsgalerie, Stuttgart, unless otherwise indicated.

14. George Brecht, interview with the author, October 16, 1980, Cologne, Germany. All subsequent quotes from Brecht, unless otherwise indicated, come from this conversation.

15. Allan Kaprow, letter to the author, November 14, 1996. Other quotes from Kaprow from same source.

16. Higgins, letter to the author, July 15, 1997.

17. Hansen, *A Primer of Happenings and Time/Space Art.* (New York: Something Else Press, 1965), 1.

18. Ibid., 57.

19. Allan Kaprow, conversation with the author, November 12, 1996. Hansen called his living space the Third Rail Gallery of Current Art, referring to the dangerous third metal rail of a train track through which high voltage current flows to the motors of electric locomotives.

20. Allan Kaprow in conversation with the author October 23, 1997.

21. Hansen attributes his Hershey bar wrapper collage signature style, the silver-on-dark-brown American candy bar wrapper collages for which he became known in the fifties and sixties, to his interest in advertising, and to his experience with a Kaprow painting: "Kaprow had a large painting made of scraps left over from paintings. It must be late fifties. He had fastened all the scraps together onto a large field. . . . It was like muddy coal-tar black, and he'd left white canvas that said 'HA,' so it was a laughing canvas, and that really stuck in my mind. And I just began tearing up posters, making simple words, 'AHA' and 'HEY' and odd names though they would all have the word 'TIME' in them and I'd tear them apart and repast it." Hansen, in Jan Van Raay,

"Al Hansen Talks to Jan Van Raay," *Artzien* [Amsterdam] 1 (September 1979): n.p.

22. Schneemann, conversation with the author, August 4, 1997.

23. Christoph Asendorf, *Batteries of Life: On The History of Things and Their Perception in Modernity* (Berkeley and Los Angeles: University of California Press, 1993), 5.

24. Brecht, *Notebooks,* vol. 2, October 1958–April 1959, 139.

25. For the critique of originality, see Rosalind E. Krauss, "The Originality of the Avant-Garde," *October* 18 (fall 1981), reprinted in Krauss's *The Originality of the Avant-Garde and Other Modernist Myths.* (Cambridge: MIT Press, 1985). For the effect of aura, see Walter Benjamin, "The Work of Art in the Age of Mechanical Reproduction," in *Illuminations,* edited by Hannah Arendt, translated by Harry Zohn (New York: Harcourt, Brace & World, 1968).

26. Quoted in Kaprow's "Happenings in the New York Scene," (1961) reprinted in Allan Kaprow, *Essays on The Blurring of Art and Life,* edited by Jeff Kelley (Berkeley and Los Angeles: University of California Press, 1993), 26.

27. See Kaprow's untitled guidelines for Happenings (ca. 1965), in *Assemblage, Environments, and Happenings* (New York: Abrams, 1966), 188–198, reprinted in Kristine Stiles and Peter Selz, eds., *Theories and Documents of Contemporary Art* (Berkeley and Los Angeles: University of California Press, 1996), 709–714.

28. John Cage and Daniel Charles, *For the Birds: John Cage in Conversation with Daniel Charles* (Boston: Marion Boyars, 1981), 80.

29. "Cage always had strong reservations about Al. He was sensitive to the physical energy and movement in him. But in those days silence in which nothing happened was golden," Kaprow explained, in his conversation with me, November 12, 1996, at State College, Pennsylvania.

—

INTERVIEW
WITH ALLAN KAPROW
—

The following interviews were conducted by Joan Marter, the editor of this book, and Joseph Jacobs, curator of the exhibition. The dates and places of the interviews are indicated. The interviews have been edited and condensed.

Newark, New Jersey
December 8, 1995

— JOAN MARTER: I would like to hear about your classes with Cage.

— ALLAN KAPROW: First of all, let's consider what I remember John Cage's presence to be. I think he was without any question appreciated by the visual arts world, to some extent by the poetry world, and not by the musical world. In fact, some of that same prejudice still prevails.

I actually became aware of John Cage in 1950 or '51, before I had a job at Rutgers. There was a performance of his music at the Cherry Lane Theater. The Cherry Lane Theater was the scene of a lot of avant-garde stuff. At that time they put on one of Picasso's plays, *Desire Caught by the Tail,* and there was a concert of John Cage's music, prepared piano music, on the same program. I interpreted it as a kind of Neo-Impressionist music. I heard the silence equiv-alencies and sound equivalencies as a kind of all-over, low-contrast Monet—like one of those great big water lily paintings. The reason I mention this is it was easy for visual artists to understand John Cage, and not easy for musicians, who were dominated by a Schoenbergian structuralism or an equally Neoclassic tendency and conservatism of that period. Cage didn't fit into any of that. He's out in left field. But we saw it very much like the kind of painting that was beginning to develop, a kind of impressionistic abstraction, like [Milton] Resnick. The assumption

that the musician is like a painter probably attracted me and other young artists at that time. They were pushing Monet into a kind of pure abstraction and *tachisme,* and Cage fit in very easily with that. I didn't look at him so much as a specialist in music as I looked at him as a kind of equivalency of painting.

I saw Bob Rauschenberg's show in 1952 or '53 at the Stable Gallery where he had all-black and all-white paintings. I had been to his studio before that. I don't remember how I'd met him. He had this very impressive loftlike studio that was on the top of some industrial building. I saw these black-and-white paintings in his studio, about 1951, around the same time I was hearing Cage. I was walking back and forth, not knowing how to take these things. I was familiar to some extent with Purist painting, like Malevich. But seeing Rauschenberg's paintings on a grand scale, I tied that grand scale to the Neo-impressionistic, abstractionist stuff of Resnick and others, with [Jackson] Pollock lying in the background. I was walking back and forth, not knowing how I should take these things, even though they had a kind of pedigree already. And then I saw my shadows across the painting—moving. Bob smiled. Cage later commented on the same thing in his writing.

Around the same time [1952] there was at Carnegie Hall a concert of John Cage, *4'33".* The weather was still warm, and windows were still open, and you could still hear the sounds on the street. So, when he did *4'33"* with David Tudor sitting at the piano doing nothing but pressing the time clock, closing and opening the keyboard cover, I immediately saw this as a part of the picture. And then I heard the air-conditioning system, I heard the elevators moving, a lot of people's laughter, creaky chairs, and coughing. I heard police sirens and cars down below. It was like the shadows in Bob Rauschenberg's pictures. That is to say, there is no marking of the boundary of the artwork or the boundary of so-called everyday life. They merge. And we the listeners in Cage's concert and the lookers at Rauschenberg's pictures were the collaborators of the artwork. It was a kind of collaborative, endlessly changing affair. The artwork was simply this organism that was alive. Sounds, coughs, police sirens, air-

conditioning, shadow on pictures. Cage later wrote that his effort was subsequent to Bob's.

— JM: You attended Cage's class?

— AK: I was doing environmental work at that time. We are now jumping to late '57 or early '58, when I felt inclined to take the picture off the wall. I began to do action collages, and action collages became bigger and bigger. Substances like electric lights and sound-making devices filled the entire gallery so one could walk into the work. I had an idea of using the image of Einsteinian space that was a total field, a unified field—nothing had a boundary. Neither my ideas nor my physical presence was the end of the artwork. It was a field in which events interpenetrated. "Events" was a word that Cage was using—borrowing from science, from physics—for his music, and which my friend and colleague George Brecht adopted in his own way.

I began to think about sounds and felt that I really wasn't experienced enough in these. At that time I told Cage that I was having trouble with the sounds that I was putting into the Environments. They had a random on/off and spatialized effect, because they were little Japanese toys, bells, and things that I put around the ceiling molding of the Hansa Gallery at that time, high up behind the drop-lights. You couldn't see them. You would hear sounds, much like in a forest where a bird sounds. There's the rustling of a leaf, or an airplane goes by or something in that kind of random fashion. I told Cage that I had trouble with that because, first, sounds are too simple when compared to visual and tactile elements—lights and so forth and the rest of the environment—and, second and more important, although for the first five minutes you could not determine some pattern in those sound occurrences, after five minutes you got to know exactly what was going to happen, and for how long. I said, "I'm more interested in a kind of randomness. Can you suggest what to do?" He said, "Why don't you come by my class at the New School the next day and we'll talk further about that." So I arrived at the class, and he said "Why don't you join us?" The class was about to begin. I sat through that class. I was so fascinated by Cage's intelligence and philosophical point of view. After the class finished, he explained very quickly how

to do tape music, for which I applied at Rutgers to get a grant to buy cheap equipment—which was all that one needed in those days. And those became the sounds for the next Environment [Hansa Gallery, February 1958]. This was much richer and much more randomized sounds. Bob Watts helped me on this, devising a randomizing wheel that went around slowly. It had bumps on it that had a bar across the top that had microswitches that switched on and off various loudspeakers so that it constantly changed. In any case, I asked Cage if I could take the class. And he said, "Of course." He was very gracious about it. Cage told me that I could be his guest without paying. I subsequently found out that just about everybody else was there free.

It was in his class that I did my first Happenings, with his encouragement. He asked me why did I want to study there, knowing that I was a painter. I said, "Well, I'm not interested in making music. I'm interested in making noise." He smiled and said "That's good." I was quite fascinated with the class and interested George Segal to come, along with other friends, like Bob Whitman. George was as fascinated as I was, but he never chose to take part in them, though I'm sure that the opening of the situation encouraged him to be more exploring in his own things; the sense of the everyday, of fragments of real environments, finding old things that you can use in your work certainly was an implicit part of Cage's music of reality. There's no question about that. It affected all of us.

I've always said that the first Happenings that I did were in John Cage's class. They were very noisy. I don't mean necessarily loud, although some of them were. One of these was an answer to the weekly assignments that he gave us. (He would always give us an assignment for a short piece that all the class would participate in, including Cage.) My pieces were usually scored, which was the word we used in those days, in such a way that it was prototypically musical, although modern in the sense that it didn't have staff lines. There would be a left-to-right lexicality in them. You'd see a line at the top of a piece, which would then have the part indicated by, for example, an electric saw. Then you'd have a duration on the line. I'd write minutes and seconds using this schema.

Then I would indicate placement, which is very important since I was interested in Environments. I even raised the question in class, which John discussed for a while. That suggested that he was interested in spatialization, too. I objected to the convention in most concerts, even of modern music, of having everything focused in one place. So, I built in several spaces into my pieces and moving sound sources, such as a person going *ahhhh,* moving from here to there, or going outside the classroom and going into the hallway, so you could hear a sound but couldn't see it. There was visuality that Cage emphasized. He said he didn't like records, compared to concerts, because he couldn't see the musicians sawing or tooting away. I objected at that time as well to the typical deep concertgoer that closed his or her eyes, or brought the score and followed it, instead of looking at this display of marvelous visuality up there. I tried to bring all of my environmental interests into that class.

— JOSEPH JACOBS: Were your Happenings in Cage's class carefully orchestrated?

— AK: No, they were carelessly orchestrated. There was precise formality to the lack of formality. Does that make sense? There is a paradox, I know. If you look at Cage's early method of chance operations, which consisted at that time of throwing coffee beans onto a big graph on the floor that was marked out according to occurrences in time and frequency and duration, and so on, the method was always a way of removing control, whether it is the control of the system that is apparent, such as a sonata form, or whether it is the control of the artist's taste. The system was actually an antisystem system. One which we would call a randomizer system, and which later computers would do with more sophistication. That was the system that I used: it wasn't carefully orchestrated; it was carefully deorchestrated.

— JM: How did you meet Brecht?

— AK: That's where my memory is very blurry. I don't remember how or when. But I'm going to guess here. Bob Watts, who knew George first, had been doing some collaborative or consultive work with George. I then met him. It was then after that we used to go to Howard Johnson's for lunch. Then,

the three of us got together—it must have been '57 or so—and devised a proposal called "Project in Multiple Dimensions." The three of us worked on that. We wanted to get a grant to set up an institute, hopefully at Rutgers, where we would be able to officially conduct experimental arts. Bob Watts thought that he might approach the Carnegie Corporation to fund this thing at Rutgers. It never got off the ground.

— JM: Tell me about your participation on the Voorhees Assembly series.

— AK: Bob Watts and I got together as a kind of appointed collaborative team between the two campuses of Rutgers University to help design a series of midday auditorium meetings, primarily for Douglass College. There was a very interesting dean at that time, Mary Bunting, who encouraged all kinds of experiments. She asked us to devise a series of midday meetings that arouse some sense of responsibility in the world, which was rapidly changing at that time, and a sense of where education might play a role. We thought that the buzzword of the day was "communication," and like so many theorists of that period, we were sure that mis-communication prevailed rather than communication. We wanted to explore what the nuances, overlaps, and ambiguities of those two words would be, and devise a series of lectures and/or performances to fill up the whole year, of which one was a visit by Cage and Tudor. In the spirit of the series, Cage prepared that now very famous essay of questions, "Lecture on Nothing." The whole lecture was question after question after question. Those kinds of heavy things like "What do you mean by meaning?" continuously arose. At the end your head was bursting, either with total irreverence, or with total confusion, or both. I think that David Tudor punctuated this with a random score of sounds on the piano.

I did my only Rutgers piece in this series. It was a series of discrete and overlapping events, such as the slow lighting of matches, the rolling of empty tin cans up and down the center aisle, the dropping of silk banners of different colors, unfurled at certain times. It had a very stately quality. I designed the piece for Douglass College with that early-American style of architecture, to make it in some ways harmonious with the formality of the space. The chapel piece used mirrors, too. There was a slow ritual lighting of matches, where I'm looking at my image in a mirror that reflected back on the audience.

My next public Happening was at the Reuben Gallery, which was called *18 Happenings in 6 Parts.* I simply had there the basic image or structure of a three-ring circus. I remember Cage was also enthralled with this, because he mentioned some of our traditions of overlapping and signal confusing as traditions like three-ring circuses. Three-ring circuses are set up in such a way that people who are at one end of the tent can't see what's going on at the other end. They give you a whole show on both ends and one in the middle as well—all of them discordant except in terms of the relative starts and stops. You can't really put them together in any kind of meaningful way. They aren't organized that way. So, I set up a three-ring circus space, in which there were three rooms that were simply framed out with one-by-twos stretched over with semitransparent film, where, of course, you could hear what was going on in all rooms, no matter where you were, but you could only blurrily see what was going on in the room adjacent to you. Events would pass from one room to another, as well as overlap in some kind of random way. Sounds in the three spaces overlapped, too.

That was my New York debut, as far as the semipublic was concerned. It was my first attempt to try to integrate an audience to the point where subsequently I would be able to eliminate it. I gave people little cards that suggested at a certain point they go from one to room to another. They could see from here to there to coordinate what the performers were doing. I remember orange juice being squeezed, and cups—orange juice was being given out to people in the audience as they moved from place to place, taking their cups with them. There were electronic sounds, clashing lights, as well as words that were said. At a certain point several of the painters that were in the movable audience were asked to come and paint on either side of the room dividers. What was seen on one side was seen, or leaked through, to the other side, and vice versa. We used house paint that would flow quickly, like blotters. One was

constructed of vertical lines. Another, circles filled the space. (So, you had "percentage" signs.)

Cage went to this. A week or so later we discussed it. I saw him on the street, and as my teacher, he said something like, "Maybe you'd be interested to hear what I thought." I said, "Yes." "Well, I thought it was a little romantic." He said he objected to being told to go from one space to another. I said "I didn't tell you. The random score told you, just as your scores tell musicians what to do."

—

INTERVIEW
WITH GEOFFREY HENDRICKS
—

New York City
October 24, 1995, and April 16, 1998

— JOAN MARTER: Can you describe the art department in Recitation Hall in 1956?
— GEOFFREY HENDRICKS: The Recitation building was where the library was when I first went to Douglass—on the two bottom floors, the basement and the ground floor. On the floor above that, the art department had one lecture room that held about seventy-five students. Adjacent to that was an office that held just enough desks for all of the faculty, plus the slide collection, plus a small desk for a secretary who came in a few days a week. All in one room. Desks were back to back, one near the window, another in the middle of the room, another near the door.

When I arrived Theodore Brenson was the chair. He was a Latvian artist who had been displaced by the Second World War. He'd been in Italy and came to New York with UNESCO, hired by Polly Bunting, I think. Then there was Bob Bradshaw, who at that point had been there the longest. He was assistant or associate professor. He was the son of an etcher from Trenton who did local scenes and had a regional reputation. Bob painted watercolors. He went to Gloucester in the summer and painted slightly cubistic scenes of the Massachusetts coast and New Jersey. Bob Watts was an assistant professor. Evelyn Burdett was assistant professor, who didn't

get tenure. She painted watercolors. She went to Cape Cod, Wellfleet, or around there. She taught art to home economics students, American art, and a certain amount of design—a good watercolor painter, expressive and fine.

Then I was hired as an assistant instructor. That was in the spring of 1956, when I was interviewing. I taught one section of the art history class, seventy-five students or so; two sections of an introductory studio class called Art Structure; and then sculpture. Sculpture and ceramics had been one class taught by Bob Watts, but it was heavily enrolled, and it was decided the year I came to break it into two classes. After that first year, I shifted and started printmaking, which hadn't been offered. So, in the summer of '57, I got a star press from Bob Blackburn, and later got an etching press from Charles Brand. I also was in charge of the gallery, which was a little room beyond the lecture room. It had two windows at the end—it was the width of two windows. It was a space that would have been a fine office. It was 15' by 30', or 12' by 24'. It was small.

In the attic, which was the top floor of Recitation Hall, we had space for the studios. It was unfinished, with steel girders. On one end—the far end toward the Raritan River—is where we had the foundation course, art structure and drawing. On the other end, toward George Street, Bob had sculpture and ceramics. Then in the middle was where painting was. When I got printmaking started, I got a corner of that separated off. So, that was it. At one end of this big central space was space for design and "Art Structure II," which was sort of advanced art making.

Now, the Rutgers art department at that point was in a small "art house," a converted private home. That's where the Rutgers College Center is now. It had a lawn in front. It had a sunporch in the back. When you went in the front door, there was an entryway. On the left was, say, a living room–parlor that was used for exhibitions. I remember seeing a beautiful exhibition of Bob Whitman's there: a cubic structure, very fragile, with tissue paper, metal foils, and wood, and so forth [1959]. Then on the right was what was probably the dining room, where they had their art history classes. It was a room that was 15 x 20 feet, if that. It probably had room enough to

hold fifteen students and a projection screen in the front. Then, the basement, it seems to me, was sculpture. There were woodworking tools, and they built things down there. On the sunporch, maybe they did some painting. Upstairs in the two bedrooms were the offices and the slide collection. Maybe a seminar room. I wasn't over there that much.

— JM: At some point, the faculty decided it should start a graduate program?

— GH: Yes. We had a lot of ambition. There was lots of talk about Black Mountain and what was going on there, and about the Bauhaus, and how can we get a similar, but of its own nature, kind of program going here. But we didn't want to do just anything. We wanted something that had a special presence— I would say myself, Bob Watts, Ted Brenson, especially. The three of us met with the people over at Rutgers, who were basically Allan Kaprow, Jim Stubblebine, who was a brand-new art historian, and Helmut von Erffa, who was chair. He'd been to the Bauhaus, and even though his field was Benjamin West, he was interested in new educational ideas. If we were going to get something interesting going, we really had to move on into graduate teaching. Since Stubblebine had just come to Rutgers, it was why don't you work with new lines that come along to build up the art history program, and we would build up the studio program.

— JM: Did you have a philosophy for this program?

— GH: We were there in the midst of new media and new thinking. Cage was certainly a guiding spirit. Kaprow was sort of spiritually there. It seems to me that it was in the spring of my first year, Bob Watts and I took our classes out to the beach. We made sand castles, poured plaster imprints in the sand, and did a range of site-specific artwork. We were both very involved in our thinking on education—new ideas. The whole program that evolved with us was not standard art class exercises. Certainly not. Departures all along. Bob Watts had this double background. He was trained as an engineer. He went on to Columbia and got his master's in primitive art. This had an impact on his teaching of sculpture. It opened up his thinking. But at that point, there wasn't a graduate program in studio art.

Indiana had a program. Ohio, maybe. One could go to Cranbrook. Iowa had a program too. Yale had a program. We started our program about 1960. The first degrees were given in 1962. At that time we were the one M.F.A. program in the East (other than Yale), and always one of the most open and cross-disciplinary ones.

Bob and I did a lot of talking privately about the nature of education—things we might do with students in classes. We were looking for a person in design. Roy Lichtenstein, who had come from Ohio and had worked in Cleveland in furniture design, was teaching in upstate New York at Oswego. He hated the cold winters and was determined and ambitious to get near New York City. He came here, arrived with a big old, maybe Chevrolet, station wagon, and had built this four-by-eight-[foot] case for the roof that held his paintings and showed us these early stripe paintings. In his slides, he was showing us his paintings of *Washington Crossing the Delaware, Custer's Last Stand*—playing with American history in a playful way—with the figures sort of stylized out of Picasso. There was a wonderful sense of humor about them. There was a playful quality about the way he thought anyway. And there was an openness. We were immediately drawn to him, Watts and me especially. So, we hired him. He came to develop the foundation drawing program and to teach design. I think his experience at Rutgers had a great impact for Roy becoming what he became.

—

INTERVIEW
WITH ROY LICHTENSTEIN
—

New York City
March 27, 1996

— JOAN MARTER: In one of your interviews, you say that "although I feel that what I am doing almost has nothing to do with environment, there is a kernel of thought in Happenings that is interesting to me." Can you comment?

— ROY LICHTENSTEIN: Well, there's more than a kernel of thought in Happenings that is interesting

to me. I put it a funny way in that interview, I guess. I was probably talking about the way Happenings related to me. Many of them tended to have American objects rather than School of Paris objects. I'm thinking of the tires, and the kind of advertising sort of things in Oldenburg's and Dine's Happenings. They were like an American street, maybe from Pollock in a certain way. The Environments are like expanded Pollocks; they are all-over in the same kind of sense. If I look at Pollock now, I think they're really beautiful; I don't get all of the gutsy stuff—the cigarette butts and house paint, and everything they're made out of. They had a big influence on Happenings. Because the Environment would envelope you the way that we thought that Pollock's paintings enveloped you—they were big and seemed to have no end. They were allover, and all of that. Some of that, I think, went into Environments, which were kind of a background for Happenings. I don't know if anybody else thinks this is true or not. But I'm just giving you my version. But the thing that probably had influence on me was the American rather than the French objects, the School of Paris objects. But, of course, the Abstract Expressionists had already bypassed the School of Paris objects, so it wasn't such a big revolution exactly. But the Abstract Expressionists still had the expressionism, which is a big part of Europe.

— JM: Was Allan Kaprow doing anything on campus when you arrived in 1960?

— RL: On campus, at Segal's farm, and in New York.

— JM: Do you remember anything specifically that interested you?

— RL: The tires he did [*Yard* at the Martha Jackson Gallery, New York, 1961]. Also other things with strips of paper and things written on them [*Words,* at the Smolin Gallery, New York, 1962]. I think the thing I most got from him was this kind of statement about it doesn't have to look like art, or how much of what you do is there only because it looks like art. You always thought artists should be original, whatever it was. I was doing Abstract Expressionism very late, 1961, and much of that was because it looked like art to me. Not that I believed that you should make art that looked like art. Allan was

important for me—the encouragement to do. He liked what I was doing and all of that. I was amazed at how much he actually liked it [referring to *Look Mickey* and the first Pop paintings]. Most people hated it at first. That was encouraging.

What I was doing when I got there [to Rutgers], I could feel that the [Rutgers] artists thought this was some old-fashioned kind of painting by an Abstractionist. I feel that they had a lot to do with me changing. Then I changed to cartoons, and I didn't think it had anything to do with anything I saw. Bill Copley did things with cartoons, and [Jasper] Johns did things with cartoons. But they were like paint-making cartoon kind of art. So, I didn't really relate the cartoons to anybody. But I realize it probably had more to do with Oldenburg than anybody. He had already done *Bacon and Eggs,* things that were merchandise and signs—they were funky. They were definitely American junk. That's probably the influence that I didn't realize, but realized after the fact.

— JOSEPH JACOBS: Were Rauschenberg and Johns an influence?

— RL: It's funny, I knew their work, in reproduction. I was in Oswego [teaching at the State University of New York]. I remember when Johns's *Target* came out in *Art News,* on the cover. That was exciting. I didn't get it, really. I thought it was nice. I didn't realize how important it was. The people I met at Douglass and through Kaprow were more direct influences on me because I knew them. Rauschenberg and Johns, although they were there and undoubtedly influenced me, I wasn't aware of the influences as much. I think all of that, the kind of fusing of objects in some way, making the painting an object—a composition book, or something like that, or mirrors—that idea really came of things that were definitely in the air. I guess the way that *Bacon and Eggs* was a thing. But also [Frank] Stella was doing concentric squares or something that might be a thing also. It wasn't a painting of it. It was the whole painting. That was kind of an influence.

— JM: In another interview you talk about the industrial landscape or the wasteland, you said that

you lived in Oswego and Ohio and that your background was in those areas. "It was almost entirely of industrial sludge, or advertising, or builders' houses, or the prosaic, the banal." Do you think as you came to Rutgers that you saw that New Jersey was more of the same?

— RL: Yes, I would say so at that time. I think the whole of America is really that way. That's what's different from Europe. There's a little more aesthetic input or something there. But I think what was new about America was the kind of commercial architecture and visual things.

— JM: Allan talks about this in the Bianchini catalog, the industrial landscape of New Jersey and how these artists all seem to come out of that environment.

— RL: I think it did. There are many parts of New Jersey, they're just completely advertising signs, junk, things that you think of as blight, but has a certain energy. The architecture is different. I mean, we had Frank Lloyd Wright, [Louis] Sullivan, and all those things, but we also have MacDonalds, and these highways, and that's what's different about it. New York City itself was, when I was growing up [Lichtenstein was born and raised in New York City], a kind of nineteenth-century leftover from earlier neo-whatever. So, I think maybe coming from New York and seeing this was a little bit like seeing through European or art historian eyes, rather than really being immersed in a Pop environment. I don't know if you really lived on the right highway in New Jersey or Ohio or any of these places that you could conceive of Pop Art because it would seem too normal. I don't know if this is really true, but if you really lived there and believed in this as a real environment, instead as something really peculiar, I don't know who would comment on it.

— JM: Somewhat earlier, you had this interest in American objects and advertising. Did something that happened at Douglass, specifically with Kaprow, renew this impulse?

— RL: I guess so. I was making a kind of Cubist dollar bill [Ten Dollar Bill, 1956], not a Pop one. The fact that it was a ten-dollar bill at all [suggests that] there was some kind of Pop influence on me that I wasn't aware of so much. They're really not Pop at

all. They're more funny, or humorous, or something. It's as though Paul Klee did Washington. Still, it's other people's work, and it has a connection with commercial art, vaguely. It may have been influenced by Larry Rivers. I guess it isn't really, because it's a little before. The big influence is Picasso, but it's Picasso's influence on Miró or Klee.

— JM: When you got to Rutgers and met Allan and saw what these other people were doing—that led into this?

— RL: Very much so. I was really worrying about what I was doing. Luckily, all the way through my art education, there was the idea that if you responded to the painting with the right color in the right place and so forth, you would be doing you—it would generally be you. I didn't realize it was really de Kooning. The idea that you had to be original was always there, but it was suppressed. I don't know what kids do now in class, because if you think you have to be completely original, how do you ever draw anything that's anything. Luckily I was naive long enough to learn something. Because I think you would be completely discouraged if you really understood how unique you actually have to be. There isn't a way to make that happen. I really stumbled on it. Even though I kept working, I was sort of in turmoil because of all of these new influences.

Then I did Mickey [*Look Mickey*], which is the first one [cartoon or comic-book image] I did. I did it as sort of a tryout to see what it would look like. I put it up in my studio, and everything else looked like mush.

— JJ: It's interesting you became original by stealing someone else's images. You became an image scavenger.

— RL: Yes, you're right, Yes, by doing something completely unoriginal!

— JJ: Did you ever see a parallel in the way that Allan and Bob Watts were scavenging objects and images?

— RL: No, I didn't. But I realize it now. I am sure that if I had stayed in Oswego nothing would have happened. I don't know what I would have gotten. It's amazing how much luck plays in this thing— being there at the right time.

— JM: I notice from one of the newspapers at Douglass that you participated in a show that was the Rutgers-Douglass Committee for a Sane Nuclear Policy.

— RL: Yes. I did a little atomic-bomb picture—an atomic explosion, a mushroom cloud. It looked like a little still life or something. It was very simply black and white, and I think it had blue dots. And that's all there was to it.

— JM: You were politically involved at that time.

— RL: Yes.

— JM: And the escalation of the Vietnam War?

— RL: Yes, I was against the Vietnam War. The military images are all about the serious militarist. But I don't know that they were antimilitarism, as a kind of macho heroism. Also, they made kind of interesting paintings. It's a subject that's not used in serious paintings. I liked that idea. They're these kind of cinematic views of things which come from comic books really, but they come from movies, where your viewpoint is maybe above the airplane or something. Just the silly way they were drawn. The whole idea of depicting these things. And the language.

— JM: Of the artists working during this period, you are one of the few who was a veteran of World War II. Does that have anything to do with it?

— RL: It's possible. I was in an engineering battalion connected to an infantry division. We met the Russians at the Elbe. I changed outfits so many times, I had all different kinds of experiences. Artschwager was in the same army.

But these paintings were probably before the Vietnam War, and I wasn't commenting on that war. Most people think they are. They are from 1961–62. The comic books at that time were about World War II—not about Vietnam. Some of them are inaccurate about the aircraft and everything else. But that doesn't make any difference to me. I don't think anyone wanted to touch the Vietnam War. The cartoonists didn't. So, they kept to World War II. Now the people come from outer space, and the comics are totally different. The style, too. They can do a lot more with color. It's pretty awful—too many options. It was much more skillful. Muscles are muscles. Everybody's angry. Now, nobody ever smiles in these kinds of comic books.

INTERVIEW WITH LUCAS SAMARAS

New York City
February 28 and March 8, 1996

— JOAN MARTER: I noticed that there was a show of Hans Hofmann's work at the art gallery in the Rutgers Art House. Do you recall that?

— LUCAS SAMARAS: It was a small show that Allan Kaprow arranged. It was terrific.

— JM: That was something you found interesting and stimulating?

— LS: Yes. Do you know what the art department looked like? It was a house. Some of the departments had houses. They weren't like regular schools, but a house with a living room. That's where they hung the paintings. One room had four or six paintings—small ones. It was like going into a living room and seeing on one wall this thing, and then there would be a window. This wasn't like a fancy show.

— JOSEPH JACOBS: Was the show food for thought for you, since your work was more radical at that time?

— LS: Hofmann was radical in the application of the paint.

— JJ: Did that have any impact on you?

— LS: Yes, I made some Hofmanns when I went to my room. I loved his vibrant colors.

— JM: Can you tell me about the Sketch Club?

— LS: The Sketch Club was something that George Segal had once a week. I believe on a Wednesday. Actually, the Sketch Club, by itself, wasn't that terrific. Usually it was a frumpy model with leotards. Whereas in high school, my teacher used to take me to a sketch class where there were real naked people. There was a huge difference. But George Segal was very nice—was wonderful. Bob Whitman was there also.

— JM: You were in a department that had a limited opportunity for actually making art. Were there classes in studio art?

— LS: Sam Weiner was a teacher there. They had some plywood tables made, and you sort of drew on top of that. They had no materials, I believe. In Sam's

class we did whatever we wanted. Allan from time to time was more adventurous. He would have a huge canvas or plywood, I can't remember, and he would have the five or six of us paint on the same painting. It was kind of fun, but unstructured. It was a little frustrating, because you'd do something, and someone else would paint on top of it. Allan was working out his New York ideas. He always approached art from an intellectual basis, rather than a gut basis.

—JJ: If you couldn't take art classes your freshman year, were you making art in your room?

—LS: I was always making art.

—JJ: Right from the get-go you were working with radical materials, such as toilet paper and smoke. Did Allan influence you?

—LS: Well, the thing about teachers is that you're always influenced by them, regardless of what you do. Whether it is something like them, or unlike them, you are influenced by them because they provide you with a certain set of ideas and then you either go with them or against them. There is no way of escaping that. But temperamentally, we're different. So, one ends up doing something different. What I got from him is like a permission: "You can do it, why not?" The permission came with something else, and that is a vague idea of what my background was; my background was Greek. He knew something about Greek art and Byzantine art. So, anything that smacked of that, he recognized. He would tap me on the back about it. It was reinforcement. Kind of helping you identify yourself through your past or your present, or whatever.

—JM: Did he encourage an interest in the Byzantine?

—LS: No. Because the real Byzantine came out later for me. The boxes, the jewels, all that stuff. Whereas, when I was in college, I was more exploring Impressionism, Matisse, and Cubism. There was no sort of direct exploration of Byzantine qualities.

—JJ: What inspired you to work with radical materials?

—LS: In the early fifties, I went to the Museum of Modern Art with my cousin. I saw a couple of shows there. I made fun of it at that time. Just like you

never thought of something, and then you just end up doing it. I remember something by Malevich, and collages and constructions by the Surrealists or Constructivists. A construction with pins of some kind—black-head hat pins. It was a constellation thing, almost like what [Lucio] Fontana did with holes. The museum had collages and so on, so it wasn't that big of a jump to associate already achieved works made out of unusual materials and then combine them with what was happening in New York.

—JJ: Did you go to New York on a regular basis?

—LS: The museum, two or three times. We went fairly often to Times Square. It was like a playland at that time. There was a wonderful place called Laff House or Play Land. There was a flea circus. On the first floor, there were games that you played, like soccer. Downstairs in the basement, there was a museum: a naked lady taking a bubble bath. They were living people. They were real. That was fantastic. It was like a circus, but very seedy. We were both embarrassed and intrigued. Just the idea of seeing a bathtub where a bathtub doesn't belong. This removal of an object from a real place to an unreal place was very shocking. Times Square and the Museum of Modern Art is what I remember.

—JJ: Did you go to the galleries?

—LS: That was later. I knew nothing about galleries in high school. When I went to college, with Bob Whitman, I went to New York. And Allan and George were members of the Hansa Gallery, so we went there often to openings. Eventually, we were invited to join them, but I couldn't because I didn't have the money. Bob Whitman did. He had a show there. But they showed me in group shows two or three times. Stable [Gallery] was around the corner. There were the ritzier places, like Janis and Kootz. And then around '58 Castelli opened. I saw Rauschenberg's show, and then there was Jasper Johns. That was quite incredible. So, we did some of that. And then downtown in '59, the Reuben Gallery was opened.

—JJ: I assume Rauschenberg and Johns had a big impact not only in new York, but also at Rutgers?

—LS: Well, Allan liked them a lot. He talked about

them. And then, one day, I think it was due to Allan, Douglass did this theater, and they invited Paul Taylor to do this dance [March 1958]. He brought some dancers. One may have been Trisha Brown. And they did a couple of pieces. They were incredible. Really wonderful. . . . John Cage also gave a lecture at the same time, or another time.

— JJ: Allan was so plugged into John Cage and breaking down the boundaries between art and life in his work. Did that have an impact on you? Kim Levin states the opposite by saying that "you were at war against ordinary reality," that you were trying to make it magical?

— LS: Whatever Allan did, he kind of avoided a kind of theatrical punch. Whenever Cage did something simple, like connecting his neck to a microphone when he drank water, the water going down his gullet was magnified—magnifying and dramatizing something simple like drinking water. Allan would have somebody squeeze oranges, and that would be it. It wasn't my kind of thing to do that bit of reality. I always want to do something else to it. It was almost like he was more into game theory, rather than phantasmogorical theory. But just the fact that he did what he did was naturally an opening to the rest of us.

— JM: I'm interested in your early work—the pastels and paintings?

— LS: They were in categories. There were still lifes, with vases and stuff. The other one is sort of an abstract category. On typewriter paper or that size that is covered with silver paint or other kind of paint so it's one whole surface of this strange-looking material. Or stripes. I do stripes behind still lifes, or just stripes by themselves. The big man at the time, in the midfifties, was Josef Albers. With Albers there was a square within a square within a square. But the squares were at the bottom. It interested me to put things at the center. I did a folding screen that is at the museum at Rutgers. The top part is tinfoil painted silver, like radiator silver, and at the bottom there are rectangles, painted with paint. The big thing is, if you make a painting of flowers or something, and if it didn't turn out very well, you'd scrape the paint, or you'd go up and down with the brush and get a kind

of muddy gray or muddy brownish tone. The painting is gone and everything is mixed together; one painting is produced. So, for some of them, what I did was I took the brush, and I made the brushstroke create the form of the painting. One side goes from the top to the bottom, and then the edge, and the top, and with each stroke you'd come closer and closer to the center. You'd have a meander, kind of like a target, but it'd be a square. I made some of those around '58. In retrospect, it was what Stella was doing at the same time, but he was doing it with rulers. With me, it was like making a pizza—it was the organic quality. That sort of interested me—the ability of making out of paint a construction. It looked like a construction, even though it was paint. If you see that screen, you'll see what I'm talking about.

— JJ: Why flowers?

— LS: There were flowers and bodies. Good question. I don't know. It's sort of a symbol for an explosion. An explosion or an emission. Consider the volcano. When you're a child and somebody gives you a pencil, you draw a volcano, an explosion. Well, it could be a volcano. It could also be something sexual. A flowerpot has a kind of phallic shape, most of the time, and then come these stems and specks, so it's a kind of emission or explosion. It's almost as though you're translating an ejaculation into a visual—the ecstasy becomes visual, instead of sexual. Suppose you boiled down your essence—your being, your past, your feelings—into an object or shape. What shape or many shapes would it take to describe you? I think for me, a lot of the things that I do have that kind of phallic basis.

— JJ: Do you feel there is something spiritual or religious that figures into your work as well?

— LS: It has to, because of my background. But there is kind of a mix-up. On the one side, it has to do with something magical that is done for the purpose of doing good for people. The other side has to do with the dramatics, the pyrotechnics, the pizzazz of the individual. In the Greek Orthodox Church, it isn't like the Quakers, where there's just some wooden furniture. There are paintings, gold, and incense. The priests have these magnificent

brocades and silk and crowns. It's drowned in jewels and color and so on. Spirituality has both these elements.

So, even when I think of a monk in the Greek Orthodox tradition, you have monks living alone in a cave. Going close to a priest you'd have the odor of wax in the beard, almost. You'd have this organic odor that you'd connect to the priest. There's this excrescence of this coating on the individual. A monk or an ascetic in a wood cellar, or in a church—in either case there is an added thing, an organic thing.

Then you add on other things which have to do with the age that you are—fifteen or seventeen or twenty, whatever. You then have the problem of joining into society. Are you going to do this thing? Are you going to do this other thing? How will society or your family like it or not like it? In the process of alienating myself from my background, they didn't want me to become an artist. I had to create another basis. It's almost like you have to create another ethic for yourself. Because middle-class ethics suggest you do this. If you escape that middle-class thing, then you have to create another set of ethics to survive, to survive with dignity for yourself. That's where the spirituality comes in. It's a device, or shield, or weapon, or food, so that you can exist.

— JM: Were you at George Segal's farm for Allan's Happenings?

— LS: That was in '58. That's when the four of us [Kaprow, Segal, Whitman, and Samaras] were very close. That was a different time. When the Happenings occurred in spaces or lofts, at the Reuben Gallery, that's when they became really important. Before that, it was a combination of a party and some loose structured stuff. I don't think it was anything to be proud of. Whereas in the gallery, it forced people to deal with the Happening.

— JM: You were in *18 Happenings in 6 Parts*. Was it your feeling that there should be more structure?

— LS: Yes. In Allan's Happenings, he used people as they are, without any modifications. Whereas in traditional theater, you make yourself be somebody else. With him, it was how you are. Whereas with Oldenburg, you became somebody else, and it usually was a character, a readable, recognizable character.

With Whitman, you became a fantasy character, somebody from dreams. So naturally, I gravitated toward those other two. There was something banal about just being myself. It was too banal for my character. There was one where I got up and gave a speech in Greek, and even that was too much for me. Because you couldn't hide under some clothing or something like that.

— JM: When you assume a character in a Whitman performance, do you wear something?

— LS: Well, they were ordinary things, but extraordinary. He would cover you with newspapers and little balls, or whatever. It wasn't traditional theater, and yet, you would have a character. You'd be somebody fantastic. So, generally, yes.

— JM: Was there actually a script or some kind of direction?

— LS: With Allan, there was a script. It's time to do this, and it's time to do that. I think that came from Cage, because he liked scores. It was not a script like in traditional theater. It was structured.

— JJ: What were Oldenburg's Happenings like?

— LS: He was not as fantasy oriented. Essentially, Oldenburg came from the gutter, and the street. It was like a Lower East Side street. It's as if you went down a dirty, grimy street with dark, burnt-out garbage. Out of that a kind of figure emerges. That's like a symbol with him. All of his poetry, all his Happenings, essentially came from that—where a character would come with a suitcase, and the suitcase would be opened up and there would be magazines inside, or combs, or things. Everything came from that—the social dregs of the city, a social situation. With Whitman, it was a dream. Nothing to do with streets. It was a fantasy level. With Allan, it was like a middle-class situation. He tended to be more literal. He would have someone squeezing oranges. It comes out of the home. He doesn't have the glue of the others. Whitman had a more oneiric dream glue. Oldenburg had a more street-level glue. Kaprow had a bourgeois glue. But bourgeois is the wrong word. There was cleanliness. Maybe a laboratory. Some kind of laboratory. Or it could be a playground. There was something clean about him.

— JM: What was the audience response?

— LS: Whitman created a situation where at the end the audience would burst into applause. I think there would be laughter, but not a jokey laughter. More a thrilling laughter, a spectacle laughter.

— JJ: The applause was because something really special has just transpired?

— LS: Yes. There was a lot of physical movement in his pieces. He would knock himself against the walls. There was physicality there. You would go to ballet, like Cunningham, and you'd see some elegant movement. But you'd come to a Happening, and you'd see people in danger of killing themselves in front of you, in an artistic way.

— JM: Did Oldenburg have anything to do with your introduction to food as a theme?

— LS: No. It's the opposite. I did my food before he did his store. I did them in 1960 in the Reuben in the summer when it was closed. His stuff appeared in the fall of the following year. He was brilliant at it. His pie looked like a pie. Whereas with mine, the materials that I used were inedible and dangerous. But I think he was interested in food before that. I think he made me stop doing my plaster work because he was so good. It was the opposite of inspiring.

— JM: When you introduced the box in your work, Allan made a box, *Grandma's Boy* . . .

— LS: It's not a box. It's on the wall and opens up. It has a mirror in it. Cornell was the one who was making boxes at that time. Then you can say that Rauschenberg did boxes. I think most of us in various degrees that did work that then became associated with us were thinking in a way that was a transgression of some kind or other. For George to make a figure, it was a transgression. For whatever Allan was, it was transgressing. For my making a box, it was a transgression, because you're supposed to make a painting, you're supposed to make a sculpture, but a box? A box is something that holds jewelry or something. It's not for art. I'm thinking that way, rather than of Cornell, because Cornell is basically vitrines. Nine-tenths of his work is a vitrine. It's box-shaped. It's glass. You look, and you see something. With me, it was the idea of opening.

—

INTERVIEW WITH GEORGE SEGAL
—

South Brunswick, New Jersey
September 22, 1995

— JOAN MARTER: When did you meet Allan Kaprow?

— GEORGE SEGAL: In the early fifties, a mutual friend introduced a newcomer, Allan Kaprow, to me. He'd just gotten a job teaching art history at Rutgers [in 1953]. We'd discovered we came from the same corner of the art world. He had studied with Hans Hofmann, and at NYU [New York University]. From 1949 to '50, I decided to go back to school at NYU to get a degree in teaching art in order to support myself while I did my own fine art. My teachers were [William] Baziotes and Tony Smith. I had already gotten credit for my Rutgers courses, briefly went to Pratt, and seen Abstract Expressionist work. I was so attracted to the look of Abstract Expressionism that I instantly switched.

I found Tony Smith both cultured and exhilarating. He had a profound impact on my thinking. I had a painting class with Baziotes. He came on talking tough, like a New York City cab driver, but he was very sensitive. He encouraged me to jump on the bandwagon of the history of art [to make Abstract Expressionist painting]. But I found myself incapable of painting pure abstraction. I listened to all of the lectures, and I was unresponsive. I took my lunch, and I'd set up a still life, and I'd paint it. It was derivative of Cézanne and Matisse. He let me alone. I refused to listen to what he was preaching. I would skip class. I couldn't work the way I was being encouraged to. He gave me a B. I was expecting him to flunk me.

[Tony] Smith was a realist. He said, "In Italy you stumble on public art in every small town. You can drive three thousand miles across the United States and not see anything at all." His passion was poured into industrial buildings. They were the genuine art in the United States at that time. He likened the experience of Abstract Expressionist painting to flying in an airplane above the western desert. He preached the reality of the new Italian

films that didn't have Hollywood gloss or decorative sweetness, but were dealing with smashed ruins of Italian cities after the war. I was struck by his grasp of reality as expressed in these movies.

Years later I met Meyer Schapiro. He would come visit at the Hansa Gallery and talk about art. Meyer would talk about the virtues of pure form, but was always connecting it with tangible reality—the need to start with reality, the transformation of reality into expressive artwork. Meyer was passionate about the making of art—the experience of art as a great primary experience. It could be central to somebody's life, and it could be packed as richly as possible. There were echoes of the marriage of reality and pure abstraction in Tony Smith's art; and I had this huge admiration for Duchamp and John Cage.

— JM: How did you find out about Cage?

— GS: Kaprow took me to Cage's class. Kaprow had studied with both Meyer Schapiro and Hans Hofmann, and he knew all about John Cage. He took me along to audit Cage's classes at the New School. He was preaching mushroom identification [Cage taught a class on mushroom identification in addition to music composition], but he was talking about all of his ideas, which involved these radical innovations in the way we see and the way we draw and paint—opening up the possibilities for inventing totally new ideas to express experience. His experience was involved with his great love for Abstract Expressionist painting, but also connecting it to the tangible visible world. So, there it was again [the connection to reality].

I was beginning to build my own convictions as I was making these connections. These were ideas that were floating in the air. And it was common to my generation of artists who started out loving Abstract Expressionism and at the same time questioning the validity of dismissing the real world, or tangible world. De Kooning and Pollock were under terrible attack by people like Greenburg and other painters for the fact that they had not wiped out every vestige of tangibility.

— JM: Allan wrote an article about the legacy of Pollock. What did you see emerging from Abstract Expressionism?

— GS: We both agreed that what we were attracted to was what we considered to be a correction or an improvement on Abstract Expressionism. To put it simply, I think we both recognized the validity of pure form. The fact that if you increase this much red in the canvas, it says something different than a tiny amount of red—a red dot. The form in an artwork is essentially the language of the artwork, not the end result. I think it was a dismissal of free-floating inter-pretations that could be personal to everybody else, to be left to the individual person—that the list of associations with the pure form, pure colors, and the pure shapes varied. I thought it was too loose and ambiguous, and I wanted to introduce the real world, but in terms of my own experience. And the prece-dents for that were locked in the work and attitudes of Cage and Duchamp.

These ideas were in the air. It was a dissatisfaction with the limitations of pure abstract painting. Nobody knew what the new work could or should look like. Each individual's freedom was encouraged. Since nobody knew what the new art should look like, each of us was free to invent our own solution. That implied an insistence on following your own personality, nature, and temperament. And then it implied, just as strongly, an applause and good reception to everybody else's invention. It was probably the origin of pluralism.

— JM: Who else do you include in this forward-thinking group besides Kaprow?

— GS: Kaprow and I called ourselves the New Brunswick School of Painting. You could absolutely include Watts, Geoff Hendricks, Brecht—you know, there's a whole list.

— JM: Is there something specific about calling it the New Brunswick School of Painting, or was it just that you were all here?

— GS: We couldn't have had any of these ideas without long-term close contact with ideas in New York. That's a given. The New Brunswick School of Painting is self-mocking. It was self-mocking about our own sense of self-importance, I think. That's the way I see it.

But this whole school of ideas began to produce a long list of personal invention out of each artist. I think a lot of people do not recognize the

connections. It was really built into the attitudes to encourage diversity and invention.

— JJ: Did you and Allan talk about the philosophy of art at all?

— GS: No. But Kaprow would give me full lectures. Kaprow was forever writing another article. We were agreeing and disagreeing. I think the arguments and disagreements were fruitful for us. They helped me a lot. Kaprow was in the middle of working out his Happenings. Dine and Oldenburg were incorporating his new ideas, which would appear in his next article. I was resisting the idea of making Happenings. I refused to make Happenings. I was influenced by these new ideas to where I wanted to make sculpture that was off the pedestal. When you put an object on the pedestal, it creates its own psychological space. It's divorced from a real environment. I was insisting on putting objects in my own space. I wanted to enter the space myself, encircle it, and be able to see a series of objects from many points of view. But I wanted something permanent, to which I could return again and again, as people return to a painting or a sculpture. I was less interested in making Happenings and ephemeral things.

— JJ: Do you think there was a dialogue between Kaprow, Dine, and Oldenburg?

— GS: I think they shared all the ideas that were in the air at the time. There was enough talk. The entire group knew about Cage.

— JJ: Can you remember any specific assignments in Cage's class?

— GS: The one class of Cage that I attended, he had asked his students to make paintings that could serve as notations for musical compositions. I was leaning against a back wall hoping he wouldn't notice me, because I was unregistered. One fellow had made a string of small paintings. I looked at them, and in my eyes, they were dead-ringer imitations of Josef Albers. So, Cage calls on me to make some sounds based on those paintings. I was silent. I couldn't do anything. So, he asked me, "Why can't you make a sound." I said that "all I could think of was why did this fellow bother imitating Josef Albers so perfectly." He burst out laughing and said, "We're going on a nature walk next week. Would you please come along?" That's

how closely he connected visual imagery with his own concerns.

— JJ: Robert Frank passed through South Brunswick in 1960?

— GS: He slept in my basement. Robert was connected somehow with the Hansa Gallery. He knew all the artists in Hansa. The same Walter K. Gutman who gave me a grant gave a grant to Robert to make a film. He filmed the *Sin of Jesus* here. Walter had given him some money, and he was going to be finished in six weeks. It stretched out six months, but it was terrific. He used my buildings, and he filmed here, locally around the neighborhood.

He took, I think Isaac Singer's story of Mosca—she was a chambermaid. She had one terrible fault. She couldn't resist going to bed with a lot of men. And she got pregnant. And she complained to Jesus to help her out. Jesus helped her out, and she goes back to her life and goes to bed and to her old promiscuous ways. He got angry at her. His sin was to get angry at her. Robert transformed the story to someone who worked on a chicken farm in New Jersey.

I'm a longtime admirer of Robert's photography. He is great. In a strange way, his photography is equally about mastery of pure form, extraordinary original composition, plus a social conscience. He comes out of Walker Evans and the FSA [Farm Security Administration]. He comes very much out of those same attitudes.

— JJ: Did you get involved with the film at all?

— GS: Yes. A lot of stuff was in my father's barn, which was burned down years ago. I used to make him sets out of old furniture that was abandoned in the place. Can you imagine? It was thrown out by farmers who were Depression types. I used to love to look at the furniture with its sturdy forthrightness, lack of decoration. All that furniture looked marvelous against the rough-hewn boards of the oak barn. I built sets for Robert.

— JJ: Were these sets total environments that may not be unlike your work?

— GS: That's right.

— JJ: Did Frank's talking about social issues and realism affect you?

— GS: Sure. I think Robert is absolutely connected.

— JJ: Was he more an influence on you than the Rutgers artists?

— GS: Influence is a strange thing. Shared values is more accurate.

— JJ: But you created these sets that evolved into your art in a way?

— GS: Yes. But it was really the furniture. They were found objects on a farm.

—

INTERVIEW
WITH ROBERT WHITMAN
—

New York City
December 15, 1995
and Warwick, New York
March 14, 1996

— JOSEPH JACOBS: You graduated in 1957, when Lucas Samaras was just a sophomore?

— ROBERT WHITMAN: Yes. I stayed there a few years after I graduated until I could find somewhere else to live and work. So, I saw Lucas, Allan, and George fairly regularly. I was living in Highland Park and making art there.

— JJ: How did you happen to drift into art, as opposed to theater?

— RW: I can't remember which came first. It seems to me I had a sense that the art world such as it was in New York was more dynamic, and radical, and interesting, and energetic than what I understood of the theater world, or the playwriting world, which was my primary interest when I went there. In a bizarre way, it is still my primary interest. You want to go where the life is. For me, it was all new. Strangely enough, I'd been following whatever surfaced in the popular magazines of the time about vanguard art.

So, I took a class with Sam Weiner in art history. I think there was a show of Hans Hofmann then. I remember that show in particular because it was the first time I had seen his work, and I was impressed by that kind of energy. I remember before Lucas got there, there was a show of Lucas's work— as a high school kid—and that was impressive. The shows were in the Art House, which was about the size of this apartment. There was a little sitting room

where they would have shows, and a bunch of old art magazines lying around. I met Lucas right away. He was unusual because he was painting at that time with a certain kind of focus.

I took a course in art history with Allan Kaprow. That would have been in modern art. I wanted to take Allan's studio course, but he didn't think I had the background. Sam Weiner interceded and said I should take the course. Lucas was in the course at that time. We worked in the basement of the Art House.

— JOAN MARTER: Were you involved in the Art Club?

— RW: Yes, I was involved with the so-called Art Club. It was called the Sketch Club. It was Lucas, myself, and a couple of other guys and Segal. George was actually good and pretty clear about certain stuff. But the whole deal is you give these characters something to do in one place at one time so they can hang out together.

— JM: Tell us about the art you were making.

— RW: I did an installation in the Art House. You have to understand that Lucas and I would sit around and yammer at each other about why is this stuff on the wall, why doesn't it do this, why doesn't it come out into the space. Why doesn't it move, and so on. That's where it came from.

— JJ: Is this a result of anything going on in New York, or because of Allan?

— RW: That part is a little unfocused. I think we were all feeding off of each other, including Allan. And Allan was giving us the opportunity to be as crazy as we could be. I suppose he needed that energy too. Occasionally we would go out to Allan's house.

— JM: Can you describe your Art House installation? Was it like the one you did later at the Hansa Gallery?

— RW: No. It preceded it. It was flatter. I couldn't take over the whole space. It was about six feet high, maybe two feet or eighteen inches deep, and just things sort of supported or hung in this space between a framework of cheap wood. I wasn't into Old World craftsmanship!

— JM: Was it made of paper?

— RW: Could be some papers, paint on paper, aluminum foil, maybe some wire, plastic. That's the

kind of stuff I would be using. They are very fragile materials, which was something else I was interested in. I had this idea of making something as fragile as you could possibly make it, and it would have a life, and it would change. First of all you wouldn't want the frame. I wasn't very rational about what I was doing. I was just trying to bring all of these things together. Where I was going with all of this was trying to develop a vocabulary where I could use the space as part of a dramatic or theatrical vernacular.

— JM: Did you attend any performances at Douglass?

— RW: I'll tell you what I remember: this was really interesting and important, in a way that I enjoyed. Paul Taylor came to Douglass, and with him—and I don't know if I'd met Bob before—came Bob Rauschenberg and David Tudor. (I've been involved with both in later projects.) David did the music.

Now, this piece is so uncharacteristic of his work as you may know it now that you can't believe it's by the same guy. My own feeling is at the time he was deeply under the influence of Bob and Cage and the community of people around them. His stuff wasn't dancey. It was beautiful, and it was great. Let me tell you about one piece that really struck me relative to my own interest. The sound for the piece was done by Bob and was taken off the telephone live. When you called the time in those days you got "The time will be exactly 10 minutes and 29 seconds. Bong." So, every ten seconds, you got this "bong." Paul Taylor did this thing in a suit. He started out every ten seconds making these gestures [Whitman makes a frozen gesture]. He went through a series of gestures with his head. Then he turned his torso. Eventually, he was doing a full body movement and bent down to the floor. This is all in a suit. It was wonderful. He did another piece. The curtains opened and the three of them came on stage in normal clothes, but did poses, like a tableau. There was just a wind coming from off stage. The music for it was Cage's *4'33"*. He did another piece—David was playing the piano. You can see how wonderful this concert was. This series of images that was quite spectacular. It was just Paul Taylor and two other people. I don't remember who they were. Two women.

After I saw Paul Taylor's thing, I started writing a piece of my own—a totally different thing. It wasn't dance, and it would be presented in a space and not on a stage. As I remember, I had something in a space. I composed other things—walks in the woods and whatnot, but they don't count. It only counts when you sign your name to it. I took Allan and Red [Grooms] on one [fall 1959]. It was great. I had figured out a way to go through different spaces and different terrains, and so on. That's all. Then Allan did *18 Happenings in 6 Parts,* which was at the Reuben Gallery. By that time, I had decided that that was what I was going to do. I was going to do performances.

— JJ: Is Red Grooms important to you?

— RW: I met Red when Allan, who had met Anita Reuben, was running around trying to help her get artists for the gallery who would be full of energy—energetic and young and dynamic. Lucas and I went up to Provincetown [summer 1959] to meet Red at one point. I didn't see Red's performance [*The Walking Man*]. He had done an early performance up there of painting a painting [*A Play Called Fire,* 1958]. He had painted a painting in front of an audience and jumped out of a window. So, at that time, some of us were in various group shows and whatnot—Red had an associate named Jay Milder, and Lucas and myself, and Jimmy [Dine] and Claes [Oldenburg] were sort of coming together at the Judson—and there was a nice coming together of a bunch of crazy people. I'm getting back to Red. He did *The Burning Building* at Delancey Street [December 1959]. I took Bob Rauschenberg there, and I took Jimmy Waring. It may be my own bias, but because of Cage—and I think a slight mis-understanding of Cage—there came about this kind of cool abstract activity. The kind of content that is just without any kind of vibrance. They move a coffee cup on a table, and they call it art. It's very conceptual and precious. I wanted people to see what Red was doing, which was raucous, energetic, and romantic. Although my work doesn't look that way, it's something I identify with. I've always thought of my work as being very romantic as well. With *American Moon,* what could be more romantic?

—JM: Lucas recalls your work as being very physical, and there were sort of daredevil things?

—RW: Well, they were definitely dangerous. I have had people inadvertently get hurt. I had a piece where somebody would be kind of . . . Let's say you put something real soft in the space on the floor, and they start off at a level like this, and they project themselves into the space. Then a flash camera goes off so they get a sort of frozen midair picture or something. So, this guy now has to take this horrific jump off this thing and hit himself into the wall. It was just nuts. At a certain point, I couldn't handle it anymore. Also, after *E.G.* [Reuben Gallery, June 11, 1960] in particular, I realized that the audience was responding more to the pace and the action than they were to the form of the piece and what was going on. I mean the images. So, this was my last, fast-paced, passionate, violent piece. *American Moon* was right after *E.G.* That's when I calmed down. The thing is, I was really interested in being able to change the space and the architecture. For me, it's kind of important, the psychological and evocative nature of actual architectural changes of the space.

—JM: The fact that people are swinging on swings in *American Moon* means there's a certain amount of physical activity. Do you see this as having any relationship to the circus?

—RW: Yeah. Not in that way, but in the circus in that it is physical and nonverbal. I think we discussed all of that before. To me, at least, consciously, the circus is very important.

—JJ: How did everyone perceive Happenings at the time? As part of the visual arts? As theater? Or did anyone even worry about it or care?

—RW: I thought of it as theater, personally.

—JJ: But not in a theater environment—an art environment?

—RW: Yes. Maybe you can see the bleak self-deception of youth, but the most dynamic cultural force at the time were the visual arts. Most vital. And the audience was most sophisticated, I think, and demanding. I am talking about it in a broad sense, not intellectual. The part that excited me, from my point of view, which is as I say a theater point of view, is that they were going back to what I think of as the roots of performance—of theater—where you're not relying on words. The plague of Shakespeare is that he wrote good words, and all the other playwrights decided they could get rid of all the other stuff and just write good words. They forgot that most of the people of the world spent most of their time not talking. They're looking at things and feeling things. And they're moving through space. The spiritually most rewarding parts of their lives had nothing to do with talking. Anyway, that's just my bias. So that where I put Happenings—in the theater.

—JJ: What were the sound sources for your work?

—RW: In *American Moon*, there was a lot of noise involved in making the piece that I incorporated into the piece. There was a lot of rustling of papers. We blew up this balloon with vacuum cleaners—four vacuum cleaners. And that was a lot of noise. Why weren't people scared? Because they were in the tunnels. But above the tunnels, in front of where the audience was sitting, I built a place where the people who operated the piece were on top. There was one section in there that was all loose boards. There was one section where people up on top were jumping up and down on these loose boards that would be over your head, making this kind of racket. In *American Moon*, I did a tape recording of a loud buzzing sound at the beginning of the piece.

When I think about Rutgers, I wonder how these events came to be. It was a bizarre series of coincidences that brought these people together.

—

INTERVIEW
WITH LETTY LOU EISENHAUER
—

New York City
April 26, 1996

Letty Lou Eisenhauer was an undergraduate at Douglass College from 1953 to 1957, and a graduate student in the M.F.A. program from 1961 to 1962. As an undergraduate and graduate student, she studied art principally with Robert Watts. Today a professor/counselor/forensic psychologist at the Borough of Manhattan Community College, previously Eisenhauer was an artist, art educator, and art historian, and is known for her performances in Allan Kaprow's and Claes Oldenburg's Happenings.

— LETTY LOU EISENHAUER: I graduated in '57. I came back as a graduate student somewhere around 1960. It was the first year Roy [Lichtenstein] was there, whatever year that was [Lichtenstein started in September 1960; Eisenhauer in February 1961]. I came back from living in France for several years in February of that year, as a graduate student and as the department secretary. The deal was, I would get to be a graduate student if I would be the department secretary. I had to fight every step of the way to get the graduate courses because Reggie Neal did not want me to do both. He wanted me to be a nice little female secretary.

— JOAN MARTER: Did you work with Watts then?

— LLE: I always worked with Watts. I have to tell you my earliest memory of Bob Watts. When I was a freshman, I went to my first art class and I remember coming back to the dormitory and saying, "I have a REAL ARTIST for a professor." I was totally taken. He had that effect on his students, both male and female, but particularly on females. He was charismatic.

— JM: Wasn't Geoff Hendricks teaching art history?

— LLE: I don't remember him teaching art history. I remember him teaching graphics. The plate for a print that I produced during that time was subjected to every known hammer or chisel I could find and beat to death. I would try all kinds of weird things. We were encouraged to experiment. What happened was that people like Bob and Geoff opened the door for experimentation. This was a questioning of the formal methods for creating art. Anything you wanted to try you could try.

Bob had a great sense of humor. He loved to make jokes and his art often had a double meaning. It made a joke that was also a satirical comment. I can remember one important instance which I believe colors much of his work. After he completed an early moving piece [pointless movement] with a record and a raccoon tail as major elements of the sculpture, his wife commented, "And I thought I married a great man," and walked away. Until shortly before this, Bob was primarily an abstract painter whose abstractions reflected the natural environment of the landscape and rocks of Monhegan Island. She meant her statement, and Bob chose to name the sculpture

And I Thought I Married a Great Man. It was in the show he did at Grand Central Moderns (December 1960–January 1961). I helped him install the show.

Although there was humor and playfulness in Bob, it was difficult to perceive. Because he was so straight in his presentation and his voice was so deep, others thought he was straight about everything. Ninety percent of what he was saying was a joke. As a student and potential artist he could hurt your feelings if you did not understand him. That was the difficult part of being around Bob. The rewarding part was that he seemed genuinely concerned about his students, their potential and eventual success. After a while you got the sense that everything—his entire house, his life—became artwork and something that could not be taken seriously; for example, the two pie plates nailed to a post in the yard to create a primitive flying saucer to encourage the real thing to land. Or was it to be taken very seriously?

— JM: What else was in the Grand Central Moderns show?

— LLE: It was a wonderful show as I recall it. It was games—and he incorporated lots of toys. I have one of the toys, a small windup frog that jumps. The frogs were in a sandbox. This is Bob being Japanese. He would clear the sand and make it nice and smooth. And then the frogs would jump a race, leaving behind a trail, their marks in the sand.

Bob created Japanese landscaping or gardens around his cavelike home in Mountainville [New Jersey]. He had similar planting around the former house in Oldwick. Bob and Virginia were both great gardeners. They did all kinds of rock-garden installations with sand and pebbles. This style was probably connected to the late fifties/early sixties period when Eastern philosophy, art, and literature impacted on Americans. There was what I call a Zen period that both Bob and George Brecht went through.

One day Bob took me to see George Brecht. I had been to George's country farm home, which was very personal and full of the box pieces he was then doing. George's new digs were in a garden-apartment complex. I walked into a room in which there was nothing. Nothing except a bedsheet hanging on the wall, which looked as if it had been exposed to tie-dye. A bowl of daisies was on a low

table, and a bunch of floor cushions were artfully arranged. The sheet in fact had been exposed to a chance process using the *I Ching*. George had gone from a highly personal art statement to a Zen world. That was Bob, too. Somewhere in all the complexities that formed Bob Watts was a Zen center. It is fascinating that Bob had within him the venerable orderliness and quietness of a Japanese garden and the iconoclastic irreverence of Dada. My own library still contains books on Eastern philosophy and Zen which I date from that period of time.

Another one of these peculiar dichotomies was Bob's preference for Howard Johnson's restaurants. Back in the 1960s, Howard Johnson's was Bob's favorite place to eat. "Quality food. It's always the same." (Later he became more sophisticated, but not too much.) Isn't that bizarre? I was thinking about this aspect of him when I was collecting stuff for this interview. I remember Bob making his meals on trays. And it was always measured. You would get so many peas. It was like some of his pieces: the plastic chops that he did later. It was so orderly. You would take your tray in and you would put your tray down on the table. Eat. And when finished, you would take your tray back to the kitchen, where it was easy to clean up and put it back into its place. Everything had its place. If Larry used the workshop, Bob would complain for days that things were out of place. He often would take tools out of my hand and replace them, saying, "The right tool for the job." But when it came to art, he would break all the rules. He would be wild.

Back to the show at Grand Central Moderns, which was a rule breaker. It was an art exhibit that was in the dark. I think Bob actually blocked the windows with paper. That was because there was so much stuff that lit up. It was like a great big Christmas tree. *Pony Express* was in that show. A piece with a pair of trousers dipped in acrylic resin and dried fully inflated as if there was a body in them. These stiff legs waved [motorized] in the air in contrast to an opened and lit umbrella. There was also a piece that went around in a circle, kind of like a merry-go-round. Many of the pieces had flashing lights on them. There were game pieces such as the previously mentioned frog game, and maybe the

marble game, which I have. And, of course, a piece of upright wood with a record and a raccoon tail randomly swung back and forth. It was *I Thought I Married a Great Man*.

— JM: Did Bob know Jean Tinguely?

— LLE: Sure. Jean had a show just about that time. They knew of each other. But I believe they were about two different things. Spiritually they really didn't communicate at all, and linguistically even less. While Bob appreciated the Dada aspects of Tinguely's work, Watts was also concerned with permanence. As I understood Jean, he accepted the changing (falling apart, breaking down) of his sculpture as part of its evolution, while Bob, ever the engineer, repaired/restored pieces.

I had been dimly aware of Allan Kaprow as the *enfant terrible* of the Rutgers art department and of his gifted students, Bob Whitman and Lucas Samaras. While I was in Paris, Bob had kept me up to date. As an undergrad I had been to Kaprow's exhibitions at the Hansa Gallery. Shortly after I returned to Rutgers I was subjected to Allan's skill as an artist and a salesman. Bob and Allan came to me with an idea. Probably Bob had the idea: "Would I do *Spring Happening*?" I was so taken aback by this—"I'm going to run around without my clothes on in public? I'm going to get arrested!" So you're caught between believing in what they're doing and fear for yourself. I said, "I have to think about this." And they worked on me for a week. I mean, they worked on me! Ultimately my belief in Allan won. I succumbed; and thus began my reputation as an art world nude and a long association with Kaprow and Happenings.

— JM: It also strikes me that this is the very end of the fifties idea about women, because the women's movement is in the sixties. This is the real end of that kind of thinking.

— LLE: Exactly. Women as objects. And women being used in some way . . . usually to benefit men . . . in the arts it benefited male artists.

— JM: There was no thought of a woman as a peer in terms of creativity?

— LLE: Are you kidding? Were you ever around in the old days of the Cedar Bar [an artists' hangout in the fifties and sixties]? I have had the pleasure of being socked in the face by Bill de Kooning [a Cedar

regular]. That caveman style illustrates how women were regarded. I don't think for a minute that we were thought of as equals. I remember, even when I was working as an active artist, running around the outside of this group of guys who were all standing around talking about art, trying to be heard. I wasn't a peer. We were thought of as sex partners or as the person who supported the artist while he struggled to get a show. And we bought into that.

— JJ: Did you meet Roy when he left his wife and moved to New York?

— LLE: No. I met Roy when I was department secretary at Rutgers. He was the funniest man I had ever met in my whole life. He used to come by my desk and tell me bad jokes or make some satiric comment and roll his eyes. He was a Donald Duck kind of "dooffy" and I couldn't help myself from laughing.

— JJ: Was there a Pop quality to that first show of Bob Watts's at Grand Central Moderns that could have had an impact on Roy or the way that Roy looked at Pop culture?

— LLE: Probably. I thought of it more as the spin-off of Stankiewicz. It was like mechanized store-bought found-object sculpture based on Bob's love of mechanical toys. Bob and Roy used to have outrageous fights/debates about what art was. Roy didn't believe it was what Bob thought it was. Art was much more under the control of the artist for Roy. Bob was saying that anything could be art. Let me put it this way. I think that Roy turns out to be much more Zen than Bob in the long run. Art and life are two separate things for Roy. Bob is saying they are the same thing, which is what Allan also said. Anything I do, anything I see in the world, is grist for the mill and is art, or can be art. I don't think Roy really believed that. Roy is really this formalist who is talking about Cézanne, and the shifts in space. Art, therefore, is something greater than life no matter how ordinary the subject matter. The work of the artist is to create, not to point out everyday objects or events as worthy of consideration as art objects.

— JM: Can you talk more about the Happening where Allan wanted you to perform nude?

— LLE: He called it *Spring Happening*. I think it had to do with the rites of spring—that we were going to re-create some kind of imagery of rebirth and growth. Allan used interesting imagery in describing things to me. Both he and Claes have often described my roles in the same way. "You're Dixie Dugan." "You're the Statue of Liberty." "You're Miss America." "You're the Great Mother Earth." Why would two men who have very different points of view as artists use similar imagery? I don't think I was originally seen as symbolic. I think I was seen as a possible naked body and that's why I was approached to do *Spring Happening*. It was a difficult decision to make . . . to perform nude, but I finally agreed to do it. Somewhere inside of me, I must have known that I was in the presence of greatness, and that something special was going to happen here. I wanted to be part of that.

— JM: And you were running?

— LLE: Yes. The Happening took place in an old storefront [the Reuben Gallery] that was being used for performances. Allan built a long narrow box down the center of the room. I don't remember how many people could get into it. It wasn't a large number . . . maybe wide enough for a double row of people on each side. There were peepholes or slits cut in the box. The audience stood inside the box and the performance was outside and around the box. It was a reversal of positions: the confinement of the proscenium was imposed on the audience, while the performers had the freedom of the public space. Because the box was jammed with people, the audience was made uncomfortable (rather than relaxed in seats) and they had to struggle to see what passed before that little slit of eye space available.

— JJ: Was there much light on you?

— LLE: No. The whole space was very dim and the subdued lighting may have assisted me to agree to be nude. I think Allan used it to persuade me, by saying, "It's not going to be well lit. You're not going to be seen easily." There were lights scattered here and there, and I would run in and out of spotlights, which may have come on and off. The concept, in my mind, and I must have taken it from Allan's description, is "Think of yourself as a deer being hunted." I ran around this box running in and out of the spotlights as if the hunter could catch me in the scope of his

gun. So, I'd run through those spotlights. I can only remember my particular part. At the end I remember the lawnmower coming down the box. It felt like the hunters got me. They mowed me down, destroyed me. The sides fell away and the audience was mowed down or out of the enclosed space.

Birth and death images are closely related. This has been explored by many creative artists, such as Picasso, Anne Sexton, T. S. Eliot. Within families, the loss of a particularly significant loved one often leads to the conception of a replacement child. If I remember correctly, Vaughan [Kaprow's wife] was pregnant at the time. This was a celebration connected to the birth of a baby. It may have even been discussed offhandedly.

My animal persona was further delineated by a chunk of broccoli in my mouth. I think Allan had music or some kind of soundtrack (which he may have composed) to accompany the piece.

— JJ: Do you think these Happenings were about something and structured in terms of having a goal?

— LLE: I think most of the work was very carefully conceived; however, all theater takes advantage of random events—but Allan's work was not random. No matter what Allan might say about Cage, it's not hooked to that kind of random-chance material. That's Dick Higgins. Although random chance would be the opposite of planned conception, even random chance selects the events submitted to chance operation. I did a piece for Dick Higgins where I had all of my instructions on a bunch of cards. I'd pull out a card and that would be the first thing that I would do.

Every performance I did for Allan had a definite plan based on an idea that he wanted to communicate. Usually there was a great catharsis in the work: at the end the killing is linked to the image of birth . . . right? . . . the lawnmower kills the deer and the people spill out of the container being reborn. The performance at the Mills Hotel [*Courtyard*] where I had to climb the mountain, it was almost like a reverse birth image. I climb up there, and then the other mountain comes down. Allan says, "It will kiss you." Well, it kissed me. It put me back into the earth. I got planted again. So I always saw it as a death image: Innocence dies to be planted and reborn.

— JM: Did you attend the Happenings at George Segal's farm?

— LLE: I went to the events on the chicken farm. Oh, sure. There were always things going on out there. And Allan and Vaughan would often have parties, and we would go back and forth between the two places. This was prior to the serious "getting into the art world." It was very low key. It was more like a family of artists buzzing around exploring new ideas together in their own individual styles. At that moment it did not feel competitive. We all knew each other. That's the amazing part. Everyone did their separate thing in their own way, but we all knew each other. How did it happen that we all knew each other, but we were all very separate people?

INTRODUCTION

Recent trends and developments have pointed with
certainty to areas for creative investigation that have
remained relatively untouched by artists. Both
scientists and artists have become aware, for the first
time in recent years, that basic concepts for discovery
and invention are common to both, and indeed,
that many conclusions possess similar ingredients.
Certainly on a basic creative level there is agreement
that both artist and scientist formulate and evolve in
much the same manner. Even though it would seem
that both have much in common, this apparent fact
has been obscured by the differences in the utilization
of their respective discoveries. Technology is fed by
scientific invention, but it is somewhat less clear just
who is sustained by the artist. Although the concepts
of progress and materialistic abundance may be
unimportant for both pure science and pure art,
there is a tendency to rationalize science by these
tenets. This rationale has gone a long way to provide
a sound base for pure scientific discovery, especially
in recent years.

The true artist is also a discoverer. Many of his
discoveries have paralleled those of science, even from
the early beginnings of the human race. Since the
turn of the century artists and scientists have, in
reality, become close allies in an examination of form
and structure, even though the alliance may not at
once be clear to all.

The scientist now has a considerable edge on
the artist because of the financial aid afforded by
industry. In general, the artist has been unable to

PROJECT

IN

MULTIPLE DIMENSIONS

—

ALLAN KAPROW,

ROBERT WATTS,

AND

GEORGE BRECHT

make use of new advances in materials and equipment for lack of financial aid to rent or purchase them. This has become a serious handicap, since most of the technological advances of recent years remain out of the artist's reach. Instead of exploiting these modern miracles, the artist is forced to spend much creative energy searching for a cheap substitute which in most cases does not exist. This frustration has indeed impeded the progress of the contemporary artist. Instead of tangible, real products, most advances in the arts either lie on paper or within the artist's mind. We feel that the opportunities are so rich and vast that the artist must be assisted in these new explorations.

The idea of multi-dimensional media, quite simply stated, implies the use of more than one medium for the production of new aesthetic experiences. An example might be an organization of sound and light, produced by electronic means, and designed to create primary responses in the audience. This would be in contrast, say, to a conventional movie film where primary responses are in relation to, or a function of, some dramatic content, and where the sound and light are mainly vehicles for conveyance of the content. There is nothing especially new about multi-dimensional concepts of this kind, and examples are known to all. Certain productions have been stimulating and effective to a degree, and they point to far greater developments. The work accomplished to date, however, demonstrates two things: one, that the conceptions are too thoroughly bound to traditional, hence limiting, ideas, and two, that new media, or media-producing equipment, are being ignored for their potential merit.

Modern science and technology have already produced, and are producing, equipment and materials that have not yet found their way into artistic usage. Great strides in electronic equipment make it possible to create and structure sound, light, color, space, and movement in totally undreamed of ways. A fantastic range of new material, especially synthetics of many varieties, can be utilized to elaborate and complement these possibilities. Experimental work over the past forty years or so mainly has ignored the possible new ranges for creative expression. Certain new materials have been used, but often within the limitations of old forms.

A Plexiglas or Lucite sculpture has nearly the same limitations as its brother in stone, even though the material might have exciting qualities of light transmission. Rather than exploiting the natural properties of the material, the artist often has rejected them by casting the material into an old mold. The problem, therefore, resolves itself into an examination of contemporary technological advances for the purpose of discovering new forms for creative artistic expression. Even a cursory glance around would indicate that many new and rich fields for exploration are open to the artist. Some examples are as follows:

I. Sound and sound production
 1. Continuous sound spectrum, electronically produced.
 2. New sound complexes and structures.
 3. Conversion of sound spectrum to light and other spectra.
 4. Stereophonic systems.
 5. New sound production devices (instruments).
II. Light, including color
 1. Continuous light spectrum, electronically produced.
 2. New light complexes and structures.
 3. Conversion to other spectra.
 4. Image production and analysis.
 5. New methods of color production and projection.
 6. Re-examination of color notation.
III. Space
 1. Formulation of time-space-movement spectrum.
 2. Conversion to other spectra.
 3. New space producing idioms, as frequency lighting, frequency movement, etc.
 4. Examination of sound and light as space dimensions.
IV. Other
 1. Formulation of tactile and olfactory spectra, and relationship to above.
 2. Audience-activated devices, as photo-electric cell.
 3. Range of non-sound, non-space, etc.
 4. Re-examination of natural materials for their expressive possibilities, such as water, plants, earth, etc.
 5. Re-examination of synthetics such as plastics, paints, chemicals, etc.
 6. Examination of whole field of pyrotechnics and explosives.
 7. Examination of the relationship of synthetic space to natural space (out-of-doors).
 8. Re-examination of aspects of old forms that may be used in new combinations, as voice, drama, dance, etc.

We believe that the human organism is capable of tremendous variety in meaningful responses that only

need to be activated. This is growth through meaningful experience. It is only in this way that one may think of progress and development of a human society. The three statements, under Section III, present some idea of the intent, scope and direction of this new work.

—

BACKGROUND

—

We are enjoying today an extraordinary frenzy of artistic activity in this country. New York City has become the leading center of this excitement and from all over the world artists come here as they once went to Paris or Vienna. It is safe to say, now that more than fifteen years have passed since the first explosions of the post-war release, that painting, sculpture, music and the dance have been changed irrevocably from their European course by Americans. As long ago as 1938 Paul Valéry, the great French poet and states-man, predicted the end of European culture. While we cannot yet tell the outcome of this morbid prophecy, and we hope it is not true, we can observe that the vitality of Europe's current writing and music is in great measure inspired by the United States. Her dance and plastic arts are a disappointing imitation of the "New York School" and it is no longer the goal of a painter to go overseas to learn his art.

This new state of affairs here is directly bound up with the notion, explicit or implicit, of art as "Avant-Garde." This concept, which has sustained art since the French Revolution, is thus a long and estab-lished tradition and the vindication which posterity has given to each successive stage since then, has more than proved the validity of its underlying philosophy. To a modern artist, "Avant-Garde" has always meant some form of discovery and renewal. It implies that while there are perhaps constant human verities, their expression continuously evolves and only that art which responds immediately to the very subtle mutations in life conditions will be a vital one.

The Avant-Garde in America has changed within itself rapidly to ever more progressive insights and an intelligent public is quickly growing with it. A recent issue of the magazine *Art in America* points to the forward-looking nature of the new, younger

collector that has emerged since 1945. While this by no means describes a flourishing economy for artists—they are as destitute as ever in spite of their occasional fame—it does hint at the youthfulness that pervades the cultural atmosphere here and suggests an optimistic future for a country that has for too long been criticized as being barren spiritually.

Now what are some of the characteristics of this new advance guard? In all the arts, we are struck by a general loosening of forms which in the past were relatively closed, strict, and objective, to ones which are more personal, free, random, and open, often suggesting in their seemingly casual formats an endless changefulness and boundlessness. In music, it has led to the use of what was once considered noise; in painting and sculpture, to materials that belong to industry and the wastebasket; in dance, to movements which are not "graceful" but which come from human action nevertheless. There is taking place a gradual widening of the scope of the imagination, and creative people are encompassing in their work what has never before been considered art. And to the new viewpoint a direct, almost crude freshness has arisen, which we feel is particularly characteristic of our country. (We do not wish to carry this to chauvinistic lengths. It is simply heartening to know that one's own actual experiences can inspire one's art rather than a model made somewhere else.)

Striking out on its own has perhaps been the chief reason why this country has a strong artistic movement. Yet in spite of the new and strange character of its current work, it has its roots deeply sunk in the recent European past. It is possible to see that with the changing conception of the Self that has taken place over the last two centuries, the depicted image in the plastic arts has undergone profound alteration from the once standard norm based upon the Greco-Roman–Italian Renaissance model. In place of an image of reality geared to a biological or visual verisimilitude, the vision of the "inner eye" was tapped. And with this followed a complete reorgani-zation of the whole meaning of composition that had until then been derived from what was measurable in the external world.

In a highly oversimplified view, this new composition corresponds somewhat to that of the

space of the mind, which we know does not have the same clear extension, boundaries or separation of objects that we have come to accept in everyday affairs. But it is also necessary to point out that even in this so-called "rational" part of our lives there has been a marked transformation of thinking and acting in recent times. As an example, the daily newspaper was once laid out in the regular proportions of the classical temple with its crowning gable as the title or masthead and all the columns of type neatly appended in even rows beneath. Today a tabloid is frequently a composition of asymmetrical groups of type and sub-headings that begin briefly in fragmented abbreviation only to be continued elsewhere in the paper, following no apparent prior order. Then in our method of reading, we are not aware that we go about it in a random manner, turning back and forth from one section to the other seeking the continuation of each article, itself chosen without regard to strict sequence of pagination. This is almost akin to following a number of entirely separate labyrinthine threads to their supposed ends, often never finding that conclusion, instead of taking up another path. For indeed, it is quite common practice in reading a newspaper to read only fragments of articles, passing from one to the other in an apparently haphazard fashion. Looked at solely as an occurrence of some widespread scope, this form of communication and response arising out of profound needs that are difficult to encompass here, is in principle quite close to the most advanced forms of contemporary art, where the traditions of clear structures having a beginning, middle and end have been largely given up. The analogy drawn to the newspaper is only one among many that would show a parallel between our common daily habits and modern art.

In fact, this homogeneity is present within much of avant-garde creation in general. The common goals of music, painting, sculpture, dance and literature has made interrelations possible among them that, in turn, produced results which might not have come about in the isolated growth of the single art. For example, it is well known that abstract artists have frequently alluded to musical forms in discussing their painting. And in the new poetry, the grouping of lines or words on the page to introduce an added visual dimension to the meaning, has depended on the writer's knowledge of progressive painting. Also true in some recent prose is the idea of organizing actions and thoughts into a "palimpsest" very much like the pasting of many layers of paper, drawing and painting that is seen in collage. In both, a sense of countless events erased and covered over, partially revealed, appearing and disappearing like an endless kaleidoscope, infuses these arts with a fluidity and transformability that feels to many artists more "contemporary" than any other technique. In this direction, the new music, which is composed entirely on magnetic tape, is actually a "collage" of prerecorded sounds spliced together just as the foreign matter in collage is pasted together.

This closeness of basic principles in the advanced arts of today has permitted a new development to occur within the ranks of the younger avant-garde. It has become clear to Messrs. George Brecht, Allan Kaprow and Robert Watts that the boundaries between these arts are so thin already that even though their media differ, a synthetic art comprising elements of several or all in a radically new form without being a mere throwing together of the already existing arts, is logically necessitated by what has come before. It is probably not inappropriate to point here to the United Nations, the many international societies devoted to exchanging cultural and scientific ideas, to studies in comparative religion and anthropology, to in fact one of the most significant developments of our age, that of the concept of a unified science. Art as we are thinking about it at the moment is similarly broad and likewise [are] attempts to break down artificial boundaries.

Yet this new art requires an entirely new range of materials, technical equipment, professional help etc., and cannot progress unless institutions, foundations or individuals provide financial assistance. In Europe and Japan, advanced researches are supported in the arts by the states or municipalities. There is nothing like this in the United States. It is felt that a university, as an institution of higher learning, can naturally act as a sponsor to these new experiments, or it can promote sponsorship which the artists themselves could not obtain. Rutgers University, by virtue of its remarkable location in respect to New

York City, and particularly because it has no traditions in art which could encumber any new ideas, is in a remarkable position to help the development of these ideas, and at the same time, become one of the most exciting places in the world of art.

—

THREE PERSONAL STATEMENTS

—

ALLAN KAPROW:

For the past two and a half years, my art has been moving steadily in a direction that appears now to involve some kind of synthesis of elements that belong to several arts. Words, sounds, human beings in motion, painted constructions, electric lights, movies and slides—and perhaps in the future, smells—all in continuous space *involving* the spectator or audience; these are the ingredients. Several or all of them may be used in combination at any one time, which permits me a great range of possibilities.

Yet, though these above elements all belong to separately developed arts, what I am doing is not a combination of these arts. This has been attempted with little success in the past and I believe that reason is simple in that (with the notable exception of songs and opera) they were conceived separately and were not intended to be combined. So, I proceeded from the everyday situation *rather* than from art, observing that in a room or on the street or in the country, we have a natural combination of material coming to the senses which is harmonious enough because it isn't forced out of already highly developed and concentrated forms, i.e., art. Taking this as a clue, I worked with very simple elements and forms and conceived of them as events occurring rather loosely together. Beginning in this way, I found that a gradual refinement took place quite easily and a "total" art seems very possible at present.

All this was arrived at, I think, logically, as an outgrowth of my long preoccupation with collage. Over the years, the pasted pieces of foreign matter grew looser, their edges were left sticking up from the canvas in an ever-increasing degree and I finally understood that I wanted to take them off the canvas completely in order that a *literal* space would exist between them, rather than the *suggested* space of

traditional painting. (This space, incidentally, can be observed over the past 300 years as proceeding, from the deep perspective of the Renaissance, to become more and more shallow until by 1912, with the discovery of collage, it was built outward from the canvas plane towards the observer with each succeeding piece of pasting.) Therefore, I hung large planes of canvas away from the original plane and then decided that this "original" starting point could be done away with entirely. The whole exhibition room became the work and instead of projecting oneself into the space with one's mind, one could literally walk among the parts.

In the meantime, the environmental character of what I was doing became apparent to me and I began to include flashing electric lights, bells and buzzers, and these were distributed over the room. After that start, the sound was enriched by composing on magnetic tapes going to four or more loudspeakers placed around a given space, making it possible to have a sound begin "here" and go "there," etc.

Then among the visible elements, a whole new area of materials became available; cellophane, strings, plastic film, gauze, chicken wire, painted cloth or printed goods, aluminum foil, wooden or welded metal constructions, water dripping, mechanically moving parts and, of course, slides or movies in several spaces at once. To this, one must add the visible human being who becomes part (automatically) of any given work once he moves into it no matter what he does.

Now much of this begins to operate in time as well as in space and I have composed some very abstract "theater" pieces over the past year, which I have performed here and there (One of them, rather larger than the rest, was done as part of the Chapel series at Douglass College devoted to "Modern Forms of Communications" and I believe it aroused some interest). In these, the voice, the body in motion, the visible construction, the audience arranged in groups within the space of the piece, the artificially produced sounds, are all combined. There is not "script" or "story," no "dance" score, no "set," no "music," no "stage," no "audience," really, since the latter has become only a passive participant in the

work. (Actually things occur in the midst of these groups of people, and at certain times they may be required to change seats.)

This then, is a general, rather sprawling picture of the work I am engaged in. Its future possibilities appear unlimited.

ROBERT WATTS:

Within the broad scope of multi-dimensional media, certain facets interest me at the present moment. These have to do with an exploration of various time-space-movement situations through the use of both electro-mechanical devices and selected synthetic and natural materials. Within this spectrum, one may explore both "environmental" and "object" situations.

In the past, abstract ideas of space-time-movement have been projected upon work in the visual arts by psychologists, critics, and audience alike. Ideas of movement were relegated to empathetic responses in the observer, picked up by the eye and relayed to the brain-mind-body. The more "eye movement" the more movement a painting or sculpture was said to contain. But in spite of a thousand analogies, the leaves of a tree never moved. It order to be up to date, both artists and critics appropriated the scientists' concept of time-space, and by wide stretches of the imagination applied it to the real substance of art as well as to subject matter or content. In wild fancy, all work suddenly appeared to acquire new dimensions that in reality it did not possess. Painting remained more or less on the wall and sculpture on the floor. Certainly there were experiments with actual space-time-movement relations. Various innovators at the Bauhaus, later in the USA, and elsewhere in Europe opened the door to its broad principles. In this country, we know that work of Moholy-Nagy, Calder mobiles, and the revolving sculpture of de Rivera.

Now it would seem worthwhile to explore further. Various environments should be developed and studied toward learning about actual situations in such things as frequency and intensity modulation of light and sound, as well as movement in selected forms. It is possible for these environments to be activated by coded devices or by the movement of the audience through the space. In the latter, the audience may be permitted to participate in either a planned or random manner. One can image an audience-environment where the audience becomes the sole activator and responds to itself.

One may explore also a new set of "objects," perhaps somewhat more related to painting and sculpture. Separate forms may be given the added dimensions of light, sound, and movement. These might exist alone or in groups within a given space. To various panels, more akin to painting, the same dimensions may be applied. An important problem to be studied here are the relationships of objects to environments. When does an object become an environment? What aspects of light, sound, movement cause an object to separate out or merge with an environment.

Natural and synthetic materials must be examined in this new light. One can imagine that such things as water, earth, stone, plants, etc., could form a new vocabulary of media and take on new meaning. Synthetics offer the means for modulation and nuance, and permit new discoveries with transparency and translucency. New pigments and dyes promise to extend the color frontier.

How it will be done depends upon the individual artist. Some work may be "pure," some may consist of totally new materials, some with mixtures of old and new. In any case, the new forms should lead us to new experiences and insight, hence to deeper meaning and broader knowledge of nature and man and his work.

GEORGE BRECHT:

The primary function of my art seems to be an expression of maximum meaning, with a minimal image, that is, the achievement of an art of multiple implications, through simple, even austere, means. This is accomplished, it seems to me, by making use of all available conceptual and material resources. I conceive of the individual as part of an infinite space and time; in constant interaction with that continuum (nature), and giving order (physically or conceptually) to a part of the continuum with which he interacts.

Such interaction can be described in terms of two obvious aspects, matter-energy, and structure, or,

practically, material and method. The choice of materials, natural and fabricated, metals, foils, glass, plastics, cloth, etc., and electronic systems for creating light and sound structures which change in time, follows inherently from certain intuitively chosen organizational methods. These organizational methods stem largely from other parts of my experience: randomness and chance from statistics, multi-dimensionality from scientific method, continuity of nature from oriental thought, etc. This might be emphasized: the basic structure of my art comes primarily from aspects of experience unrelated to the history of art; only secondarily, and through subsequent study, do I trace artistic precursors of some aspects of my present approach.

It seems reasonable to expect this expression, if it comes from a unitary personal experience, not to be inconsistent with other aspects of that experience, and this is the case. When this art, without conscious roots, is examined on a conscious level, in terms of basic concepts such as space-time, causality, etc., it is found to be consistent with the corresponding concepts in physical science, and this is true in general of the work of certain exploratory artists whose work seems to stem, individual as it is, from common conceptual roots (e.g. John Cage, Allan Kaprow, Paul Taylor). In this sense, it seems to me, it would be possible to show how this art reflects fundamental aspects of contemporary vision, by examining it in terms of space-time, inseparability of observer-observed, indeterminacy, physical and conceptual multi-dimensionality, relativity and field theory, etc. This study may be left to critics and theorists.

To summarize, my work is a complex product of a personality continuous with all of nature, and one making progressively better-integrated efforts to structure experience on all levels. Thus, what can be made of nature though rational effort (such as

scientific understanding), though it is never a *conscious* part of my work, being a part of the personality, becomes part of the work. In this way, all approaches to experience become consistent with each other, and my most exploratory and dimly-felt artistic awareness, insights based on the most recent findings of modern science, and the personally meaningful ancient insights of oriental thought, just now being found appropriate to our modern outlook, form a unified whole. The consistency of such an overall approach to experience serves to reinforce the validity of each of its component parts, much as scientific constructs gain validity through their mutual function in explaining experiences. This consistency becomes apparent only after each aspect gains independent maturity, however, and is in no case a pre-condition, or requirement, for satisfaction with any aspect. My art is the result of a deeply personal, infinitely complex, and still essentially mysterious, exploration of experience. No words will ever touch it.

———

PROPOSED PROGRAM

———

November: A program consisting of two parts:
 Part One: A Group of Events
 (Kaprow, Watts, Brecht)
 Part Two: Discussion

December: Event (Allan Kaprow)

January: An Evening of Music by John Cage, followed by a discussion by the composer.

February: Event (Robert Watts)

March: Music by Advanced Contemporary Composers Westbrook, Feldman, Wolff, Brown, Stockhausen

April: Event (George Brecht)

———

NOTE

This document was written as a grant proposal in 1957 (finished summer 1958). Courtesy of the Robert Watts Studio Archive.

— 1951

Robert Motherwell publishes *The Dada Painters and Poets: An Anthology.*

Robert Rauschenberg makes his white paintings, which reflect light and capture cast shadows (fall).

— 1952

John Cage performs what is often considered the first Happening at Black Mountain College, with Robert Rauschenberg, Merce Cunningham, David Tudor, and others; later it became known as *Theater Piece No. 1* (summer).

John Cage writes *4'33"*, a musical composition that consists of ambient sounds generated in a concert hall during a period of four minutes and thirty-three seconds; the debut is performed by David Tudor in Woodstock, New York (late summer).

Robert Watts is hired by the engineering department at Rutgers (fall).

Allan Kaprow, with Richard Stankiewicz, is cofounder of the Hansa Gallery, an artists' cooperative in New York City (fall).

— 1953

Allan Kaprow is hired to teach art history and studio art in the art department at Rutgers College; has solo exhibition in the gallery of the Art House, a departmental building (fall).

Robert Watts transfers to the art department, Douglass College (fall semester), where he teaches sculpture and ceramics; has solo exhibition of his abstract paintings at the Douglass College Art Gallery (fall).

Robert Whitman enrolls as a freshman at Rutgers College (fall semester).

Hansa Gallery Members, a group exhibition, is presented at the gallery of the Art House, Rutgers College (December).

George Segal buys chicken farm across from his father's farm in South Brunswick, New Jersey; meets neighbor, Allan Kaprow.

— 1954

Allan Kaprow has solo exhibition of paintings and drawings at the Hansa Gallery (April).

Gutai Art Association is formed in Ashiya, Kansai, Japan, by Jiro Yoshihara (December).

— 1955

Lucas Samaras is awarded scholarship to attend Rutgers College and enrolls as a freshman; has scholarship exhibition at the gallery of the Art House, Rutgers College (fall).

Allan Kaprow hires George Segal as instructor for the Art Club (also called the Sketch Club), an extracurricular activity affiliated with the art department at Rutgers College (fall).

Allan Kaprow and poet John Ciardi are faculty advisers for the *Anthologist*, the Rutgers College literary magazine (vol. 26, no. 3).

— 1956

Allan Kaprow has a solo exhibition of paintings and drawings at the Bernard-Ganymede Gallery, New York (February).

George Segal has a solo exhibition of paintings at the Hansa Gallery (March).

Geoffrey Hendricks is hired to teach in the art department, Douglass College (fall semester).

FIGURE 81
Allan and Anton Kaprow
with George and Helen Segal,
ca. 1960.
Photograph by Vaughan Rachel.

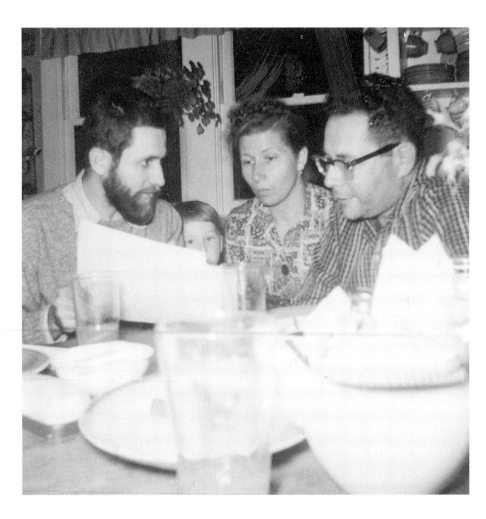

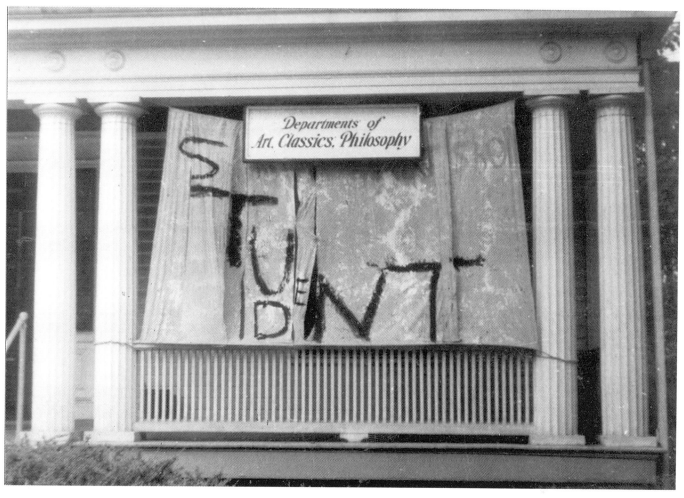

FIGURE 82
Student art exhibition at the Art House,
Rutgers College, May 1960.
Photograph by Vaughan Rachel.

Allan Kaprow and George Segal have a joint
exhibition at the Z and Z Kosher Delicatessen,
New Brunswick (September).

Twelve Rutgers University Artists is presented at the
Studio Gallery, 94 Albany Street, New Brunswick;
faculty include Allan Kaprow, George Segal,
Helmut von Erffa, and Samuel Weiner; students
include Lucas Samaras.

Allan Kaprow is faculty adviser for the *Anthologist*
(vol. 27, nos. 1 and 4); has solo exhibition at the
Art House, Rutgers College (December).

John Cage first offers a music composition class at the
New School for Social Research in New York,
which he teaches until 1960.

— 1957

Geoffrey Hendricks has solo exhibition of litho-
graphs, woodcuts, and oil paintings at the
Douglass College Art Gallery (January).

Robert Watts has solo exhibition of Abstract
Expressionist paintings at the Douglass College
Art Gallery (February).

Allan Kaprow has solo exhibition of painting,
collages, and sculpture at the Hansa Gallery
(February–March).

George Brecht, Allan Kaprow, and Robert Watts
start writing "Project in Multiple Dimensions,"
a grant proposal submitted to Rutgers University
and the Carnegie Corporation to obtain funds

for avant-garde projects (proposal was completed in summer 1958).

Allan Kaprow publishes "Rub-a-Dub, Rub-a-Dub" in an "Art" issue of the *Anthologist* (vol. 29, no. 2).

Lucas Samaras is assistant editor and art director of the *Anthologist* (vol. 29, nos. 2–3); he designs the cover of an "Art" issue (vol. 29, no. 2).

Robert Whitman graduates from Rutgers College (June), but remains in New Brunswick area for two years.

Robert Watts creates his first works with electronic components and begins making mixed-media collages.

— 1958

Allan Kaprow attends John Cage's "Music Composition" course at the New School for Social Research, and creates prototypes for Happenings (late winter 1957 or spring 1958).

George Segal has solo exhibition of paintings and pastels at the Hansa Gallery (February–March).

Allan Kaprow presents an untitled Environment featuring audiovisual effects, electric lights, and crushed cellophane at the Hansa Gallery (March).

Robert Rauschenberg exhibits his combine paintings in a solo exhibition at the Leo Castelli Gallery (March).

Robert Watts, Allan Kaprow, and George Brecht create a "proto-Happening" on the Douglass Campus in two rooms of a classroom building; the project includes sound and flashing lights (spring).

Allan Kaprow and Robert Watts organize a series of avant-garde presentations as Voorhees Assemblies at Douglass College; the series includes John Ciardi's poetry reading (January 28), John Cage's lecture of *Questions* (March 11) Paul Taylor's dance group (March 18) and Allan Kaprow's first Happening: an untitled work, at Voorhees Chapel, Douglass College (April 22); Lucas Samaras and other students participate in the performance.

Allan Kaprow publishes "The Legacy of Jackson Pollock," *Art News* (April). The essay was written shortly after Pollock's death in August 1956.

Allan Kaprow presents *Pastorale* at a picnic for Hansa Gallery members at George Segal's farm, South Brunswick (summer).

George Brecht writes *Confetti Music* and *Three Colored Lights* for John Cage's "Music Composition" class (summer); also taking Cage's summer class are Allan Kaprow, Dick Higgins, Jackson Mac Low, and Al Hansen, who presents *Alice Denham in 48 Seconds*.

Geoffrey Hendricks, Allan Kaprow, and Robert Watts exhibit in Faculty Art Show at the Douglass College Art Gallery (September–October).

Geoffrey Hendricks has solo exhibition of large abstract paintings at the Douglass College Art Gallery (November).

Allan Kaprow presents an Environment with sound, light, and odors at the Hansa Gallery, New York (November–December).

Lucas Samaras is art director for three issues of the *Anthologist*: the "Poetry" issue (vol. 29, no. 3), "Drama" issue (vol. 29, no. 4), and "Freshman" issue (vol. 30, no. 1). Robert Whitman (who has already graduated) designs covers for the "Poetry" issue and the "Drama" issue. Samaras designs cover for the "Freshman" issue.

Lucas Samaras establishes Rutgers Co-op Gallery at 82 Somerset Street, New Brunswick, the building where he lives; Whitman has the first solo exhibition in this space.

— 1959

Allan Kaprow publishes "The Demi-Urge; something to take place: a happening," in the *Anthologist* (vol. 30, no. 4).

Robert Whitman has a solo exhibition of multimedia constructions at the Hansa Gallery (January).

George Segal has a solo exhibition of paintings and life-size figures made of burlap dipped in plaster over wire armatures at the Hansa Gallery (February).

Rutgers University Show of Robert Harding, Allan Kaprow, Lucas Samaras, Samuel G. Weiner, and Robert Whitman is presented at the 92nd Street

FIGURE 83
A vandalized sculpture in the student art exhibition outside the Art House, Rutgers College, May 1960. Photograph by Vaughan Rachel.

Young Men's and Young Woman's Hebrew Association, New York (March).

The New York Audio Visual Group, which includes Al Hansen, Dick Higgins, and Larry Poons, performs in a program of "advanced music" at Kaufmann Concert Hall at the 92nd Street YMHA (April 7).

The New York Audio Visual Group performs on television on the *Henry Morgan Show* (April).

Samaras completes his controversial Henry Rutgers Honors Project, and receives his B.A. degree (June).

Roy Lichtenstein, while teaching at the State University of New York at Oswego, has a solo exhibition of Abstract Expressionist paintings at the Condon Riley Gallery, New York (June).

George Brecht presents *Candle Piece for Radios* and *Time-Table Event* in John Cage's composition class at the New School for Social Research (July).

Red Grooms performs *The Walking Man* at the Sun Gallery, Provincetown, Massachusetts (September).

M.F.A. Program is launched by the art department at Douglass College (fall semester).

Allan Kaprow and Dick Higgins perform on the *Henry Morgan Show* (September).

The Reuben Gallery opens with Allan Kaprow presenting *18 Happenings in 6 Parts*; the Happening is the first to appear in an art gallery (October 4, 6–10).

Claes Oldenburg, Jim Dine, Dick Tyler, and Phyllis Yampolsky establish the Judson Gallery at the Judson Memorial Church.

George Brecht has a solo exhibition titled *Toward Events—An Arrangement* at the Reuben Gallery; the show includes games and assemblages that the visitor can rearrange (October–November).

Geoffrey Hendricks and Robert Watts organize *Group 3*, an exhibition at the Douglass College Art Gallery. Artists include Robert Rauschenberg (with *Factum I* and *Factum II*), Allan Kaprow,

George Brecht, Robert Watts, and others (November–December).

Lucas Samaras has a solo exhibition of paintings, pastels, and plaster figures at the Reuben Gallery (November).

Robert Whitman has a solo exhibition of multimedia constructions and collage paintings at the Reuben Gallery (November–December).

Red Grooms performs *The Burning Building* at the Delancey Street Museum, New York (December).

Below Zero, a group exhibition of mostly mixed-media work by George Brecht, Jim Dine, Al Hansen, Allan Kaprow, Claes Oldenburg, Robert Rauschenberg, George Segal, Richard Stankiewicz, Robert Whitman, and others, is held at the Reuben Gallery (December–January).

FIGURE 84
Larry Poons performing at Douglass College
as part of "An Experiment in the Arts" weekend, April 1963.
Photograph © 1963 by Peter Moore.

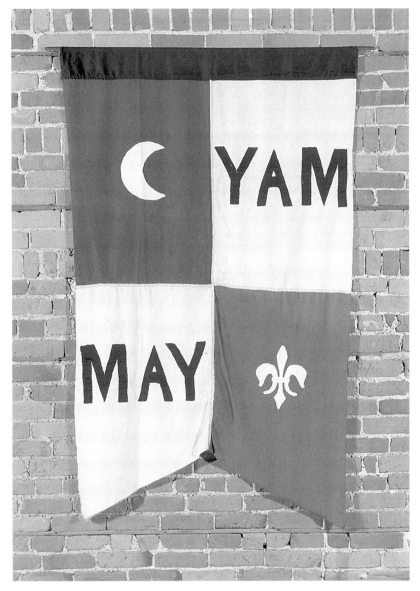

FIGURE 85
Robert Watts, *Yam Banner,* 1963.
Sewn fabric.
70" x 41"
The Gilbert and Lila Silverman
Fluxus Collection, Detroit.
Photograph by R. H. Hensleigh.

— 1960

Allan Kaprow presents a program of Happenings at the Reuben Gallery: Red Grooms, *The Magic Train Ride,* Allan Kaprow, *The Big Laugh,* and Robert Whitman, *Small Cannon* (January 8–11).

A group exhibition including Allan Kaprow, Claes Oldenburg, Lucas Samaras, George Segal, and Robert Whitman is held at the Reuben Gallery (January–February).

Claes Oldenburg presents a program called *Ray Gun Spex* at the Judson Gallery, which includes perfor-mances by Jim Dine, Dick Higgins, Al Hansen, Allan Kaprow, Oldenburg, and Robert Whitman (February 29, March 1–2).

George Brecht performs *Card Piece for Voice* and *Candle Piece for Radios* for *A Concert of New Music* at the Living Theater, New York; the program also includes John Cage, Al Hansen, Ray Johnson, and Allan Kaprow (March 14, 1960).

Jean Tinguely presents *Homage to New York,* a self-destructing mechanized device in the Sculpture Garden, Museum of Modern Art, New York (March).

Claes Oldenburg presents *The Street,* drawings, sculpture, and constructions at the Reuben Gallery (May), a revised version of the Judson Gallery installation.

Robert Watts presents the *Magic Kazoo,* a twenty-four-hour continuous Happening that takes place in New York City and New Jersey (June).

New Forms—New Media I, a group exhibition of seventy-one artists including George Brecht, Allan Kaprow, Robert Rauschenberg, and Robert Whitman is presented at the Martha Jackson Gallery and David Anderson Gallery (June); the show is modeled on the *Below Zero* show held at the Reuben Gallery.

An Evening of Sound Theater—Happenings, is presented at the Reuben Gallery, and includes Robert Whitman's *E.G.,* Kaprow's *Intermission Piece,* performances by George Brecht and Jim Dine, and electronic or taped music by Allan Kaprow and Richard Maxfield (June 11).

Roy Lichtenstein is hired for by art department, Douglass College, to teach "Art Structure" 101–102, "Design and Advanced Design" (fall semester).

First graduate students enroll in the art department, Douglass College.

New Forms—New Media II, a group exhibition of seventy-two artists including Brecht, Dine, Kaprow, Oldenburg, Rauschenberg, Samaras, and Whitman is presented at the Martha Jackson Gallery and David Anderson Gallery (September–October).

Robert Whitman presents *American Moon,* a theater piece, at the Reuben Gallery (November–December).

Allan Kaprow installs *Apple Shrine,* an Environment, at the Judson Gallery (November–December).

George Segal has a solo exhibition of paintings and sculptures, Green Gallery, New York (November–December).

Robert Watts has a solo exhibition of assemblages and motorized constructions at Grand Central Moderns, New York (December 20–January 7).

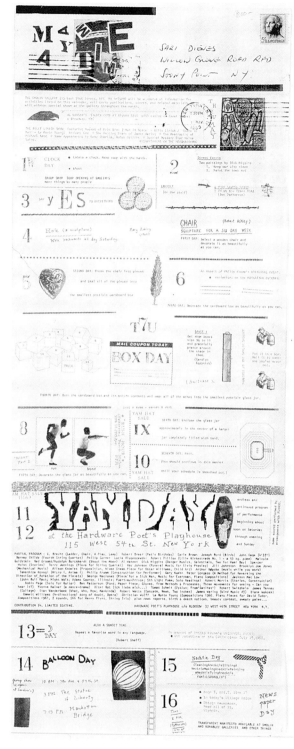

FIGURE 86
George Brecht and Robert Watts, *MAYAM TIME*
(*Yam Calendar,* recto).
Green and blue ink on paper.
22" x 8 1/2"
The Gilbert and Lila Silverman Fluxus Collection, Detroit.
Photograph by R. H. Hensleigh.

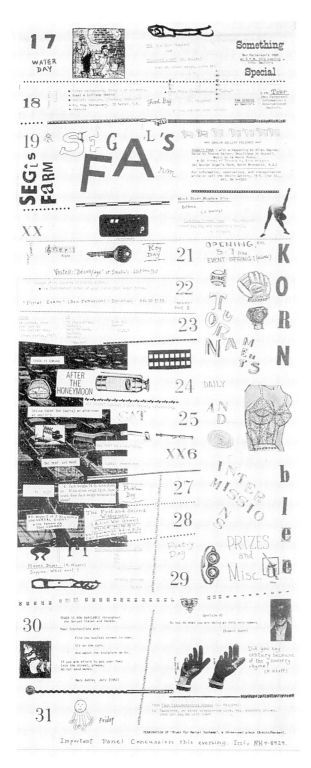

FIGURE 87
George Brecht and Robert Watts, *MAYAM TIME*
(*Yam Calendar,* verso).
Green and blue ink on paper.
22" x 8 1/2"
Gilbert and Lila Silverman Fluxus Collection, Detroit
Photograph by R. H. Hensleigh.

— 1961

Roy Lichtenstein has a solo exhibition of Abstract Expressionist paintings at the Douglass College Art Gallery (January).

Allan Kaprow presents *A Spring Happening* at the Reuben Gallery (March).

Robert Whitman presents *Mouth,* a theater piece, at the Reuben Gallery (April).

Reuben Gallery closes (May).

Environments, Situations, Spaces, an exhibition of six artists that includes Kaprow's *Yard,* Brecht's *Three Chairs Event,* Oldenburg's *The Store,* and Whitman's untitled environment is presented at the Martha Jackson Gallery and David Anderson Gallery (May–June).

Allan Kaprow is denied tenure and leaves Rutgers College at the end of the spring semester.

Roy Lichtenstein makes his first Pop painting, *Look Mickey,* which he shows to Allan Kaprow (summer).

The Art of Assemblage, a historical survey of 142 artists that includes George Brecht, Lucas Samaras, and Robert Watts is held at the Museum of Modern Art, New York (October–November).

Lucas Samaras has a solo exhibition of pastels, plasters, and boxes at the Green Gallery (December).

Robert Whitman presents *Ball,* a theater piece, at the Green Gallery (December–January).

Claes Oldenburg presents *The Store* at the Ray Gun Manufacturing Co., New York, in cooperation with Green Gallery (December–January).

Allan Kaprow programs the Hall of Issues at the Judson Memorial Church and presents *The Best of the Hall of Issues* (December–March).

George Maciunas chooses "Fluxus" as the name for a proposed interdisciplinary journal to present new work by experimental artists, writers, and musicians (March).

George Segal makes his first cast-plaster figures installed in found environments.

George Brecht and Robert Watts hatch the concept of the *Yam Festival* at their weekly lunch meeting

at Howard Johnson's, New Brunswick (most likely 1961; possibly early 1962).

Yoko Ono presents *A Grapefruit in the World of Park* at Carnegie Hall, with sound and movement by George Brecht, Jackson Mac Low, and others (November 24).

George Brecht starts mailing event cards and Robert Watts makes his first stamps.

— 1962

George Brecht presents *Dithyramb* (music and objects) at the Henry Street Playhouse, sponsored by James Waring and Dance Company (January).

Robert Watts has a solo exhibition of constructions, events, objects, and games at Grand Central Moderns (January 6–25).

Roy Lichtenstein has a solo exhibition of Pop paintings at the Leo Castelli Gallery (February–March).

Allan Kaprow performs *A Service for the Dead* and Robert Whitman presents *Movies with Sound, Song, and Play* at the Maidman Playhouse, New York (March 22).

George Segal has a solo exhibition of paintings and life-size plaster figures, Green Gallery (May–June).

Allan Kaprow presents *Chapel,* an Environment, and *The Night,* a Happening, at the University of Michigan, Ann Arbor (May).

First Fluxus performances in Europe, which include *Kleines Sommerfest: Après John Cage,* an evening of readings by George Maciunas and musical perfor-mances by Dick Higgins, Maciunas, and Ben Patterson at the Galerie Parnass in Wuppertal, (West) Germany, (June 9) and *Neo-Dada in der Musik,* which includes works by Nam June Paik, George Brecht, Dick Higgins, Toshi Ichiyanagi, George Maciunas, Jackson Mac Low, and La Monte Young in Düsseldorf (June).

Allan Kaprow presents *Sweepings,* a Happening, in the *Ergo Suits Festival* in Woodstock, New York, which also includes performances by Al Hansen, Alison Knowles, and La Monte Young (August).

George Segal enrolls in M.F.A. program at Douglas College for full-time study, after receiving a Walter K. Gutman Foundation grant (fall semester).

Fluxus Internationale Festspiele, the first official Fluxus festival, is held in Wiesbaden, and includes work by George Brecht, George Maciunas, Dick Higgins, and Alison Knowles (September 1–23).

Allan Kaprow presents *Words,* an Environment, at the Smolin Gallery, New York (September 11–12).

A *Faculty Art Show* in the Douglass College Art Gallery includes stamp machines by Robert Watts, paintings by Roy Lichtenstein, and constructions by Geoffrey Hendricks (October).

The New Realists, an exhibition of twenty-nine artists including Roy Lichtenstein and George Segal, is presented at the Sidney Janis Gallery (October–December).

Allan Kaprow presents *Chicken,* a Happening, at the YMHA in Philadelphia (November 7).

Allan Kaprow presents *Mushroom,* a Happening, in the Lehmann Mushroom Caves in St. Paul, Minnesota, sponsored by the Walker Art Center (November 17).

Allan Kaprow presents *Courtyard,* a Happening sponsored by Smolin Gallery, at the Mills Hotel, New York (November 23).

Festum Fluxorum, a Fluxus music festival at the American Students' Center in Paris, includes works by George Brecht and Robert Watts (December 3–8).

Al Hansen presents Happenings at his Third Rail Gallery of Current Art at 104 Hall Street, Brooklyn.

— 1963

Robert Watts and George Brecht present a *Yam Lecture,* a component of the *Yam Festival,* in New York (January 21).

Allan Kaprow presents *Eat,* an Environment in the caves of Ebling Brewery, Bronx, New York (January).

Robert Whitman shows *An Interior of Sculpture: New Work* at 9 Great Jones Street, New York City (January–February).

ALISON KNOWLES YAM HAT SALE
OPENING MAY 9, 8 P.M.

HATS HATS HATS HATS
HAT MADE IN U.S.A.
SALE
SMOLIN GALLERY
19 E 71 ST
SHOW UNTIL MAY 17th

HATS CREATED BY:
HANSEN, KAPROW, AYO,
PATTERSON, LEZAK, KNOWLES,
BRECHT, WATTS, GRAVES,
HIGGINS, EISENHAUER,
JOHNSON, GROOMS, WALDINGER
and others

Postkarte
BRUNSWICK
JAN 17
1963
N.J.
U.S. POSTAGE

An
YAM LECTURE MONDAY JAN 21, 1963
8:30 PM
133 2ND AVE. THIRD FL.
CONTRIBUTION $1.00

E. M. Plunkett
303 E. 76th St.
New York 21
N.Y.

NOTICE: A HAPPENING BY ALLAN KAPROW
 AT GEORGE SEGAL'S FARM SUNDAY
 AFTERNOON, MAY 19.

 FOR RESERVATIONS CALL SMOLIN
 GALLERY, N.Y.C. RH 4-8929.

FIGURE 88
Invitation to *Yam Hat Sale* and *Yam Lecture*, 1963.
Courtesy of Jon Hendricks.

Festum Fluxorum Fluxus, a Fluxus music festival that includes pieces by George Brecht, Al Hansen, Robert Watts, La Monte Young, and George Maciunas is held at the Staatliche Kunstakademie Düsseldorf (February–March).

Robert Whitman presents *Flower,* a theater piece, at 9 Great Jones Street, New York City (March).

A weekend dedicated to "An Experiment in the Arts" at Douglass College features Allan Kaprow as keynote speaker (April 5) and includes Happenings, experimental music, plays, and a faculty panel discussion. Al Hansen's *Parisol 4 Marisol* is presented at the Old Gymnasium and Hansen's *Carcophany* on the Corwin Campus; other works are by George Brecht, Dick Higgins, Ray Johnson, Joe Jones, Alison Knowles, Ben Patterson, Larry Poons, Emmett Williams, and La Monte Young. Participating in the faculty panel discussion are Roy Lichtenstein and Robert Watts (April 6).

Allan Kaprow presents *Push and Pull: A Furniture Comedy for Hans Hofmann,* an Environment at the Santini Brothers Warehouse, New York, sponsored by the Museum of Modern Art as part of *Hans Hofmann and His Students* (April 17).

Yam Festival organized by George Brecht and Robert Watts climaxes in a month of events that includes the following: *Group Shop Soup Opening* at the Smolin Gallery, New York (May 1); a *Party/ Benefit,* including an auction, at 498 East Broadway (May 4, 11, 18); *Yam Hat Sale* at the Smolin Gallery (with hats by Hansen, Vostell, Kaprow, Brecht, Watts, Eisenhauer, Grooms, Higgins et al.) (May 9–11); *Yam Day,* a program of music by John Cage, Morton Feldman, Philip Corner, and Karlheinz Stockhausen at the Hardware Poet's Playhouse, New York (continuous twenty-four-hour event, May 21–22); *Balloon Day,* a series of events by Brecht, to take place at Fifty-fourth Street and Seventh Avenue, the Statue of Liberty, and the Manhattan Bridge (May 14; all may not have occurred); *Tours by Ben Patterson,* New York (May 16–18); events by Robert Watts and Joe Jones at the Kornblee Gallery, New York (May 21–29); Ben Patterson's *Final Exam* at Smolin Gallery (May 22); Wolf Vostell's *Morning Glory,* a "de-coll/age" Happening at the Smolin Gallery (May 22–June 8); Robert Watts's *Spring Event Two* at the Smolin Gallery (May 25; may have been canceled); *The First and Second Wilderness/A Civil War Game* by Michael Kirby, at Kirby's loft at 113 Green Street, New York (May 28).

Yam Festival events at George Segal's farm in South Brunswick include Allan Kaprow's *Tree,* a Happening, Charles Ginnever's *A Sculpture Dance,* Yvonne Ranier's *A Dance,* La Monte Young's *Music;* Dick Higgins's *Lots of Trouble,* and Wolf Vostell's *Television De-collage.* The presentations are sponsored by Smolin Gallery (May 19).

George Segal presents his master's thesis exhibition of paintings, pastels, and sculpture at the Douglass College Art Gallery (January); he receives his M.F.A. degree in June.

Allan Kaprow performs *Bon Marché,* a Happening, at the Theatre Récamier in Paris (July 11–13).

Roy Lichtenstein takes a leave of absence from Douglass College (fall semester) and has a solo exhibition of Pop paintings at the Leo Castelli Gallery (September–October).

Allan Kaprow presents *Out,* a Happening, in the courtyard of McEwan Hall, Edinburgh, as part of the Edinburgh Festival (September 7).

Robert Whitman presents *Water,* a theater piece, in a garage behind 521 North La Cienaga Boulevard, Los Angeles (August 20–September 4).

Pop Art—USA, a group exhibition of forty-seven artists including George Brecht, Jim Dine, Roy Lichtenstein, Claes Oldenburg, and Robert Rauschenberg is held at the Oakland Art Museum and the California College of Arts and Crafts (September).

George Brecht, Alison Knowles, and Robert Watts present *Blink,* an environment and events at the Sissor Bros. Warehouse in Los Angeles (October 7–November 2).

— 1964

Lichtenstein submits letter of resignation to Douglass College.

— 1965

Ten from Rutgers exhibition is organized at the Bianchini Gallery by Allan Kaprow and includes George Brecht, Geoffrey Hendricks, Allan Kaprow, Gary Kuehn, Roy Lichtenstein, Phil Orenstein, George Segal, Steve Vasey, Robert Watts, and Robert Whitman. (December 18–January 12).

GENERAL BOOKS

Alloway, Lawrence. *American Pop Art*. New York: Collier, 1974.

Amayo, Mario. *Pop Art . . . and After*. New York: Viking, 1966.

Armstrong, Elizabeth, and Joan Rothfuss, eds. *In the Spirit of Fluxus*. Minneapolis, Minn.: Walker Art Center, 1993.

Battcock, Gregory, and Robert Nickas, eds. *The Art of Performance: A Critical Anthology*. New York: Dutton, 1984.

Brecht, George. *Chance Imagery*. New York: Something Else Press, 1966.

Brentano, Robyn, and Olivia Georgia. *Outside the Frame: Performance and the Object*. Cleveland: Cleveland Center for Contemporary Art, 1994.

Cage, John. *Silence*. Cambridge: MIT Press, 1966.

DeSalvo, Donna, and Paul Schimmel. *Hand-Painted Pop: American Art in Transition 1955–1962*. New York: Rizzoli, 1992.

Duberman, Martin. *Black Mountain: An Exploration in Community*. New York: Dutton, 1972.

Goldberg, RoseLee. *Performance: Live Art 1909 to the Present*. New York: Abrams, 1979.

Hansen, Al. *A Primer of Happenings and Time/Space Art*. New York: Something Else Press, 1965.

Harris, Mary Emma. *The Arts at Black Mountain College*. Cambridge: MIT Press, 1987.

Haskell, Barbara. *Blam! The Explosion of Pop, Minimalism, and Performance 1958–1964*. New York: Whitney Museum of American Art, 1984.

Hendricks, Jon, ed. *Fluxus Codex: The Gilbert and Lisa Silverman Fluxus Collection*. New York: Abrams, 1988.

Henri, Adrian. *Total Art: Environments, Happenings, and Performance*. New York: Praeger, 1974.

Hopps, Walter. *Robert Rauschenberg: The Early 1950s*. Houston: Fine Arts Press, 1991.

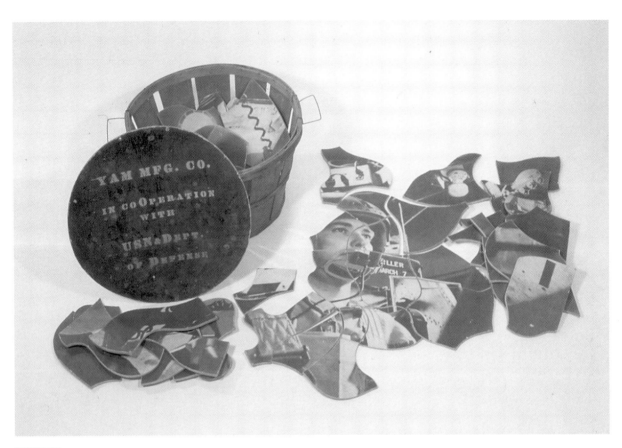

FIGURE 89

Robert Watts, *Yam Mfg. Co. in Cooperation with the U.S.N. & Dept. of Defense,* 1962–63.

Basket: 12" x 22" x 18"

Puzzle: 50 1/2" x 39 3/4" x 1/4"

Courtesy, The Robert Watts Studio Archive, New York.

Photograph by Larry Miller.

Kaprow, Allan. *Assemblages, Environments, and Happenings.* New York: Abrams, 1966.

Kirby, Michael. *Happenings: An Illustrated Anthology.* New York: Dutton, 1966.

Klüver, Billy, Julie Martin, and Barbara Rose, eds. *Pavilion: Experiments in Art and Technology.* New York: Dutton, 1972.

Kostelanetz, Richard. *The Theatre of Mixed Means: An Introduction to Happenings, Kinetic Environments, and Other Mixed Media Performances.* New York: Dial, 1968.

Lippard, Lucy. *Pop Art.* New York: Praeger, 1966.

McLuhan, Marshall. *The Mechanical Bride: Folklore of the Industrial Man.* New York: Vanguard, 1951.

Russell, John, and Suzi Gablik. *Pop Art Redefined.* London: Thames and Hudson, 1969.

Sandford, Mariellen R., ed. *Happenings and Other Acts.* London: Routledge, 1995.

Sandler, Irving. *The New York School: The Painters and Sculptors of the Fifties.* New York: Harper and Row, 1978.

Schimmel, Paul, Kristine Stiles, et al. *Out of Actions: Between Performance and the Object, 1949–1979.* Los Angeles: Museum of Contemporary Art, Los Angeles, 1998.

Seitz, William. *The Art of Assemblage.* New York: Museum of Modern Art, 1961.

Stich, Sidra. *Made in U.S.A.* Berkeley and Los Angeles: University of California Press, 1987.

Tomkins, Calvin. *The Bride and the Bachelors.* New York: Viking, 1968.

———. *Off the Wall: Robert Rauschenberg and the Art World of Our Time.* New York: Doubleday, 1980.

Whiting, Cecile. *A Taste for Pop: Pop Art, Gender, and Consumer Culture.* Cambridge: Cambridge University Press, 1997.

GEORGE BRECHT

Brecht, George. *The Book of the Tumbler on Fire: Selected Works from Volume 1.* Los Angeles: Los Angeles County Museum of Art, 1971.

———. *Chance Imagery.* New York: Something Else Press, 1966.

———. *Notebooks.* 3 vols. Edited by Dieter Daniels. Cologne: Verlag der Buchhandlung Walther König, 1991.

Martin, Henry. *An Introduction to George Brecht's "Book of the Tumbler on Fire."* Milan: Multipla Edizioni, 1978.

Onnasch Galerie. *George Brecht: Works 1957–1973.* New York: Onnasch Gallery, 1973.

GEOFFREY HENDRICKS

Berliner Kunstlerprogramm des DAAD. *Geoffrey Hendricks.* [West] Berlin: Berliner Kunstler-programm des DAAD, 1984.

Hendricks, Geoffrey. *Ring Piece by Geoff Hendricks: The Journal of a Twelve Hour Silent Meditation.* Barton, Vermont: Something Else Press, 1973.

———. *Between Two Points/Fra Due Poli.* Reggio Emilia, Italy: Edizioni Pari & Dispari, 1975.

Kunsthallen Brandts Klaedefabrik. *Geoffrey Hendricks: Day Into Night.* Odensee, Denmark: Kunsthallen Brandts Klaedefabrik, 1993.

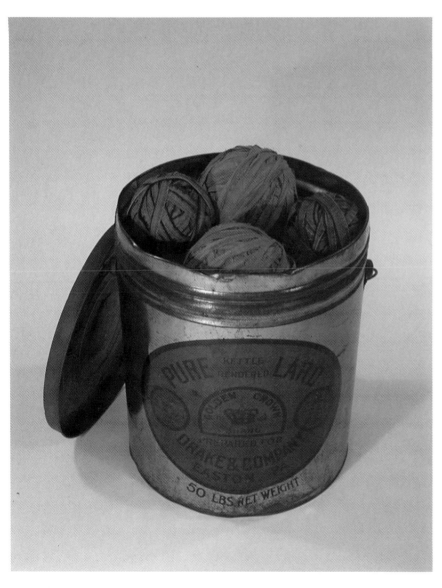

FIGURE 90
Robert Watts, *Balls of Rug Material, Readymade.,* 1959.
Found object, cloth in commercial tin bucket.
14 3/4" x 13" x 13"
Courtesy, The Robert Watts Studio Archive, New York.
Photograph by Larry Miller.

ALLAN KAPROW

Kaprow, Allan. *Assemblage, Environments and Happenings.* New York: Abrams, 1966.

————. *Essays on The Blurring of Art and Life.* Edited by Jeff Kelley. Berkeley and Los Angeles: University of California Press, 1993.

————. *Seven Environments.* Rome: Mudima, 1992.

Museum am Ostwall. *Allan Kaprow: Collagen, Environments, Videos, Broschüren, Geschicten, Happenings, und Activity-Dokumente 1956–1986.* Dortmund: Museum am Ostwall, 1986.

ROY LICHTENSTEIN

Alloway, Lawrence. *Roy Lichtenstein.* New York: Abbeville, 1983.

Busche, Ernest A. *Roy Lichtenstein: Das Frühwerk, 1942–1960.* Berlin: Mann, 1988.

Cowart, John. *Roy Lichtenstein.* New York: Hudson Hills, 1981.

Rose, Bernice. *The Drawings of Roy Lichtenstein.* New York: Museum of Modern Art, 1987.

Waldman, Diane. *Roy Lichtenstein.* New York: Abrams, 1971.

FIGURE 91
Robert Watts, *Goya's Box II,* 1960
Motorized kinetic construction, postage stamps, ink on paper, painted cloth, carpet, glass ornament, ping-pong ball, mirror.
15" x 11" x 7"
Courtesy, The Robert Watts Studio Archive, New York.
Photograph by Larry Miller.

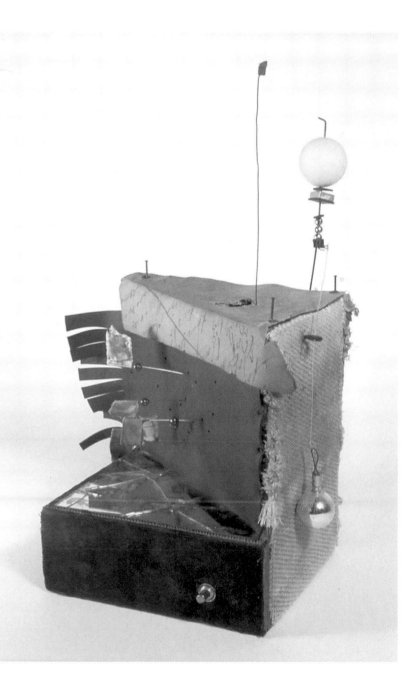

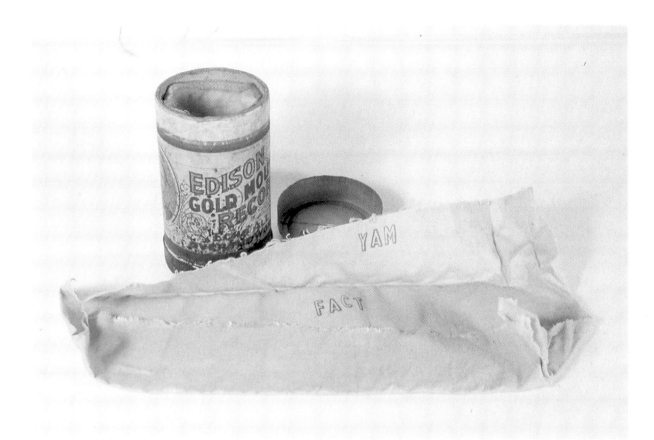

FIGURE 92
Robert Watts, *Yam Fact,* 1962–63
Canister: 4 1/2" x 2 5/8" x 2 5/8"
Rubber stamped ink on cloth; commercial cardboard container.
Courtesy, The Robert Watts Studio Archive, New York.
Photograph by Larry Miller.

———. *Roy Lichtenstein.* New York: Solomon R. Guggenheim Museum, 1993.

LUCAS SAMARAS

Alloway, Lawrence. *Lucas Samaras: Selected Works, 1960–1966.* New York: Pace Gallery, 1966.

Denver Art Museum. *Lucas Samaras: Objects and Subjects, 1969–1986.* Denver, 1988.

Doty, Robert M. *Lucas Samaras.* New York: Whitney Museum of American Art, 1972.

Glenn, Constance, and Jack Glenn, eds. *Lucas Samaras: Sketches, Drawings, Doodles, and Plans.* New York: Abrams, 1987.

Levin, Kim. *Lucas Samaras.* New York: Abrams, 1975.

Lifson, Ben. *The Photographs of Lucas Samaras.* New York: Aperture, 1987.

Schjeldahl, Peter. *Lucas Samaras Pastels.* Denver: Denver Art Museum, 1981.

GEORGE SEGAL

Finkeldey, Bernd. *George Segal: Situationen, Kunst, und Alltag.* Frankfurt am Main: Lang, 1990.

Friedman, Martin L. *George Segal: Sculptures.* Minneapolis, Minn.: Walker Art Center, 1978.

Hunter, Sam. *George Segal.* New York: Rizzoli, 1984.

Montreal Museum of Fine Arts. *George Segal Retrospective: Sculptures, Paintings, Drawings.* Montreal: Montreal Museum of Fine Arts. 1997.

Tuchman, Phyllis. *George Segal.* New York: Abbeville, 1983.

Van der Marck, Jan. *George Segal.* New York: Abrams, 1975.

FIGURE 93
Robert Watts: *Yam Collage,* 1961
Photograph of a wood engraving, dye cut partial alphabet, black cardboard, collaged printed images of body parts.
10 3/4" x 8 3/4"
The Gilbert and Lila Silverman Fluxus Collection, Detroit.
Photograph: R. R. Hensleigh.
This piece by Watts is believed to be the first use of the yam which was later adopted by Watts and Brecht for the *Yam Festival.*

ROBERT WATTS
Lafayette College Art Gallery. *Robert Watts.* Easton, Pa.: Lafayette College, 1991.
Leo Castelli Gallery. *Robert Watts.* New York: Leo Castelli Gallery, 1990.
Stamp Art Gallery. *Robert Watts/Artistamps/ 1961–1986.* San Francisco: Stamp Francisco, 1996.
Watts, Robert. *FluxMed, Robert Watts obra grafica.* Madrid, 1987.

ROBERT WHITMAN
Hudson River Museum. *Robert Whitman: Palisade.* Yonkers: Hudson River Museum, 1979.
Klüver, Billy, and Julie Martin. *Robert Whitman: Theater Works, 1960–1976.* New York: DIA Foundation, 1976.
Museum of Contemporary Art, Chicago. *Robert Whitman: Four Cinema Pieces.* Chicago: Museum of Contemporary Art, 1968.

SIMON ANDERSON is the head of the academic division at the School of the Art Institute of Chicago. He has published numerous articles on Fluxus and Performance, including "Fluxus Publicus" in *In the Spirit of Fluxus* (Minneapolis: Walker Art Center, 1993).

JOSEPH JACOBS is the curator of American art at the Newark Museum. His publications include *Since the Harlem Renaissance: Fifty Years of Afro-American Art* (Bucknell University, 1984), *This Is Not a Photograph: Twenty Years of Large-Scale Photography* (Sarasota: The Ringling Museum of Art, 1987), and *A World of Their Own: Twentieth-Century American Folk Art* (Newark: The Newark Museum, 1995).

JACKSON LEARS is Board of Governors Professor of history at Rutgers, the State University of New Jersey. His books include *No Place of Grace: Anti-Modernism and the Transformation of American Culture, 1880–1920* (New York: Pantheon, 1981), which was nominated for the National Book Critics Circle Award. Another book, *Fables of Abundance: Cultural History of Advertising in America* (New York: Basic, 1994), received the Los Angeles Times Award and the New Jersey Council on the Humanities Award for best book in the humanities.

JOAN MARTER is a professor of art history and the director of the Curatorial Studies Program at Rutgers, the State University of New Jersey. Her books include *Alexander Calder* (New York: Cambridge University Press, 1991 and 1997

[paperback]), *Theodore Roszak: The Drawings* (Seattle: University of Washington Press, 1991), *José De Rivera* (Madrid, 1980), and [as co-author] *American Sculpture: The Collection of The Metropolitan Museum of Art* (New York, Metropolitan Museum, 1999). She has received the George Wittenborn Award, Art Libraries Society of North America; the Charles F. Montgomery Prize, Society of Architectural Historians; and a Graduate Teaching Excellence Award at Rutgers University.

KRISTINE STILES is an artist and an associate professor of art and art history at Duke University. She coedited (with Peter Selz) *Theories and Documents of Contemporary Art* (Berkeley and Los Angeles: University of California Press, 1996), and her forthcoming books include *Correspondence Course: The Letters and Performances of Corolee Schneemann* (Baltimore: Johns Hopkins University Press) and *Uncorrupted Joy: Considering the Social Value of Performance Art Internationally* (University of California Press). She has written numerous monographs and articles on destruction, violence, and trauma in art, and contributed to such exhibition catalogs as *Out of Actions: Between Performance and Its Objects, 1949–1979* (Los Angeles Museum of Contemporary Art) and *In the Spirit of Fluxus* (Minneapolis: Walker Art Center, 1993).

LENDERS TO THE EXHIBITION

Bill Bass

Hermann Braun, Remscheid, Germany

Robert Delford Brown

The Chrysler Museum, Norfolk, Virginia

Nye Ffarrabas

Geoffrey Hendricks

Jon Hendricks

Sidney Janis Gallery, New York

Allan Kaprow

Palais Liechtenstein, Vienna

Larry Miller

Moderna Museet, Stockholm

The Museum of Contemporary Art, Los Angeles

The Museum of Modern Art, New York

The National Gallery of Art, Washington D.C.

The Newark Museum

PaceWildenstein, New York

Robert Rauschenberg

Lucas Samaras

George Segal

The Gilbert & Lila Silverman Fluxus Collection, Detroit

The Sonnabend Collection, New York

The Robert Watts Studio Archive, New York

Claudia, Kathryn, and Patricia Weill

Harold and Lois Weitzner

Robert Whitman

The Whitney Museum of American Art, New York

The Jane Vorhees Zimmerli Art Museum, Rutgers, The State University of New Jersey

Numbers in italics refer to black-and-white illustrations. Color plates are indexed by plate number.